George Nelson: The Design of Modern Design

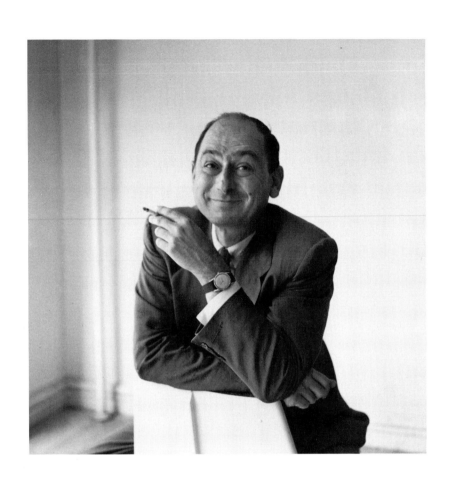

George Nelson: The Design of Modern Design

Stanley Abercrombie

foreword by Ettore Sottsass, Jr.
appendixes compiled by Judith Nasatir

The MIT Press
Cambridge, Massachusetts
London, England

Set in Frutiger by DEKR Corporation.
Printed and bound in the United States of America.

Library of Congress Cataloging-in-Publication Data

Abercrombie, Stanley.
 George Nelson: the design of modern design / Stanley Abercrombie;
 foreword by Ettore Sottsass, Jr.; appendixes compiled by Judith
 Nasatir.
 p. cm.
 Includes bibliographical references and index.
 ISBN 0-262-01142-5
 1. Nelson, George, 1908–. 2. Designers—United States—
 Biography. I. Nasatir, Judith. II. Title.
 NK1412.N45A24 1994
 745.4′492–dc20
 [B] 94-13536
 CIP

Contents

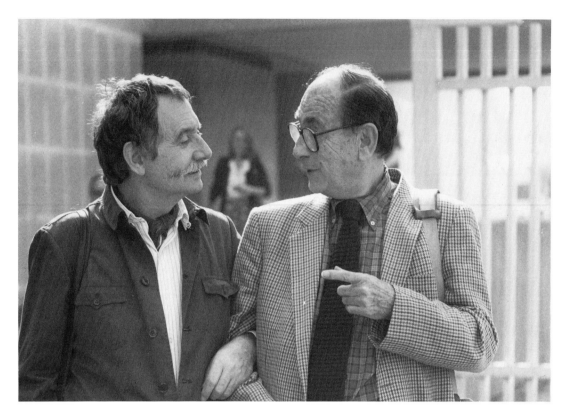

Ettore Sottsass, Jr., and George Nelson.

Foreword

In 1953–55 in Italy, as far as design (and not only design) was concerned, we were in a bit of a disastrous state. I, at any rate, was in a very disastrous state.

There was no civilized industry, no industry for people. Chairs, tables, cupboards, lamps, sofas, beds—everything—was made by hand, and there wasn't even the vaguest idea of what private and public culture might become when pressed by industrial conditions.

In those days I personally hated craft industries. For me and the so-called avant-garde architects and designers, craft industries were a metaphor for classical refinements at the price of slavery and poverty.

Instead, there was a new society to be designed. . . .

On the other hand Italian industry, the industry that was to produce dishwashers, vacuum cleaners, electric razors, forks, spoons, and so on, was just beginning, very slowly, to become aware not only of the new techniques and technologies but also of the new existential people, the new figures. It was beginning to notice the new needs and desires of a society plunging at supersonic speed into modernity and the future.

One day, or rather one evening, I don't remember the date, but perhaps one of those horrible foggy Milan winter evenings, George Nelson arrived at our house accompanied by Lisa Ponti. I don't know if you have ever happened to receive a calm, absolutely calm man in your house, and suddenly to know that the air around you has changed, that words have changed, that all the normal reference points of your life have changed—to realize all of a sudden that you've got to speed up the whole general method, speed up your visions, your programs, or maybe even your entire utopia. Young ladies, perhaps, find themselves in this state of mystery when they meet an absolutely calm, good-looking man. I have personally, a few other times, fairly seldom, but just occasionally (because I am a lucky man), found myself in a mysterious state similar to that created by the presence of George Nelson. I met Hemingway, who had a chest covered in white hair and a deep clear voice and who embraced me with heavy tender hugs. I met Ginsberg, with his desperate, slow, Hebrew total vision of the planet's destiny. Once, Francesco and Alba Clemente

came into my house and filled it with all the possible mysteries, odors, and colors of the East and also other mysteries of the Italian Mediterranean.

One evening George Nelson arrived.

He smiled and talked in a hoarse voice, smoking king-size non-filter cigarettes and coughing. He spoke about everyday things; he didn't mention either design or manufacturers, or offices, or anything like that: he spoke about everyday things. Besides, there weren't many other things to say, because usually, in these cases, you talk gossip, about people and friends in common, about people coming and going, people you know and don't know; you talk really to size up the situation, to see whether you are traveling on the same wavelength or not.

Evidently we were traveling on the same wavelength. Indeed, George was traveling on mine, without effort, because I knew little or nothing about America and he knew everything about Italy. He knew the Italian intellectual game very well, he knew all about the Italian crafty ways, he knew about Italian conceits and sins, the courage, patience, sophistication, and secrets; he knew the whole comedy; he knew that the Italians always fly up into the air, seeing landscapes that don't exist, imagining themselves in a present and future that always vanish, into their own fragility.

George Nelson was traveling effortlessly on our wavelength, possibly because he had been in Italy a few years but mainly because his mental mechanisms, his curiosities, and his enthusiasms had no borders; they were not provincial; they roamed everywhere, in all directions, imagining history and "histories" continually expanding in a global sphere. George Nelson's existential vision acknowledged no compartments, partition walls, specializations, or special keys. Life and thought, the irrational, the rational, the true and the imaginary, were for him open regions, permanent collages, continuous landscapes to be crossed.

Anyway, that evening long ago perhaps we became friends, more by words unspoken than spoken, more by hopes announced than by established programmes, more by mysterious necessities or mysterious inclinations than by any sort of certainties.

He said to me: "Why don't you come and see me in New York?" I told him I didn't have enough money. Italy was in a disastrous state, and so was I. He said: "Come and work with me for a while." "Really?" I said. . . .

I found myself in New York, a black, opulent city, invaded by yellow cabs, unexpected fumes, and green glass canyons, after a very long

flight on a Constellation, probably a war relic. The evening I arrived I went to sleep at George's place. George had a large, modern, dark apartment, with lamps hidden in the ceiling from which beams of theatrical light descended. Then there was the furniture designed by him, long elegant, subtle pieces, lacquered in gray and orange, with attractive drawers and tiny handles, resting on black carpets, and then plastic Danish, smooth, dark red cups, and tables in stainless steel and white plastic laminate, all polished and sophisticated, all as mysterious as a hidden ritual. . . .

Actually, during those years George (with Eames, Girard, and a few others) was concentrating on a long, complicated ritual. He was experimenting with a solitary, special initiation that would eventually enable him to bear the deafening roar of machines that had tipped and kept on tipping on top of people, at every hour and minute—that kept churning out disconnected avalanches of new, uncontrolled, ominous, uncontrollable existential conditions. That evening many years ago, on entering George's dark apartment, with that strange silence and those rare, strange noises of hidden pipes, muffled by possibly black or maybe Prussian blue moquettes and carpets, with those odd odors never smelt anywhere else, of miscellaneous plastics, glues, and innumerable varnishes, I felt as if I was entering an imaginary crypt, where an equally imaginary religious service was being conducted, a wordless ceremony wafted on the odors of exotic incenses. If I think of him now, I really believe that George in those days must have been pursuing a vast solitary vision, perhaps not in a totally organized way, but sure of his own destiny.

I truly believe that in those years George Nelson, and his very few traveling companions, were trying to offer the whole of America—the whole noisy, breathless America, the greedy, ferocious America, the uncertain America—a new proposal; that they were trying to offer the design for a new metaphor for a new society, a society that for better or worse would be increasingly conditioned by the narrow mechanisms of the "industrial civilization."

Certainly for George Nelson doing design did not mean going out to look for just any more or less updated "style," and certainly nothing was further from his mind than to be or to become an "interior decorator." George Nelson was not planning to give a figure, or to design metaphors for American society just as it was, nor was he interested in designing landscapes "from life" as interior decorators do. George Nelson endeavored to design imaginary landscapes. He wanted to design for an American society to come, a society that could have become the new soci-

ety, invaded by prosperity, by the certainties of technology, invaded by optimism—a relaxed society, a society capable of playing, a society capable of humour, and above all a society without fear.

That George Nelson, horribly alone, was trying to design for a society of people without a shade of fear (not, certainly, for the Rambos, the most scared of all) is something I know for sure, because I know for sure that George was the first not "to be afraid." I know, despite his thousand cigarettes a day, despite the cigarette smoke that used to hide him as if in a pale blue cloud, that he was calm, always ready to start again from scratch. He never announced anything, neither his power nor his greatness; he never showed off his successes or moaned about his disasters; he just carried straight on, smiling, tackling problems unsolved by others, playing down the horrors, continuing to hope. . . .

I worked in George's studio for a few months, until I had to come back to Italy. In his studio I learned that America was there, and I learned that George Neson was there, that he was going on imagining a calm, strong, panic-free America with people who could build a clear future for themselves.

I learned a great lesson on life, on culture. I learned that architecture and design were not just a matter of being more or less "artists," more or less "original," more or less "creative," as they say today. Instead I learned that being an architect or a designer also means abandoning yourself completely, as you are, day after day, understanding where society is going, or rather where history is going, where our destinies and other people's are going, where everybody's destiny is going.

I watched George. He moved about day after day, like a man who knows how complicated it is to know something, how complicated it is to imagine the future, how complicated it is to design metaphors with at least a vestige of reliability.

George reminded me of those workers who dig a hole in the ground and dig very very slowly because the hole is very big and deep and they mustn't get tired too quickly. Those workers lift the earth slowly to get to the bottom where there's something to be repaired, maybe a water pipe. . . .

George received his slightly aggressive, slightly coarse clients, in a hurry to get down to business, and explained things in his hoarse voice, with his measured gestures, enveloped by the holy cloud of his cigarettes. He would explain slowly, as if what he was saying was only just the very

outermost tip of a vast iceberg of knowledge, experience, and possibilities, of visions that lay underneath everything that was being said.

You had to say very little to George, because that very little was exactly the right possible and sufficient amount to vulgarize a vision so sophisticated, ambiguous, and frail that beyond those few words it could not have been vulgarized. In overexplaining there is always the risk of denying mysteries, of slowing down the tempo, of stifling the vibrations and excluding the unknown.

Sometimes George used to show slides that he had done himself, perhaps with the idea of explaining a bit better. George's logic in choosing the photographs to be taken inevitably and exactly fitted the logic of his existential design.

He went ahead by small steps, slowly but insistently digging out an image of the world that surrounded him. It was not a world that could be defined outright, not a total landscape or reality, but a world that could, if anything, be defined as a compound of dynamic links between infinite quantities of details, infinite quantities of rapid images, visible and invisible, seen, foreseen, and never actually appearing, infinite surface and subterranean tensions.

I remember the projection of slides, representing pieces of an exploded and buried world, pieces and fragments of colors, textures, hinges, reflections, lines, sharp edges, words, materials . . . intense, clear, dry fragments, perfectly defined in themselves, but every fragment—by itself—without, or almost without, meaning. Really those slides were the isolated fragments of an enormous, highly complicated, incomprehensible puzzle, certainly never simplified, never defined, never finished nor ever to be finished; it was the puzzle formed by the logic and figures of contemporary history.

I believe George took millions of photographs and wrote and spoke millions of words in trying to pursue a hypothetical figure of contemporary life and its fragmentariness. I also believe his architecture and products were justified by the same anxiety: that of approaching a permissible figure of contemporaneity by uninterruptedly piecing together the fragments of a continuous puzzle, relying very little on memories of ancient coagulations and, still less, on new, even if provisional coagulations.

For many years we did not meet. Sometimes we would bump into each other hurriedly at conferences or occasions like that, he with his

camera, his cigarettes, his pale blue cloud, his hoarse voice, and the sadness that grew with time as utopia became increasingly a flight into the cosmos, as the world around him got steadily heavier.

The last time we met was at Aspen. He was coming down from the platform, where he had once again, despite everything, recounted his hope, and I was going up to the platform to give the speech I had been asked to deliver.

In passing we shook hands.

We were both dressed in black.

Ettore Sottsass, Jr.

Acknowledgments

Nelson himself made fun of these things. In his own acknowledgments for *How to See,* he wrote:

> I have always marveled at the massive battalions assembled to assist in the creation of a book: prides of lofty academics who "criticized the manuscripts and offered invaluable suggestions"; gaggles of tireless researchers who, presumably, researched; loyal secretaries pecking away into the small hours to come up with the flawless manuscripts; patient wives without whose unflagging encouragement— and on and on.

Despite Nelson's teasing, there are many people to be thanked for this present book. First, there *has* been a patient wife: Nelson's own. Jacqueline Nelson was the person who asked me to write this book. She made available for my use her considerable archives and suggested other sources of information. While never interfering or censoring, she insisted on an impossible requirement: that, no matter what else it might reveal, the book must have the flavor of Nelson's personality. I hope she will think there has been some small success in this direction, but it is necessarily far from total.

Second, there has been the friendly and intelligent guidance of Nelson's friend Rolf Fehlbaum, who kept the project on track. Allon Schoener has also been a helpful ally to the project.

I am grateful to the Design Arts program of the National Endowment for the Arts for supporting some of the time and travel the project required. I thank Randolph McAusland of the NEA, and I also thank those who wrote in support of my grant application: Peter Blake, Niels Diffrient, Ann Ferebee, and Edgar Kaufmann, jr.

At Herman Miller, Inc., John Berry and Linda Folland have been extraordinarily generous and constructive, opening their archives and arranging interviews for me with many key people, including D. J. De Pree, who at age 98 appeared to have complete recall of his company's early history.

The Archives of the History of Art at the Getty Center for the
History of Art and the Humanities, in Los Angeles, made available corre-
spondence between Nelson and Frank Lloyd Wright. For other correspon-
dence I thank Tom Pratt, Hilda Longinotti, Theo Crosby, Arthur Gensler,
and the Lamar Dodd Archive at the University of Georgia.

My friends Ann Ferebee and David G. De Long both read the
manuscript and made helpful suggestions.

Judith Nasatir, credited with the important appendixes at the end
of the book, deserves credit for more as well. She was an indispensable
guide to the material in Jacqueline Nelson's archives, and she repeatedly
helped improve my own text with her gentle but pointed questions.

Erica Stoller of ESTO Photographics and Gil Amiaga contributed
generously to the book's illustrations, and thanks go as well to the work
of all the book's other photographers, some of whom we were unable to
contact.

Acknowledgment should also be given to the many talented peo-
ple who worked in the Nelson office. As for any large design office, the
credit due to those in the drafting room relative to the credit due to the
one whose name is on the door is often debatable, and not all employees
of the Nelson firm may be content with their recognition in the story that
follows. But this is not meant to be a book about specific products, many
of which are mentioned only in an appendix, or about those who worked
on the products, but rather about the ideas behind and beyond them.

Even more important than printed materials has been a series of
interviews (a few only by telephone or mail, but most conducted in
person) with some of the many people who knew Nelson, and I am
grateful for their time and memories. They include Saul Bass, Ronald
Beckman, Arthur BecVar, Maria Bergson, Robert I. Blaich, Peter Blake,
Bruce Burdick, Susan Burdick, Ralph Caplan, Ivan Chermayeff, Colin
Clipson, Mildred Constantine, Theo Crosby, Virginia Dajani, D. J. De Pree,
Hugh De Pree, Max De Pree, Lucia de Respinis, Niels Diffrient, Lamar Dodd,
Jack Dunbar, William Dunlap, Dolores Engle, Alan Fletcher, Sam Friedman,
M. Arthur Gensler, Jr., Philip George, Milton Glaser, Michael Graves, Paul
Grotz, Irving Harper, Helena Hernmarck, Paul Heyer, Sheila Hicks, Thomas
C. Howard, John Johansen, Rosamind Julius, Henry Robert Kann, Wendy
Keys, Françoise Jollant Kneebone, Alexia Lalli, Paul László, Richard
Latham, Mary Jane Lightbown, Leo Lionni, Hilda Longinotti, Jim Lucas,

Randolph McAusland, Peter Marino, Jack Masey, Peter Millard, Charles Morris Mount, Preston "Pep" Nagelkirk, Jacqueline Nelson, Mico Nelson, Norbert Nelson, John Neuhart, Marilyn Neuhart, Kathryn Noles, Elizabeth Paepcke, John Pile, Tom Pratt, Harvey Probber, Christopher Pullman, Elizabeth Reese, Ettore Sottsass, Jr., Joe Schwartz, Jane Thompson, George Tscherny, and Henry Wolf.

S.A.

A Personal Preface

George Nelson (1908–1986) was a central figure in the crucial early period of modern design. He was an important designer, but design in the conventional sense was not one of his major concerns. This book is, primarily, about those concerns.

Not that Nelson and his office were negligible in production or creation. Nelson invented or contributed to some of the most familiar features of modern living: the shopping mall, the storage wall, the multimedia presentation, the open-plan office system. Some of the particular products of his studio were icons of their time: the bubble lamp, the sling sofa, the ball clock. And some of his larger-scale designs were among the most important of their day: the Fairchild house of 1941, the Moscow exhibition of 1959. He was responsible for urban design, architecture, interiors, exhibitions, graphics, furniture and product design, slide shows and films, articles and books.

But it was Nelson's greatest strength to see and communicate the shortcomings of the new world he had helped to form. These shortcomings included the proliferation of consumer products, well designed and otherwise. He deplored the American consumer's obsession with material goods, and he often regretted his own contribution, as a product designer, to that obsession. His happiest moments, I think, came not in his studio but in his travels, sampling the world's design, wandering its cities, meeting its most creative people, testing his ideas against theirs, arguing and persuading.

I was privileged to know Nelson for the last dozen years of his life, when the most innovative period of modernism was ending. We met when I was working for the magazine *Architecture Plus,* and Peter Blake, the editor-in-chief, had asked me to cut an article by Nelson to fit an available space.[1] Edit George Nelson! I was awed by the task and wary of showing such an eminent writer the results, but when the time came Nelson smiled and said that my changes had actually improved his piece. We both knew this to be quite a big lie, but his kindness was a great relief. A couple of months later, he spotted me at an Aspen design conference—my first—and instantly became my tutor and protector, introducing me to

people, finding me chairs at luncheon tables, and including me in conversations with the wise and the celebrated, among whom he himself was one of the most celebrated and certainly the most wise.

We were friends ever after, but of the sort that can go for months at a time without contact. On several occasions and for several different magazines we repeated the writer-editor relationship. Once, at his suggestion, we even worked together on a design project—a mechanically animated exhibition for the lobby of a building for the Herman Miller furniture company. The experience gave me a close look at how he worked, at least on that occasion. We would have lengthy meetings with generous amounts of talking, drinking and smoking, during which Nelson would describe his vision for the design, never lifting a pencil. I would leave, attempt to put on paper some semblance of what I thought he meant, and return with my sketches. Sometimes Nelson would find them hopelessly foreign to what he had pictured; sometimes they would be acceptable; but even when right on target, they served mainly to provoke him into thinking of other possibilities. "What if . . . ," he kept saying, and "Why couldn't we. . . ." The process could have gone on forever. In the end the job stalled, then stopped, an outcome that I later suspected Nelson had anticipated even as we were working, but we had a very fine time along the way.

More often, though, we just talked with no particular goal in mind—usually at The Players, a dark-paneled New York theatrical club that was a convenient stop between Nelson's Park Avenue South office and his Gramercy Park apartment. Or, rather, Nelson talked and I listened.

This pattern was not, for Nelson, a way to pass the time, but part of his working process. His ideas rolled out, hopped about, branched, and sometimes focused, and the process of verbalizing them was part of his serendipitous approach to conclusions, an example of the "productive inefficiency"[2] he relished. My own role was simply as a sympathetic receptor of sound, my responses mostly murmurs and grunts, and my own enlightenment a lucky by-product—but a delightful one. Being educated by Nelson was never a pedantic process, but one graced by his personality and mind. The photographs in this book can hardly suggest the character of his presence. He constantly gave the impression—through a near-wink, an almost-smile, or a knowing peer over the top of his horn-rimmed glasses—that he was about to say something clever and slightly scandalous. He didn't disappoint: he always *did* say such a thing. And in an inimitable voice. His good friend Bill Dunlap has described Nelson as "an

unremitting smoker" with "an uncontrollable, raspy, consumptive cough."[3] The smoking, for all its ill effects, may also have contributed to that voice, cultivated in tone but grainy in texture, quiet but deep, a voice one instinctively heeded.

He had a distinctive voice as a writer, too, and, like his talking, his writing was part of his working process—a means toward correctly formulating a design problem and thus precluding the easy solutions of lesser designers (solutions that would be stereotypical and unsatisfactory because they answered an inexactly defined need). Because his writing was not only skillful but crucial to his work, a great deal of it—some previously published, some not—is quoted in the book. The idea of paraphrasing Nelson's prose seems ridiculous.

Talking or writing, Nelson was never boring; in return, he expected not to be bored. Generous as he was with his time and his ideas, he was impatient with pretense, and he took delight in deflating the self-important and in exposing the absurdity of widely held beliefs and commonly accepted knowledge. He edited, always, the superior from the ordinary, not only in writing and not only in design but in everything around him. He could be acerbic as well as congenial, and even when he was bubbling with good humor he held himself at a critical distance from the world's commerce and conventions.

One result of this detachment was that, for all his talents, Nelson never developed the knack of being a shrewd businessman—it just didn't engage him—and he once described his role in his own office as that of an "unwilling administrator."[4]

Another result, perhaps, was the erratic pattern of his attention. Whereas many designers of his stature show enthusiasm for finished development, Nelson loved the initial invention of a solution, then liked galloping along to a different solution or to the next problem. In contrast to his designer colleague Charles Eames's way of working by pursuing the perfection of technical details, which Nelson considered "rigorous," he described his own as "sort of a grasshopper way."[5]

Judith Nasatir, to whom much of the credit for this book is due, has remarked that this description of Nelson's working method reminds her of Plato's description of Socrates as a gadfly. While Nelson would have promptly skewered such a pretentious analogy, there was something a bit Socratic in his lack of dogma, his skeptical questioning, and his scrutiny of conventional wisdom and religion, and something very Socratic indeed in his love of talk with informal groups of disciples. And when, according to

Plato, Socrates says that he plans in Hades to "find out who is wise, and who pretends to be wise and is not," he describes an activity Nelson greatly enjoyed on earth.

Nelson's work as a designer was also complicated by the fact that he had so many interests other than pure design. In fact, he saw that pure design was pointless, if, indeed, it ever existed, and he was well aware of design's limitations: "It cannot transform a dark brown little life into a large, brightly colored one—only the person living the life can do that."[6] He had a passion for relating things to one another: technology to education, social change to aesthetics, invention to war, global crisis to love. He also had a passion for communicating, which may be pretty much the same thing. None of his discoveries or intuitions was held private in hopes of personal gain; they were always eagerly communicated to friends, colleagues, or students in his conversation and to wider audiences in his writing.

"What the creative act really means," Nelson wrote, "is the unfolding of the human psyche in the sudden realization that one has taken a lot of disconnected pieces and *found,* not *done,* a way of putting them together."[7] His emphasis, as in this definition of creativity, was always on the newly found relationship, never on the isolated object. He produced some beautiful objects, of course, but they are incidental to his most serious interests.

This record of Nelson's accomplishments is therefore different from the usual designer profile. It is not a picture book of designed buildings and objects, nor is it a biography chronicling marriages, births, and honors.[8] Instead it tries to trace something more unusual: an investigative adventure that took place not primarily at the drafting table but in one man's remarkable imagination.

S.A.

George Nelson: The Design of Modern Design

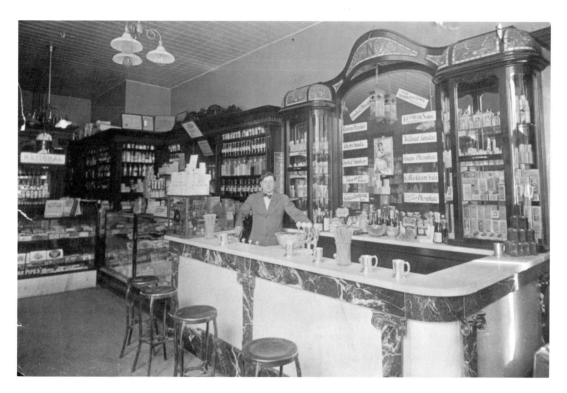

Simeon Nelson in his drug store, ca. 1925.

Even if George Nelson could have imagined the wildly varied career that awaited him, there would have been no way of finding a formal education that could have prepared him for it. He didn't need one. The education that he did, almost by chance, select—that of an architect— probably served him better than any other of the time could have, however, for it was the sort of training that encourages seeing things as related: buildings to their cities and to their neighbors, exteriors to interiors, heights to widths, concepts to details.

George Harold Nelson was born in 1908 in Hartford, Connecticut, which decades later he would call "a progressive little city widely known as 'the Insurance Capital of America.'"[1] His grandparents were Russian Jews. His father Simeon, who had come to America at the age of 15, was a successful pharmacist with his own drugstore. Simeon Nelson read to the family constantly in the evenings—often Pushkin and other Russian authors, but always in English translation, for he was dead set on becoming American. George's mother, Lillian Canterow Nelson, born in the United States to parents who were both physicians, was equally intent on culture. For her this meant china painting, needlework, and music; for her three sons (George was the first[2]) it meant as intellectual and cultivated an atmosphere as she could devise. The scene for this mandatory refinement was a two-family house in the north end of Hartford, described by George's brother Norbert as a "post-Victorian zoo" of bronze statues, alabaster figurines, and cut-glass lamps.[3] The family emphasis was definitely on civilization, not on commerce. As George Nelson recalled years later, "there was nobody around who said 'Go out and get rich,' so I followed their instructions and never did."[4]

Nelson finished Hartford Public High School in 1924, his two contributions to the graduation ceremonies being the playing of Mendelssohn's *Rondo Capriccioso* and a brief speech about the American composer Edward MacDowell. Although Nelson would remain a classical music enthusiast, his interest would never develop into professional involvement, and in his later writings about visual arts of all sorts music seldom seems to be mentioned even as illustration or metaphor. An exception was his relish in the late 1970s for Pink Floyd's rock album "The

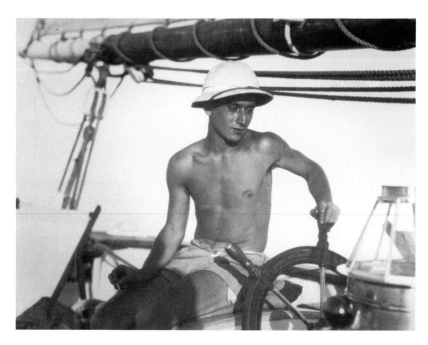

George Nelson sailing at age 19.

Wall," which he described as "a long musical poem dealing with sadism, child abuse, Momism, mass insanity, a psychotic axe murderer, the Bomb, and other familiar items in the daily news"[5] and which he compared to José Ortega y Gasset's similarly despairing remark that "our time, being the most intensely technical, is also the emptiest in human history." In a manner typical of his mature years, however, Nelson noted these observations without sharing their despair, pleased at making the connection between a Spanish philosopher, a Danish mystic (he also dragged Kierkegaard into the argument), a Czech writer (Kafka), and a rock group. "The connections game is a process of building patterns," he said. "Patterns make things intelligible."[6]

In the fall of 1924, at age 16, Nelson entered Yale—"because it was the nearest school and it represented something great in my father's eyes."[7] Despite the decade's epithet, "roaring," it was generally a placid and prosperous time in American history. Friml's *Rose Marie* and Romberg's *Student Prince* were both on Broadway in 1924; Buster Keaton's *Navigator* was on the movie screen; and the country, four years

into its experiment with prohibition, was in the grips of the Mah-Jongg craze, switching from auction to contract bridge and about to elect Calvin Coolidge.

Nelson had entered Yale with no clear course of study ahead of him, but in his sophomore year, as he later recalled, he experienced a revelation. Cutting through the architecture building to avoid a sudden shower, he happened on "a series of ten-day design projects by some student architects. The title of the project was 'A Cemetery Gateway,' and the presentations were watercolor and tempera renderings. They were the most exquisitely beautiful and exciting things I had ever seen in my life. I fell in love instantly with the whole business of creating designs for cemetery gateways. This was when, without any further question on my part, I decided I had to be an architect."[8]

So Nelson went to see the dean, Everett Victor Meeks, "a pretty wise old bird" who "knew a number of things that I didn't know. One was that the student projects were really awful. . . . He wasn't worried about talent because he was accustomed to students who seemed to have no talents at all. Furthermore, this was in the mid-twenties, and he was very hard up for students because everybody wanted to be a customer's man on Wall Street and get rich overnight. So I had no trouble getting accepted."[9]

Nelson's study of architecture in the 1920s coincided with a revolution in design, but at the time the excitement was far from New Haven. Most of the foundations of the modern movement had been laid in Europe.[10] The Bauhaus, founded in Weimar in 1919, moved to its Walter Gropius–designed home in Dessau in 1925; Le Corbusier had published *Vers une architecture* in 1923 and was at work on the La Roche and Jeanneret houses in Paris; Ludwig Mies van der Rohe was proposing glass skyscrapers for Berlin. In the United States, modern architecture could boast of only one native master: Frank Lloyd Wright, whose own teacher, the great proto-modernist Louis Sullivan, had died in 1924. Wright's Larkin building, Unity Temple, Imperial Hotel, and Robie and Coonley houses were all famous accomplishments, but Wright in 1924 had few American companions on the march toward modernism.

Architectural training at Yale was not then directed toward involving the students deeply with the tenets of either classicism or modernism, but rather toward teaching them the techniques of making convincing visual arguments. Nelson recalled:

At this point I had no idea what architecture was except a lot of pretty renderings of cemetery gateways. Presumably there could also be gateways to post offices, municipal garbage dumps, or courts of law. I was carried away by the fact that I was going to be allowed to take a crack at this, but also scared of failing. So I signed up for a correspondence course in pencil sketching, completely confusing the creation of architecture with the making of pencil sketches.[11]

Nelson was diligent about the sketching course and soon became adept. In the family house in Hartford, the bronze statues were being joined by his drawings, etchings, and watercolors, and his drawing skill even brought him some early fame. In 1930 *Architecture* magazine[12] published six of his pencil drawings. In December of the same year *Pencil Points* (whose title suggests its original emphasis on draftsmanship, but which would be renamed *Progressive Architecture* in 1945) published his lithograph of St. Etienne du Mont, calling it "an American interpretation . . . of the spirit of old Paris" and calling Nelson "one of our coming young men in the field of graphic art."[12] The following month *Pencil Points* published Nelson's largely self-illustrated article "On the Making of Pictures and the Thumb-nail Sketch." Perhaps because of this exposure, he was hired during his last year at Yale to do renderings for the New York architecture firm of Adams & Prentice.[13] This early mini-career shows that his later minimal dependence on drawing was a chosen work habit, not a necessity.

A particular idol among the Yale faculty was Otto Fallion, a partner in the firm of James, Gamble & Rogers, designers of many of the Yale quadrangles. "He was a very mixed up and incomplete man," Nelson remembered, "but with tremendous vitality and quite clearly a man of fantastic talent, and we all worshipped him. He would come in drunk, and he did all those things that we as kids associated with a free-thinking, free-loving person. He was a tremendous influence."[14] Years later, in a letter to Nelson, R. Buckminster ("Bucky") Fuller would remember a Yale cocktail party at which Fallion "entered through the window of one of the students' rooms, having been jetted from below with a liquid fuel blast off."[15]

In general, however, Nelson's instruction at Yale, where Beaux-Arts teaching methods were still the rule, was very conservative, and many of the assigned projects "absurd":

VIEILLES MAISONS-ROUEN. GEORGE NELSON '29.

Sketches made by Nelson while an architecture student at Yale.

I remember one sketch problem—a sketch problem is a thing that lasts two to ten days. The title of this problem was "A Residence for a Western Diplomat on the Outskirts of Peking," and you were supposed to design this residence for entertainment, guest quarters, servants, and it's got to be like a huge embassy. Well, what a bunch of nineteen-year-old kids from small towns in America with mostly middle-class parents knew about an ambassador's establishment on the outskirts of Peking—this was a little difficult to figure out.[16]

Yet there was something positive in trying to cope with such inappropriate problems:

> . . . at that point if someone had come to me and said, "Would you like to redesign Venezuela?" I would have said, "I need a bit of information, but I'll do it!" And that marvelous inability to realize that here is a project you weren't equipped to cope with was one of the things that made it possible to switch from architecture to publishing to industrial designing without even realizing I was making a transition.[17]

Nelson earned his B.A. from Yale University in 1928 and a B.F.A. with honors from the Yale School of Fine Arts in 1931. In his words:

> I got through architecture school and was made a teaching assistant. The great crash of 1929 had happened, but we weren't yet aware of its full impact. I was feeling pretty smug and looking forward to a tranquil life as an academic because it all seemed so safe and pleasant. But if you're lucky, you are not allowed to stay safe. You're thrown into jeopardy. After one year I was dropped, because the school was beginning to feel the pinch. I was at the bottom of the totem pole, so off I went. And now a real panic, because jobs were vanishing and my nice safe teaching spot was gone, and I thought, "My God, what do I do now?" Then I thought, "Well, I guess I had better go win the Paris Prize." A bit presumptuous, but what else could I do? I had been at Yale, which had consistently won the Rome Prizes. Catholic University, a bedraggled school on the outskirts of Washington, D.C., always won the Paris Prize. I'd saved up a bit of money and went to

Two of Nelson's drawings for the 1932 Rome Prize competition.

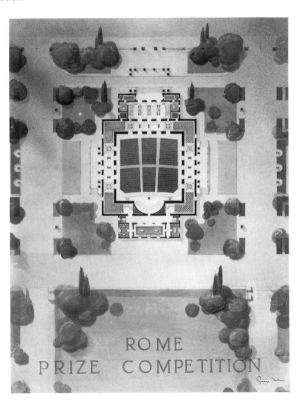

Catholic University[18] to win the Paris Prize. . . . It was like training for an athletic contest: I got up at seven in the morning, no dates, no movies, no nothing . . . just work, work, work. I did this through all the school year, no other courses, no distractions. I lived in a little rooming house near the school. I dove into the Paris Prize competition, almost made it, didn't quite,[19] but had developed such terrific momentum that when the Rome Prize came along I moved in without really thinking much about it and won. I remember the telegram: don't tell anybody now but you won. What the Rome Prize meant to me was two years in Rome with all expenses covered.[20]

The American Academy in Rome had been founded by Charles Follen McKim in 1894 as The American School of Architecture in Rome and had been housed since 1914 in a huge mock-palazzo of McKim, Mead & White's design on the Janiculum Hill, nestled just inside the Aurelian Wall and enjoying a splendid view of the city. Thoroughly classical in concept and detail, the building was less than 20 years old when Nelson arrived there. It would have been difficult in such a setting and in the ancient city below it to avoid considerations of modern versus traditional styles. As Nelson remembered,

In the early thirties there was a great deal of controversy whether modern architecture was here to stay or not. Back home, there was considerable doubt about it. Architects were still covering their buildings with pilasters and columns and arches and all that, which, I must say, look better today than they did when we were in rebellion against them. But in Rome the extraordinary thing I learned was that *everything was modern.* You would be walking down a street past a 15th-century palazzo and sticking out of the wall of the palazzo would be a ruin of an arch; the palazzo was built around the ruin centuries older than the palazzo. Then, because business wasn't good in Rome either, a corner of this palace had been remodeled and somebody had put in an ultramodern candy shop. So there were these three epochs coexisting in one building. And suddenly you realized the obvious, that everything that is worth anything is always modern because it can't be anything else, and therefore there are no flags to wave, no manifestoes, you just do the only thing you can honestly do *now.*[21]

Also inescapable at the Academy was the notion of relationships among various arts and disciplines. In addition to architects, the establishment simultaneously nurtured landscape architects, painters, sculptors, composers, and classicists. (Edward MacDowell, Nelson's high school graduation subject, had been an incorporating trustee of the Academy, and it was at his urging that the field of music was represented.)

The director of the Academy in Nelson's years was James Monroe Hewlett,[22] whose son-in-law, Bucky Fuller, would become Nelson's good friend. In those years, Fuller was serving as director and chief engineer of the Dymaxion Corporation in Bridgeport, Connecticut, where he was trying (unsuccessfully) to establish mass production of his Dymaxion car, and was also serving as both editor and publisher of the short-lived journal *Shelter,* for which he was successfully soliciting articles from Frank Lloyd Wright and other important designers. While Fuller and Wright were mutual admirers at the time, their opinions of the proper relationship between technology and design were beginning to diverge, Fuller ridiculing the "quasi functional style"[23] and Wright warning in Fuller's own magazine that modernists could "by way of machine worship, go machine mad."[24]

From his privileged perch at the Academy, Nelson traveled throughout Rome (on a bicycle he had found on the grounds) and throughout Europe, one product of these explorations being practice in language skills. (He became fluent in Italian, French and German, and would later add some knowledge of Japanese and Spanish; Portugese, however, he would find "not to be a language at all, but a secret code."[25])

Another result, prodded by the inevitable comparisons of classicism and modernism, was a dozen interviews with leading modern architects of the time. They were to be published between January 1935 and November 1936 in *Pencil Points* as "Architects of Europe Today." Nelson was later to say that all he knew about writing had been taught him by Howard Myers, his publisher at *Architectural Forum* in the 1940s,[26] but these interviews suggest that he had already been at work on his verbal skills as well as his visual ones. Here, for example, is his brief portrait of Le Corbusier:

> He is a plain-looking man, this Le Corbusier. No striking irregularity of feature, nothing unduly prominent except possibly a high forehead. He wore large tortoise-shell glasses whose blank stare disguised any facial expression; one could only see an immobile

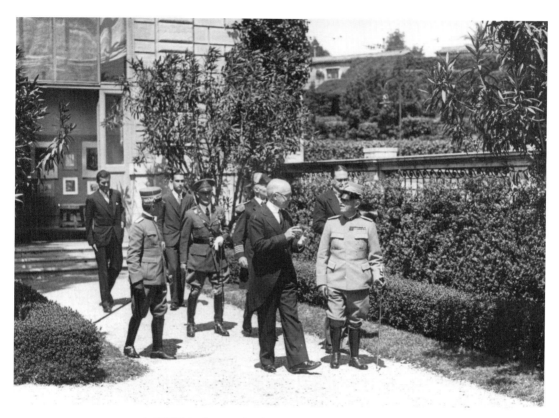

In 1933 Victor Emmanuel III, last King of Italy (third from right), visited an exhibition at the American Academy in Rome including travel drawings by Nelson (third from left).

face, tremendous areas of glass, and thin hair. That such ideas as the organization of traffic in Algiers on fast motor highways three hundred feet in the air, and the demolition of the center of Paris could have originated behind this noncommittal facade seems a bit incredible until one hears him talk. Then anything is credible.[27]

And here he is on Mies:

On the top floor of a rather dowdy old house in Berlin there lives a man who, in spite of having built little, spoken less, and written not at all, has somehow come to be considered one of the greatest architects of his time. Such is the power of personality and an idea. . . .

In spite of his unwillingness to dramatize himself, Mies is no dreamy recluse to whose garret door the world has beaten a path: the luxuriously simple apartment in Berlin is no garret, and for this ample, well-fed German the meagre life holds no attractions. He likes his food and knows his wines, and with a sufficient quantity of both inside of him he can become a charming and mellow conversationalist. . . .

He is brilliant, slow, affable and vain. Impractical, utterly uninterested in politics, the social or economic aspect of architecture, he is paradoxically the only one among Germany's great modern architects who has anything like a sure position in the country at this time. . . . Physically he is strongly and heavily built, but lazy. A fine draftsman, he prefers to have his drawings done for him, and if sitting is the final test of a chair, the metal chairs in his office leave nothing to be desired. . . .

As I got up to leave I noticed a beautiful engraving of an Ionic capital, prominent in the modern room, and asked what it was doing there. Mies looked at it seriously for a moment before replying. "The old architects," he said finally, "copy this sort of thing. We appreciate it."[28]

Nelson's dozen subjects included three of the undisputed giants of modernism: Mies, Le Corbusier, and Gropius. For the other nine, Nelson made some prescient choices: from Italy, Marcello Piacentini, Gio Ponti and Giuseppe Vaccaro; from Denmark, Bent Helweg-Moeller; from Sweden, Ivar Tengbom; from Germany (in addition to Mies and Gropius), the brothers Hans and Vassili Luckhardt; from France (in addition to Le Corbusier), Eugène Beaudouin; and from England, young Raymond McGrath and the Tecton Group. Of these last nine, Piacentini and the Luckhardts had enjoyed the most visible careers; although the others would come to have important reputations, only Tengbom and McGrath were being extensively published at the time Nelson was writing.[29]

The most prominent contemporary list that could have influenced Nelson's own, of course, was that of Henry-Russell Hitchcock and Philip Johnson's epochal International Style exhibition at New York's Museum of Modern Art in 1932, just three years after that museum's opening. It included the work of 48 firms, but none of Nelson's nine less-than-giant figures was mentioned. In any case, the exhibition had, in one stroke, legitimized the modern movement and established its standing in the

United States.[30] Although the show must have been powerful reinforcement for Nelson's interest in modernism, it is probably fair to say that his interest was considerably deeper than that of Hitchcock and Johnson. Their MoMA show, for all its visibility and influence, emphasized modernism's shared stylistic appearances and neglected both the movement's social aims and its new acceptance of industry.[31] It was these underlying attitudes that were to make the modern movement's adherents zealous to a degree that no mere visual fashion could have commanded.

Writing 45 years later, Nelson took a modest view of his choices: "Compared to my three giants, all of the other architects interviewed were inevitably second-string, and this was quite clear even way back then. And there were a few, notably Piacentini, who could not be described as even third string."[32] Today, however, Piacentini seems a natural choice. Born in 1881, he had been responsible in 1908 for the dramatic vehicular tunnel under the Quirinal and in the last years before the First World War for a series of award-winning exhibition pavilions in Rome, Brussels, and San Francisco, and his reinforced concrete Corso Cinema of 1918 was a radical break with Roman tradition. In the 1930s, however, he had become the official architect for the Italian Fascist government, and later he would be responsible for Mussolini's Terza Roma (E.U.R.). (It seems likely that Nelson's disavowal of Piacentini's importance was based not on architecture but on politics, even though at the time of the interview Mussolini had not yet embraced Hitler as an ally.)

One architect Nelson regretted not including was Alvar Aalto, whose competition-winning Paimio sanatorium (1929–1933) had established him as an international figure. As Nelson later explained: "The problem was that Finland was far away and Aalto had never bothered to respond to a letter I had written him. . . . The gamble on the cost of a trip to Helsinki with no assurance that Aalto would be on tap, or willing to waste time on a student, was too much for my modest travel budget. But even then he was a kind of hero, and I was sorry."[33]

Nelson's choices seem even more remarkable if seen in the context of *Pencil Points*' other pages in 1935. Modern design had first been introduced in the magazine in 1929, but in a modest way[34]; in 1935 the publication was still dominated by federal doorways and gambrel gables. Selected details (for it was an eminently practical magazine) explained such features as oriel windows with leaded glass. In contrast, Nelson clearly sided with the modernists he was interviewing, deriding "bastard Gothic" and "emasculated Colonial" and being particularly critical of

American college campus architecture ("a cross between a setting for *Hamlet* and a country club for . . . decadent millionaires"[35]). Although Nelson's articles were given prominent placement (eight of them immediately following the magazines' editorial pages), it is not surprising that editor Russell Whitehead felt it necessary to include a caveat that the series was meant for information only—not, God forbid, for emulation.[36]

Remarkable, too, was Nelson's frankness about the political threat he saw growing in Europe. This is from his piece on the Luckhardts:

> To speak at all of the work of the brothers Luckhardt one must use the past or the future tense. They along with Le Corbusier, Oud, Gropius and a few others may be considered as the pioneers in a new way of building. They built the first modern house in Germany. They anticipated the house built of prefabricated standardized units which is today the subject of so much experimenting in America. They were among the first to study the city plan in intelligent relationship with the serious problems presented by fast-moving traffic, and they began the revival of the use of models for the study of buildings. Now the office is empty. They have no work. What is more, they can't do any work: it is forbidden by law. . . .[37]
>
> Still talking, we left the studio and went down the street towards the subway station. There were many people in brown shirts, dripping with swastikas, symbols of the new Germany that has ruined the men who brought her world-wide respect. And of these wasted talents, the brothers Luckhardt are, in my humble opinion, by no means the least.[38]

Such a series of interviews is not easily assembled without mishap. As Nelson later explained to John Morris Dixon, the editor of *Progressive Architecture,* who had praised the series' "courage and insight"[39] and who particularly admired "Corbu's on-the-spot sketches from the café"[40]:

> Like other assorted geniuses, Corbu was a bit of a rascal, and when I asked him to send photos of his work from Paris, he demanded (and got) prepayment for the prints and mailing, but then, despite repeated pleas by mail from New York, later on, nothing ever arrived. This left me with no choice but to produce forgeries of his building sketches, and I am deeply flattered by your

Sketches of "Corbu" made by Nelson for his 1935 profile.

assumption that they were his. (Why is it that we all get so much more pride and pleasure from illegal acts we have gotten away with than from any possible worthwhile, respectable achievements?)[41]

Returning from Rome with a wife[42] in the depth of the Great Depression, Nelson earned money working on WPA murals for the Hartford post office.[43] Soon, on the strength of his *Pencil Points* essays, he found work in New York for *The Architectural Forum* (commonly called "the *Forum*"), the leading professional publication at that time. He was writing about architecture rather than designing it.

Nelson was established as an Associate at the *Forum* when, in October 1937, the magazine produced a special issue on domestic interiors. Five designers—Richard Neutra, Ernest Born, Gilbert Rohde, Eero Saarinen, and Russel Wright—were commissioned to prepare studies for the issue,[44] and Nelson devised an illustrated introduction advocating modernism:

> Our environment contains the stuff for creating new backgrounds and changing the old. The pressure of modern existence, as much as anything, killed the overstuffed interior, and while the monastic cell is no solution, the requirements of daily life must be provided for before decoration is considered. . . . The functional approach is basic and provides the framework for this issue.[45]

A 1938 highlight of the *Forum* was a special issue entrusted to Nelson and devoted completely to the work of Albert Kahn (1869–1942), who in 1903 had been responsible for one of the first reinforced concrete factories in the United States and whose office, at the time of Nelson's writing, employed a staff of 400, producing almost a fifth of the country's architect-designed industrial buildings.[46] Except for the Ford Motor Company's Rotunda (a huge concrete drum shaped like a set of transmission gears and housing an exhibition designed by Walter Dorwin Teague), which was added in 1934 to the 1933 Century of Progress Exposition in Chicago, the *Forum* showed none of Kahn's non-industrial work, which, like most work of the time, was stylistically derivative.[47] Kahn's plants and factories, however, were pragmatically dedicated to performance.[48] Though less evocative than Peter Behrens's industrial buildings in Germany, they often achieved a straightforward sort of power, and even,

when long spans demanded structural bravura, exhilaration. "Because these buildings are completely functional," Nelson wrote, "they are beautiful as a good machine is beautiful. And because they so clearly express the character of our time they represent its best architecture." With some additional material, the special issue was converted into hard-cover form the following year, Nelson's first book.[49]

Another special issue of *Architectural Forum* in 1938 was devoted to Frank Lloyd Wright, then 71, whose recent Fallingwater and Johnson Wax Building had thoroughly revived a career many had assumed to be finished. Indeed, only a few years earlier, Wright had been a largely forgotten figure. Nelson later remembered that, when he had interviewed Mies, "all Mies wanted from me was news of Frank Lloyd Wright. Then came the shameful realization that, as a graduate of a U.S. architectural school, I had barely heard this man's name and knew nothing about him except some scandalous newspaper tidbits, and this was our greatest national resource in architecture. I was not unique in my ignorance."[50] He certainly was not. In the five years between the Lloyd Jones house of 1929 and the Willey house of 1934, not one of Wright's designs had been built, and his proposals for Chicago's Century of Progress exposition had all been ignored.

Plans for publicizing Wright's newly revived practice had originated with *Forum* publisher Howard Myers, who originally proposed devoting "a minimum of sixteen full pages" to the Johnson Wax headquarters.[51]

Nelson was assigned to plan the issue, along with the art director, Paul Grotz, who had arrived at the magazine the year before Nelson and whose graphic design was setting high standards. The two were sent off to Taliesin, Wright's summer quarters at Spring Green, Wisconsin, to look at possible material. It was clear at once to Nelson that, in addition to Johnson Wax, there was also other new work by Wright that should be covered, most notably Fallingwater. Soon Myers was telling Wright that he was "delighted to learn through George Nelson that you are in fine health and spirit" and speaking of an entire Wright issue of "approximately seventy pages."[52] In the end, the issue's 106-page Wright coverage included Fallingwater, Johnson Wax, the Herbert Johnson house, the Hanna house, the St. Mark's Towers project, and other works.

Although Nelson was, in the end, responsible for the text, and Grotz for the layouts, the two soon learned that the production of the issue was to be largely Wright's own show. Grotz remembered that "Wright

was very nice to us, but we were quite subordinate, treated as Wright's apprentices, waiting for the great master to present us with material. . . . Wright gave George a little drawing to do for the issue, to replace a badly damaged plan. I designed a cover for the issue and worked with Wright's publisher. Hedrich-Blessing had already been hired by Wright and told what to photograph. . . . The whole set-up was very peculiar."[53] Nelson's own memory was that, despite Wright's professed democratic ideals, "Taliesin was run like a marine boot camp. . . . And those kids were absolutely scared witless, if not of Mr. Wright, then of Mrs. Wright, who, in my book, was always the more scary of the two."[54]

The January 1938 *Forum* made clear the resurgence of Wright's leadership in American architecture[55] and "served admirably," according to Edgar Kaufmann, jr., "as fanfare for Wright's 1939 appearance in London to deliver four lectures . . . to a distinguished professional audience."[56] It also had served admirably as Nelson's introduction to Wright. Theirs was to be a friendship that developed slowly, and Wright was not always easy or congenial.

In 1940, for example, the *Forum* editors were in charge of the eastern United States section of an architecture exhibition for the Golden Gate International Exhibition. Asked to choose the 25 best contemporary buildings east of the Rockies, they selected three by Wright: Fallingwater, Johnson Wax, and the 1937 Jacobs house in Madison, Wisconsin. But when Nelson cabled Wright the good news and asked for material, the master cabled back: "Not interested. Object to the classification."[57]

Nelson's writing about architecture, before he began to work on any design projects of his own, earned him the Gold Medal from the Scarab fraternity in 1941, given annually to an architect under 35 for meritorious work in the profession. Reporting the award, the *Hartford Times* noted that he was serving as a member of the Museum of Modern Art's committee on architecture and as a member of the architectural advisory committee of the U.S. Housing Authority.[58]

In 1943, with some of its staff overseas, the *Architectural Forum* promoted Nelson to the top-level job of Co-Managing Editor, a position he shared with Henry Wright. (Henry Luce reserved the title of editor-in-chief for himself at every magazine he published.) After a year, Nelson was asked to become the head of an experimental department for *Fortune* and the *Forum* that worked, in great secrecy, planning possible new magazines, but he would remain a consultant to the *Forum* until 1949.

Nelson's friendship with Frank Lloyd Wright was considerably strengthened when in 1945 Nelson sent Wright "the first fan letter I have ever written" after seeing him present his plans for the Guggenheim Museum at New York's Plaza Hotel. Nelson reported being impressed: "When the building is up and New Yorkers walk in it for the first time, they won't know what hit them." The presentation had given Nelson, he wrote apologetically, an understanding of Wright's work he had never had before: "You may recall that during our many years of occasional association I have taken considerable pleasure in arguing with you about anything and everything. I realize now I had too deep a respect for you to do anything but argue, since . . . I obviously hadn't known what you were talking about." And he concluded that he would be proud to tell his children that "I once knew the greatest architect that ever lived—and, I believe, one of the greatest persons."[59]

If this last had an element of calculated hyperbole, the calculation worked. Wright replied a week later: "Dear George: Your letter was truly fine appreciation such as all men covet and seldom get. It brings me closer to you because I was never sure of you. I am sure now because you are. We'll be seeing more of each other?"[60]

They would. Nelson was back at Taliesin West, Wright's Arizona headquarters, the following April, and was arranging for *Fortune* to publish a story on the winter camp. "By stroke of luck," he telegraphed Wright, "Ezra Stoller available to photograph camp."[61] The *Fortune* story was not a complete success, however, for Nelson later wrote Wright about "the bad reproductions of Stoller's beautiful kodachromes."[62] Wright, for once, was less critical, replying that "although the reproductions in Fortune were good they couldn't do justice to [Stoller's] negatives."[63] In any case, the text gave Nelson an opportunity to express his growing appreciation of Wright's rare provision for the civilized life:

> "I have always been willing to go without necessities," Frank Lloyd Wright once remarked, "as long as I might enjoy the luxuries." One difference between Wright and other people who may have expressed the same idea is that he has lived it. There was a winter toward the end of the depression, for instance, when funds were so low that his house was close to the freezing point. Providentially, a client turned up with an important commission and a check covering a sizable retainer. Wright used the money to buy a harpsichord instead of coal. He has always considered

living—in the fullest possible sense of that misued word—more important than the deferments and substitutes so urgently recommended by contemporary society. That is why Wright lives in two of the most luxurious homes in America. He built them when he had money, and he kept on building them when he was up to his ears in debt. He is still working on them. . . .

The importance of Wright's houses is not that they were in advance of their time. Nor that they would cost nearly a million dollars if put together by a contractor today. The important thing is very simple: they enclose space as if it were precious, not for the sake of the space itself, but for the life that goes on within it.[64]

The Time publishing empire presented a more negative view of Wright in a 1946 *Life* profile by Winthrop Sargeant that, in its first paragraph, compared Wright's private life with those of Cellini and Casanova. "The clergy has deplored his morals," Sargeant wrote. "Creditors have deplored his financial habits, writers his literary style, wives his infidelities, politicians his opinions."[65] Nelson wrote Wright that the story "perplexed and rather disgusted" him by its "approach which emphasizes the unimportant, makes public what would be better left private and ignores those things that might make for genuine interest and, in the case of your work, excitement."[66] This time Wright reacted ferociously, denouncing "this latest evidence of fast and Luce journalism" and declaring "absolute resignation from further publicity favors from the *Forum* or, for that matter, anywhere else. We have just put up the 'NOT open to visitors' sign here at Taliesin. After the piece *House Beautiful* has already prepared[67] there will be no more of my work published with my consent nor journalese allowed on the premises at any time while I live." But Wright appreciated Nelson's sympathy. "At least you have paid me out beautifully," he wrote Nelson, "for my suspicious attitude toward you some years ago. I have a flair for trusting the wrong people, I guess. Come and see us, George. You will be welcome."[68]

Wright's ban on journalism was short-lived, of course. By the next February, Nelson was writing him of the *Forum*'s plans for a second special issue.[69] Wright was amenable,[70] and Nelson visited Taliesin again that spring.[71] Wright in turn visited New York to discuss the plans[72]; he was reminded by Nelson of the pressing need for materials[73]; and finally

the issue appeared in January 1948. It celebrated the American Institute of Architects' shamefully belated award to Wright of its highest honor, the AIA Gold Medal.[74]

As World War II came to an end, the United States looked forward to a new era and Nelson looked forward to a career still unclear but full of promise. His education and experience had developed his communication skills, which his *Forum* association had sharpened. The *Forum* had also given him wide recognition and something else that would prove equally valuable: His years of editing, each month's issue bringing new assignments, must have developed his facilities for shifting easily from one subject to another and for penetrating quickly to the heart of whatever subject was at hand. These would remain the patterns of Nelson's work.

Nelson's talent with words would play an increasingly important role in his working life, while his early interest in music and his much-practiced drawing skills would play negligible parts, the 2B pencils being replaced almost entirely by cameras.

Ralph Caplan remembers his friend's camera work this way:

> Few designers took more pictures than George did or used them as compellingly, although many designers are far better photographers than he was. Technique was not what we learned from him; his photography lessons had nothing to do with F-stops. When you looked at a Nelson picture, or at a dozen of them, you did not wonder, "How does he get those effects?" You were more likely to wonder, "Where does he find things like that?" Later you would realize that the scenes George shot were everywhere for the finding: patterns and aberrations in the built environment. [George] noticed them and, in noticing them, revealed the patterns as extraordinary, the aberrations as understandable, and both as enlightening.[75]

Nelson may have abandoned drawing for photography because he felt the camera to be a step closer to reality, its representations more true. Quite unlike the photography (mostly movies) of his future colleague Charles Eames, which would be a vehicle into realms of imagination, fantasy, and illusions of scale and movement, Nelson's photography (mostly slides) would be, like Whitman's poetry, a medium in which "nothing is

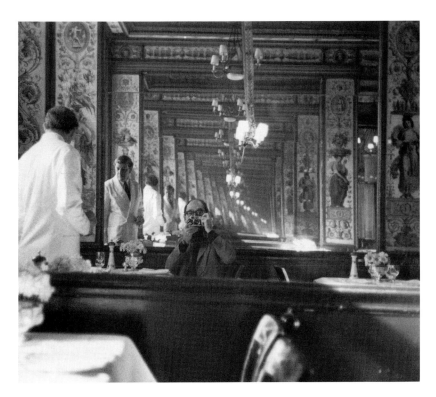

Nelson photographing the Grand Vefour, Paris.

poetized . . . nothing for beauty's sake, no euphemism, no rhyme."[76] It would be proof that Nelson's speculations about contemporary urban life were accurate, the perfect documentation of the discoveries of his eye.

 Drawing would also prove less necessary for Nelson's type of design work than it would be for Eames's. One can imagine Eames tracing the outline of the back of a chair over and over until its shape was perfected. Nelson would never have the patience for such activity or great interest in such a result; he would prefer to consider more fundamental matters like the habit of sitting and the need for chairs. This kind of questioning—his special genius—came to maturity at a time when many questions needed to be asked. A new postwar world was to be made, and Nelson would be one of its makers.

A New Cause: Modern Architecture

Even as a young man, before actively entering the field of architecture, Nelson had shown in his *Pencil Points* interviews that he had moved beyond the isolation and provincialism of interwar America. Not long after his years in Europe, many of modernism's founding fathers began to flee Germany; when finally they brought modernism to America in full force, he would be eager to welcome it.

Josef Albers was one of the first Bauhaus faculty members to leave, going in 1933 to begin a teaching career at Black Mountain College in North Carolina. In 1934 Walter Gropius went to London; in 1935 so did Marcel Breuer (via Switzerland), Gyorgy Kepes, and Laszlo Moholy-Nagy. In 1937 Gropius and Breuer sailed for the United States, where they began to transform Harvard's Graduate School of Design; the same year Moholy-Nagy founded what would become the New Bauhaus in Chicago; and the following year Mies would take charge of the architecture school at Chicago's Armour Institute (later the Illinois Institute of Technology).

As these men were beginning to influence American work, a 1938 exhibition at the Museum of Modern Art ("Bauhaus 1919–1928," curated and designed by another Bauhaus exile, Herbert Bayer) popularized their past accomplishments. The following year, the 1939 New York World's Fair brought visions of modernism to the masses through such displays as Henry Dreyfuss's Democracity diorama and Norman Bel Geddes's Futurama. The idea of modern design had unmistakably arrived, even though, with the advent of war, there would follow a period in which there was little chance for the idea to be tested.

Nor had the doomed traditionalists capitulated. In 1940 Nelson explored the continuing traditional/modern controversy in an exhibition he designed for the Architectural League of New York. Called "Versus," it provoked heated debate among the League's members and added to Nelson's growing reputation as a young iconoclast.

Beginning in 1937, Nelson, while pursuing journalism and other interests as well, had gone to work for the architecture firm of Fordyce & Hamby, the occasional architectural arm of Raymond Loewy's industrial design (or, perhaps more accurately, industrial styling) office. Fordyce &

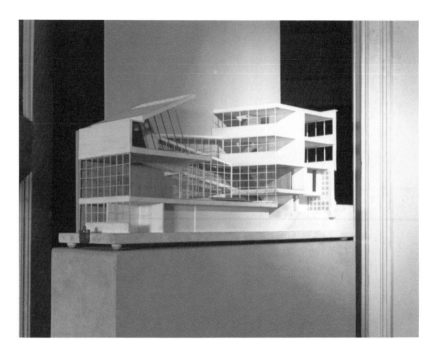

A study model for the Fairchild town house (1941).

Hamby was one of the few New York firms already beginning to work in the new vein. There Nelson probably met Gordon Bunshaft, an architect of about the same age then working for the Loewy firm and not liking it. Bunshaft derided the office's "very superficial industrial design, which consisted mainly of Raymond Loewy putting a gold line on the engine of the Pennsylvania trains or a gold line on a packet of cigarettes."[1] (Loewy, however, was later given the commission for the interior design of Bunshaft's early masterpiece, Lever House; *that* must have rankled.)

Nelson also met William Hamby, with whom he would later practice architecture in partnership.[2] One of the last and certainly the most significant of the buildings by Hamby & Nelson was a New York townhouse, finished in 1941 at 17 East 65th Street, for airplane builder Sherman Fairchild. In a city of traditional brownstone houses, new stylistic precedents had been set by two modern townhouses designed by William Lescaze.[3] Nelson had mentioned the earlier of these in his March 1935 *Pencil Points* essay on the Luckhardts: "Recently considerable interest was aroused by the Lescaze town house, whose facade of glass brick and stucco stands out in sensational contrast beside its rather dowdy brownstone neighbors."

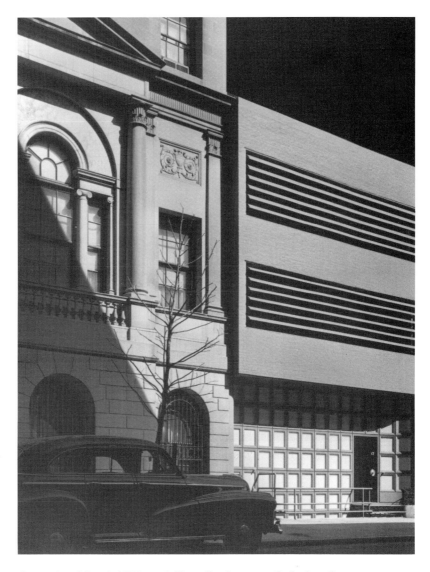

The exterior of the Fairchild house (still standing, but now radically altered).

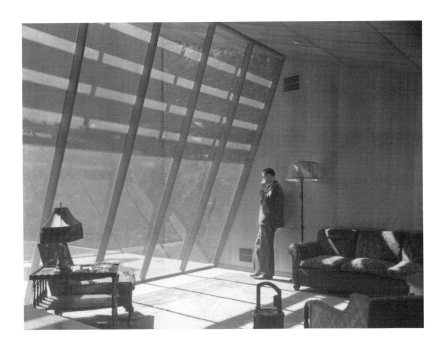

Nelson in the studio at the top of the Fairchild house's rear wing.

The Fairchild house, like Lescaze's, broke dramatically with the look of the New York row house, but the house was not just visually startling; in some unprecedented ways, it was a "machine for living." *Fortune,* which showed a section through the house on its cover, thought it not only "a masterpiece of individual design" but also "the last word in the prewar house."[4] As *The New Yorker*'s "Talk of the Town" column reported, "it has ramps instead of staircases, electrically operated Venetian blinds on the outside of the window panes, complete air-conditioning and soundproofing, a living-room floor of teakwood mounted on rubber springs to provide resiliency, amoeba-shaped furniture, and a glass-walled courtyard embellished with a crab-apple tree and a couple of wisterias. Fairchild has spent $75,000 on the house."[5] The most innovative thing about the house, however, was its plan. Hamby and Nelson split the conventional Manhattan row house into two separate elements, one at the back of the site for the living room and the study and one at the front of

All major rooms of the Fairchild house faced an interior courtyard rather than the street.

the site for the kitchen, the dining room, and the bedrooms, so that rather than having the conventional Manhattan views—the street in front, the neighbors' fire escapes at the back—both elements enjoyed controlled views into the central garden. Nine years later, Philip Johnson would adopt the same *parti* for his Rockefeller townhouse at 242 East 52nd Street,[6] and Nelson himself would repeat it, with very practical justification, for a 1949 Long Island beach house with ramps joining two separate buildings, one for the owner and the other for his wheelchair-bound mother.[7]

The United States' entry into World War II meant the end of building for a while. In 1942, with Hamby & Nelson closed and with the *Forum* editorship his only employment, Nelson, just slightly overage for military service, looked about and found a job at Columbia University's school of architecture.[8] For the next three years he served as head design critic for Columbia's night school (then very popular, with many of its students employed during the day as draftsmen on war projects).

Modernism, by then, was in full sway at Columbia, but in a stylistically orthodox manner that Nelson had already come to view as restrictive and monotonous:

> The main problem was the poverty of the design vocabulary. Any building, whether church, bank or dwelling, was designed with
>
> - a flat roof,
> - one or more glass walls,
> - lally columns,
> - a wall of natural stone or brick, to show that the student approved of nature, and
> - continued from inside to outside to show that he approved of continuity.
>
> In addition, there was also a "free form" element, either a canopy, pool terrace or wall decoration to show that the student approved of free forms and/or had seen the work of Arp.[9]

Such a limited view ignored the timeless aspects of good building design, he thought: "Architecture was architecture before glass block came in, and it will be architecture after glass block goes out."[10] It also ignored the real significance of the modern movement. This, Nelson saw, was more

than that of the latest style in a continuing succession of styles. Modernism signified the end of the importance of crafts, the advent of the importance of mechanization, and the popularization of the art of building. These changes were intimately connected to one another and also to modernism's avowed social mission, for it was mass production that promised good design for the whole population rather than just for the elite. Modernism was a threshold through which design was passing for the first time; there would in the future be nostalgic glances backward, but it was a step design could never retrace. Nelson's impatience with a group of predictable designs was directed not toward modernism but toward his students' narrow interpretation of it.

Michael Graves, who worked in the Nelson office in 1959 and 1960, calls Nelson "the consummate modernist,"[11] not because of any stylistic signature, but because of his insistence that every design be considered from the beginning, never dictated by current taste or habit. The patterns that Hitchcock and Johnson had identified as constituting the International Style[12] had become patterns Nelson disliked, and he disliked them *because* they were patterns, repeated by rote. "It happens to be fashionable to use an extravagant amount of glass in buildings these days," he wrote, condemning the fashion as the "kind of nonsense" that was "part of a style that has become truly international."[13] Nelson "*required* that people in his office think freshly," Graves says.[14]

In the 1940s, Nelson challenged his Columbia students with an unconventional studio assignment:

> The students were instructed to take a "perfect" design and to present a graphic analysis of the design in whatever form they chose. The hope was to enrich our unbelievably limited vocabulary. When the cries of outrage died down, the designs to be analyzed were given out. These included a shark, a Windsor chair, a hundred-watt bulb, a tailor's shears, a wine barrel, an umbrella and similar objects.[15]

As the students worked, denied their flat roofs and glass walls, outrage changed to enthusiasm:

> Although no requirements had been given regarding size or type of presentation, most of the projects submitted ran from twelve

to twenty feet in length when exhibited, as compared with two small sheets of drawing paper normally presented after the same period of time on design problems.[16]

Also on the Columbia staff from 1943 to 1945 was Minoru Yamasaki, a Seattle-born architect four years Nelson's junior. The two became good friends.[17] At least twice, in 1945 and again in 1951, they planned to work as partners in their own architecture firm, but the plans never jelled.[18] Yamasaki's own later work was decorative to a degree that led him to be seen as an early apostate from modernism; it is likely that, even as a young teacher, he agreed with Nelson about the unfortunate uniformity of much modernist education and practice.

An opportunity to summarize the accomplishments and short-comings of the modern movement had come when Nelson was asked to contribute an essay to a 1944 book on architecture and planning being edited by Paul Zucker. "That the battle for acceptance [of modernism] is practically over can no longer be doubted,"[19] Nelson wrote, but he had begun to see that there were limitations to modernism's powers. It needed a symbolic soul, he thought, but it would not find it by retreating to the past. It needed to move forward, not back:

> The contemporary architect, cut off from symbols, ornament and meaningful elaborations of structural forms, all of which earlier periods possessed in abundance, has desperately chased every functional requirement, every change in site or orientation, every technical improvement, to provide some basis for starting his work. Where the limitations were most rigorous, as for example in a factory, or in a skyscraper where every inch had to yield its profit, there the designers were happiest and the results most satisfying. But let a religious belief or a social ideal replace cubic foot costs or radiation losses, and nothing happened. There is not a single modern church in the entire country that is comparable to a first-rate cafeteria, as far as solving the problem is concerned. . . .
>
> There is a contradiction between the demand for monumentality and a general lack of faith in the institutions normally glorified in monumental architecture and sculpture.
>
> There is a contradiction between the admittedly high social ideals of the contemporary architect and planner, and

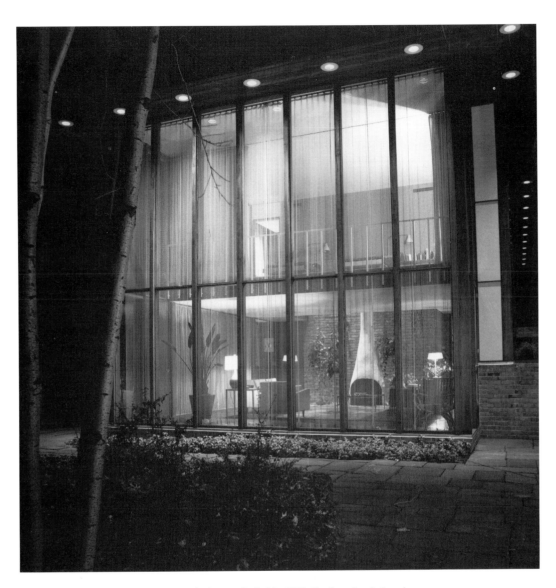

The J. T. Kirkpatrick house, in Kalamazoo (Nelson & Chadwick, 1955). The firm also designed the interiors. A few years later, Nelson would be criticizing the "extravagant amount of glass" in most modern houses. Even in this case, the house's longest walls are predominantly solid. (photo: Norman F. Carver, Jr.)

the fear with which they shrink from everything but the most utilitarian problems. . . .

The monumental expression in architecture, which will become increasingly pressing as a task for the contemporary designer, will be solved, and not by a move back to the past. Like what we have already achieved in the new architecture, it will continue a tradition deeply rooted in the people, their ways of living and, more significantly, their aspirations. To continue the tradition, architecture will have to throw away its crutches, move up to another plane, and express itself in another scale. But express itself it will. We have been preoccupied with closets and minimum shelter and undersized bedrooms and all the minimal paraphernalia of a pinchpenny architecture long enough.[20]

These are brave words. In hindsight, they are also poignant words, for Nelson's own design practice, like most others, was to be necessarily occupied with the problems of "closets and minimum shelter" and all the rest of the era's mundane realities. These included the tedious process of getting a building built—a process, then as now, in which design control is easily lost. In one of Nelson's notebooks[21] there is this quotation from Eric Gill's autobiography:

It is assumed in the first place that the architect is not a builder, but a gentleman. It is assumed in the second place that the builder is not an architect, but a man of business. In the third place it is assumed that the builder's workman is incapable of intellectual responsibility and that, though he is often 'a grand chap' and often of great technical experience, you can't and mustn't trust him to do anything without measured and precise directions and drawings. . . . The whole thing is completely inhuman. And the result is what anyone might expect but few people see—a world in which buildings are not only dead but damned.[22]

Nelson, for better or worse, was impatient with the demands of these realities. His concern for architecture in the broadest sense—and his corresponding lack of concern for its narrow manifestations—was something that he felt he had learned from Frank Lloyd Wright. Eight years after Wright's death, Nelson recorded this memory of Taliesin West:

One early spring evening, I was out on the terrace at [Wright's] camp, looking at one of those spectacular Arizona sunsets. The place was deserted. I think the apprentices were off somewhere making dinner or cleaning up. Anyway, the terrace was empty. I heard a door slam, looked back, and there was the old man coming out of his apartment. He'd apparently had a pretty good day. He was wearing his porkpie hat, his stiff collar, his cape, his cane, and he was feeling sociable. He saw me standing there, sauntered over twirling his cane, made some small talk about sunsets or Arizona or whatever, when suddenly he said, "George, do you know what architecture is, what architecture *really* is?" I replied, "Mr. Wright, why don't you tell me?"

Behind us on the terrace there was a big palo verde tree—a desert tree that has a green trunk and branches, spines in place of leaves, and at that time of year, February or March, it bursts out with the most beautiful, delicate yellow blossoms you can imagine. He waggled his stick, pointed back at this tree, and said, "Architecture is like that palo verde tree bursting into bloom." I sagged with disappointment. I had thought he was going to tell me something. . . . Then he went off about five or six feet, suddenly stopped, turned back. He said, "Well, maybe it isn't quite like that palo verde tree bursting into bloom; maybe it's more like a boy falling in love with a girl." And I thought, "You old blackguard, you had the chance of telling me. Why didn't you?"

It took me ten years to realize that he had told me the most important thing he could possibly tell me. I've been lucky in my teachers, but sometimes too slow as a student.[23]

In 1949 Nelson sought the fulfillment Wright had described by devoting more of his time to design and less to journalism. Although in 1948 he had begun an association with *Interiors* magazine as a contributing editor, he had also begun in 1945 his dramatically productive association with the Herman Miller furniture company. He would always continue to write, but from this point on as a commentator, not as a reporter. And, on a more personal level, he had established fruitful intellectual exchanges with three men who would always be heroes to him: Bucky Fuller, Dirk Jan (D. J.) De Pree, and Frank Lloyd Wright. He once wrote to Wright that "trying to establish one's own office is quite differ-

ent from the free-wheeling life of a magazine editor, and travel as a result has been drastically curtailed. In spite of this, it is very pleasant indeed not to be a magazine editor any more."[24]

In 1953 Nelson began to practice architecture in partnership with Gordon ("Chad") Chadwick, a former Wright apprentice whom Nelson had met in Aspen, where Chadwick was working for the architect Fitz Benedict.[25] The Nelson-Chadwick association was always an informal one,[26] and its products were never Nelson's main interest. Although he would always be concerned with general design problems common to houses or offices or cities, the specific problems of individual commissions came to seem less significant to Nelson. Even so, the firm produced some notable work. The Spaeth beach house in Southampton, New York, made quite a stir when it was finished in 1956. Asked about this spirited restatement of McKim, Mead & White's Low house of 1887, Nelson admitted to being "pleased that something that witty came out of the office" but insisted the design was "100 percent Chad's."[27] Nelson's disclaimer may be attributable to his own lack of enthusiasm: the Spaeth house was a precocious forerunner of the historical references that would soon flood the profession, preceding even Robert Venturi's widely discussed beach house project of 1959 (a design that, less literally, also recalls the Low house), but Nelson was never convinced that historicism was a promising direction to pursue.

Among the interesting by-products of Nelson's architectural practice with Chadwick is an entry in the 1960 competition for a memorial to Franklin Delano Roosevelt in Washington. Michael Graves had told Nelson that he and his friend Richard Meier planned to work nights and weekends outside the office on the project, but Nelson gave Graves space and time for working on it during office hours; Meier joined him in the evenings. Graves also remembers working on a curious "house for storage," one element of a two-part residential compound "for a collector." One unit held conventional living quarters, the other nothing but storage units sliding on tracks like today's movable library shelving.[28]

Other by-products were in the related field of interior design.[29] The firm's innovations included what seems to have been the earliest example of track lighting, devised for a 1948 remodeling of Herman Miller's showroom in Chicago's Merchandise Mart. Jack Dunbar,[30] a designer hired by Nelson to work on the showroom, packed suspended sections of Unistrut steel sections with wiring, disregarding electrical codes but providing unprecedented flexibility for lighting placement.[31] That flexibility was com-

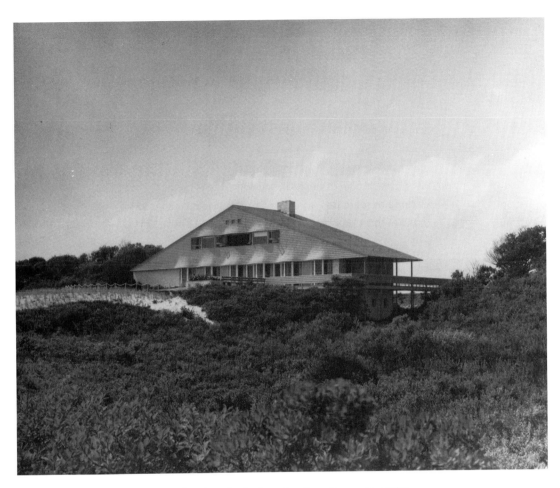

Nelson and Chadwick's Spaeth house of 1956, on the Southampton dunes. Its conscious refer-
ence to McKim, Mead & White's 1887 Low house marks it as one of modern architecture's first
experiments with historicism.

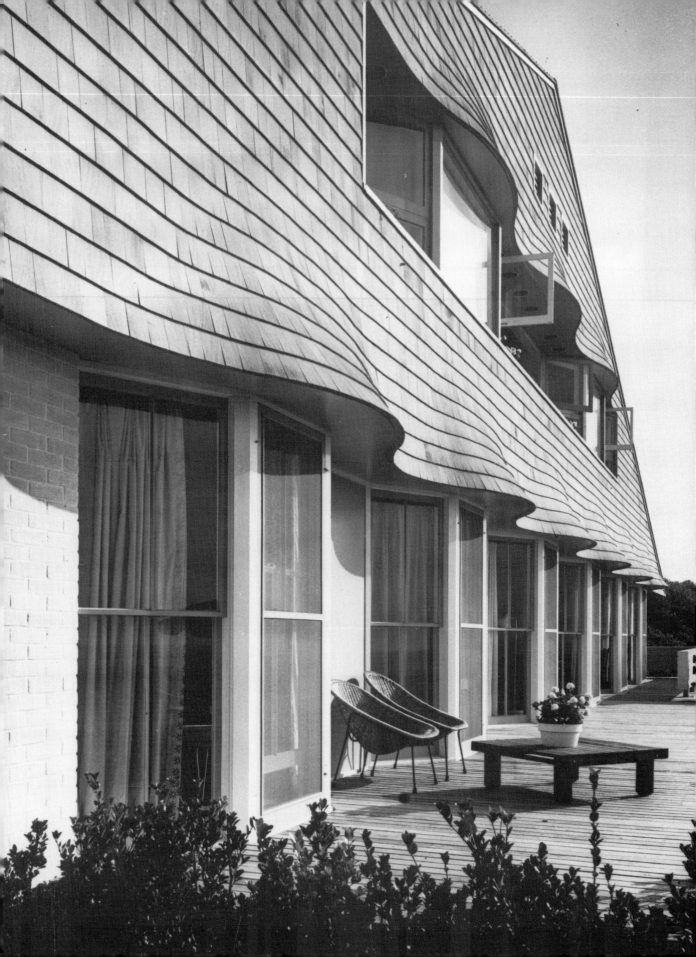

Nelson and Chadwick's O. R. Johnson house (Amagansett, N.Y., 1958) continued the shingle style but abandoned the overt historical reference. (photo: Ulf Fredrik Wahlstrom)

A 1948 forerunner of track lighting, devised for the Chicago showroom of Herman Miller.

A detail of the shingled exterior of the Spaeth house.

plemented by the use of theater-type dimmers, which Nelson had already introduced in several residential applications.[32]

Among other interior designs were two that, for a while, stood near each other on New York's Fifth Avenue, spiritual and physical neighbors to the 1954 Manufacturers Trust Company bank of S.O.M.'s Gordon Bunshaft. The Rosenthal Studio-Haus opened in 1968 at 584 Fifth, selling designs in porcelain by Walter Gropius, Raymond Loewy and Richard Latham, Tapio Wirkkala, Wilhelm Wagenfeld, and others. To house this collection, the Nelson office, with Paul Heyer[33] as project director, provided a cylindrical bronze entrance, a blinking digital clock that "kept passers-by puzzled,"[34] and a sidewalk periscope looking down into the lower floor.

Shortly after the Rosenthal shop opened, the office began two years of work on La Potagerie, with Charles Morris Mount in charge of design.[35] A soup restaurant for 554 Fifth, it would be distinguished for the thoroughness of its design. Staff members studied menu designs, trays, and cutlery, commissioned tapestries from the textile artist Sheila Hicks, and even threw some of the pottery themselves.

And, naturally, Nelson was interested in interior design principles that transcended specific installations. Naturally, too, his interest was expressed in writing, including a series of four books (one on living spaces, one on chair design, one on display techniques, one on storage) collectively called the Interiors Library.[36] One principle he investigated for *Interiors* magazine was the virtue of what he called the "dead-end room":

> Frank Lloyd Wright's approach to house design—a field in which he is unsurpassed—offers many illustrations for the popularity of the dead-end room. . . . Wright's clients have been conspicuous for their enthusiasm about their houses, and without discounting the many other important factors which contribute to their feeling, I am convinced that one reason is that Wright always finds a way to put walls at their backs. . . . All we have to do is keep in mind that people still remember, however dimly, those far-off days when a cave felt like a good place to live.[37]

For the same magazine, he also investigated the "New Subscape" of metal legs supporting the new furniture,[38] and considered the public acceptance of "Modern Decoration": "Come to think of it, I never did run into a client who asked for plywood and rubber plants."[39]

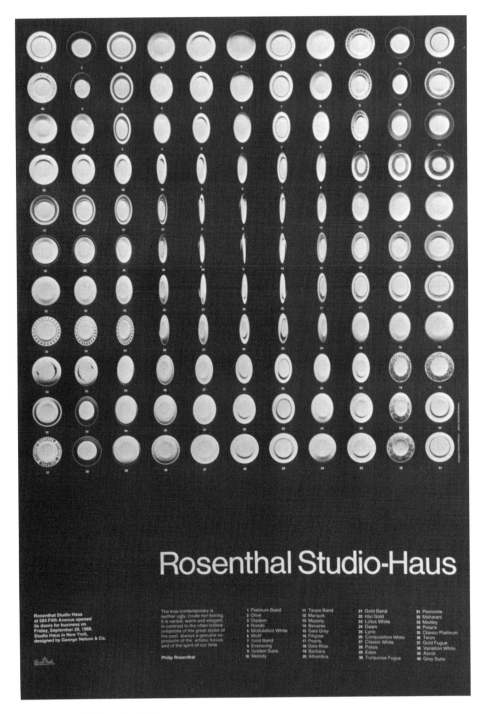

A 1968 poster for Rosenthal china.

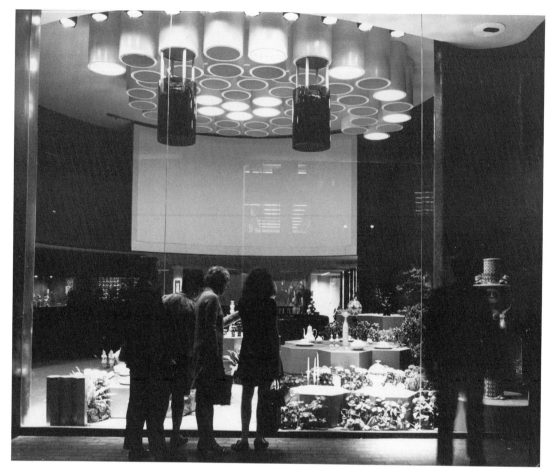

The Rosenthal Studio-Haus in New York (1968).

An illuminated display wall in the Rosenthal shop.

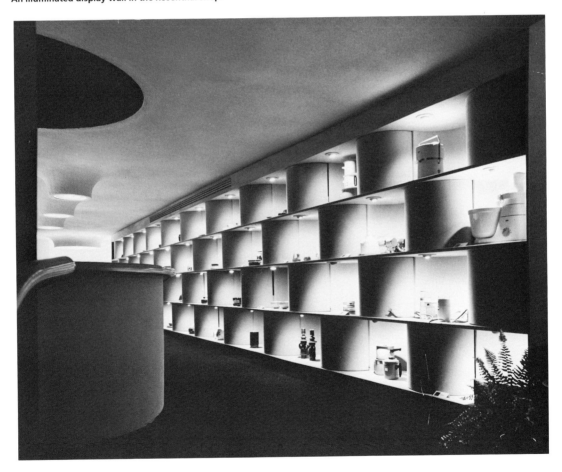

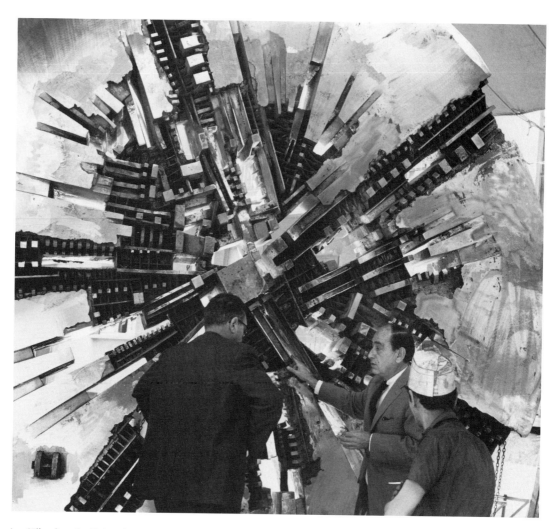

In a Milan foundry, Nelson inpects a Pomodoro sculpture intended for the front of the Rosenthal shop. Judged too heavy for the Fifth Avenue sidewalk, it was never installed.

By the 1970s it was obvious to many that modernism, in both interior design and architecture, had lost some of its initial vigor. While continuing to be capable of isolated high points,[40] its general practice had become depressingly routine. Nelson put it this way: "Our skyscrapers are like toothpaste forced from tubes. You can go from one end of the country to the other, and it's squirt, squirt, squirt—40, 50, 60, 70 stories. Big deal![41] Even so, over the next decade and a half, Nelson would continue to resist postmodern kleptomania as a worthy successor. Privately, writing to his friend Theo Crosby, he complained of "all those jobs Michael Graves et Cie. are mauling with such untutored vigor."[42]

But modern/postmodern bickering never engaged Nelson's attention as had the traditional/modern war, and he came to think architecture of *any* style uninteresting, perhaps even unnecessary. This notion, of course, was consistent with his growing conviction that the modern world was "too much with us":

> Like everyone of my generation, I grew up in a social context which included a belief in progress so total that no-one ever bothered to talk about it. . . . The key word [was] "more," more of everything, with the emphasis on the "thing" in "everything."[43]

But an excess of architecture, of furniture, of products, of design in general, had brought only a tragic diminution of visual variety and individuality:

> I know that in my own lifetime we have changed from a small-town mercantile, agricultural and manufacturing society to megalopolis and all that that implies, inside a mass technocracy on a permanent war basis, in which personal freedom is being steadily eroded and the rugged individual who used to be the American model is finding fewer and fewer places where it is comfortable for him to be either rugged or an individual. . . . A mass society [is a] strange, sleazy place.[44]

In the 1972–73 school year, Nelson was a visiting critic in architecture at the Harvard Graduate School of Design. Sharing a group of students with associate professor Joan Goody, he set them to work responding to his idea that cities might benefit from less-visible architecture:

Gordon Chadwick and George Nelson at work.

> Michigan Boulevard is Chicago's great street, primarily because
> for much of its length some of the buildings are missing, replaced
> by parks and river crossings. Could any of us imagine this street
> improved by any architect alive, with buildings continuous on
> both sides? I doubt it.[45]

This led him to the following hypotheses:

> First, we have the observation that a substantial degree of visual
> pollution in cities is created by the buildings themselves.
> Second, we have the proposition that if offending build-
> ings cannot be removed, many services can be so housed that the
> buildings become invisible as buildings.

Third, this possibility of the visual elimination of architecture exists because so many facilities have no need for windows.[46]

There were two ways of achieving these goals, his students were told: to build underground, and "to build above ground, using structures like low-profile Aztec or Mayan pyramids, covering them with topsoil and planting nasturtiums, poison ivy or whatever comes to mind. Such structures would of course be visible, *but not as architecture,* which I see as their great virtue."[47] Nelson had produced such a design himself as an unsuccessful competition entry for the U.S. pavilion for Expo 70 in Osaka.[48] Through massive earth moving, it would have offered underground exhibition spaces and surface parkland.[49] Similar interests were expressed in a 1973 article that rather gleefully predicted "The End of Architecture":

> This much seems clear: what we think of as the 'reality' of architecture, which has so long been a conspicuous expression on the exterior (just think of Venice or Paris or Florence for a moment) is now shifting with considerable rapidity to the interior. Such a transformation is not necessarily bad, but it does give rise to questions about what is happening to architecture as we are accustomed to think of it. My own hunch is that a lot of it is simply going to vanish, first by becoming increasingly uninteresting and then by being swallowed up into megastructures or by being buried in the earth or covered with topsoil and planted. . . .
>
> It doesn't matter so much whether architecture is coming to an end or not, for the central problems of our time are not architectural, but have to do with the humanizing of technology, with getting this runaway monster under control. Technology cannot possibly be humanized unless people become human first, which is no mean task when we consider the extent to which the present passive acceptance of mass violence and truly insane brutality has gone. . . .
>
> These speculations represent a highly personal scenario; other concerned individuals will write their own. But despite the innumerable variations one could imagine, I cannot believe that the creative role for the designer *now* can be anything other than the production of humane environments. Anything else, given the social context, is anachronistic, inconsequential, egotistical and empty posturing.

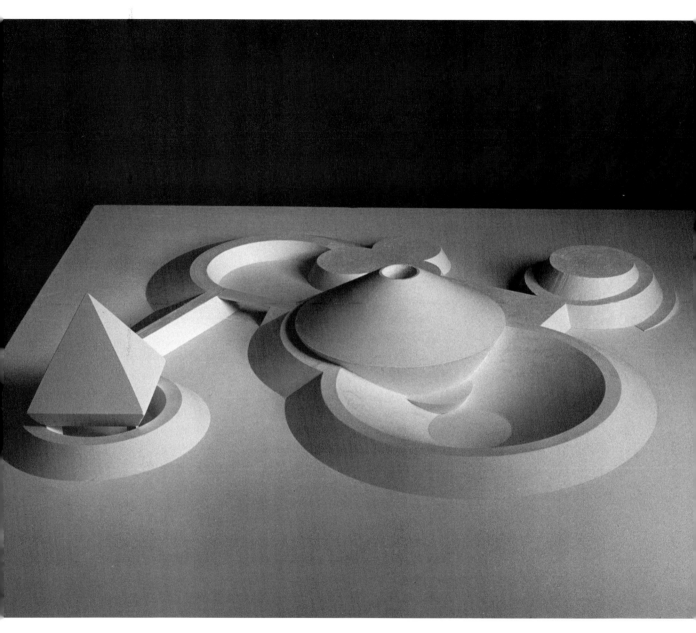

The competition model for the U.S. Pavilion at Expo 70 in Osaka.

The real problem for the designer is not only to find clients: *he must first determine what a humane environment really is.* The answers are not available in the supermarket. What seems to be needed is observation, study, interdisciplinary friction and thought, directed towards the creation of a new cultural base, which is an indispensable prerequisite for a revised set of social priorities.

The human environment is not a slogan: it is a mystery which can only be penetrated by humane people.[50]

Nelson never again focused his attention on the conventional problems of architecture. His brief autobiography in the first catalogue he produced for the Herman Miller Furniture Company said simply that he had studied architecture "by mistake," and years later, looking back at his early desire to become an architect, he wrote that "it took some years to discover that what had attracted me was architecture as expression rather than technique."[51]

Just as well; there were many other fields to which Nelson was drawn, among them the burgeoning young field of industrial design. Shifting his major attention there would mean a shrinking of the scale of the objects designed, but it would also mean a dramatic expansion of the audience designed for. Industrial design's opportunities for effecting positive change were obvious, even if, paradoxically, they entailed adding to the threatening surfeit of consumer goods. As he later wrote:

The weakness of the architect was that, while he used mass-produced components, he still saw architecture as a one-of-a-kind signed masterpiece. Because of this preoccupation with the personally crafted monument, he also failed to see that the building was not the end of the road, but that it was merely a component in the synthetic environment. The industrial designer has none of these hang-ups; he likes the idea that the millionth product will be exactly like the first off the line.[52]

3 A New Profession: Industrial Design

Introducing Nelson before a lecture[1] at the Smithsonian Institution, Bill Lacy joked: "Most people think that George Nelson, Charles Eames, and Eliot Noyes invented industrial design. That is, of course, an exaggeration. George did it without any assistance from the other two."

The less entertaining truth is that Nelson, returning from Rome in 1934, had found the field of industrial design already established and flourishing. He later observed that it had "appeared in the United States and Germany around the middle 1920s" and that

> Industrial design, like the asparagus beetle, emerges when the local situation is ripe for it. Ripeness can be identified by a certain technical sophistication in the industrial community and by a level of production that covers a broad range of items. . . . In the United States, the industrial designer began as the man who persuaded industry to make those dreary household gadgets and appliances look glamorous, thus starting a love affair with the American housewife that is not yet over.[2]

In those depression years, industrial design was, in fact, one of the few fields that had been growing rather than retrenching, and Nelson was intrigued.

Published earlier than the interviews with European architects, but almost certainly written later (after his return from Rome) was Nelson's examination of the newly identified profession. As those pieces on architecture had preceded his practice of architecture, so this long essay would serve as his introduction to a field he would make his own. For the February 1934 issue of *Fortune,* he described the work of ten prominent designers, comparing their ages, previous experience, achievements, staffs, clients, and fees.[3] He listed the "art industries" that had "always had the problem of appearance" and had traditionally used the services of designers—the fields of furniture, lighting fixtures, textiles, wallpaper, ceramics, jewelry and printing. He also listed the "formerly artless industries" that were beginning to employ designers—producers of aluminum

manufactures, electrical machinery, cars, clocks, locomotives, stoves, sewing machines, optical goods, and much else. Design, Nelson said, was "certainly here to stay in a number of industries that knew it not before." Eight brief case histories gave tooling costs, production costs, and sales increases (one as high as 900 percent) for recently designed products.

Nelson chose his ten designers as well as he had chosen his dozen architects; most of them are well known today. The first six were Walter Dorwin Teague ("suave, able, successful, . . . the generally acknowledged doyen of the profession"), Raymond Loewy ("the least publicized and one of the largest earners"), Henry Dreyfuss (at 29 the youngest of the group, a consultant to Bell Laboratories and the recent designer of Sears, Roebuck's Toperator washing machine), Harold Van Doren ("working the Middle West out of Toledo and conceded to have the business there sewn up"), Gustav Jensen (the designer of the Monel Metal sink, "generally regarded as the top man from the purely artistic point of view"), and John Vassos (who "might claim to be the most inquiring of industrial designers on the ground that he investigates two worlds for his ideas, the conscious and the subconscious"[4]). To these first six were added four "whose methods and ideas [were] far enough apart to indicate the boundaries" of the field: Lurelle Guild (who was said to redesign "about a thousand products a year" but who Nelson found "never ahead of his time or behind it" and "more interested in sales points than in classic grace"), Donald Dohner (a former academic with the very new title of Director of Art in the engineering department of Westinghouse), George Sakier (head of the Bureau of Design Development of the American Radiator & Standard Sanitary Corporation), and Norman Bel Geddes ("dynamic, volubly articulate, . . . the P. T. Barnum of industrial design," who had claimed back in 1927 to be the first industrial designer and whose staff of 30 was the largest Nelson reported). Also mentioned, much more briefly, were established artists just entering the field: Donald Deskey with furniture designs and Russel Wright with designs for radios.

In the *Fortune* article, Nelson defined the new "depression-weaned vocation" in terms of three dimensions: appearance, cost ,and use. His ten practitioners occupied different positions in the field in accordance with the relative importance each of them accorded these three concerns. For all of them, however, Nelson foresaw some common working methods and some common results. His description of these was prophetic of his own relationship with Herman Miller, which would begin 11 years later:

As far as single manufacturers are concerned, a company will probably get one designer and stick to him until its entire line is done, because the methods and personality of one designer will fit the organization better than another's and because there is thought to be a merchandising advantage in having a family likeness among products in a line. Such jobs have already been successfully undertaken by independent designers: Teague has been retained for six years continuously by Eastman, has designed cameras, is designing the stores in which to sell them. He has also done a line of Taylor instruments, of Pyrex ovenware. Guild has redesigned the Aluminum Co.'s Wear-Ever line, did a similar job for Chase Brass, is undertaking others. In industries large enough to warrant, industrial design is gradually being assimilated. Dohner and Sakier are already on the inside. Teague and Guild, who have done the greatest volume of work, play very close to their clients. . . .

Whatever the immediate results of his contact with the plant, whether headaches or triumphs, most manufacturers agree that the industrial designer has stimulated all those he has met in the company's organization, given them new ideas, new energy, a new attitude. The stimulation has often led ultimately to profits which cannot always be directly traced to the designer but which are in a measure due to his influence.

Designers will not cure our industrial ills, for our ills lie deeper than design. But the success of industrial designers is symptomatic of a changing attitude on the part of the manufacturers, a growing recognition of the old American ideal of progress: cheaper and *better* goods for all.

The profession grew quickly in prominence. Within a few months of Nelson's article both the Metropolitan Museum of Art and the Museum of Modern Art staged exhibitions of industrial design for the home, and a third New York show, "Art in Industry," was held at Rockefeller Center. *Forbes* soon followed *Fortune*'s lead with an article on the subject.[5] Popular attention was captured by the "streamlined" designs of the New York Central's *Twentieth Century Limited* and the Pennsylvania Railroad's *Broadway Limited,* both introduced on the same day in 1938,[6] and even more fanfare attended the exhibition designs created for the 1939 World's Fair.[7] By 1940, Harold Van Doren and Walter Dorwin Teague were

Nelson's office at *Fortune*, ca. 1945. His custom furniture designs include the first version of his slat bench. (photo: Ezra Stoller)

promoting their own ideas by writing books about them, and the following year Raymond Loewy did the same.[8] As early as 1940, however, the editors of *Art Digest,* in panning a series of room displays by Donald Deskey and others, noted that "the first blush of romance [was] passing out of industrial design."[9]

Fifteen years after his first article on the subject for *Fortune,* Nelson wrote a second one. By now, industrial design was firmly established not only as a respectable profession but also as a real force in the marketplace, and Nelson had established himself as a bright young star in the design field, his first furniture collection for Herman Miller having been a sensational success three years earlier. Speaking now with more authority, he said:

> It has been the glib assumption of most manufacturers and designers that the prime function of industrial design is the creation of added sales appeal. Actually this is a temporary and superficial aspect of the designer's activity, far less important in a long-term sense than his part in the job of reintegrating a society shattered by the explosive pressure of a new technology or institutions unable to cope with it.[10]

But Nelson was being overoptimistic. Creation of added sales appeal is an aspect of industrial design that today seems to be permanent and fundamental, and the "old American ideal of progress" bringing "cheaper and *better* goods for all" was an idea that, operating only in the service of the marketplace, would later haunt him. He continued:

> This may sound like talk straight out of the ivory tower, but it happens to be a fact that there has never been a society with sufficient vitality to survive in which there was not a direct and healthy connection between the arts and the business of daily living. In this particular time most of the traditional arts are dead or moribund. But it is possible to arouse a genuine interest in the curve of a fender or the shape of a kitchen sink. . . .
>
> The industrial designer is an artist because he shapes things in an effort to give order and beauty to a mass of material, and because in so doing he infuses an emotional content into an inanimate object. This emotional factor operates when the housewife buys toaster X instead of toaster Y, which sells for less

money—it has to operate because both toasters function in about the same way and only an engineer could possibly tell which is mechanically superior. Everything else the designer does—everything that goes beyond his function as an artist working in industry—is a secondary or a subsidiary activity. He will be judged ultimately on the appropriateness with which he shaped the things that were handed to him.

In the end, even this most prosperous and glamorous and complicated of professions comes down to a thing that is very old and very simple: one man's integrity against another's, one man's capacity as a working artist against another's, the vision with which he establishes his standards and the courage with which he sticks by them. The rest is trimming.

In 1947, while preparing the second *Fortune* article, Nelson was beginning to consider industrial design as a field for himself. He confided in Frank Lloyd Wright:

Our microscopic office has been in existence for a couple of months, and while there have been a few nibbles and a few false starts we have no architectural projects in work, and rent and salaries are being paid by furniture, graphic jobs, lamps, electric clocks and odds and ends. I suppose this makes me an "industrial designer" but at the moment the labels seem unimportant. Having interviewed some forty-odd designers during the summer, in connection with a *Fortune* story, . . . I can see nothing unworthy of respect in industrial design. . . . The problems are real; one struggles with materials, structure, function, assembly, and so on precisely as in architecture, and I am completely content to try to work out a good bed lamp until there is a chance to try to do a good house. . . . Whether the office ends up doing industrial design, or architecture, or both, I have no idea at present. It may turn out that I have no real place in either of these activities and that eventually I shall settle down to writing ponderous tomes that nobody will read.[11]

By the early 1950s, the profession of industrial design was ready for some of the institutions—such as conferences, publications, and societies—that older professions possessed.[12] The first of these, an annual con-

ference, was established in 1951, also the year of the Festival of Britain. The unlikely spot for the conference was Aspen, Colorado, a village filled with relics of prosperity as a silver-mining town and looking forward to prosperity as a ski resort. Aspen had been adopted by Walter J. Paepcke, the progressive chief executive of the Container Corporation of America,[13] as the site of an "American Salzburg." The Goethe Bicentenary had been celebrated there in 1949, and to house its lectures[14] and concerts Paepcke had commissioned Eero Saarinen to design a large and spirited tent. The following year, the town had been host to a world ski championship and a photographers' conference.

The idea for a design conference at Aspen seems to have originated with Egbert Jacobsen, the design director of the Container Corporation of America, and Herbert Bayer, the Bauhaus artist and graphic designer who had been a consultant to the same corporation since 1946. They sold their idea to Paepcke (quite easily, one imagines), and the International Design Conference at Aspen was born.[15]

Its character at first was less theoretical than it came to be in later years. The theme of the first conference, in fact, was thoroughly pragmatic ("Design as a Function of Management"), and its purpose was to tell designers and businessmen how they could work together for mutual profit. In addition to Paepcke, Jacobsen, and Bayer, the first conference's speakers included René d'Harnoncourt, Edgar Kaufmann, jr., Louis Kahn, Leo Lionni, Josef Albers, Stanley Marcus, Charles Eames, and, not surprisingly, George Nelson.

According to one observer, Nelson "gave everyone hell, businessmen and designers alike." "Designers," Nelson is reported to have said, "should realize that they are not a special kind of man, but that every man can be a special kind of designer. The designer and business man must have the opportunity to do what they want according to the ability of each, operate without fear and accept change without losing equilibrium."[16]

Nelson reported on the second Aspen conference in *Fortune*.[17] He included photographs and brief descriptions of the four speakers (Bucky Fuller, Walter Dorwin Teague, publisher Alfred A. Knopf, and Richard Gump, president of a store in San Francisco) and of a number of attendees—including D. J. De Pree of Herman Miller, whom he showed with a group of Eames chairs, and the Chicago designer Dave Chapman, who was credited with a hard-boiled definition that Nelson must have hated: "In-

dustrial design is planned control of consumer reaction to manufactured products, their merchandising and distribution."

Although Nelson would not formally serve as chairman of an Aspen conference until 1965, he was a guiding spirit of the conferences for more than 30 years, energizing board meetings and heading the planning committee. Although there *were* other people on the committee, board member Jane Thompson later recalled that Nelson "could never quite remember their names." "Planning," she continued, was "a *solo* he performed annually, with relish, . . . describing with pyrotechnics what the subject of the next conference should be, who might be in it, what its controversies and resolution would be."[19] Aspen board member Milton Glaser, who sometimes sought a more democratic planning process, found Nelson "cantankerous, but always intellectually stimulating." "We seemed to be constantly arguing," Glaser recalls, "but the arguments produced better conferences than the usual agreements."[20] Even when he was not performing any official role, Nelson felt a proprietary duty to see that everything at Aspen came off as intended. He watched events like a hawk, usually from the back of the tent (so that he could easily slip out for one of his beloved cigarettes) and not always approvingly. At one of the last conferences he attended, finding one of the speakers extremely dull, he turned to a friend and remarked: "There are two ways to empty a tent. This is the slow way."[21] (As a perennial board member and a principal nurturer of the Aspen conference, Nelson can be given much of the credit for that institution's decades of success, but he must also bear some responsibility for its shortcomings. These include, for much of the conference's history, a hermetic inner sanctum of leadership and a self-indulgent pattern of expensive board meetings in places like Santa Barbara, Cancun, Ixtapa, Jerusalem, and Venice.)

Nelson also played a role in the creation of a magazine for the field of industrial design, shaping a communications medium that would both stimulate and legitimize the field. The story of its formation suggests how small and incestuous the New York design world was at the time: A young man named Arthur Drexler had been working in the Nelson office, and Nelson, noticing that Drexler had remarkable abilities, not necessarily including design,[22] had suggested in 1950 that his colleagues at *Interiors* magazine hire Drexler as architecture editor. Soon after, Peter Blake left the post of curator of architecture and design at the Museum of Modern Art to return to *Architectural Forum,* where he had originally been hired by Nelson.[23] Jane Thompson was also at MoMA in 1950, having stepped

Nelson at the 1965 Aspen design conference, for which he was chairman. Behind him is his second wife, Jacqueline; between them is their son Mico. (photo: Ferencz Berko)

into the department's assistant curator spot after Ada Louise Huxtable left for Italy on a Fulbright grant. Drexler was offered the curatorship vacated by Blake; Thompson was offered the editorship vacated by Drexler.[24]

Arriving at *Interiors,* Thompson found "a certain tribal wisdom in the editorial room." "In fact," she noted, "it is a former handbag showroom, and five females[25] huddle within its windowless interior as [publisher] Charlie Whitney's Handbag Ladies, greatly in awe of the Male Editorial Legacy: there had been the fierce founder, Bernard Rudofsky,[26] the fantastical historian, Francis deN. Schroeder,[27] and now the omniscient contributor, George Nelson.[28] The publisher lets us know that Nelson has the word on practically everything, from chairs and furniture to design and architecture; he even has a hotline to Frank Lloyd Wright. Furthermore, Nelson's is the *final* word, especially after the weekly three-martini lunches between Charlie and George."[29]

In 1953, according to Thompson,

The idea of producing a new magazine on industrial design seems to bubble up out of those martinis,[30] and Whitney emerges, as always, sold by George. He asks me to be editor, saying, 'The responsibility is all yours . . . except . . . the money is all mine, the design is all Alvin Lustig's,[31] and the ideas, if you have any, are all

Nelson, in left foreground, with other board members (and a couple of guests) of the International Design Conference in Aspen. The setting was the La Costa resort, near San Diego, in December 1974. Top row, left to right: Milton Glaser, Ivan Chermayeff, Jaquelin Robertson, Bill Lacy. Second row: Jane Thompson, John Eckerstrom, Saul Bass, Julian Beinart. Third row: Consuela Rovirosa, Richard Farson, Jivan Tabibian, Henry Wolf, Einour Ackerson. Front row: Ralph Caplan, Richard Saul Wurman, Jack Roberts, Joan Bardagy, Niels Diffrient.

subject to the approval of George Nelson.' Ha! Obedient and snail-like, I crawl over to 57th Street to pick up my orders, thence to share them with co-editor Deborah Allen. But . . . no dice, no orders from those quarters. I find my superior decidedly uninterested in superiority or authority. The macho power play is not in his working vocabulary. He is not *even* willing to accept appointment as a mentor. . . . George wants only to *contribute,* to kick things around as equals and explore notions head to head. He

sees the magazine as a testing ground for broader design ideas, a sandbox in which we all could play together, in the company of such other regular playmates as Jay [Doblin], Dick [Latham], Art [Drexler], and Charlie [Eames]. We had fun in that sandbox.

Promoted to an instant equal by this early male feminist, I also found him an instant ally in ideological and financial struggles with the publisher. I then qualified for a series of mostly one-martini lunches (which, even so, is a lot of olives over four or five years). We lobbed ideas from his generalist's manifesto: the meaning of *things;* the battle against dehumanization in industrial society; technology and sensuality; the persistence of form; design for the needs of people—needs mostly undiscovered as yet.[32]

These were ideas that would concern Nelson always. Two quotations reflecting related views appear in his notebooks, the first from William Barrett and the second from Erich Fromm:

It remains to be seen whether we moderns can find ourselves at home in this world.[33]
We live in a world of things, and our only connection with them is that we know how to manipulate or to consume them.[34]

It is, of course, the nature of an industrial design office, no matter what the philosophy of its principal, to produce "things," and Nelson clearly saw the irony of his role as one of the producers. Interviewed by *Interiors* in 1965, he would say:

What does affluence mean to the designer? The current consumer orgies should give most self-respecting interior designers a belly-ache. It also means a designer can get rich enough so he can quit work and ride around in the fiberglass boat he designed the year before. The trouble here in our office is that we haven't designed any fiberglass boats. As for its impact on society as a whole—Look, society pays the price for the goodies it gets.[35]

Nelson must have particularly relished a series of commissions that came to the office in the late 1960s and the early 1970s for the Social Security Administration. This work was not concerned directly with things

at all, but rather with process and attitude. At first asked to rethink the agency's field offices and all its printed matter, the Nelson office, with Christopher Pullman as project director, went on to consider the reduction of contact time between claims takers and claimants and, even more basic, the reduction of friction between them. One main problem, Nelson determined, was that the offices and all its written communications looked like the government: impersonal, gray, overcomplicated, and intimidating; another problem was the polarization between the government writers who fashioned the documents' contents and the government designers who fashioned their form. From these considerations came a nine-page pamphlet, "Making Messages Visible,"[36] which ostensibly taught Social Security field representatives how to make their own posters, flyers, notices, and news releases, but which really taught the rudiments of clear writing and clear design to those who lacked either skill or interest in those subjects. Long before the phrase "information design" became fashionable, Nelson was examining impenetrable legalese and seeing it as a design problem.

"Making Messages Visible" led to another training booklet for the Social Security Administration, "How to See,"[37] which sought, according to its introduction, "to open our eyes to a world of visual information available to us every minute but ignored by us much of the time."

Some of this available visual information showed pretty clearly where society's general priorities lay. In his essay "The Future of the Object," Nelson noted that "the most disciplined, the most elegant, the most beautiful"[38] objects being designed and manufactured were either weapons or tools for scientific exploration. This idea had found rather extreme expression in "How to Kill People," a 1960 television program Nelson had created for the CBS *Camera Three* series and had adapted for the January 1961 issue of *Industrial Design.* His friend Peter Blake claims that Nelson was "incapable of being nasty or vicious," a view not universally held. But even Blake says that he could "be guaranteed to take the most outrageous, impossible, irritating position on any subject," and that "How to Kill People" was "typical George," providing "something to outrage everyone."[39] Straightfaced and heavily ironic, the article presented killing as a design problem that had been not only long sanctioned and well rewarded, but also the beneficiary of great ingenuity:

> Design for killing is interesting because war occupies so much of our attention, and receives our unquestioning support. The great

advantage for the designer in this area is that nobody cares what anything costs. This attitude has been prevalent from the siege of Troy to the bombing of Hiroshima. And it's this kind of attitude toward money that has always attracted creative people. This is the reason, probably, that the design of beautiful and efficient weapons has progressed continuously without serious interruption. What we're talking about is killing—but not murder, for murder is of no interest to the designer. Murder weapons are almost always improvised—a bathtub, a breadknife, a clothesline. What we are talking about is the kind of killing that is supported by society.[40]

A survey of developments in weaponry and defense—clubs, spears, armor, stockades, castles, pistols, cannons, rockets—ended with Nelson's conclusion that, with increased scale and decreased personalization,

> The designers have designed the excitement out of killing. We will never see the whites of their eyes again. Or the likes of General Wolfe breathing his last at the siege of Quebec. The designers have put the generals a thousand feet under the ground, where their companions are radar screens and humming banks of computers. . . . We have designed war and its instruments to the point where not only have we recreated the boredom, the tedium of peace, but we have also made the weapons incomprehensible. . . . Is it any wonder that in every medium of entertainment we have shifted from the respectable kind of killing to murder? How else can we reintroduce the personal element into the activity that has been man's favorite throughout history? If legalized killing should ever be brought to an end, the newest designs tell why: it has become too impersonal to be interesting, too complex to be comprehensible.
>
> But if peace ever does break out, we designers needn't worry. We'll find something else to do—though it may not be so profitable—and, personally, I hope it will have to do with people.

Less dramatically, Nelson found another peak of industrial design activity in the equally anonymous field of sports equipment. In a 1976 article in *Du* he looked admiringly at hockey masks, baseball gloves, running

shoes and racing bicycles, finding in them a relationship to weaponry, a survival of craftsmanship, and, as with weapons, superior design:

> Games have symbolic meanings, some related to life-and-death confrontations, seen in the competitive nature of sports. Competition identifies strengths and isolates weaknesses. In sports, the chances of winning are influenced by the design of the equipment, a fact which leads to intense concentration on minute details. . . .
>
> Furthermore, an examination of [baseball gloves] shows something that has almost disappeared from consumer products: a visible concern for quality of materials and workmanship that extends to every detail. It is strange: the evidence of loving care we associate with the best preindustrial craftsmen suddenly surfaces again in articles for a highly commercialized mass sport. . . .
>
> Sports equipment, viewed as design, moves into the top rank of man-made products because of the extreme efforts put into it by people who are in the rare position of craftsmen-designers, asked only to meet the highest performance levels in whatever way they think best.[41]

Nelson's own particular passion was for the design of writing instruments. He loved pens and pencils, his son Mico remembers, the way some people love cars or boats or horses, and he could never pass a stationery store without going in.[42] He did most of his writing on an Olivetti Praxis typewriter, designed by his friend Ettore Sottsass, Jr. ("a very crisp little object, very Italian"[43]), but when traveling he carried a fat Mont Blanc "Diplomat" fountain pen:

> Anyone with a writing chore and a deadline is always looking for some legitimate way to goof off from time to time, and refueling the pen, in this respect, was ideal. Not only did the reservoir and nib have to be washed out in water each time, but when the pen was finally filled it had to be wiped carefully with tissue, or your fingers would be semipermanently stained. All this took at least five minutes, and with a little practice I was able to stretch it to ten.[44]

But a few typewriters, pens, and catchers' mitts, Nelson saw, were only a drop in the discouragingly large bucket of mediocrity. He quoted

Boris Pushkarev, chief planner for the New York Regional Plan Association, as having said that "the beautiful objects of our contemporary man-made environment tend to be grouped at the extreme ends of the scale, the micro and the macro, while the intermediate range, the so-called human scale, contains most of the ugliness," and he imagined the purchaser of objects in Pushkarev's middle range as being confused:

> The modern consumer, poor little alienated bastard, is the most upward-mobile character who ever lived, but his problem is that he isn't quite sure where "up" is. His new affluence, a heady brew compounded of some cash in the bank and a large amount of installment credit, teaches him that the basis of status is dollars, and there is precious little in his environment to suggest anything else. The central philosophy of a technocentric culture is based on a faith in "efficiency," in its most narrow and localized sense, and in quantity. The effects of this philosophy are to make people helpless and insignificant, to encourage conformity, to cripple the faculties needed for living a full life, and to discourage both thinking and feeling. People, in this context, tend to become objects themselves—things—and hence their judgment in such matters as design is not reliable.[45]

While most designers would seek the remedy for this situation in better object design, Nelson imagined a beneficial lessening of our dependence on objects, however designed:

> As the object continues to show occasional signs of disappearing, either into larger systems or the growing heaps of litter, the possibility of future surprises for future objects is always there. One eminent sociologist, Dr. Nelson Foote, when queried by one of the industrial giants regarding possible consumer wants in 2000, studied the available data with his customary scholarly thoroughness and came back with the answer that the most desired commodity at that not-so-distant time might conceivably be— conversation.[46]

At the end of 1983, *Industrial Design* celebrated its thirtieth year of publication. Because an article by Nelson had appeared in its first issue, the magazine's publisher, Randolph McAusland, felt it "altogether fitting" to ask him to help celebrate with another piece.[47] Adapted by Nel-

son from notes for a book that he would never get around to finishing,[48] it was a long text titled "Design on a Small Planet." Characteristically, it gave his fellow designers hell for not knowing what design was, not knowing how it was done, and not knowing the difference between design and marketing:

> I remember Walter Dorwin Teague sitting in his pink office like an overstuffed little pouter pigeon, telling a group how he "designed" a new Boeing plane. The fact that the plane had been *designed* by a variety of engineers, physicists, mathematicians and God knows who else was blithely ignored, although the work of this anonymous group was the reason a plane is able to take off and land without killing everybody. What Teague's office had done was the interior design or decoration, a perfectly respectable activity, but hardly central to keeping passengers and crew alive. . . .
>
> There have been proposals to "improve" design by converting it into a kind of science. Those with even a smattering of recent history will remember that the same attempts were made in psychology and sociology. I suspect that such efforts are not so much an attempt to improve, but rather to get a free ride on the enormous prestige science enjoys. Design is not science and it never will be, for the simple reason that science deals with process, like an earthquake or a star going nova, which is observable, measurable, and even predictable sometimes, while design deals with human activity. You can "explain" things like Frank Lloyd Wright's Fallingwater or the Eiffel Tower or an Eames chair, but there is no way to predict them before the fact, not even if we could pack Madison Square Garden solid with Cray computers. . . .
>
> There is a good deal of soul searching going on among members of the various design professions, but what I encounter is not so much a desire to improve personal capabilities, but worries about the status of the designer, or whether his work has suitable "impact" on the world of his clients. It is a waste of time, all of it. It is a merchandising concern, not a desire to develop human potential. (If you are designing a point-of-sale display for sugar-free gum at the supermarket, a concern for "impact" is perfectly proper: it sells more gum if handled properly.) Genuine professional concerns have to lie elsewhere.[49]

4 The House

One area for genuine professional concern was housing. Nelson, as we have seen, was no slouch at designing individual houses. With William Hamby, and later with Gordon Chadwick, he designed a number of fine ones. The Fairchild townhouse, in particular, is among the most inventive early modern houses in America. But what came to interest Nelson, more and more, was not design for specific clients but something broader and more generic: not houses as custom solutions, but the house as building type. He may also have wanted to bridge the gap between the one-of-a-kind practice of architecture and the multiple-product practice of industrial design, and he may also have sought a healthy synthesis of the gentleman/artist/architect and the businessman/builder.

In 1940, in any case, with the United States on the verge of war, there was already a tightening of money and material available for private building, and there was also widespread speculation about new forms of housing in the postwar world. That year Nelson began a series of articles, "When You Build Your House," for *Arts & Decoration* magazine.[1] In these pieces he examined the possibilities of current residential design element by element, continuing his gentle advocacy of modernism as the only sensible course to follow: "There is no such thing, generally speaking, as a Louis XIV kitchen or Italian Renaissance bath, any more than there are Colonial refrigerators or Tudor stoves."[2]

In 1942 Nelson and Edgar Kaufmann, jr., were advisors for the housing exhibition that Eliot Noyes curated for the Museum of Modern Art, and in 1943 Nelson, with Henry Wright and others, articulated wartime hopes for postwar houses in *Fortune:*

> The U.S. house industry, everyone will recall, was headed for a revolution only a dozen or so years ago. The word functionalism was the battle cry. . . .
>
> A handful of modern architects who have found clients hardy enough to go along with their ideas have taken the engineering approach to housing, but few have realized its full potentialities. Despite their vaunted functionalism, they have paid

surprisingly little attention to many of the most basic functions of houses. The overwhelming majority of designers—including some of the most "modern"—have kept right on being less the engineer than the artist, less the analyst of function than the arbiter of taste. For them modernism meant mere streamlining—which is to say, styling.

The postwar revolution in housing will not be a revolution in style any more than the internal-combustion engine was a revolution in style. It will be a revolution in performance. The designer's approach will necessarily be analytical. He will have to get down to fundamentals. He will be forced to define the basic purpose of the house, to ask himself whether that purpose is being fulfilled to the limit of the materials and techniques available. If he is good, he will appraise the efficiency of every room, of every facility, even of every door and window. Out of such thoroughgoing searching of methods and devices generally taken for granted will come the long-promised house that works.[3]

Nelson was also continuing, of course, to report on new house design and other matters for *Architectural Forum.* In 1943 or 1944 he and his *Forum* colleague Henry Wright decided to put their thoughts on the subject into book form. The result was *Tomorrow's House,* published by Simon & Schuster in 1945, with layouts by Paul Grotz, photography by the Hedrich-Blessing studio, Ezra Stoller, and others, and works by Frank Lloyd Wright, Walter Gropius, Marcel Breuer, Richard Neutra, Philip Johnson, Edward Durrell Stone, Joseph Esherick, and Carl Koch. The book was a great success. Four months after publication, it was selling 3,000 copies a week and was in its fourth printing[4]; by November 11, 1945, it was number 14 on the *New York Times* best-seller list; a week later, number 13; the next week, number 9. Even Nelson's curmudgeonly friend Frank Lloyd Wright (whose Fallingwater was the subject of the book's only two-page-spread photograph) came very close to praising it: "*Tomorrow's House,*" he said, "is nearest to something intelligent and helpful that I have seen published on the subject."[5]

Tomorrow's House did not concentrate on the practical problems of financing, site selection, service connections, and mechanical equipment, as other books of the time were doing, nor did it examine the house room by conventional room. Rather, it surveyed domestic activities

and suggested sensible accommodations for them. ("You will not find a chapter on bedrooms . . . but a great deal about sleeping."[6]) These suggestions, of course, were unencumbered by tradition, and, while the book was not ostensibly an argument for modernism, its examination of living patterns and their solutions led to this conclusion:

> Wherever we look—whether at the present or the remote past—the answer is the same. The great tradition in architecture is honest building. It is true right now as it was in the days of the Pyramids. We have included only modern houses in this book because in our time they are the only way to carry on the great tradition. There is no possible chance to turn the clock back. In designing houses today we have to be ourselves—twentieth century people with our own problems and our own technical facilities. *There is no other way to get a good house.* No other way at all.[7]

However, the book advocated modernism not as a style (International or otherwise) but as a reasonable response to needs, unfettered by convention:

> If your lot is a hillside and common sense demands that you put the garage in the attic and the bedrooms two floors below, don't fret because this is a violent departure from grandmother's Colonial farmhouse. Of course it is, but you aren't grandmother. . . . The modern house is a good house because it is a "natural" house.[8]

For all its good sense and happy reception, however, Nelson later described one stumbling block on the way to *Tomorrow's House:*

> [Simon & Schuster] had given us advances, and like any young writers we had spent them and hadn't done the work. . . . We were well-qualified to write the book, except when we got to the chapter on storage: we simply could not write the required 5,000 words. This produced frustration of an acute sort. We had done all sorts of research; we knew, for instance, that housewives' pet peeve was inadequate closets. (This was the beginning of the American possessions explosion.) We also knew that closets were

Part architecture, part fur-
niture, the 1944 Storage-
wall promised to hold the
postwar family's burgeon-
ing supply of consumer
goods.

very good for clothes, but not so good for golf clubs or coffee percolators or watering cans, but we couldn't break through anywhere to write 5,000 words.

I was sitting in my office, staring at the wall, miserable; we had just had another angry call from the publisher. I was looking at the wall and something in my head said, "What's inside, how thick is that wall?"

I thought, "Who cares how thick the wall is, it's probably 4 or 5 inches, go away."

And again, the real feeling of a dialogue with an unwanted visitor:

"What is inside the wall?"

"Hollow tile with plaster on top of it."

"What else?"

"Nothing."

"Do you mean there is a vacuum?"

"Not a vacuum, air."

"Air" was the trigger. Suddenly all those unrelated things crashed together, and I realized that the essential element in any storage unit of any sort or size was *air*. A closet has so much air; a kitchen cabinet has so much air. And I thought, "My goodness, if you took those walls and pumped more air into them and they got thicker and thicker until maybe they were 12 inches thick, you would have hundreds and hundreds of running feet of storage. It didn't take enough inches off the room on either side to be noticed." This was the birth of the storagewall.[9]

In his 1954 book *Storage,* Nelson added this:

> It was here that the idea of a new kind of partition, suitable for industrial production in standard units, took form and received a name. An essential part of the . . . concept was that the storage wall was basically a two-sided affair, not an assembly of boxes or shelves against a partition, but a replacement for it.[10]

On its way to becoming the missing chapter of *Tomorrow's House,* the Storagewall concept was published in *Architectural Forum* and then in *Life.*[11] It proved to be significant not only for the book and for the prob-

lem of residential storage, but also for Nelson's own future and for the development of a whole field of commercial interior design not then imagined.

The most interesting thing about the concept was not its accommodation of snowshoes, tennis rackets, and vacuum cleaners; the most interesting thing was its creation of a new hybrid—not exactly architecture, not exactly furniture, but with qualities of each, structurally independent and substantial but also modular and infinitely flexible.[12] Perhaps Olga Gueft, editor of *Interiors* in its most important years, was not being excessive when she wrote in 1975 that "all open plan systems are derived from the possibilities generated by Nelson in that 1945 *Life* spread."[13] Similarly, the *Penguin Dictionary of Decorative Arts,* in its entry for "System Furniture," notes that "the invention of the 'storagewall' by George Nelson in 1945 . . . was basic to the whole innovative development."[14]

Another element of the postwar house that needed nearly as much attention as storage was the kitchen. For most American families, a hired cook was a remote memory; gone, too, was the commodious size of the old-fashioned kitchen. In their place there was the (often exaggerated) promise of new technology.

Nelson made his first venture into kitchen design in 1943. His prefabricated kitchen core, sketches of which were published in *Fortune,*[15] featured "dashboard controls," deep refrigerator drawers with glass tops flush with the counter, a separate freezer and ice-cube maker, a vertical broiler "to broil steaks on both sides simultaneously," foot-pedal controls for the water taps, and a large double-glazed window box for growing fresh herbs.

Tomorrow's House, which soon followed, had surprisingly little to say about the kitchen, but its ten pages of kitchen photographs included one by Nelson & Hamby, one by Frank Lloyd Wright, an "ideal kitchen" with "so far unobtainable equipment," and a one-piece manufactured kitchen "actually in production but not yet in wide use."[16]

In 1953, General Electric's kitchen equipment designers, led by Arthur BecVar, attempted to catch up with Nelson's ten-year-old sketches and hired him as a consultant. He developed two specific products for GE: a wall-hung refrigerator and a mechanized storage unit ("MSU") that would raise or lower shelves to accessible heights. The refrigerator suffered from the weight of the materials then available and the consequent need for reinforcing the kitchen wall behind it; today's lighter materials might warrant a revival of the idea. In any case, neither product was a big

In the late 1950s the Nelson office developed a mechanized kitchen storage unit ("MSU") for General Electric. The prototype is shown here in closed position (behind the lower cabinets) and open. It was never put into production.

seller. Of greater potential importance was something called the Unit Kitchen,[17] Nelson's concept of a pre-plumbed, pre-wired package incorporating all mechanical needs. This was even harder to sell. "It was still necessary," Nelson complained,

> . . . to argue the proposition that the *kitchen* should be treated as the basic product, not the different appliances. The appliances, I insisted, were not true objects anymore, but really components, since they functioned together as part of a . . . process. It was hard going. It was not easy to persuade the high-ranking manager of a department—say, refrigeration—which did a business of several hundred millions of dollars a year that his beloved product was nothing more than a mere component. . . . I lost the battle, after eight or nine years of interesting work and lively controversy, but won the war. Any appliance store will show what has happened.
>
> Today's kitchen is styled as a system. That is, the separate appliances are no longer isolated sculptural objects, but matching modular boxes which fit together in a variety of ways.[18] Furthermore, many of them are designed to be built in.[19]

It was probably inevitable that Nelson would soon apply the principles of modularity, flexibility, and prefabrication to the house as a whole. In 1957, immediately after Nelson & Chadwick's design of the Spaeth house, Nelson became deeply involved with work on a more generalized solution to the housing problem, an "Experimental House" based on the repetition of similar units and thus susceptible to modern techniques of mass manufacture. For a short while, he had as a collaborator on this project not only Gordon Chadwick but also the Italian architect and designer Ettore Sottsass, Jr., who was then just beginning his work for Olivetti.[20]

Nelson had been intrigued with the possibilities of mass-produced housing for a number of years. For example, in 1951, Nelson—trying to persuade Minoru Yamasaki to form a joint practice—had written to his onetime Columbia colleague: "We could be the little boys who gave the industry-built house its great *big* push."[21] And earlier he had called the single-family house "the only important consumer product left which is still assembled by craftsmen."[22]

The concept of industrialized housing was not Nelson's invention, of course; it was a prominent and widely discussed issue of the time. The

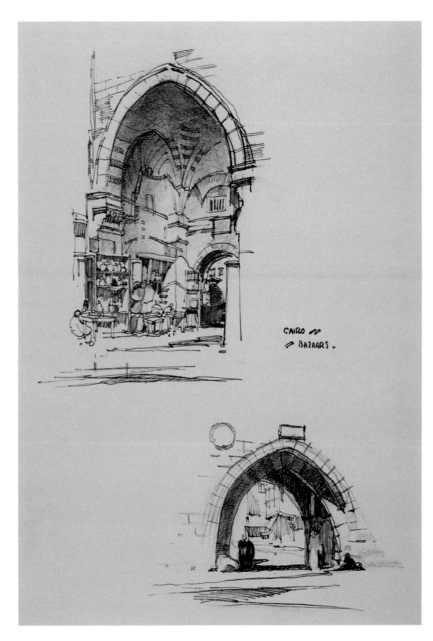

CAIRO
BAZAARS.

A sketch made by Nelson during his stay at the American Academy in Rome.

Six of Nelson's photographs from his "Civilized City" presentation to a 1947 conference of the Industrial Designers Society of America.

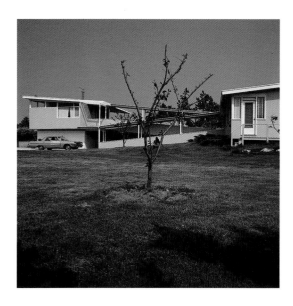

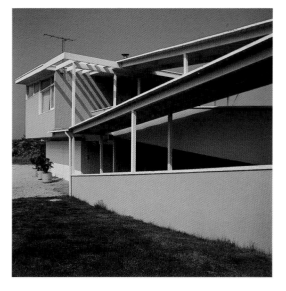

Three views of the Sidney Johnson house in East Hampton, designed by Nelson in 1949.

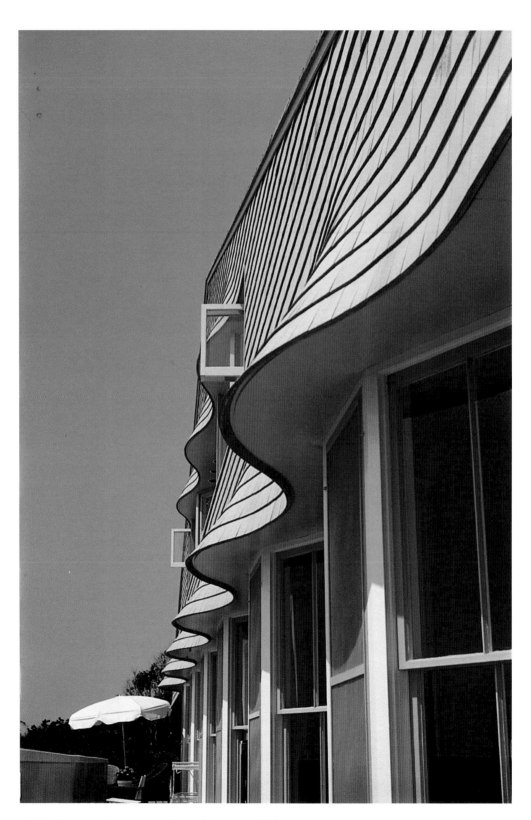

The Spaeth house in Southampton (Nelson & Chadwick, 1956),

A sampling of logos and corporate images from the graphics department of the Nelson office. First row: Herman Miller, 1946; Everbrite Electric, 1960; Creative Playthings, 1968. Second row: Scott Paper, 1961; *The Misfits* (film publicity), 1960; cover for 1967 USIA brochure "Industrial Design USA." Third row: American Express, 1961. Fourth row: Troia land development project, Portugal, 1964; USIA Research and Development, 1970; American National Exhibition, Moscow, 1959.

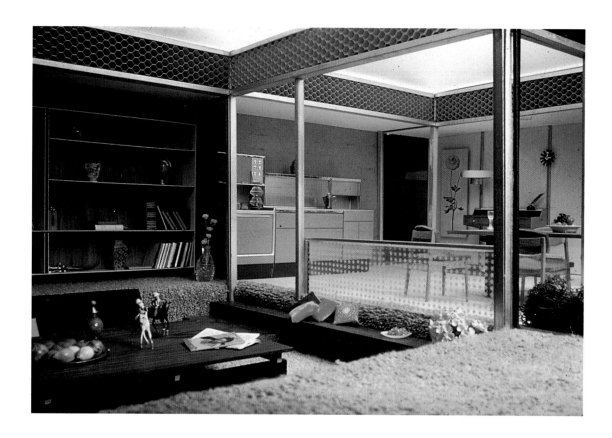

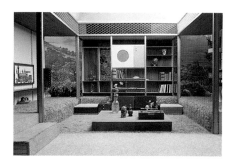

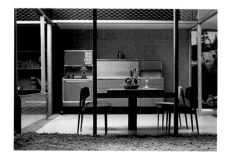

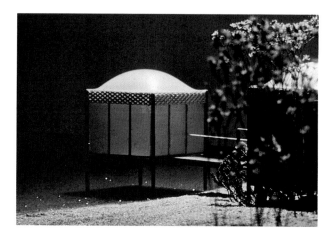

Four model views of Nelson's Experimental House.

Jacket designs for the 1948 and 1952 Herman Miller furniture catalogues.

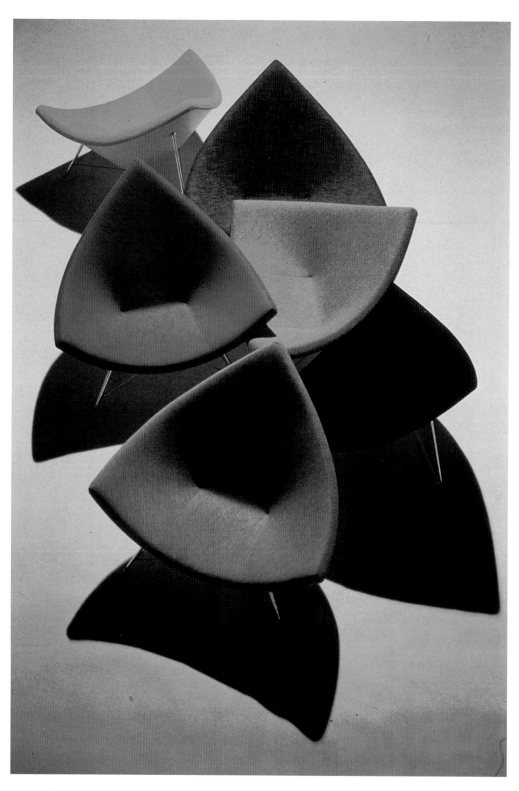

A group of Coconut chairs produced by Herman Miller in 1955.

imperative of industrialized housing was more than a matter of being in step with modernity; it was a matter of need. Society's inability to properly house its urban poor had become evident by the time of World War I; Franklin Roosevelt, in his 1937 inaugural address, noted that "one-third of the nation [was] ill-housed"; and in the years after World War II even the middle class was subject to serious housing problems.

The Luckhardts had experimented with the idea of industrialized housing before World War II, as Nelson had noted in *Pencil Points,* and Fuller's 4-D and Dymaxion Houses, dating from the late 1920s, had been intended for mass production. It was typical of the early reception to these notions, both from a threatened building industry and from a conservative architecture profession, that in 1928, when Fuller generously offered the patent rights for his 4-D house to the American Institute of Architects (of which his own father-in-law was then serving as vice-president), the AIA not only rejected the offer but formally resolved to "establish . . . itself on record as inherently opposed to any such peas-in-a-pod-like reproducible designs."[23]

In the early 1930s, such giant corporations as U.S. Steel, American Radiator, and General Electric took a more enlightened stand. From 1932 to 1935, GE and American Radiator took part in a collaboration (also involving a research institute called the Pierce Foundation) that built a number of steel-framed, asbestos-clad prefabricated houses designed by the architects Holden & McLaughlin.

The real leaders of the architectural profession, of course, were also more enlightened than the AIA. Le Corbusier had insisted in 1923, with characteristic fervor, that "we must create the mass-production spirit. The spirit of constructing mass-production houses. The spirit of living in mass-production houses. The spirit of conceiving mass-production houses."[24] Mies had written in 1924: "I consider the industrialization of building methods the key problem of the day for architects and builders. . . . I am convinced that traditional methods of construction will disappear. In case anyone regrets that the house of the future can no longer be made by hand workers, it should be borne in mind that the automobile is no longer manufactured by carriage-makers."[25] And Gropius, in a 1923 lecture, had preached of "art and technology, a new unity."[26] At the Bauhaus before the war and at Harvard later, Gropius had urged his students to understand and incorporate industrial processes. Marcel Breuer, Gropius's colleague at both schools and until 1946 his partner in a Cambridge architecture practice, had drawn proposals for prefabricated

housing as early as 1925, and in 1942 produced two interesting new prototypes for such housing: the "Yankee Portable" and the "Plas-2-Point" house. Both were intended for rapid construction from prefabricated wood elements, and the latter was meant to be cantilevered from two central supports.

In 1941 Gropius took in, as a long-term house guest, a young European refugee named Konrad Wachsmann, who had arrived in the United States with little more than a set of drawings for a modular building system. Wachsmann developed these with Gropius's help. In 1942 their system, called the Packaged House, was patented, and a company, called the General Panel Corporation, was formed to manufacture it. A demonstration model built in 1943 received a great deal of attention in the press.[27] Four years later, though, only a few test houses had been built; none had been mass-produced and none had been sold. By late 1951, when General Panel was finally liquidated, the firm had lost approximately $6 million and had sold fewer than 200 houses.[28]

In 1946 a version of Fuller's Dymaxion House, a transportable shelter made from fewer than 200 parts, was built in Wichita, Kansas, and *Architectural Forum* described it as "ready for mass production at Beech Aircraft." (Years later, Fuller would remember Nelson's "visiting at Beech Aircraft in 1945–46 to report in *Fortune* the realization of our first, airspace technology produced, full scale dwelling machine."[29]) Beech decided against production, however. In 1951 the *Forum* showed Fuller's geodesic-dome framing system, another major possibility for new shelter, noting that Fuller's innovations had previously "not been timed right for a hammer-and-nail building technology."[30] They still weren't.

Meanwhile, the New England architect Carl Koch and his collaborators had made several less dramatic but more successful efforts toward mass production. The first of Koch's efforts, the demountable Acorn house of 1945, was built only twice (hardly mass production), and its appearance was described by Koch himself as "rather unobtrusive and demure."[31] In 1949 Koch served as consultant to the Lustron Corporation for a prefabricated house. Production of 100 per day was ambitiously projected, and 3,000 were actually built; however, this house's design was even less distinguished than the Acorn's, and the failure of the venture cost Lustron's investors (including the federal government's Reconstruction Finance Corporation) more than $30 million.[32] In 1951, the Eames office was commissioned by the Kwikset Lock Company to design a prefabricated house that

could be sold as a kit of parts. For its design, the authority within the office was designer Don Albinson, who had been living in one of the Gropius-Wachsmann General Panel houses. The Kwikset house, a non-modular design that was to have been roofed with a single large plywood vault, was never produced, however.[33] In 1953, Carl Koch finally came up with some marketable houses: the Techbuilts. Yet these were, in all versions, visually unprepossessing, having the look of woodsy, pitched-roof cottages—factory-made imitations of conventional handmade houses.

The first published indication of Nelson's interest in the subject seems to be a 1943 advertisement in the *Forum* for Barrett Specification Roofs. Titled "Department Store in 194X," it shows Nelson at a drafting table and predicts "prefabricated houses for sale on the roof of a department store."[34] Two years later Nelson was writing this: "To date, nobody has made a factory-built house that is more satisfactory than the conventional article and sells for less money. The time is not too far off, however, when such houses will be available. Ultimately they will represent the majority of new American dwellings."[35]

Nelson experimented with additive modules in his unbuilt Ansul Chemical Factory project and in his 1956 factory for Herman Miller, each a cluster of buildings around a central plaza or along a central spine. It was inevitable that, even without the support of a specific client, Nelson would have wanted to address the problem of prefabricated housing with more vigor and wit than his colleagues had shown.

And he did. The result, published in *Architectural Record* in December of 1957 and in *Industrial Design* the following month,[36] was a visually sprightly and unconventional additive scheme of 12-foot cubes. Corner foundations of anodized aluminum cylinders were to be bored into the ground; aluminum cages were to rest on these, with lightweight panels clipped to the frames of the cages; translucent plastic domes (or combinations of metal and plastic) would top each module. There would also be supplementary units, 4 feet by 12, providing alcoves, services, or circulation. Conceptually, the design was somewhere between the work of Fuller and that of Gropius, less radical than Fuller's uniform houses produced as wholes[37] yet more adventurous than Gropius and Wachsmann's goal of a wide variety of housing types custom-made from small mass-produced parts.

Nelson saw what Fuller failed to see: that the house was far more than a machine, and that production efficiency was therefore beside the point if the result lacked psychological appeal for those who were to live

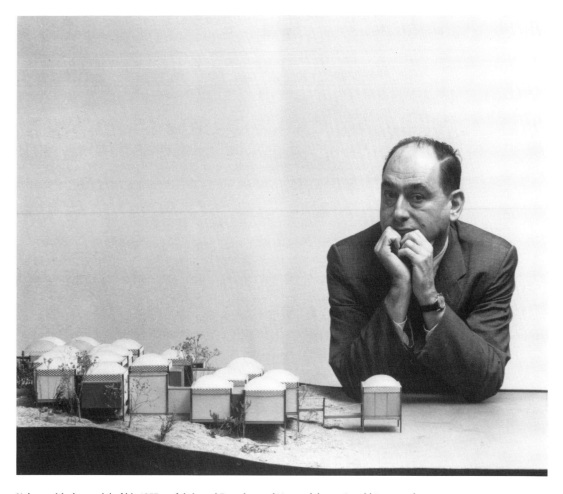

Nelson with the model of his 1957 prefabricated Experimental House. (photo: Arnold Newman)

The Experimental House's roofscape of translucent plastic domes.

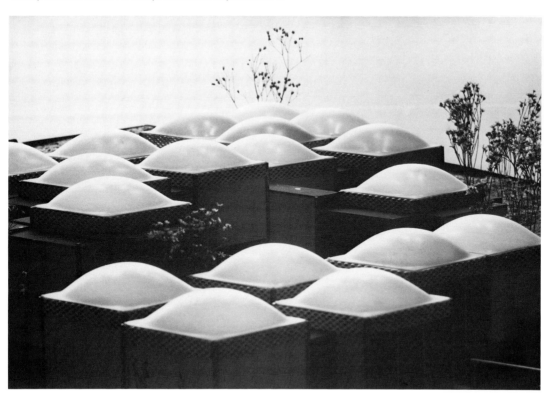

in it. His Experimental House, unlike Fuller's, offered endless configurations, yet its repetition of quite distinctive room-sized elements would in every case have produced an immediately identifiable design, unlike Gropius's. Of the dozens of schemes for prefabricated housing produced in those years, Nelson's was not the most visionary (that distinction being Fuller's) or the most practical (that being Koch's), but had it been built it promised to be the most delightful. Charles Eames's impression of the house was that "one is immediately drawn into thinking of the space as an experience. An experience in which one wants to take part. It is hard to say what the connections are—remembered Alhambras, or playing house under grandmother's cutting table. Whatever it is, I suspect that it has little to do with conscious style and has a lot to do with human scale—and human need."[38] Minoru Yamasaki wrote that "George Nelson's aluminum house is the most exciting new thinking I have seen in the field of house design. It shows for the first time positively the advantages possible through the full use of technology and prefabrication. I think it wonderful because it points the way out of our present housing dilemma."[39] Arthur Drexler, then curator of architecture and design at New York's Museum of Modern Art, called it "a product technically superior to its handcrafted competitors."[40] And the architect Pietro Belluschi wrote that "of all the prefabricated and experimental houses I have seen in recent years, this gives me the greatest thrill. . . . I hope some industry will finance its development."[41]

None did. The Experimental House remained an experiment, and the seemingly inevitable movement toward low-cost prefabricated housing remained unrealized—blocked by building codes and mortgage-approval processes tied to conventional building practices, blocked by recalcitrant and self-protecting unions in the building trades, blocked too by a false public perception that conventionally built housing was more personal and flexible. Popular reactions against new techniques and materials also played a part; years before, Nelson had quoted one woman's description of her own prefabricated house: "We are simply mad for our new house. I think the stone front is particularly wonderful—no-one would know that there was plywood underneath." He noted: "I have a mental picture of the same woman writing about a new dress—when she puts it on, no-one would dream that there was a woman underneath."[42]

However, some elements of Nelson's Experimental House—its domed modules, its lightness, its translucency, its prefabrication—were re-

alized soon after in his celebrated 1959 pavilions for the American National Exhibition in Moscow. And one thing Nelson noted with interest during his months in Russia was an attempt at the sort of industrialized housing he had been unable to effect at home:

> The problem is how to produce immense quantities of housing in a country lacking building skills. The answer: get rid of the need for the skills. Take the buildings away from the carpenters and bricklayers, and put them on assembly lines. Convert building, in one huge leap, from a slow, handicraft trade to a mass-production industry.[43]

This effort, Nelson reported, was being undertaken by a Russian organization called the Institute for Experimental Building, created two or three years earlier: "I discovered there that the method which produced the sputniks may have even more spectacular results in building."[44] But it was a method that would not prove transferable to the United States, nor would its promise be fulfilled in Russia. Nelson would have much greater influence on how the modern house was furnished than on how it was built.

One of the interested readers of the *Forum* story about Nelson's Storage-wall idea was Dirk Jan (D. J.) De Pree, head of the Herman Miller furniture company in Zeeland, Michigan—a firm that had started in 1905 with the name Star Furniture,[1] with Sears, Roebuck its biggest customer, and with a fancy confection called the Princess dresser as its biggest seller.

Gilbert Rohde, Herman Miller's chief designer since 1930,[2] had died suddenly, at the age of 49, a few months before the story appeared. Besides being responsible for the furniture designs that probably saved Herman Miller from bankruptcy in the wake of the Depression, Rohde had been responsible for converting De Pree to modern design. His first two groups of bedroom furniture had impressed De Pree as "just boxes—plain as a doorknob,"[3] but when De Pree then asked him to add some "eye value"[4] Rohde began to explain that the relatively unadorned designs were suited to actual needs and possessed an integrity that would be spoiled by decoration. A deeply religious man, De Pree understood the ethics of a simplicity that eschewed pretense and that, free of any ornament that might disguise flaws, demanded good materials and good workmanship. The development of his taste in furniture, like that of the Shakers, was based on a demand for honesty rather than on a demand for beauty. "With his simplicity," De Pree said later, "Rohde had taken away our means of covering up. We had to learn new manufacturing techniques, such as how to make mitered joints in a very precise way."[5] In the fall of 1944, having learned these techniques, having been converted to Rohde's beliefs, and having begun to be known as manufacturers of the new look in furniture, Herman Miller needed a new designer and wanted a modern one.

One architect who was seriously considered, and with whom De Pree had "a wonderful visit,"[6] was Eric Mendelsohn, who had emigrated to the United States[7] and was then living in New York. But the leading contender for the job was Russel Wright. He had designed theater sets and costumes with Norman Bel Geddes, a line of aluminum oven-to-tableware, a successful furniture collection (the round-edged bleached maple "American Modern" line for the Conant Ball Company, in 1935),[8] and din-

nerware (for Steubenville Pottery, in 1939).[9] His work had been published extensively; *Architectural Forum* alone had done three articles (two in 1937 and one in 1942).

Around the first of November, De Pree had "tentatively decided on Russel Wright" and "went up to his penthouse to sort of make the final agreement." But things went less agreeably than De Pree had hoped, with Wright seeming "penurious," insisting that Herman Miller employ no other designer, and "seeking for little ways of doing private work and all that, which would encroach on the exclusivity that I thought he should give us on furniture." De Pree's memory is that "I sat there and thought, well, here I'm making a lifetime arrangement, and I can't live with this fellow. . . . I terminated the thing after a bit and walked out, and never told him what I was there for."[10]

Less than a month later, the November 1944 issue of the *Forum* arrived, featuring the Storagewall. Advocating storage built into the walls of houses, the concept was a potential threat to the casegoods industry and must have seemed anathema to most furniture manufacturers. But De Pree was attracted by the originality of the idea and telephoned Jim Eppinger, the company's sales director and chief man in New York, asking him to get in touch with the two designers. Eppinger called back with the news that one of them, Nelson, was about to leave for Detroit to judge a design competition sponsored by General Motors.

Nelson and De Pree had dinner the evening of November 27 at Detroit's Book Cadillac Hotel. "Had a great evening," De Pree remembered. "Spent all evening arguing about religion. I don't know when we got down to furniture."[11] It was the first of many such discussions between the devout Dutch Reformist and the firmly disbelieving designer, who had written a few months earlier that churches were "frantically installing bowling alleys and Boy Scout club rooms to stave off the consequences of spiritual bankruptcy."[12] For Nelson—but certainly not for De Pree—it was also a discussion lubricated by numerous martinis. Who actually paid for these drinks was later as hotly contested as religion: Nelson said De Pree picked up the check; De Pree said he "would never have done that."[13]

Despite their differences, the two hit it off. "Impressed no end,"[14] De Pree wrote Eppinger two days later that Nelson "has been doing a tremendous amount of thinking on the home and on its facilities for living, . . . has a splendid background; is thinking well ahead of the parade; does not want to be limited to the use of wood in planning furniture; . . . is a

star in at least some of the things he is doing" and should be considered "for the good designing connection we want to make."[15]

Eppinger then met with Nelson several times in New York and was similarly "infatuated with his manner."[16] But Nelson was frank about his lack of experience in furniture design and not eager to rush into an agreement. Eppinger "did not find him very enthusiastic"[17] at first; a few days later Eppinger thought he was interested but "would prefer to conclude a deal with us a little later than at the present time."[18] Perhaps it would be wise not to count on Nelson: Eppinger suggested De Pree write to Russel Wright "so that the door is still kept open,"[19] and passed along the news that Mendelsohn was also still interested.[20]

But De Pree declined Wright's offer to visit Zeeland in late December for further talk,[21] and instead arranged a visit from Nelson in early February. Meanwhile, the January 22, 1945, issue of *Life* carried eight pages on the Storagewall. Meetings with Nelson on February 7 and 9 left De Pree with this impression: "His thinking and approach is the very thing we want. He is without a doubt a 'comer.' In spite of his many activities he is very much interested in working for us. He . . . is actively working on the things that will make for better living. He does not appear to be as interested in the money end of it as Wright is, and he felt that it wouldn't be much of a problem to work out the 'gory' details of finance when we got to that point. He realizes that he has to make an extensive study of furniture manufacturing and woods."[22]

Negotiations became increasingly detailed over the next six months. How to divide the royalties on Rohde's designs between Nelson and Rohde's widow was a tricky issue, as it was assumed that Nelson would modify the designs considerably. A further complication was that during this time Nelson was making his unsuccessful plans for an office partnership with Minoru Yamasaki, who therefore became another party to the negotiations.[23]

Whereas Russel Wright had insisted on being Herman Miller's sole designer, Nelson began bringing others into the picture even before his own contract was signed. The first of these was the sculptor Isamu Noguchi, whose glass-topped coffee table he presented to De Pree and Eppinger in early June.[24] On January 7, 1946, Nelson wrote to De Pree that Noguchi was "willing to let Herman Miller make the coffee table on any terms we consider fair." By late June of 1945, Nelson had begun suggesting some changes to the bases of the Rohde furniture,[25] and in August the "gory" details were concluded.

It was time, Nelson realized, to learn something about the furniture industry—not that, despite his protestations to D. J. De Pree, he was a complete novice:. He had done a number of custom furniture designs for specific applications, and a slat bench design, which De Pree had seen on a visit to Nelson's New York office,[26] turned out to be a fundamental part of his first Herman Miller collection. But Nelson was not yet at home in a furniture factory, nor was he familiar with the workings of the furniture industry. "So," he later recalled,

> one of the ways I pursued my education at the cost of Time, Inc., was to go on this massive tour. . . . I was working on *Fortune* then, and I thought it would be nice if I could see a lot of furniture factories, so I persuaded them to schedule an article on the furniture industry, at which point as a *Fortune* writer I went off with a researcher, and we . . . visited all kinds of factories—east, middle and west. . . . We must have visited twenty factories.[27]

Nelson was also educating himself about business:

> On this tour—it's incredible how naive you can be. We would ask certain questions since *Fortune* is a money magazine; the researcher would say, What are your gross sales? So many dollars. And as a young architect I would say, How many square feet of production space do you have? Well, if you divided one into the other, you would get a number . . . like each square foot of the factory was producing thirty dollars a year gross income, or a hundred dollars a year, or whatever it was. So out of the blue I discovered this magic formula: that there was a relationship between square footage and gross sales, that it can be stated as so many dollars a square foot. And you began to realize that certain companies were getting much higher returns per square foot than others, and those turned out to be more successful. Well, it must've been years before I discovered this was a common way of doing it in industry.
>
> One of the things I noticed was that [when companies began to do] three million dollars a year or more, which was very respectable in those days for a factory, . . . suddenly new characters appeared on the stage, who were engineers who made time/motion studies and all this kind of thing. And it struck me that

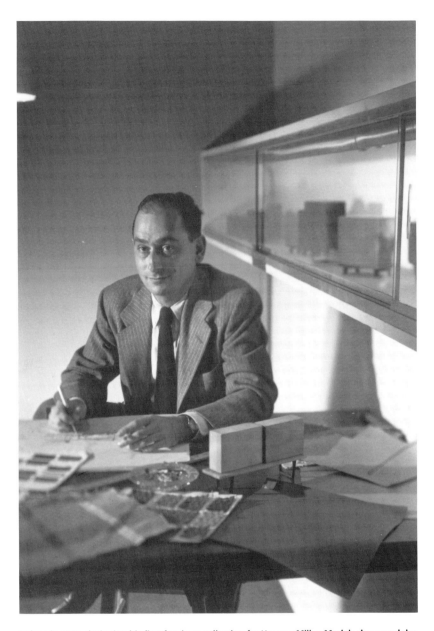

Nelson in 1945, designing his first furniture collection for Herman Miller. Models show modular storage units on platform benches.

Herman Miller just had to have at least one of these guys in order to get more efficient or whatever. So I wrote [D. J. De Pree] this very enthusiastic letter saying I was on this tour and this and that, and that I had observed that at about three million dollars these engineers appear, and I think it's essential to have such people stepping up the production and quality and everything . . . all over the factory. Therefore . . . Herman Miller must [expand] to three million dollars. So then D. J. wrote back and said, look, George, we think you're a wonderful designer, why don't you stick to what you know about. He was very polite about it, but in effect this is what he said.

Then later, when we did get up to some number like this, we agreed it was really quite interesting that it actually happened. But we never did get the time/motion study engineers.[28]

Nelson's tour, taken while he was beginning work on his own first furniture collection, gave him, as planned, a comprehensive understanding of how furniture was being made and marketed. He disapproved of much that he saw, and didn't hesitate to say so. In the January 1947 issue of *Fortune,* he reported:

The only simple statement that can be made about the furniture industry is that it is the second largest producer of consumer durable goods in the U.S. The rest of the story is confusion, contradictions, more than a trace of catalepsy, and some exciting potentials. . . .

The most important single fact about furniture is that it is a craft product built around one material —wood—using techniques that originated centuries ago, and practically every distinguishing characteristic of the industry can be traced back to this fact. That there happens to be a substantial amount of metal home and office furniture does not alter the situation except in terms of possible future developments: the majority of factories making household furniture are equipped to work only in wood, and to this material the buying public is equally firmly committed. As a direct consequence of the nature of the product, the industry is composed largely of small producers. . . .

Domination by a swarm of small fry brings with it an interesting chain of consequences. It means, for instance, that

furniture is one of the few remaining industries in which the individual can make an independent place for himself as a producer. . . . But it also means that most manufacturers lack the capital needed for the research to take the product beyond a craft status, that the small-town producer is more likely than not to show a small-town approach to his business, and that he is rarely in a position to attract high-priced executive or design personnel or to establish his product through consumer advertising. . . . The typical producer gives the industry its tone and embodies its fundamental weakness: he has no control over anything or anybody, either the design of his product or its retail price, either the man who sells it or the woman who buys it. . . . The layman who can list a dozen of the 3,500 or more manufacturers belongs on a quiz program. . . .

Whenever furniture is criticized, the public is blamed. "When they want something better," runs the refrain, "we'll be only too glad to make it for them." The average manufacturer has no convictions whatever about design, or any understanding of it. Today he is making a lot of "eighteenth-century"—tomorrow, if he believed it would sell, he would cheerfully switch to Turkish Bordello. . . .

Because of the emphasis placed on selling, the retailer and his opinions take on extreme importance. . . . This is unfortunate, because the incompetence of the average retailer in matters of design is breath-taking. . . .

The public, as always, buys what it is shown and does not clamor for things that do not exist. The public, too, has long been conditioned to lump furniture in the category of things for display and finds it reassuring to be surrounded by fake French provincial . . . and ersatz Americana. If the manufacturer tries to change his product drastically, the retailer can effectively prevent change until the manufacturer establishes direct contact with the public, which will not happen until the manufacturer has enough money to advertise, production large enough to provide the money, and a product he believes in sufficiently to want to break through control by dealers. And so the circle continues on its merrily vicious way.[29]

Within this dismal circle, however, Nelson detected a few "new gaps" and reasons for hope of better design. The designers he specifically named as "top-flight" were Charles Eames, Jens Risom, T. H. Robsjohn-Gibbings, and Edward Wormley. Of these, he chose Eames for particular praise, citing his exhibition at the Museum of Modern Art the previous March and noting that some of the pieces were scheduled to be produced by the Evans Products Co. of Grand Haven, Michigan, in mid 1947:

> The chairs and other pieces designed by Charles Eames are composite units that employ molded plywood, plastic impregnated papers, metal and rubber. They are light in weight, extremely durable and comfortable. They have drawn paeans of praise from the modern-minded, and audible sniffs from representative members of the furniture industry, who are still much inclined to the view that grandfather knew best. Should the furniture prove acceptable to the public in both design and price, Eames will have added to a brilliant contribution to furniture design a production and merchandising factor of immense importance, for the present craft basis of the industry will be further undermined.[30]

Nelson—and the world in general—had first seen Eames's hand in the furniture he had designed in collaboration with the architect Eero Saarinen for the Museum of Modern Art's 1940 "Organic Design in Home Furnishings" competition.[31] Their work together, with the assistance of Ray Kaiser (who was to become Eames's second wife in 1941) had taken place at the Cranbrook Academy of Art in Bloomfield Hills, a Detroit suburb. Eero's father, Eliel Saarinen, a noted Finnish architect who had become the first director of Cranbrook in 1925, had offered Eames a scholarship to the school in 1938; Eames studied there for a year, then taught there for two years.[32] Other students at Cranbrook in those days included Ben Baldwin, Harry Weese, Ralph Rapson, Harry Bertoia, and Florence Schust (later Florence Knoll).

Eames and the younger Saarinen had won first prizes in two of the MoMA competition's nine categories, one for a system of modular wood cabinets and the other for a first foray into the field of molded plywood seating with shells of double curvature (unlike the earlier chairs of Aalto and Breuer with plywood bent in one direction only), a field that Eames would later investigate thoroughly.

Eames's next New York appearance, this time a solo,[33] was a press

preview in December 1945, in the Barclay Hotel, of his molded wood children's chairs and stools (manufactured by Evans Products[34]), a prototype of a plywood elephant toy[35] (never manufactured), and, of most importance, the first side chair of plywood shells shock-mounted to a steel rod frame. In February 1946 the furniture was shown at New York's Architectural League, and in March at the Museum of Modern Art. It made a strong impression on Nelson, who announced to D. J. De Pree that Herman Miller "must get Charles. He's doing something that I can't do."[36] De Pree pointed out that the hiring of Eames might not be in Nelson's best interest: "I told him we're only a $400,000 company, we're small time, and you're beginning to share your royalties with somebody, and there's only $400,000 in size. 'Well, then,' he said—he was self-abandoned about that—'it's time I find out what I can do. But . . . you're not going to be a $400,000 company any more. Before you realize it you'll be $2 million and $4 million.'[37] I said, 'Would you put that in writing? And what about the royalties?' He said, 'We'll talk about it'"—and we never did. But that was because, I think, he was humble, and he was very candid about admitting things."[38]

At Nelson's insistence, De Pree came to New York to see MoMA's Eames show. He apparently concurred with Nelson's judgment; however, Evans Products was uncertain about entering the furniture field in a larger way, and negotiations did not go smoothly at first. On July 30, Nelson wrote De Pree:

> I have been very much alarmed . . . by the lack of developments with Evans. After a long conversation with Jim [Eppinger] and another with Alfred Auerbach[39] it seemed advisable that I join you at your next discussion with Evans in Detroit. As I understand it, the Eames furniture is more or less . . . a stepchild in the Evans organization, and apparently it will take some pressure on our part to get them to meet their commitments as far as furnishing prices, time schedules, etc. . . . If our future plans are going to be realized fully or in part, the Eames group is of vital importance.

But Eppinger did persuade Evans to manufacture Eames's furniture in greater quantity and to let Herman Miller market and distribute it. Eames officially joined Herman Miller as a design consultant under Nelson's design direction in 1947, and in 1949 Herman Miller bought the manufacturing rights for his furniture from Evans.[40]

Nelson's own first collection of furniture was produced in the first sixteen months after his signing the contract with Herman Miller, and while he continued as a full-time contributor to *Fortune* and a consultant to *Architectural Forum.* At the suggestion of Jim Eppinger, he turned for assistance to Ernest Farmer, a young man who had worked in Rohde's office and was thus familiar with furniture production and with the Herman Miller organization.[41] Farmer was bright, meticulous, and trained in the European tradition of craftsmanship. He would report daily to Nelson's office in the Empire State Building to discuss Nelson's ideas, and every night he would revise the drawings as Nelson wanted.

The collection took shape with surprising speed. Before its introduction, however, Nelson felt the need for further assistance, particularly with the design of the advertising campaign that would publicize it. He had written D. J. De Pree that "the best typographical designer I know is Paul Rand. Rand, or someone comparable, should be the person to develop [Herman Miller's] advertisements."[42] But De Pree suggested that Nelson produce the ads himself. Fortunately, Farmer called a friend, Irving Harper. Harper had graduated from the Cooper Union architecture school in 1938, when there was virtually no architecture work to be done, and had gone to work for Rohde, who was already doing some furniture design for Herman Miller but whose main work at the time was for the New York World's Fair. When war was declared, Harper had joined the Navy; after serving, he had gone to work for Raymond Loewy. Harper applied to Nelson for the job of producing the ads and got it, becoming a mainstay of the Nelson office.[43]

The first George Nelson collection was remarkable not only in size (close to 80 pieces) but also in originality (being less dependent on the Rohde precursors than probably either D. J. De Pree or Nelson himself had anticipated) and in quality. It included casegoods, beds, desks, tables, chairs, and sofas. The seating took full advantage of foam rubber, which had first become available in 1940, enabling designers to abandon the plump profiles of traditional upholstered pieces. Innovations in the collection included a dressing table with lights (behind and below surfaces of diffusing glass) that were turned on automatically when the doors were opened, a headboard that could be tilted for reading in bed, and a coffee table whose drawers held removable trays that, when reversed, formed extensions to the table top. Herman Miller's 1946 presentation also showed designs by Eames and by Noguchi.

In March 1947, *Interiors* proclaimed "Available now: the best furniture in years," noting that much of it was by the notorious author of the "painfully precise analysis" that had "cut the industry into shreds." And two months later the same magazine reminded its readers how "stormy petrel George Nelson" had "set the furniture industry to screaming with his *Fortune* article, then left it speechless with his new furniture designs." (*House Beautiful* was a bit more timid. While proclaiming in its June issue "There's a new pattern in furniture behavior," it showed ten pages of the same collection in the conservative company of Early American portraits, damask curtains, and cut-glass decanters, demonstrating "modern furniture completely at home against a traditional background.")

Of all the designs in Nelson's first collection, the most promising for future development was the large group of modular storage cabinets, some based on a 24-inch module and some on a 34-inch one. These cabinets, which could serve a wide variety of purposes (file, bookcase, radio cabinet, china cabinet, vanity, etc.), could be placed on the already-designed slat bench,[44] could stand on their own legs, or could be hung on a wall. The bench, made available in four lengths, could also be used as a low table or, fitted with foam rubber cushions, as seating.

Modularity was not new in furniture design, of course. A 1909 Sears, Roebuck catalogue had advertised "sectional bookcases," and unit bookcases by Bruno Paul were published in Germany in 1910.[45] Unit furniture by Gilbert Rohde had been shown in the 1933 Chicago Century of Progress Exposition's "Design for Living" house, and Rohde's 4200 Blueprint Group of 1942 had also included modular storage. Nelson, in his 1947 *Fortune* article, had recalled "the old unit bookcases"[46] and shown a photograph of "Mengel's Module furniture, designed by Morris Sanders." This kind of furniture, Nelson wrote, "has a long history and undoubtedly an important future."

In the work of the modern masters, modular furniture can be traced back to two simultaneous and independent developments. One of these was the Casiers Standard storage cabinet group, designed by Le Corbusier and Pierre Jeanneret and shown in the Pavilion Esprit Nouveau in Paris in 1925[47]; the other was a system of components developed by Marcel Breuer soon after he took over the direction of the Bauhaus furniture department in 1924.[48] But even if it was not without precedent, the use of modularity in Nelson's first collection evidenced an understanding of the role the principle was to play in all modern furniture, offering flexible, customized effects from standardized components and promising

The slat bench as produced by Herman Miller in 1946. (photo: Ezra Stoller)

The bench as base for modular radio and phonograph cabinets.

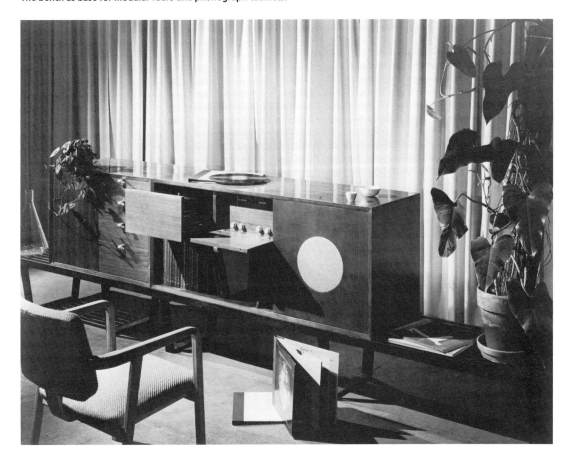

economies of stocking and shipping. It was a principle Nelson had already used in his Storagewall and one that he would develop with virtuosity. As already mentioned, he, like Breuer and others, would try to apply the principle to housing itself, with equal logic but with less success.

Nelson was quite certain of the superiority of the new storage to traditional designs. "The bureau," he wrote, "is one of the silliest storage compartments ever created by man. It contains three to five drawers, which are twice as wide and as deep as they need be. The bottom drawer is close to the floor, and one generally has to squat to open it. . . . And it is expensive."[49]

Just as innovative as Nelson's furniture designs was the manner of their presentation. The first advertisements, produced by Irving Harper, *had* to be innovative, as the furniture collection had not been designed yet. "So," Harper remembers, "the only thing we could work with as a graphic device was the name, and the name was just Herman Miller."[50] Nelson once noted that "the design process can only work in the presence of limitations"[51]; the result of this particular limitation was the use of a large, stylized red M. "That," Stephen Frykholm of the Herman Miller Company later recalled, "was really the beginning of our logo. . . . No-body in Zeeland even saw it; they ran it; D. J. and the boys didn't say any-thing; they ran it a few more times; the rest is history."[52] The M became the persistently repeated symbol of Herman Miller, and Nelson later sug-gested that this nucleus of a corporate identity program was "quite possi-bly the first of its kind in the U.S.[53]; Harper said that it was, in any case, "the cheapest . . . program ever."[54] For all their visual flair, the ads had lit-tle literary quality. Their texts came not from Nelson but from the public relations office of Alfred Auerbach. (Harper recalls "a series of set phrases that we used to get. . . . We were always depressed by it every time it came, but we used it. . . . It was just type."[55]) Herman Miller did take Nelson's advice about advertising in general, however. Nelson insisted on full-page ads with a second color (red) added to black and white, even though this expense meant advertising less frequently. He also had some advice about a catalogue.

Furniture catalogues traditionally had been furtive little publica-tions, showing pictures but—for fear of being copied—never giving actual dimensions. Nelson saw that this secrecy hindered designers' use of the products, particularly modular ones, and was, in any case, futile. He pro-posed a big, informative, hardcover book, with dimensioned drawings and with the best available photography (by Ezra Stoller). When D. J. De Pree

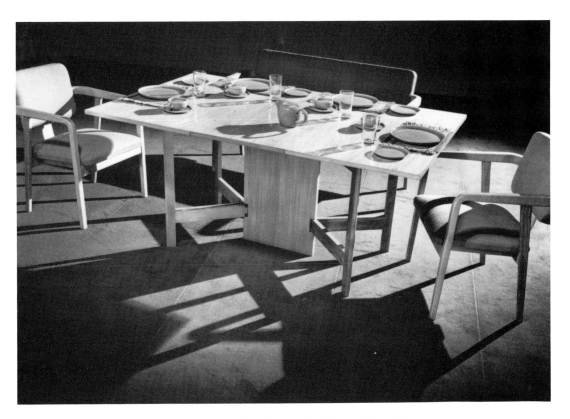

The gateleg table from Nelson's 1946 collection. Its dimensions matched those of the modular storage cabinets so that all pieces could be aligned. (photo: Ezra Stoller)

**Designs for Herman Miller drawer pulls and hardware, castings of zinc alloy finished in silver
(1946). (photo: Ezra Stoller)**

rightly protested that it would be very expensive, Nelson countered with the radical idea that it not be given away but sold. In De Pree's words, "The cheek of the thing was so staggering!"[56]

The price of the 1948 catalogue was $3. However negligible that may sound today, it was a substantial price for a book in those days,[57] when, as Nelson said, "You could buy a brand new Ford convertible for $640, complete with rumble seat and white-wall tires."[58] The price, however, seemed to add to the catalogue's cachet, as did, certainly, its design, prepared in Nelson's office. Ernest Farmer was responsible for the organization and the layouts, and Irving Harper for the dust jacket, which featured the names of four designers: George Nelson, Charles Eames, Paul László, and Isamu Noguchi. The title page naturally featured the red M logo, and Nelson's foreword outlined his view of the company philosophy:

> The attitude that governs Herman Miller's behavior, as far as I can make out, is compounded of the following set of principles:
>> What you make is important. . . .
>> Design is an integral part of the business. . . .
>> The product must be honest. . . .
>> You decide what you will make. . . .
>> There is a market for good design.[59]

Nelson's statement of principles is interesting for what it leaves out: any goal of popularity. Although it claims "a market for good design," it also claims that the manufacturer (or its design director) decides what will be made, not the salesman or the customer. That same year, in a letter to Charles Eames, Nelson had described a recent experience:

> All went well at the Institute in Chicago until the question and answer period during which I narrowly escaped lynching. One earnest young man got up and said, "Why is this nice modern furniture you do so expensive that people can't afford it?" I gave him the answers that came to mind and at the end said, "I think I ought to tell you that, as a designer, I don't give a damn about the people." In the mob scene that followed [Serge] Chermayeff and two janitors grabbed sub-machine guns, and I left the building unharmed.
> Last week I went up to MIT and repeated the performance, this time taking care to explain what I meant, at which

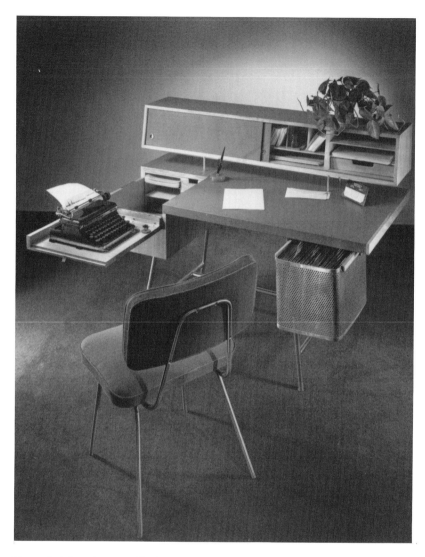

A home desk from the 1946 collection. Storage unit is raised above desk surface; Pendaflex file is hung inside basket of steel mesh. The upholstered side chair has a frame of aluminum rods.

point Aalto who had just come in from Finland and had dropped by to hear the talk jumped up and said, "I agree completely." This eliminated the possibility of renewed violence because, in the MIT scale, Aalto comes first and God second. It was perfectly wonderful running into him—Aalto, not God—and we went out afterwards and consumed the entire stock of the local bar.[60]

A more terse expression of the same notion came in a 1951 speech by Nelson to members of the American Institute of Architects: ". . . nothing is less consequential in the creation of a work of art than good intentions."[61]

The new catalogue, the new program of magazine advertising,[62] and (of course) the furniture all reinforced one another, and Herman Miller became highly visible as a leader in the field of modern furniture. (Not, however, alone there: *Interiors* had also reported that Edward Wormley was designing modern furniture for both Dunbar and Drexel and that Hans Knoll, who had established his own furniture company in 1938, had begun to import "a delightful collection from Sweden, to be sold through the department stores."[63])

In 1948, the year the first Herman Miller catalogue appeared, Charles Eames followed up the great success of his and Saarinen's 1941 molded plywood chair with a new design for a chair of stamped aluminum or steel. "Metal stamping," Eames said, "is the technique synonymous with mass production in this country, yet 'acceptable' furniture in this material is noticeably absent. . . . We feel it is possible to free metal furniture of the negative bias from which it has suffered."[64] The design was developed with engineers from the University of California and entered in the International Competition for Low-Cost Furniture Design, directed by Edgar Kaufmann, jr., at the Museum of Modern Art. The jurors included Kaufmann, Alfred Auerbach, and Ludwig Mies van der Rohe. In January 1949 it was announced that, from among 3,000 entries, the Eames design had won second prize.[65] Herman Miller, naturally, was interested in production.

The metal prototypes were being produced in the Eames's shop with a machine called a drop hammer. As Ray Eames and John and Marilyn Neuhart have described, "Using a block and tackle, a 250-pound weight was hoisted four feet above the forge. When the pulley ropes were cut, the dropped weight stamped the aluminum into the mold. After about four 'drops,' the desired shapes were achieved. . . . People in the neighborhood reported dishes rattling in their cupboards and thought the shaking was caused by earthquakes."[66]

George Nelson and Irving Harper casually at work. The prototype ottoman being used as a work surface is similar to a piece that entered the Miller line in 1950.

Nelson has explained that, even though he was officially Herman Miller's director of design, Eames's entry into that company made the title ridiculous, "because nobody was going to direct Charlie. This was an absurdity."[67] Nevertheless, Nelson was bold enough to make a suggestion. Eames, he said, "wanted to make this [chair] out of . . . stamped steel shell, like your car fender, which would be neoprene dipped." "I don't know," Nelson continued, "if the neoprene would have held up or not, but . . . I remember saying I've been hearing about this fiberglass, and we called up Charles and said why don't you look into fiberglass. . . . He never liked to be reminded of that. Once when I was out at the coast I mentioned it— you know, said how fortunate I reminded you there was this material. He got really mad. Charles had a different kind of ego from mine, I think."[68] Whether as a direct result of Nelson's suggestion or not, there was a switch of materials: ". . . steel was too heavy and you couldn't use it for a lot of purposes, so fiberglass turned out to be just dandy, and that was that."[69]

When MoMA's exhibition of competition winners was opened in 1950, the Eames chair was shown in fiber-reinforced resin. Edgar Kaufmann, jr., wrote: "Now it has been possible to find a plastic substance and a molding process which allow this kind of shape to be produced economically."[70] Herman Miller had the prospect of another brilliant product.

That same year, Nelson brought another talent, Alexander Girard, to Herman Miller to join Eames, Noguchi, and himself. Of the group, it was Charles Eames who had first met Girard, while in Detroit in 1946 talking with the Evans Products company. Eames had seen a radio cabinet designed by Girard,[71] then working as an architect in Grosse Pointe. They became friends,[72] and Girard began to sell Eames's children's furniture in a shop he and his wife Susan were operating.[73]

In 1949 Girard organized "An Exhibition for Modern Living" for the Detroit Institute of Arts.[74] Nelson's view was that Girard ("lost for more years than anyone can remember in a golden haystack known as Grosse Pointe, one of the stuffier of the nation's suburban communities") "suddenly came forward with a statement of what a major exhibition should be."[75] The exhibition consisted of seven model rooms, and the designers chosen by Girard were Nelson, Charles and Ray Eames, Alvar Aalto, Florence Knoll, Bruno Mathsson, Jens Risom, and Eero Saarinen. There was also a "Hall of Objects" (the hundred selected objects including Nelson's ball clock for the Howard Miller Clock Company[76]), a gallery presenting "The Background of Modern Design," and a large mural by Saul

Nelson's 1949 molded plywood tray table. Its polished chrome base was adjustable in height.

Steinberg, from which illustrations for the exhibition's catalogue were taken. In that catalogue Edgar Kaufmann, jr., wrote that the exhibition was "the most comprehensive statement yet made in favor of modern design rooted in the necessities and character of the American community today."[77] About Nelson's particular installation, he wrote: "In this room, George Nelson admirably develops his thesis that, as much as possible, furniture should be included *within* the design and construction of the room itself. Here . . . is a comfortable, well-equipped living area in which the furniture is confined to two light chairs and a small sofa-table—everything else being built-in."[78] As Nelson remembered it,

> a number of people were handed little chores by Sandro [Girard], and we were picked to do with a room what we wanted. The theme I picked was a room that had no visible furniture in it. Normally, a designer working for a furniture company, given a conspicuous spot like this, would not do this. People said, look, George, don't you think this is a little unfriendly, considering all the money we're going to pay you, or something. [But] D. J. thought this was very amusing, that rooms would be nice without visible furniture—that was fine. Of course, being a canny Dutchman, what he also realized was that [the built-in] was a very high cost item, and he was making that, too. This was Herman Miller's first crack at a descendant of the original Storagewall.[79]

In 1950 Nelson persuaded De Pree to invite Girard to join the firm, where he was put in charge of developing a new fabric line.[80] At first Girard's duties at Herman Miller were light, and in 1951 (along with Eero Saarinen) he was also working for General Motors as a color consultant. In 1952, Miller established a textile divison, with Girard as its first director of design, and from this post he came also to be in charge of a retail venture unusual for Herman Miller: a New York shop called Textiles and Objects (or, more familiarly, T&O). While popular with design buffs, it seems not to have been a financial success; it was closed in 1963.

Girard's fabric designs for Miller, however, were both successful and influential. Strongly patterned and boldly colored, they were in striking contrast to the more muted fabric then common. Master fabric artist Jack Lenor Larsen has called Girard, Dorothy Liebes, and Jim Thompson "three Americans who revolutionized our sense of color and cloth."[81]

The Nelson room at Alexander Girard's 1949 Detroit Institute of Arts exhibition. Everything that could be built in was.

Girard also participated in showroom design for the Miller company,[82] designed furniture for a short-lived Manhattan restaurant called l'Etoile, and collaborated with Eames on a line of furniture for the New York restaurant La Fonda del Sol (perhaps Girard's best-remembered design).[83]

A fourth designer Nelson secured for Herman Miller—but with less success—was Budapest-born Paul László, whose Stuttgart studio Nelson had visited during his Rome Prize years and who was then working in Los Angeles. Nelson had included pictures of several of László's California houses in *Tomorrow's House.* He wrote D. J. De Pree about him and about his "small upholstered chair" in 1946.[84] Three of László's designs—the chair, a matching sofa, and a circular coffee table—were shown in the 1948 Herman Miller catalogue, but they were not long in the line.[85]

Two other suggestions by Nelson were never effectively pursued, however, even though De Pree wrote Nelson in August of 1946 that "Your suggestion regarding Mies van der Rohe and Aalto makes a hit with me. Several years back I seriously considered contacting van der Rohe, but I heard so little about him and saw so little of the work that he had done since he arrived in this country that I wondered whether he was in voluntary retirement, which in my judgment would be bad for a designer." In 1948, Miller's major competitor, Knoll Associates, made an arrangement with Mies for marketing his Barcelona chair and stool; these were great successes, and the arrangement was extended to other Mies designs. Aalto's furniture designs had been manufactured in Finland by Artek, Ltd., since the end of 1935, and Nelson had been an early owner of several pieces,[86] loaning them to the Museum of Modern Art for a 1938 exhibition.[87] There is no indication that either Nelson or De Pree contacted Artek about American distribution, however.

By 1952 a new Herman Miller catalogue was needed. This time it had 116 pages, 45 more than in 1948, and the price was raised to $5.00.[88] Most of the design was again by Nelson's office, and again the layouts were by Ernest Farmer and the dust jacket by Irving Harper, but this time the 28-page section devoted to Eames furniture was designed by the Eames office, with layouts by Charles Kratka and with Charles Eames's own photographs. D. J. De Pree wrote Nelson that the book was "a marvelous piece of work," but caught the fact that two captions had been transposed and complained about one of the photographs: "I don't like to see a picture of one of our pieces equipped with intoxicating liquors."[89]

Nelson also found time for furniture design of a more experimental nature. Arthur Drexler has described how "at night the staff gathered around Buckminster Fuller and labored with him over the birth of a Seating Tool."[90] Nelson and Fuller had known each other at Time, Inc. From 1938 to 1940 Fuller had served as science and technology consultant to Fortune, and in a 1946 article Nelson had described Fuller as "a chunky, powerful little man with a build like a milk bottle, a mind that functions like a cross between a roll-top desk and a jet-propulsion motor, and one simple aim in life: to remake the world."[91] Fuller, 13 years older than Nelson, was already quite famous, having published his first two books, having designed the mast-hung Dymaxion House, the three-wheeled Dymaxion Car, the one-piece Dymaxion Bathroom, and the square-and-triangle-based Dymaxion Airocean World Map, and having invented (but not yet built) the geodesic dome.

Nelson and Fuller were similar in many ways. Both were obsessively concerned with new ways of living, both regarded art and science as natural partners in the development of those new ways (just the opposite of C. P. Snow's vision of two opposed cultures), and both were gifted with multiple talents. If one had to give capsule descriptions of the two, one might call Fuller a technophile enthusiastic about human potential and Nelson a humanist fascinated by science. Both of them were more concerned with generic concepts having broad application than with one-time solutions to one-time problems. Neither of them had much patience with politics, which they found divisive.

The two were alike socially as well. Both were exceptionally convivial, both slightly bohemian as well as intellectual, both fond of partying as well as of creating, both famously adept at thinking aloud. Of the two, however, only Nelson was an accomplished writer, Fuller tending to lapse into notoriously convoluted "Fullerese" that few could decipher.

Fuller and Nelson also shared a sense of values in which financial gain was far from primary. Fuller advocated a currency based on units of energy rather than wealth. He even invented a hypothetical company called Obnoxico, which, he said, could make a fortune by exploiting human sentimentality and producing worthless goods—among them silver-plated baby diapers which adoring parents could use as planters or hang in the rear windows of their cars. When he announced, facetiously, that stock in Obnoxico would soon be sold, he was beseiged with orders (proving his point).[92]

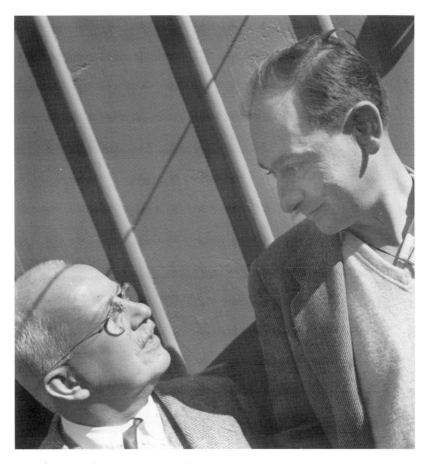

Charles Eames's photograph of Bucky Fuller and George Nelson in the early 1950s.

Fuller's attitude towards money was so cavalier that it seemed impractical even to Nelson. In a 1951 letter to Charles Eames, Nelson reported: "Bucky is again moving towards some effort to find a commercial base for his stuff, and I have anticipated without pleasure a repeat of former disasters."[93] A couple of weeks later he added:

> Regarding any kind of business deals with or for Bucky, I am totally skeptical. The stuff one deals with is so powerful that one becomes . . . immersed . . . or one remains on the outside and is as helpful as is practical. I am going to try to stay in the second group for a whole series of reasons. . . .
>
> Where I might best help Bucky, I think, is in connection with special projects that may be coming up. . . . The office will be turned over to him to whatever extent is practical, and I will try to arrange things so that our costs, if anything, are paid and Bucky gets a substantial fee in connection with any given project. This might produce the money he needs and further the practical development of whatever it is he may currently have in mind. I most emphatically do not want to get mixed up with any kind of company [because] I am convinced that such a venture would do Bucky less than no good. At least, this has been the history in the past.[94]

Fuller articulated his attitude in a maxim: "Make money or make sense; the two are mutually exclusive." Even so, if making sense *led* to making money, there would be no harm; neither Fuller nor Nelson was *averse* to financial success. Paradoxically, success came in great measure for Fuller, his annual income (due mostly to fees for his patented dome designs) later coming to exceed a million dollars. Such success never came to Nelson (he had bought a single share in Fuller's corporation). However, Nelson's lack of wealth was not a result of antipathy or even indifference on his part; the products his office designed were just never hugely profitable (unlike the seating designs of Eames). Nelson and Fuller's Seating Tool, for example, was never even a candidate for popular success. According to Arthur Drexler, it "was made of two aluminum reflector shields of the sort used by photographers, a sheet of celluloid, and, most important, a piece of piano wire. After the celluloid was properly cut and rolled to make a truncated cone, it was set down on the rim of the larger of the two reflectors. The small reflector was set on top of the cone; the wire was passed through it

and was fastened to the underside of the base. Pulled toward each other by the wire, the two reflectors held the celluloid rigid and demonstrated what remarkable strength some materials have when used in certain ways. But unfortunately anyone sitting on this nearly invisible object completely overhung the seat, and appeared to be balancing painfully on a knitting needle."[95]

Also around 1947, Fuller took part in another of the Nelson office's product innovations: the ball clock, a design that, despite its almost complete abstraction, was highly symbolic of the 1950s, managing to refer to two of the key images of the time—the starburst and the asterisk[96]—and also managing to suggest the structure of the atom. Nelson recalled:

> We were all involved in cooking up these clocks, and Irving [Harper], in the end, was the one who made them complicated, beautiful, and so on. And there was one night when the ball clock got developed, which was one of the really funny evenings. Noguchi came by, and Bucky Fuller came by.
>
> I'd been seeing a lot of Bucky those days, and here was Irving and here was I, and Noguchi, who can't keep his hands off anything, you know—it is a marvelous, itchy thing he's got—he saw we were working on clocks and he started making doodles. Then Bucky sort of brushed Isamu aside. He said, "This is a good way to do a clock," and he made some utterly absurd thing. Everybody was taking a crack at this, . . . pushing each other aside and making scribbles. At some point we left—we were suddenly all tired, and we'd had a little bit too much to drink—and the next morning I came back, and here was this roll [of drafting paper], and Irving and I looked at it, and somewhere in this roll there was the ball clock. I don't know to this day who cooked it up. I know it wasn't me. It might have been Irving, but he didn't think so. . . . [We] both guessed that Isamu had probably done it because [he] has a genius for doing two stupid things and making something extraordinary . . . out of the combination. . . . [Or] it could have been an additive thing, but, anyway, we never knew. So we did the ball clock, which was, in its piddling way, a sort of all-time best-seller for Howard [Miller, because] suddenly it was decided by Mrs. America that this was the clock to put in your kitchen. Why [the] kitchen, I don't know. But every ad that showed a kitchen for years after that had a ball clock in it.[97]

Four of the many designs produced by the Nelson office for the Howard Miller Clock Co. in the late 1940s and the early 1950s. (ceramic design, opposite, top, photographed by Midori)

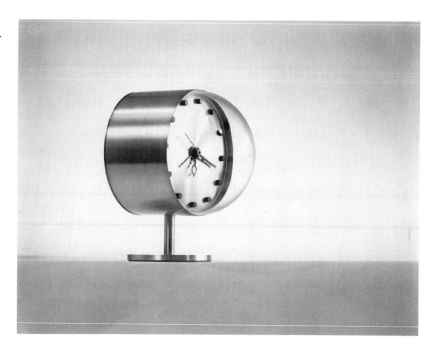

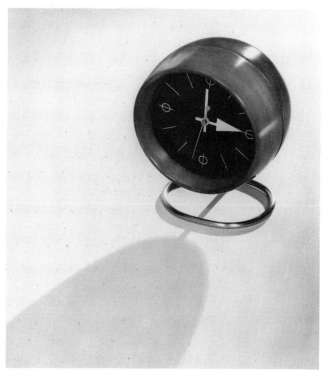

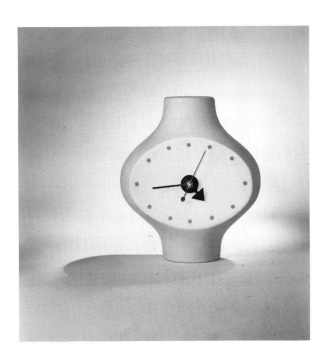

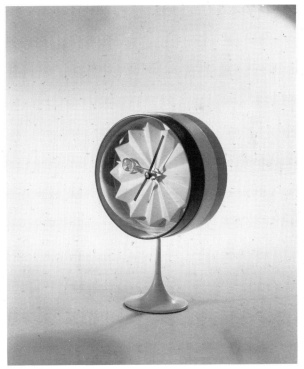

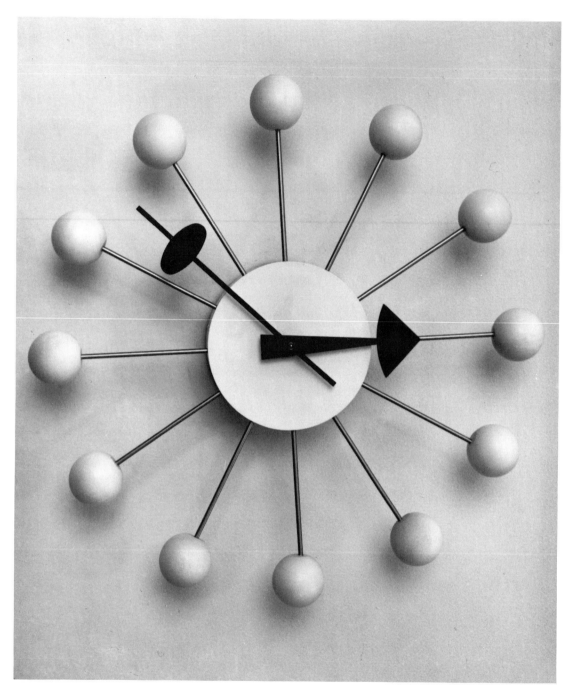

The 1950 ball clock, an icon of modernism for the following decade.

(Although to Nelson's eye the ball clock may have been equally suitable for any room in the house, for most Americans in the late 1940s modern design was welcome only in commercial spaces—movie theaters, shops, cocktail lounges—or in bathrooms, kitchens, and other utilitarian areas where function was expected to override aesthetics; in their living rooms, Early American still reigned. As Penny Sparke has pointed out, modern design entered the American house by the kitchen door.[98])

Fuller also spent the summer of 1952 in the Nelson office. He had been asked to construct a geodesic dome house in the garden of the Museum of Modern Art, and Nelson had not only offered him office space but had also hired three students who would work part-time with Fuller and part-time on Nelson office projects. When the dome was finished, Nelson explained to the office staff, they would furnish the interior. A model of proposed interiors was built while Fuller's dome plans were still in the works, and Nelson became enthusiastic about the possibilities: "We will live in space containers. They will be ventilated, humidified, dehumidified, daylighted, artificially lighted and acoustically treated to serve our needs."[99] At the same time, Fuller reportedly came to think that he himself should design the interiors. Thomas C. Howard, one of the three recruited students and now president of Synergetics, Inc., remembers that Fuller "had locked in his mind" that the house would be free of what he called "contemporary showroom products."[100]

In any case, Fuller's presence was the occasion for many animated office parties at which the chunky genius would show "thousands of slides, some backwards, some upside down,"[101] as John Pile, whose first summer it was in the Nelson office, remembers. As Nelson wrote Charles Eames,

> Bucky threw a slide party in the office and everyone stayed to see the pictures and listen to him. The result was, as you might imagine, considerable excitement mixed with a certain frustration since it is difficult to keep up with him and to understand what he is saying or driving at. The pictures were fantastically beautiful and one does get the impression that here is real growth towards something quite extraordinary although it is a little difficult to tell just what. . . . [102]

Several weeks into the MoMA project, Fuller was asked by Henry Ford II if he could construct a dome to cover the 93-foot-diameter court-

yard of the Rotunda at Ford's River Rouge plant, designed by Albert Kahn and shown in Nelson's 1939 monograph.[103] Fuller scraped together money for a train ticket to Detroit. "Typically," Howard recalls, Fuller "wanted to impress the potential client with far more than was necessary, so he had me stay up most of one night making parts for a dome model that he agreed to assemble on the train."[104] The scale was miscalculated, however, and "Bucky built a model that he couldn't get out of the train compartment." Even without the model, he got the job.[105]

A few years later Fuller was again given free desk space in the Nelson office. This time he was working on a waterless (well, almost waterless) toilet, a project even further from the mainstream of the office's commissions. And, naturally, Nelson and Fuller's conversations ranged far beyond matters of design. Nelson later recalled: "I remember [Bucky] speculating, one evening, on the question of which had killed more innocent people, the Church or the automobile, and at that time . . . he thought the Church was way ahead."[106]

Nelson was always willing to serve as a social critic or as a design critic, and in either role he could be demanding. Asked to join a 1950 Museum of Modern Art panel, moderated by Philip Johnson, on "The Esthetics of Automobile Design," Nelson took dozens of slides, not of whole cars, but of their hardware, lights, emblems, trim, and other details. The victims of his scrutiny included the torpedo-nosed 1950 Studebaker designed by Raymond Loewy, who was also on the panel. One of the more absurd hood ornaments Nelson photographed consisted of a chrome rod penetrating a chrome ring. "There is an elaborate Freudian theory about this sort of thing," he told the audience. "They say these strongly thrusting, dynamic objects represent the motor manufacturers, whereas the more receiving shapes represent the American public. I don't know."[107] Loewy, unamused, responded: "Of course, anyone can take a camera and take a close-up of anything, whether it is an Egyptian column or a Greek temple, and make it look horrible."[108]

Another common object Nelson examined critically (as did his friend Bernard Rudofsky) was the bed. Ever intrigued by multi-functional designs, he wrote admiringly of an 1866 patent

> issued to the inventor of a piano which contained (in addition, no doubt, to a keyboard and strings) a bed and two closets for bed-clothes, water pitcher and towel. . . . A family of six, installed in one of the tight little ranch boxes we put on large tracts and de-

scribe as "homes" may well find, if it takes a census of the square feet available for daily living, that beds occupy a shocking 15 to 20 percent of available floor space. In light of the pressure on existing space, such ideas as a piano that can be slept in begin to reveal a contemporary logic. (The logic, to be sure, has flaws. What happens if one member of the family gets an urge to play the piano while another is sleeping in it?) . . .

Some years back I tackled the problem of bedmaking in collaboration with Eero Saarinen, an architect who has since devoted himself to more sizable problems, and we came up with an answer—elimination of the bed. But, as is frequently the case when something is "eliminated," the device making this possible was more complicated than the bed. It was a cubicle, a kind of room-within-a-room, the floor of which was covered with mattresses. These were lighter in weight than the conventional models, had cloth loops at the edges so that they could be hung on wall hooks by day, and looked much like those pads one sees on the walls of freight elevators. There was even to have been a little air-and-temperature-conditioning system for the enclosure to eliminate the need for blankets.

We were very young when all this took place, taken in by the propaganda about the desirability of doing away with work, and we had more enthusiasm than education. Some time later I realized that all we had done was reinvent the Japanese bed and bedroom.[109]

A more successful development was a practical technique for making something called the Bubble Lamp, an item that Howard Miller began manufacturing in 1952 and that soon became ubiquitous. When Nelson had opened his own office in 1947, he later noted,

It was important to me to have certain status symbols around, and one of the symbols was a spherical hanging lamp made in Sweden. It had a silk covering that was very difficult to make; they had to cut gores and sew them onto a wire frame. But I wanted one badly.

We had a modest office and I felt that if I had one of those big hanging spheres from Sweden, it would show that I was really with it, a pillar of contemporary design. One day Bonniers,

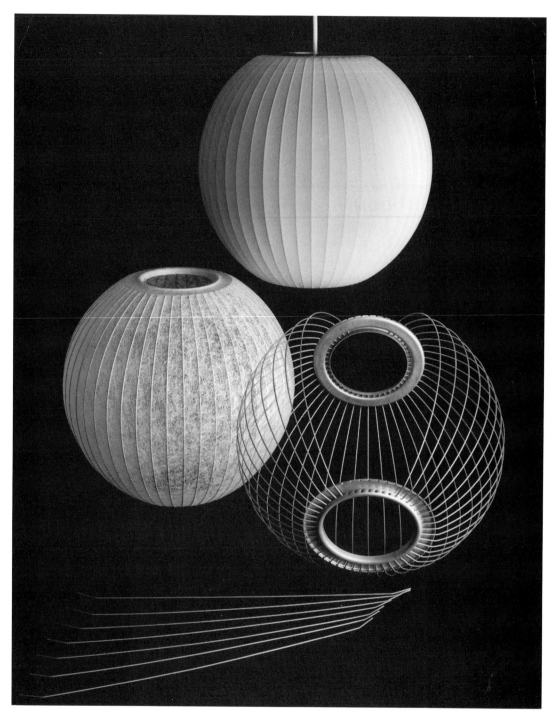

The first Bubble Lamp, designed in 1947 and produced by Howard Miller in 1950.

a Swedish import store in New York,[110] announced a sale of these lamps. I rushed down with one of the guys in the office and found one shopworn sample with thumbmarks on it and a price of $125.

It is hard to remember what $125 meant in the late 'forties. . . . I was furious and was stalking angrily down the stairs when suddenly an image popped into my mind which seemed to have nothing to do with anything. It was a picture in *The New York Times* some weeks before which showed Liberty ships being mothballed by having the decks covered with netting and then being sprayed with a self-webbing plastic. . . . Whammo! We rushed back to the office and made a roughly spherical frame; we called various places until we located the manufacturer of the spiderwebby spray. By the next night we had a plastic-covered lamp, and when you put a light in it, it glowed, and it did not cost $125.[111]

By the mid 1950s, the Nelson office's designs being manufactured by Howard Miller also included fireplace accessories, weathervanes, birdhouses, and, of course, clocks. Typically, the Nelson office also designed Miller's brochures, advertisements, stationery, and packaging. But these activities were spinoffs of furniture design, and it was the Storagewall that had been responsible for the Nelson office's entry into that field. However, as a memo (dated May 9, 1958) from Nelson to D. J. De Pree's son Max makes clear, for all the influence the Storagewall idea had had (for instance, "on architects' drawings in the form originally intended—as a partition replacement with access from both sides"), it was an idea that Herman Miller had not yet managed to market successfully. About the same time as Nelson's memo, however, another important step in the development of modern storage came about.

Aluminum Extrusions, Inc., was a small company in Charlotte, Michigan, about an hour from Zeeland. It had been started in 1947 by five young veterans. Their leader was William E. Dunlap, 26 years old, who before the war had worked at Extruded Metals, Inc. (later Reynolds Metals) in Belding, Michigan. *Fortune* later reported that, "although they had no technical schooling beyond high school, they did know how to extrude aluminum"—something then being attempted only by three giant American companies: Reynolds, Alcoa, and Kaiser. "To start their business," *Fortune* noted, "each put up $3,000. They sought plant space by writing to

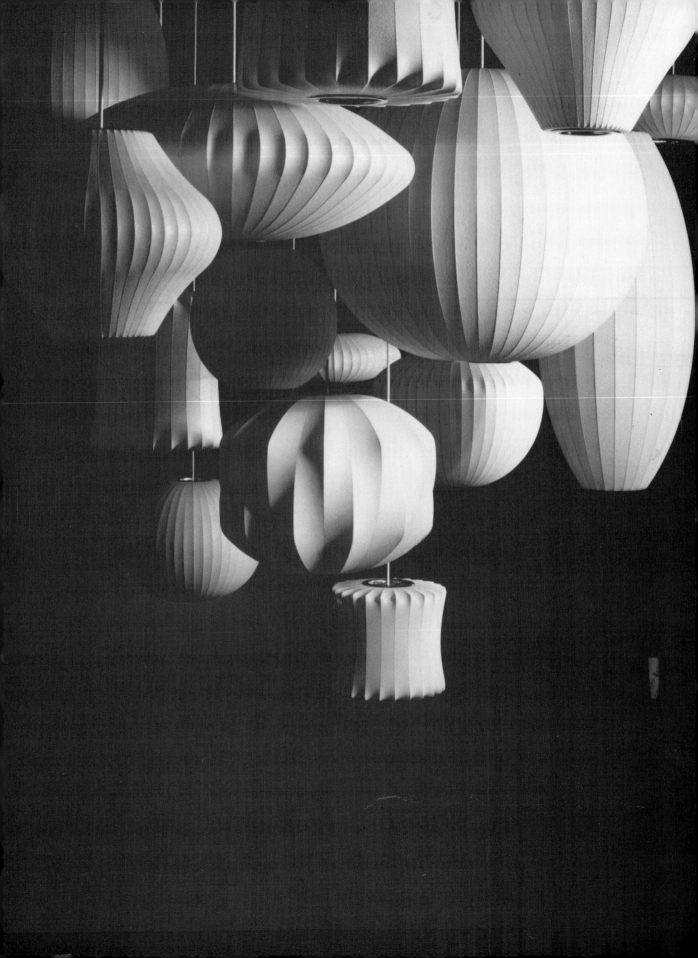

Later versions of the Bubble Lamp offered a greater variety of shapes.

sixty Michigan chambers of commerce, and when Charlotte, a quiet, rural community, offered a building rent free for six months, they moved in early September, 1946. The five men and four wives (Dunlap is a bachelor) improvised living quarters in the plant while they built the press. By January, 1947, they had finished it at a cost of $5,200, and, much to the surprise of everyone except its builders, it worked."[112]

In 1949 a fabricating subsidiary, Aluminum Manufacturing Co., was formed, and by 1956 the company had grown to 450 employees and was looking for a new product with which it could diversify its output. Dunlap, a subscriber to *Architectural Forum,* wrote to both George Nelson and Charles Eames asking for help. Eames was uninterested, but Nelson suggested a meeting when he was next on his way to Zeeland. "George flew to Detroit on a hot August day," Dunlap remembers. "I met him in a T-shirt; he was equally slovenly dressed. The drive to Charlotte was about

A 1952 lamp design for Howard Miller: panels of stetchable, washable lastex over a black wire frame. It was available at B. Altman for about $16.

three hours . . . en route we talked of philosophy, poetry and almost every esoteric subject except design and aluminum. It was clearly evident we were destined to become friends, even without a business relationship."[113] Nelson found Dunlap "interesting, unusual,"[114] and Dunlap later thought Nelson ("sometimes intolerant, but sometimes so sensitive and interested"[115]) to have had more influence on his life than anyone else.

One of Nelson's favorite writers, according to Dunlap, "was José Ortega y Gasset, whom he often quoted. He once gave me his book, *The Revolt of the Masses*, which he inscribed, 'for Senor Guillermo Dunlap with the compliments of the author.'"[116] As Nelson once explained Ortega's view,

> By "masses" he does not mean any of the familiar categories, such as commoners versus aristocrats, or workers versus professionals or management. For Ortega there are only two kinds of people, "those who make great demands on themselves . . . and those who demand nothing special of themselves . . . mere buoys that float on the waves."
>
> These masses and minorities, as Ortega has defined them, have always existed. What has changed (as observed in the Europe of the 1930s) is that now "the mass believes that it has the right to impose and to give force of law to notions born in the café. . . . The characteristic of the hour is that the commonplace mind, knowing itself to be commonplace, has the assurance to proclaim the rights of the commonplace and to impose them wherever it will.[117]

It seems likely that Nelson recognized in Dunlap (as he always called him) one of Ortega's few who make great demands on themselves, and the two thoroughly enjoyed each other's company. After one weekend together in Charlotte, they drove to Grand Rapids, where Nelson was to deliver a slide show, sponsored by Herman Miller, on his recent travels in Europe. Dunlap recalls a typically Nelsonian excursion: "We left early in the morning, taking the back roads through the countryside, he with his camera. We spent hours climbing over fences, over gates, over manure piles, photographing old barn windows. I remember the startled farmers peering out their windows at the two of us invading their barnyards."[118] Dunlap appointed Nelson a director of his company, and Nelson made

Dunlap a member of his office's board (or what passed for a board—Dunlap's memory is that the board meetings consisted of "George just talking about everything except what a board should be talking about"[119]).

But some real business developed between the two, as well. The product Nelson designed for Dunlap was a square-section extruded aluminum pole that could be erected between a floor and a ceiling and held there by springs, with no attachment to a wall. The poles were designed to hold any number of components between them—shelves, storage cabinets, files—and could be used in children's rooms, dining rooms, living rooms, libraries, offices, or exhibitions.[120] It was a new step in a new kind of furniture, one of the first examples of which had been the Nelson firm's own StrucTube system, developed in 1948, a simpler system of tubes sliding over round aluminum rods, joined to horizontal members with slotted connectors.[121] (StrucTube had originally been free-standing, but later modifications had added the floor-to-ceiling mounting feature.)

Nelson provided the new system with a name (Omni), and his office designed a trademark, a letterhead, bills, tags, shipping labels, and even graphics for trucks. "My thought," Nelson said, "was that we were going to generate a kind of aluminum lumber, and, since everybody needs storage in their houses, [they could] just go to the lumber yard and get these elegant aluminum poles and shelves and brackets."[122]

A mock-up of the Omni system, showing seven or eight possible configurations and uses, was built in the Charlotte factory, and Nelson invited Herman Miller executives Hugh and Max De Pree (their father D. J. having become less active in the firm) to a presentation. It was Dunlap's hope that Herman Miller would agree to take over the marketing of the system, but they did not. Neither did the lumber-yard distribution plan prove workable. Finally, Dunlap assumed the marketing effort himself, and Omni went on sale in Marshall Field's and other retail stores. Nelson used it himself in the Spaeth house, in the Williamsburg information center, and in his own New York apartment.

Seeing the product's apparent success, the De Pree sons became interested after all, reminding Nelson of his exclusive contract with them and hinting at disloyalty. Dunlap suggested that Nelson design another such system for Herman Miller, reasoning that if there were several pole systems around they would become more familiar and more marketable. The result was Herman Miller's highly flexible CSS (Comprehensive Storage

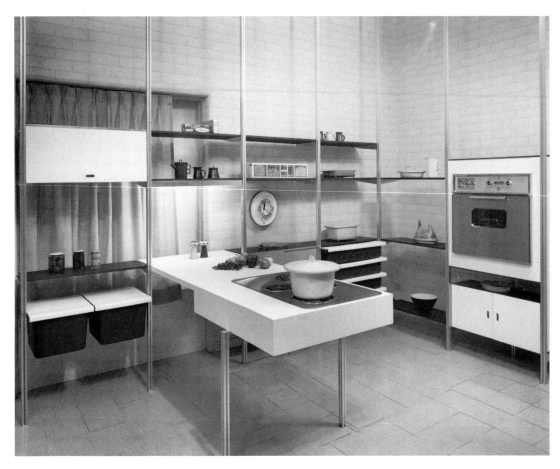

The Omni pole system in a kitchen application. (photo: Idaka)

System).[123] While it employed the same principle as Omni, the CSS was based on a tube with a quite different section and used different connectors; as we shall see later, it led, unexpectedly, to advances in office furniture.

For all their novelty and promise, the pole systems, it must be admitted, often had to be installed by skilled workmen and never were structurally foolproof. Witness a bit of correspondence from the early 1960s, beginning with a customer's letter to Herman Miller (with a copy to Nelson):

> In the early hours of this morning, I was jarred from my sleep by a thunderous roar throughout my apartment. My first thought was that an earthquake had struck. I leaped out of bed and rushed into the living room. There, in a twisted heap . . . with books and art objects scattered over the floor, was one of your Herman Miller Comprehensive Storage Systems which I have only recently purchased. . . . [124]

Nelson, in response, tried a chummy approach, telling of a similar recent experience of his own:

> I was the proud owner of another storage system known as Omni. This was installed in my apartment which was then made available for the use of a friend while I was in Europe. Said friend was in the kitchen, making herself a glass of iced tea (it was a very hot day) when a thunderous roar, similar to yours, shook the building. She rushed out (clad only in bra and panties, according to the report) to find there was approximately one ton of books, shelves, brackets and poles between her and the telephone in the living room. The door to the hall was unblocked, but the lady was unable to use it, feeling that her costume, even in a community as liberal in its attitude as New York, might provoke comment. Three hours later, she had made a tunnel which permitted her to reach the telephone. Perhaps, when one thinks of the experience of the Count of Monte Cristo, three hours was not too long. . . .
>
> I do not know what your solution to this problem might be—mine is to get rid of all systems.[125]

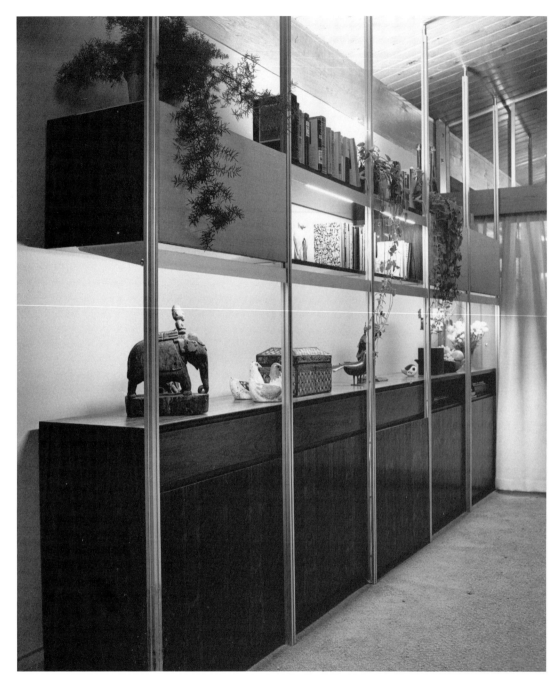

The CSS (Comprehensive Storage System), 1957. (photo: Balthazar Korab)

The customer was not amused:

> The problem, Mr. Nelson, is—WHO THE HELL IS GOING TO PAY
> FOR MY WIFE'S ANTIQUE CHINA COLLECTION?
> It's all very well for you people who can have friends like
> you describe wandering around in no close, but frankly, it isn't
> funny, no matter what you think. . . . The point is YOU DESIGNED
> THIS DAMN SYSTEM and it *DON'T WORK!*[126]

Forbidden by Herman Miller to continue developing products for
Dunlap, Nelson suggested as a replacement his Chicago friend Richard
Latham.[127] Later, also at Nelson's suggestion, Dunlap hired the New York
designer Henry Robert Kann,[128] who produced a refinement called Omni/
Plus. (Dunlap found it "handsome, but expensive."[129]) However, Nelson
continued to design graphics and brochures for Dunlap—one of which
showed his own design for Herman Miller's Action Office desk with a roll-
down top of "black anodized tambour extrusions . . . fabricated by AE." In
1969 Dunlap sold the company, and its new owners, unsympathetic to the
products, let Omni and Omni/Plus disappear from the market.

Another design problem Dunlap asked Nelson to solve was the in-
terior of Aluminum Extrusions' office and manufacturing building, a thor-
oughly utilitarian structure with exposed concrete block walls, inside and
out, and with exposed ducts, pipes, and wiring overhead. Guided by
Dolores Engle (the Nelson firm's chief interior designer from 1955, when
she joined the firm, until 1968, when she left to form her own practice[130]),
the solution simply made the best of meager elements and a modest bud-
get, but it was prophetic of a whole school of design that would follow a
decade later. Concrete blocks—not whole walls, in the conventional man-
ner, but individual blocks—were painted in vivid colors, and color was also
applied to the exposed structure, plumbing, wiring, mechanical equip-
ment, and manufacturing machinery, thus celebrating rather than disguis-
ing the working elements. This was a precursor of "supermannerism."[131]

The Nelson office was also asked to design Dunlap's own house in
Charlotte. "George did the original design, which frightened me because
of cost and innovation," Dunlap remembers. "The house he designed was
entirely enclosed by a wall (it was in the country), designed . . . around a
greenhouse concept. The dining room was designed in the actual green-
house, where the dining table appeared from the floor, by pushing but-
tons."[132] Dunlap settled for a less adventurous scheme by the Grand Rapids

architect John Knapp, but asked the Nelson office, again with Dolores Engle in charge, for interior design. One unusual feature of the result was a by-product of another commission: a redwood-framed floor-to-ceiling screen of stainless steel, made from the scrap left from the punching out of knife blades designed by the Nelson office for the Carvel company.

In the mid and late 1950s the Nelson office created a series of highly visible furniture designs for Herman Miller, most of them with both commercial and residential applications. The Coconut chair of 1955, an upholstered foam scoop encased in a sheet-steel shell and perched on bright aluminum legs,[133] was followed by the Marshmallow love seat of 1956, which, like the ball clock before it, exploded its parts into separate elements—in this case, into an array of eighteen individual circular cushions rather than one solid upholstered slab.[134] The Marshmallow's atomistic look, like that of the ball clock, was visually intriguing, even iconic, but, as Joe Schwartz of Herman Miller put it, "not too many people wanted to choose which cheek to place on which marshmallow."[135] And those who were tempted to choose one of the marshmallows at the very end would sometimes find the whole sofa flipping over on top of them.[136] In 1957 came the Pretzel chair, an ingenious twist of laminated oak prompted by Nelson's notion of a chair's being "something you could lift with two fingers."[137] In 1958 there was the Swaged-Leg Group of chairs, tables and desks,[138] which, according to *Interiors* (October 1958), had "started with this statement of purpose: 'Wouldn't it be beautiful to have some kind of a sculptured leg on a piece of furniture?'"

In 1957, while working on his daybed design for Herman Miller, Nelson took the 90-year-old Frank Lloyd Wright on a tour through the Miller showroom in New York. Max De Pree remembers with distaste that Wright kept his hat on throughout the tour and, while asking questions, kept whacking the precious furniture with his cane.[139]

The following year Nelson wrote to Wright, sending some photographs "taken somewhere around 1940" and mentioning that he had passed the Guggenheim Museum in the last day or so and that the recently completed building looked "very strange" in its Manhattan context—"like a healthy young person in a stadium of basket cases." He also speculated that "the only worthy goal for a good 1958 American is to aspire to the down payment on a Cadillac Eldorado. It may not make for interior peace in this lifetime but I have been given to understand that there is an all-electronic kitchen waiting for the chosen many in the next."[140] Wright replied: "Dear George: Glad to have the pictures and to

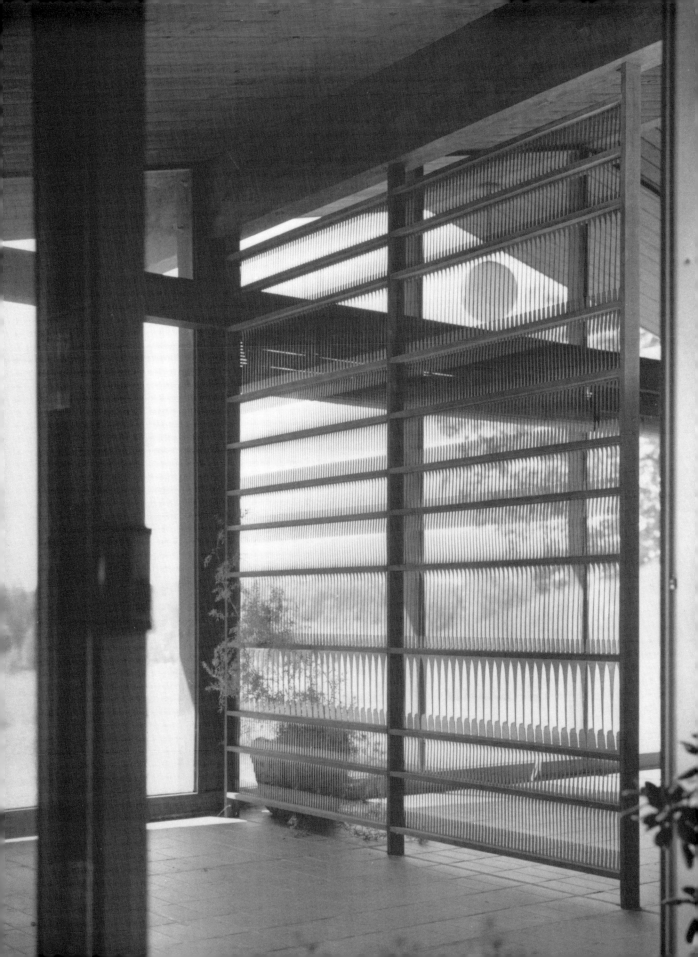

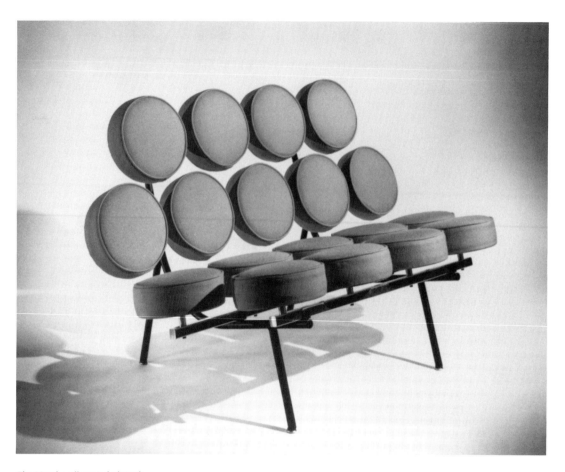

The Marshmallow Sofa (1956).

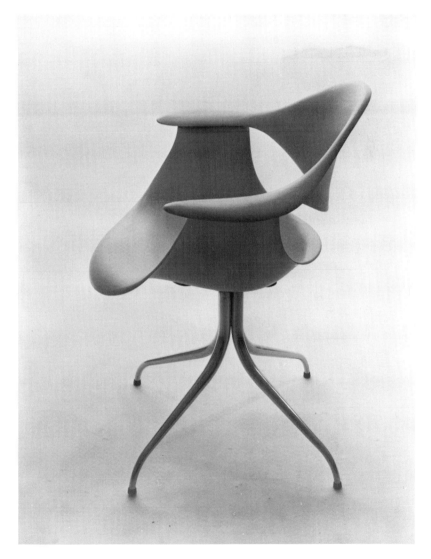

The Swaged-Leg Chair (1958).

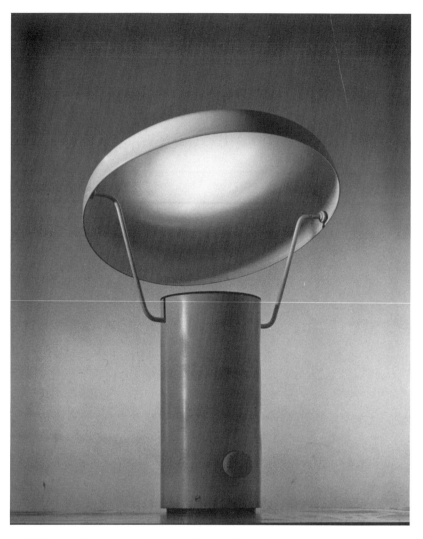

A 1960 fixture, with a pivoting reflector, designed for Nessen Lighting.

hear from you again. When do you come to visit the Taliesin West of 1958? Affection, Frank Lloyd Wright."[141] It was their last exchange; Wright died on April 9, 1959.

In the early 1960s the Nelson office produced two more seating designs for Herman Miller, the first of which is still being produced. The notion behind it came on a sweltering summer day during a drive in the French countryside. George Nelson and his wife Jacqueline were driving south from Paris in a little Citroën "Deux Chevaux." George stopped and asked Jacquie to get out. Hot and dismayed, she retreated to the shade of a lone tree and watched while he removed the car's seat and examined the rubber support that cradled it. "Haven't you noticed," he asked, "how comfortable this seat is?"[142] It was a diversion that left Jacquie almost literally steaming, but after almost three years of development it led to the Sling Sofa, in which loose leather-covered cushions were supported by fabric-reinforced rubber webbing hung from a hoop of chromed steel tubing.[143] "At first," Interiors reported in November 1963, "Nelson seems to be enlarging on an earlier statement by Marcel Breuer, who in 1925 designed the first bent tubular metal chair. On closer inspection, however, the technical advance of the Nelson pieces suggests new departures both for tubular metal furniture and for upholstered furniture." The Sling Sofa is also one of the most beautiful of modern furniture designs.

The second new design, called the Catenary Group,[144] was as close as the Nelson office ever came to overt Fuller-like technology. "Steel cat's cradles support catenary slings," according to Progressive Architecture; Nelson's own description was of independent cushions "strung on cables like beads," and he was careful to present the results as the product of a logical process, not of a conscious attempt to appear avant-garde. "The look of this furniture," he said, somewhat defensively, "can be explained as a logical expression of the idea of how the chair is built. It has its own look and is not a variation on anything else. In other words, if there is anything surprising looking, that just happened. Nobody was very interested in making it surprising looking. . . . The chair does make a statement about the industrially produced product, but we could with equal logic go off on an opposite tack: This is a chair and not a manifesto."[145]

The Sling Sofa and the Catenary Group were the office's last major designs for seating and lounge furniture. Years earlier, Nelson had already imagined a less obtrusive role for such products: "Today furniture design is prominently featured as a vehicle for individual expression. I

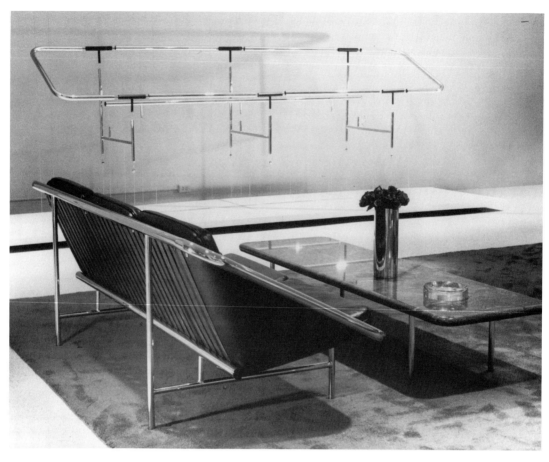

The Sling Sofa (1963) and, suspended beyond it, an
exploded skeleton of its structure.

An elevation drawing for Catenary Group seating (1962).

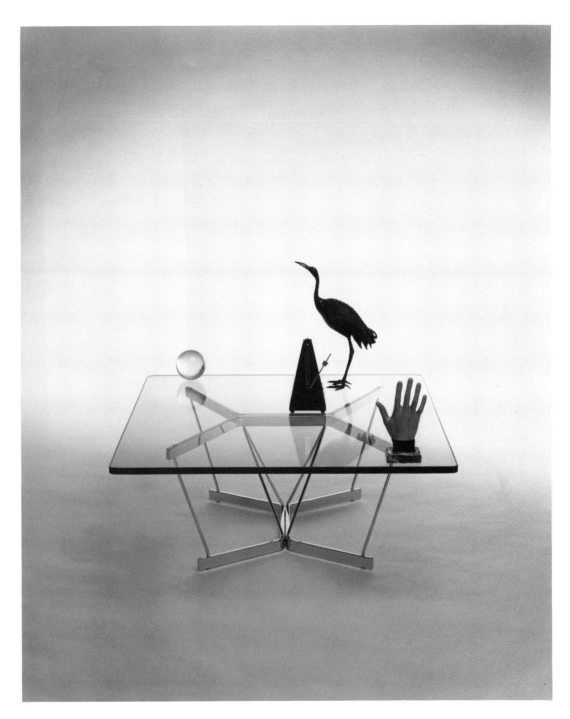

A glass-top table from the Catenary Group.

think it will unquestionably lose this position and tend to recede into a serviceable anonymity in much the same way as lighting and plumbing."[146]

In the years that followed, both Nelson's attention and the attention of the Herman Miller company would turn toward what seemed a more important and more difficult problem: the design of the office environment. In this turning, their paths would diverge. But despite this divergence, and despite their disparate views of life (and afterlife), D. J. De Pree and George Nelson would always remain profoundly admiring of each other. They were both, after all, highly moral men, and each of them had an unusually detached perspective on the material world with which they dealt professionally. Edgar Kaufmann, jr., once quoted a conversation Nelson had with the U.S. head of Olivetti: "George asked, 'What do you think really makes a corporation great?' And the executive answered him very nicely, 'A great corporation is one that *also* makes money.'"[147] Like Olivetti, Herman Miller under D. J. De Pree was a company that *also* made money.[148]

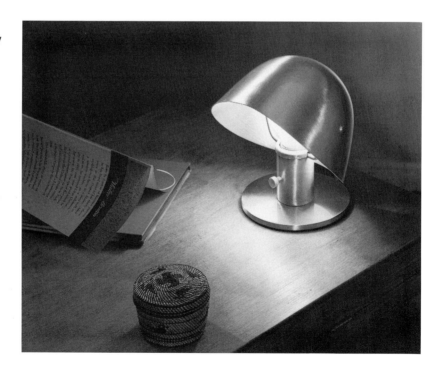

A miniature reading light designed for Koch & Lowy (1975). (photo: Hope Sanders)

D. J. De Pree.

An item in one of Nelson's notebooks seems to describe a quality he and D. J. shared:

Alfred North Whitehead, *The Aims of Education:*
Style, in its finest sense, is the last acquirement of the educated mind; it is also the most useful. It pervades the whole being. The administrator with a sense for style hates waste; the engineer with a sense for style economises his material; the artisan with a sense for style prefers good work. Style is the ultimate morality of mind.

A quarter century after hiring Nelson, De Pree would write:

Dear George

One of the days of this month, which day I don't know, is the 25th Anniversary of an event I am personally celebrating with deep gratitude to God. This event took place on a hot August afternoon in 1945 when you and Jim Eppinger and I, sitting on a park bench facing the Ottawa Beach shoreline of Lake Michigan, finalized your entrance into the Herman Miller company as its designer.[149]

In that quarter century, the world had changed. Everywhere, the human factor seemed in danger of being overwhelmed. Another notebook entry reads as follows.

José Ortega y Gasset, *History as a System:*
Today I am more than ever frightened. I wish it would dawn upon engineers that, in order to be an engineer, it is not enough to be an engineer.

Viewing the profession of architecture in 1973, Nelson himself made some observations that could have applied just as well to the furniture business and to much of modern life:

Architecture has long been the business of architects, whether they called themselves priests, craftsmen or master builders. It has been a professional calling, carried on with love, dedication and long study.

This is changing. . . . The architect as a professional is gradually becoming the architect as a corporate type, inevitably taking on corporate values. . . . In theory, there is nothing to prevent a corporate design and planning group from turning out work of superb quality, and there are indeed occasional examples of just that. But, generally speaking, the professional who becomes personnel [a phrase that, earlier in the same article, Nelson attributed to Paul Goodman] shortly turns into a bureaucrat, concerned for his job, his status and his pension. More often than not he ends up doing what he is told to do. As he becomes a skilled bureaucrat, he knows what he has to do before anyone tells him,

The Herman Miller design team together at the Walker Art Center in November 1975. From left to right: Robert Propst, D. J. De Pree, Nelson, Alexander Girard, Ray Eames, Charles Eames.

> thus preserving the illusion of independence and personal free-
> dom. This process of transformation in which a man becomes a
> mouse, or, as Kafka put it, a cockroach, is not due so much to the
> organization of the corporation as to its aims, which are almost
> invariably not human aims.
>
> Thus we finally confront not only the dehumanization of
> architecture, but of the architect as well. There is nothing special
> in this process: it is going on all through society.[150]

But such "dehumanization," Nelson saw, was not *necessarily* the result of an increasingly corporate economy and an increasingly dominant technology. Could not, indeed, that very technology be harnessed to support a superior level of civilization? It was an idea Nelson would seek to apply to the crucial field of education.

6 Education

"Early in the summer of 1952," as Nelson remembered, "the phone rang
and the caller identified himself as Lamar Dodd. I had heard of a Lamar
Dodd who was a painter and was vaguely aware that he had some connec-
tion with a school in the south. Beyond that, nothing."[1]

Dodd, longtime dean of the Department of Fine Arts at the Uni-
versity of Georgia, had just received a grant from the Rockefeller Founda-
tion, one he could spend as he wished without the approval of the
university's administration, and he wanted to use it to import someone
who would stimulate his department. It was a large department, one of
the strongest in the country. Althought it was popular with the students,
very few them pursued careers in art after graduation. Dodd's prospective
list of visitors included Francis Henry Taylor of the Metropolitan Museum,
Bucky Fuller,[2] and the architect Frederick Kiesler,[3] but he called Nelson
first.

The first conversation was inconclusive.[4] In a second conversation,
Dodd asked Nelson to come down to Athens for a day or two of talk, with
no particular assignment. Nelson protested that he was ignorant of educa-
tional policy. "I know," Dodd said. "That's why we want you." Nelson ap-
parently thought he could end the matter by stating a daily consulting fee
of $750, an unheard-of sum in those days. But Dodd, who admits that "if
he had told me $100 a day, it would have seemed a great amount," was
undaunted. "Do you know what I had you budgeted for?" he asked. "$750
a day!"[5]

So it was that on a hot May afternoon, after a change of planes in
Charlotte and a flight that Dodd warned would be "like hedge-hopping
with stops about every 30 minutes," Nelson arrived in Athens, immedi-
ately requesting a martini. A martini, those days, was the drink of choice
for only a few in Athens, but Dodd's secretary, Betty Cabin, was one of the
few, so an acceptable drink was produced. (In any case, as the designer
Philip George says, "George could get a martini out of a forest."[6]) It was
the beginning of a fruitful episode, and at the end Nelson told Dodd that
he could forget the fee entirely; he had had too much fun to charge for
the experience.

Although Nelson was not entirely innocent of classroom experience, having taught architecture at Yale and Columbia and having lectured at many schools,[7] the teaching of painting and sculpture was a new problem for him, as were the constraints of tenure, budget, and faculty staffing. Initial discussions focused on whether or not a graduate year should be added to Georgia's four-year curriculum, but "a feeling gradually developed that it might be worth re-examining objectives and perhaps trying some experiments in educational techniques—though at the time no-one had any very clear idea of what the experiments might be." "We decided." Nelson continued, "to have another session in the fall, and Lamar Dodd, who had guided the discussions with an extraordinary combination of firmness and sensitivity, suggested the formation of a small advisory committee. I asked him to invite Charles Eames."[8] Dodd obliged. Nelson then wrote to Eames as well, telling him about Dodd ("a rather remarkable guy") and mentioning a further possibility:

> They are planning to put up an Art Building, and Dodd is in a spot where he can name the architect, and we talked about this a bit. I named all the usual guys, and he asked if I would be interested. I suggested that he consider the possibility that you and I be given a crack at the design, since, as we were members of the committee, there would be a degree of involvement with the school that might lead to a good solution. This fired his enthusiasm; and, I must confess, also mine as I would love a chance to work with you on some project sometime, and this might be it.[9]

Unfortunately, these plans never materialized, and we can only imagine what an art school designed by Nelson and Eames might have been like, or even if the pair could have collaborated on such a large project.[10]

Nelson and Eames did collaborate constructively on the Georgia curriculum project, but they did so by segmenting the task and taking different assignments. The two designers visited classes at the school that fall, and they began to suspect that "much time was being wasted through methods originally developed for other purposes. For example, one class was finishing a two-week exercise demonstrating that a given color is not a fixed quantity to the eye but appears to change according to the colors around it. In a physics class such a point would have been made in about five minutes with a simple apparatus, and just as effectively."[11]

This conclusion may have been influenced by Nelson's general prejudice that the techniques of science were more efficient than the subtler workings of art. His views at the time were also certainly influenced by Erich Fromm, whom he knew and admired not only as a psychoanalyst and personality theorist but also as a humanistic thinker who advocated meaningful relationships rather than material possessions—being rather than having.[12] On the subject of education, Fromm had written in 1941 of "methods used today which in effect . . . discourage original thinking. One is the emphasis on knowledge of facts, or I should rather say on information. The pathetic superstition prevails that by knowing more and more facts one arrives at knowledge of reality. Hundreds of scattered and unrelated facts are dumped into the heads of students; their time and energy are taken up by learning more and more facts so that there is little left for thinking."[13]

Nelson came to feel that the Georgia curriculum was guilty not so much of an overemphasis on isolated facts (except perhaps in the art history lectures) as of an overemphasis (in the studios) on isolated techniques. Nelson was out to vanquish isolation. He and Eames decided that

> the most important thing to communicate to undergraduates was an awareness of relationships. Education, like the thinking of the man in the street, was sealed off into too many compartments. If a girl wanted to know something about decorating her future apartment and what she got was a class in painting, this might make perfectly good sense, but it was up to the school to build a bridge between the two so that she might see how they were related. Whether this was accomplished by personal or impersonal methods seemed of little consequence.[14]

Expressing vague doubts about teaching methods produced only confusion, however, not stimulation, so the two designers offered to present a specific example of their thinking as a sample lesson for an imaginary course, promptly labeled "Art X,"[15] that would "develop high-speed techniques for exposing the relationships between seemingly unrelated phenomena."[16] Nelson considered inviting Walter Gropius as a third member of the committee to prepare the course,[17] but then agreed with Eames to invite Alexander Girard (the third member of the Herman Miller design triumvirate) instead. "After leaving Athens," Nelson recalled,

[Charles Eames and I] went to Michigan to see Girard, who was working in Grosse Pointe, and as we examined possible courses of action we began to realize what we had let ourselves in for. In addition to getting our own work done during the next five months, we had offered to turn out something pretty close to the scale of a Hollywood production, and with practically none of the needed technical resources. We didn't even know what the subject of the one-hour lesson might be. And there was an even more serious problem: Eames was located in California, Girard in Michigan and I was in New York.

Problems are made to be solved. We solved ours by working up a subject for the lesson and then dividing it into parts which could be worked on separately. Girard agreed to do a facsimile of a small traveling exhibition. (It had been decided that each "lesson" would be accompanied by a related exhibit.) We then parted company and went home to do some work. "Art X" as a project was under way; the ideas it generated did not fully emerge until later.

The subject selected for our hypothetical lesson was "Communication," and if you asked me now how we picked so impossibly difficult a theme I can only answer that at the time we did everything the hard way. As we went from one possible subject to another, what we were most interested in finding was something which would permit the exploration of relationships, and if it offered nothing else, "Communication" certainly did that. We also felt that since the lesson was to have some connection with art, it would not be unreasonable to begin with the thought that art was a kind of communication. In any event, we had our subject, and we were stuck with it.[18]

While Girard worked on exhibition plans, Nelson and Eames divided the one-hour lesson between them.[19] Dodd, meanwhile, was preparing his students (and perhaps his faculty, too) by presenting a display of furniture and products by the three designers, which, in January of 1953, attracted unusual crowds.[20] Dates in early March were set for presentation of the lesson. Having to be out of town on the day set for the designers' arrival, Dodd wrote, "How I wish I could be there when you and Charley get together on this project."[21] Nelson replied:

All this turmoil gives me great satisfaction and the most horrible qualms. What if what we turn out should be a complete dud? Or what if we don't get it finished? The time schedule on the movie thing is absolutely insane, anyway. And what if—?

For heaven's sake, don't regret being absent when Charlie and I get down there. For at least two days we are going to be the most disagreeable human beings you have ever encountered.[22]

In March the three designers met in Athens, "burdened with only slightly less equipment than Ringling Brothers."[23] This included a movie projector, three slide projectors, three screens, three or four tape recorders, cans of film, boxes of slides, and reels of magnetic tape. Girard brought a collection of bottled synthetic odors that were to be fed into the auditorium during the show through the air conditioning ducts.

The beautifully put together hour-long lesson began with a 10-minute film by Nelson that dissolved into a 10-minute series of three-screen slide projections, also composed by Nelson. A 10-minute film by Eames on "communications process" came next; then more slides by Nelson (some single, some triple) on the subject of abstraction; then a 4-minute excerpt from a French film on the evolution of lettering and a 3-minute fragment, edited by Eames, on "the animated calligraphy of sound." Next, 10 minutes edited by Nelson from a film on Egyptian art and architecture by Ray Garner; and, to close, another Eames film segment on "communications method."[24] Here is Nelson's description of the brief section on abstraction:

A slide goes on the screen, showing a still life by Picasso. A narrator's voice identifies it, adds that it is a type of painting known as "abstract," which is correct in the dictionary sense of the word, since the painter abstracted from the data in front of him only what he wanted and arranged it as he saw fit. The next slide shows a section of London. The dry voice identifies this as an abstraction too, since of all possible data about this area, only the street pattern was selected. Then follow other maps of the same area, but each presents different data—routes of subways, location of garages, etc. The voice observes that each time the information is changed, the picture changes. The camera closes in on the maps until only a few bright color patches show; the commu-

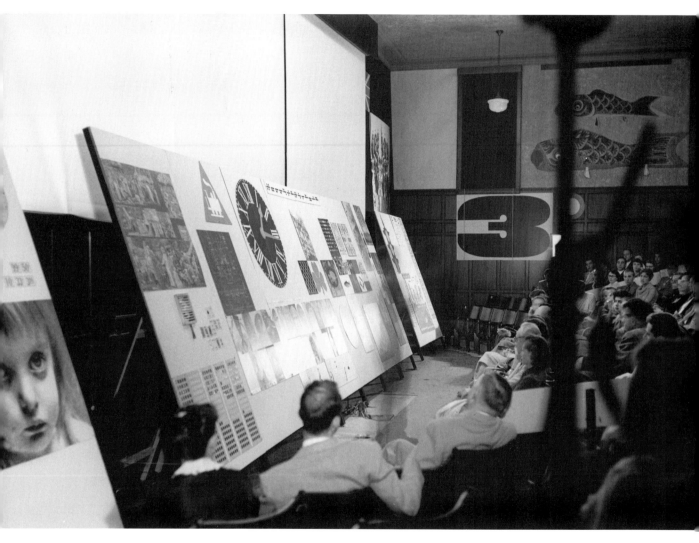

Part of the "Art X" exhibition/film/slide show/lecture/event (1953).

nication is now useless to the geographer, but there is something new in the residue of colors and shapes. Then a shift to a distant view of Notre Dame, followed by a series which takes you closer and closer. The narrator cites the cathedral as an abstraction—the result of a filtering-out process which has gone on for centuries. The single slide sequence becomes a triple-slide projection. Simultaneous exterior views change to interior views. Organ music crashes in as the narration stops. The interior becomes a close-up of a stained glass window. Incense drifts into the auditorium. The entire space dissolves into sound, smell, and color.[25]

This was a multi-media event of unprecedented complexity and scope. It dazzled its audience. It was shown several times in Athens in 1953. In 1954 it played to even larger audiences at the University of California at Los Angeles—where, Nelson reported to Dodd, "the funniest thing about the whole affair was that none of the six audiences showed any disposition to go home and they just sat and sat until they were told they had to leave."[26] Dodd gratefully wrote Nelson that he was "not competent to thank" him "for the position of leadership that [he had] assumed in this gigantic undertaking."[27] And William Howland, a *Time* bureau chief, wrote all three designers calling the new teaching aid "one of the most exciting things I have seen, heard, and smelled in many years."[28]

Nelson and Eames both returned to Athens the next year, and Dodd's faculty members[29] began to turn out their own variations on the "Art X" theme. For Nelson, the contact with Dodd led to a commission, in 1955, for the design of interiors for the university's new Continuing Education Center.[30] He furnished its auditorium, dining room, and guest rooms with Eames chairs, and its foyer with one of his new Marshmallow sofas.

Nelson's hope for some sort of grant that would fund a dozen multi-media lessons never materialized,[31] but the expensive equipment that would have made the process easier was not, as the three designers had proved, essential for a small number of lessons. Although turning out such lessons on a large scale *would* be expensive, the costs of the packaged results could be shared by large numbers of schools; one big investment at the outset, comparable to tooling up for a new automobile model, would eventually result in a lower cost per student than conventional methods. The lesson showed the way toward the application of mass production to the classroom.

There was another advantage: Only the best teachers would be used, and they would be given tools not often at their command. If, as Nelson thought, the objective of a general liberal education (which he considered quite distinct from a technical one) was not to help the student "remember the date of the battle of Thermopylae or the name of the bar-room where Kit Marlowe got into his final brawl" but to help that student "form a coherent picture of human activity, a capacity to understand its great achievements, an ability to form independent judgments, and above all, to learn to relate isolated bits of information in terms of a large context,"[32] then the multi-media lesson, with its bombardment of thousands of those bits of information, efficiently composed, seemed ideal.

Charles and Ray Eames clearly had the principle of Art X in mind when, in 1958, they were asked to suggest a program for professional design training in India. Their report stated: "In order to be a real contribution in these fast-moving times . . . information must be *organized* and *communicated* in a far-reaching, digestible way. This means exhibitions, films, literature, made and organized as part of the service program of the institute."[33] Indeed, after the experience of Art X, the Eameses concentrated on communication design (with multi-screen presentation a staple) at least as much as on product design.

And Nelson's friend Bucky Fuller later proposed a similar development in his 1962 book *Education Automation*.[34] He advocated the selection of "the faculty leaders in research or in teaching" to present lectures to be recorded and improved over time. "Others," he wrote, "will gradually process the tape and moving picture footage, using communications specialists, psychologists, etc. . . . What is *net* will become communicated so well that any child can turn on a documentary device, a TV, and get the . . . thinking and get it quickly and firmly. I am quite sure that we are going to get research and development laboratories of education where the faculty will become producers of extraordinary moving-picture documentaries. That is going to be the big, new educational trend."

There has been, of course, little further progress toward such educational technology, nor is there any documentation that the students who were so dazzled and entertained by Art X actually learned anything. The Nelson-Eames-Girard experiment was certainly precocious, coming well in advance of the surfeit of visual images now bombarding us from MTV and other sources, but it was based on an optimistic view that such bombardment, carefully planned, would convey a large amount of information. It is by no means clear that such optimism was justified.

Nelson was aware that the advent of mechanical teaching aids would bring fears of depersonalization in the classroom. But he insisted that the presence of the teachers who had prepared the lessons would still be felt. Here is his own summary:

> "Art X" was not offered as an invention, but as a statement. As a statement it said that there is no longer room in the world for barriers—political, economic, temporal, intellectual, scientific, racial, or any other kind. It said that art, like every other discipline, is not an isolated thing but intimately related to everything in creation, including man and all his works, past, present, and future. It said, by clear implication, that modern man cannot live alone and survive. It said these things in an industrial vernacular because industry has given us more and better ways to say things than we had before. The pictures which flickered across the multiple screens were made by machines, developed by machines, and projected by machines. The voices, music, and sound which were heard were electronically recorded, played back, and amplified. But it was people who said the words, wrote the music, held the cameras, and made the final statement. This is why we do not have to be afraid of our tools—even in education.[35]

7 Exhibitions

As with architecture, industrial design, and furniture design, Nelson first approached the field of exhibition design by writing about it. As with those other fields, he came quickly to a clear and critical view.

In 1936, as New York approached the deadline for the design of its 1939 World's Fair, he undertook for *Architectural Forum* an examination of the whole subject of fairs. The 20-page article was titled "Fairs: their lusty ancestry; their vigorous maturity; their present indecisiveness; and what of New York 1939?" It began:

> More than any other corporate human activity, fairs picture an epoch. How people live, what they are interested in, their amusements, aspirations, and beliefs, what they wear, how they travel, how they kill each other and reduce infant mortality—all these are reflected in fairs, which since the middle of the last century have been taking on fantastic proportions. Fairs had a vital reason for existence in the beginning: for centuries they were the only means of exchanging goods and spreading culture on a large scale. . . . Today our market is permanent, and the commodity fair given way to the department store. . . .
>
> Human existence has become too complex for a Fair to present all its phases without drastic simplification, and a measure of interpretation. It is significant that the outstanding fairs of the present century have not only been small but have each dealt with a specific phase of life. The pattern that served the large fair for nearly a century is no longer workable. . . . But one thing is certain: unless their influence is to stop at the turnstiles, fairs must change.[1]

The nature of the change Nelson thought was needed was made evident in the text that followed: "The days of representing Montana with a stuffed cow, or Florida with a bungalow constructed of oranges, have passed." And visitors must not be bored:

Components of Nelson's
StrucTube system, stacked
and assembled for a 1947
exhibition at the Brooklyn
Museum.

At the Crystal Palace[2] the public was so fascinated by the exhibits
that no thought was given to amusement. Today no fair dares
open without the support of a Midway, and millions yawned as
the light from Arcturus opened A Century of Progress.[3] All is not
well with the fair: man's capacity for wonder is undiminished,
but, finding little to wonder at, he makes for the roller coasters.

The trouble, Nelson reported, was simple:

> Modern man no longer is awed by mechanical ingenuity or scien-
> tific accomplishment: he takes the automobile, and transoceanic
> flights, and television as a matter of course. But he is wondering
> what it all proves, what it means to him in the way of better
> living—witness the agitation for decent housing, statistics on
> the automobile as a destructive agent, the political upheavals in
> Russia, Italy, and Germany, and the unrest in our own country.
> Project a picture of a planned environment using modern techni-
> cal resources to the fullest, present the *social implications* of the
> machine, and you will have a timely theme. . . . What is important
> is whether social objectives—the live issues of the day—will be
> stressed, or whether the public will be expected to look at the
> same old mechanical displays painted a new color and go home
> satisfied. . . . It would be a pity to spend $50,000,000 to create a
> fair born dead.

It was a view not heeded to any great extent by the planners of the 1939
fair, but one that Nelson himself would remember and use to great effect,
most notably in the American National Exhibition in Moscow two decades
later.

Nelson's own first venture into exhibition design came in 1938
with a show, for Yale University and *Life* magazine, of new housing and
building techniques, including two trailer-mounted bathrooms designed
by Bucky Fuller.[4] This was followed by his work on the Architectural
League's provocative traditional-versus-modern show, mentioned in chap-
ter 2 above.

More exhibitions followed after the war. By then, the Nelson of-
fice's clients included Gartner & Bender, primarily a manufacturer of
greeting cards but aspiring to branch out. In 1947 Nelson designed for

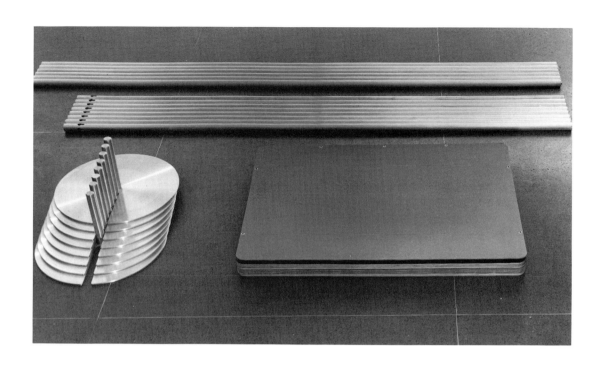

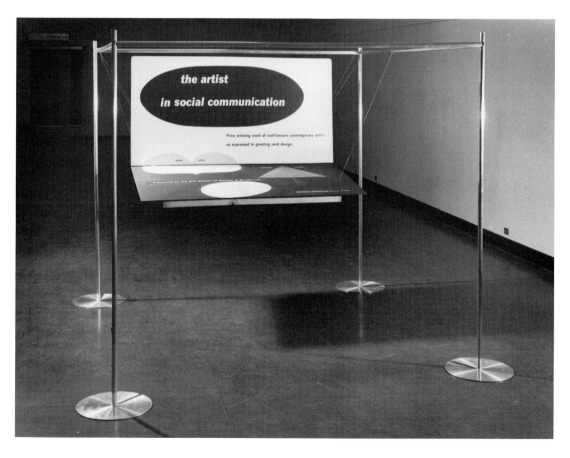

them an exhibition that was shown at the Brooklyn Museum; though it had the impressive title of "The Artist in Social Communication," it was really a display of prize-winning greeting card designs. Even so, the artists were some of the most prominent of the time, the winners including Reginald Marsh and John Atherton and the honorable mentions including Ben Shahn. And for Nelson there was a further significance: the exhibition structure was his own StrucTube aluminum pole system.

Nelson's early exhibition experience was summarized in his 1953 book *Display.* Like his *Forum* article, it ridiculed past naiveté ("up to quite recently it was official opinion that the best way to represent U.S. life and culture was to ship out an undersized version of Mount Vernon"[5]) and presented more sophisticated modern examples. It contained a 12-page section devoted to the work of Bauhaus alumnus Herbert Bayer, a Miesian "Project for a Museum" designed by Peter Blake, and the first four of Edgar Kaufmann, jr.'s "Good Design" exhibitions for New York's Museum of Modern Art and Chicago's Merchandise Mart—the 1950 exhibition designed by Charles and Ray Eames, the 1951 version designed by Finn Juhl, the 1952 version by Paul Rudolph, and the 1953 version by Alexander Girard. The book also offered a useful 32-page compendium of display systems that had recently become available, including Unistrut and Struc-Tube—systems with important implications for future furniture systems. As Nelson explained,

> Virtually without exception, these systems build themselves into open cages of steel, wood or aluminum. . . . One can put things in them or on them, open spaces can be filled with solid panels if desired, flooded with light from attached lamps. . . . If these advantages really exist, is it not curious that these solutions hardly existed half a dozen years ago? Why did display structures then consist of panels which could only be assembled into walls and boxes? Obviously the answer does not lie in the functional properties of the new cages, because these could have been established much earlier. What has happened . . . is that there has been a change in our feelings about space and how it should be handled.[6]

Nelson's knowledge of display technique was put to work in a 1954 installation for the *New York Times* at the Cross County Shopping Center in Yonkers and in a visitors' center for Colonial Williamsburg. For

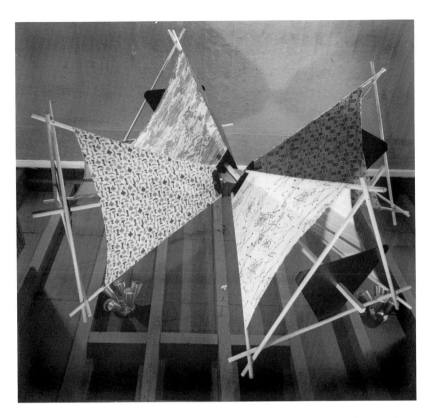

A fabric "kite" designed for a 1951 exhibition of Schiffer Prints textiles at the Architectural League, New York. Some of the fabric designs were also by the Nelson office.

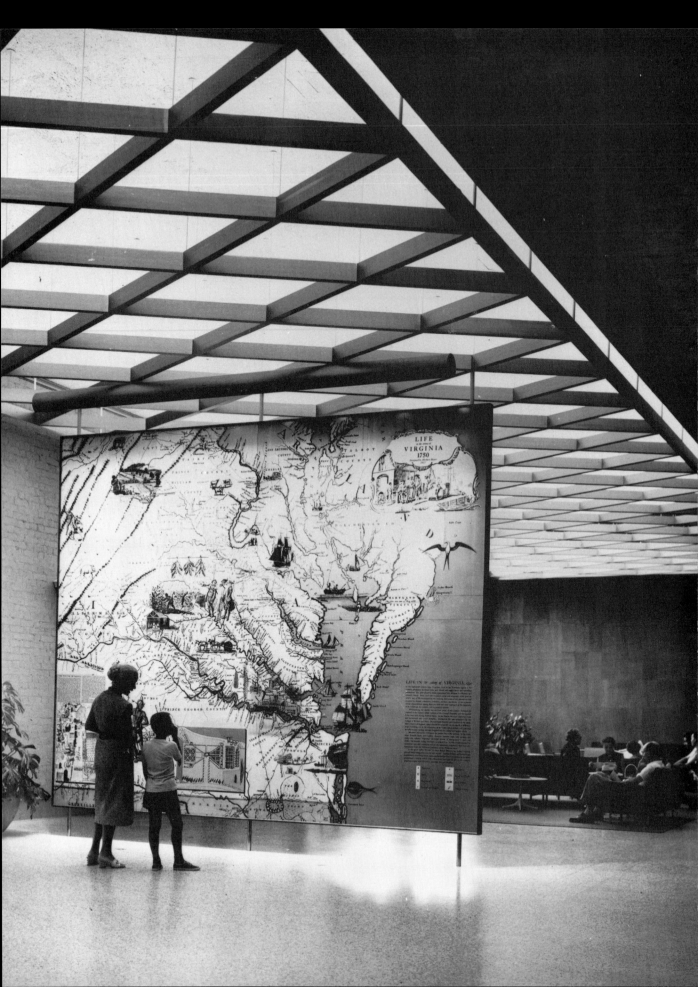

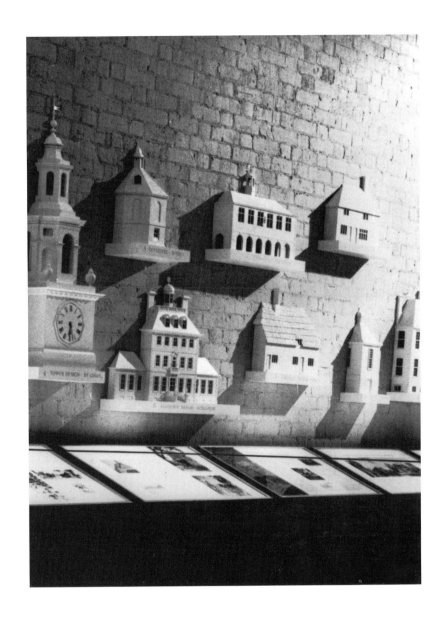

The visitors' center designed for Colonial Williamsburg in the late 1950s. The mural, based on a historic map, is one of a pair commissioned from Herbert Bayer.

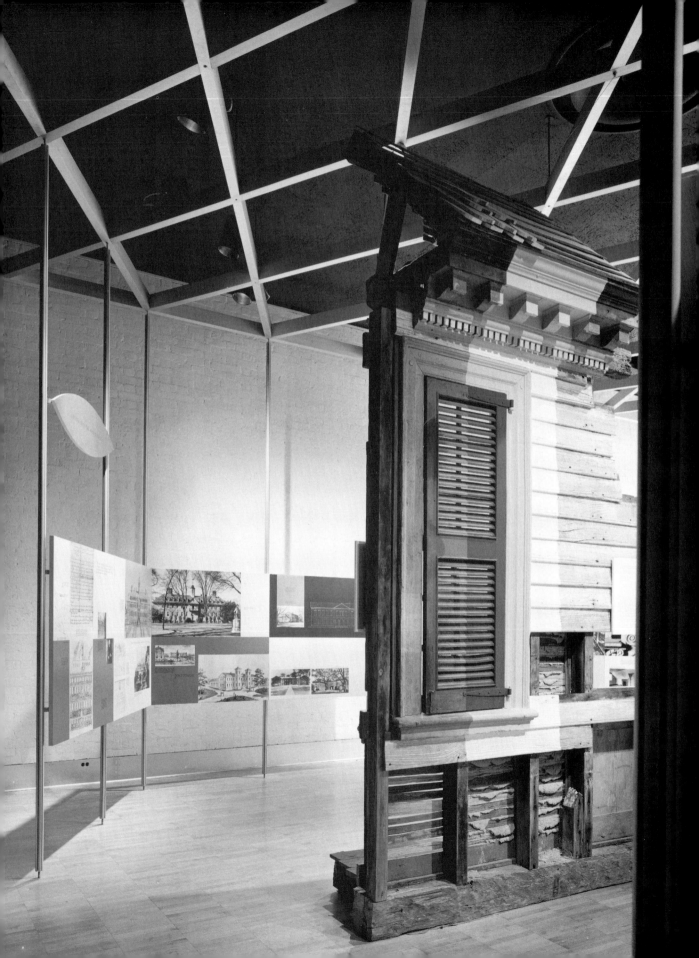

the latter, Don Ervin of the Nelson graphics staff devised a typeface based on one dating from 1790, and Nelson brought in Herbert Bayer to design two 12-by-15-foot murals based on historic maps.[7]

The Nelson office's first design commission from the United States Information Agency was for the show "Education for Theatrical Design" at Brazil's São Paulo international biennial in 1957. The three pavilions, designed under the supervision of Irving Harper and titled "Preparation for Theater," "What They Learn," and "Where They Go," won the biennial's Gold Medal for "best cultural exhibit." This success led to the office's working on a USIA nuclear energy exhibition for Moscow. After the completion of the drawings, however, the project was canceled. This was a disappointment, but hardly a complete surprise; the Cold War had chilled most hopes of civil contact between the United States and the Soviet Union. But on the last day of September 1958 Nelson received a call from Washington reporting an agreement just signed by the two countries for an exchange of national exhibitions on "Science, Culture, and Technology"—quite a startling breakthrough in relations. Perhaps, the caller suggested, the projected nuclear energy exhibit might become part of the U.S. show. No one then suspected that Nelson's role would grow to encompass the design of the whole show, which was to be one of the most visible and most acclaimed exhibitions of the era.

Initially the prospects did not look bright. Attending a Washington dinner in early October with a small group of designers being tentatively considered for the project, Nelson found little information available beyond the proposed site (Moscow's Gorky Park) and the hair-raising deadline. The negotiators, apparently better versed in international relations than in the realities of design and construction, had agreed to an opening date of July 4, 1959, less than 9 months away. Nelson's office notes record this: "It is made clear that the project will be far too big for one office to handle. Violent arguments until 2 a.m. on the basis of no facts whatsoever."[8]

The following week Nelson huddled at lunch with three key members of his staff, Irving Harper, John Pile, and Gordon Chadwick, to discuss the prospect. In his logbook Nelson wrote:

> Expression of strongly mixed feelings regarding possibility of association with Moscow exhibition. On the one hand, glamor plus realization that the exhibition could have an important effect on US-USSR relations. On the other, the possibility of wrecking the office by taking on too large a project. . . . No decisions.

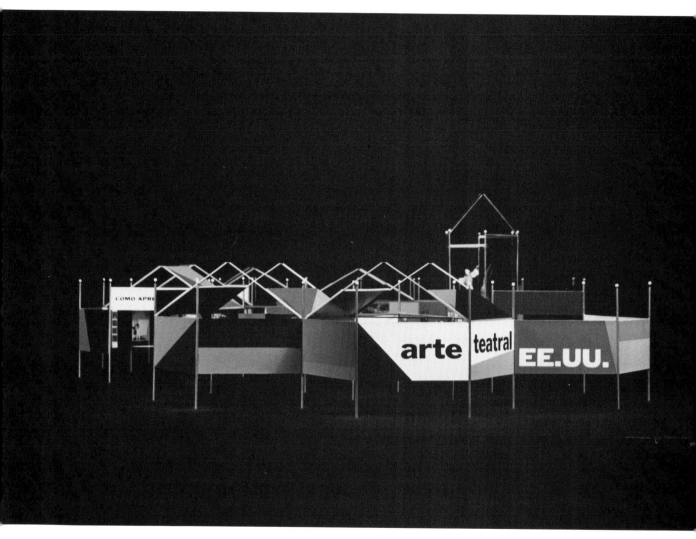

A model of the prize-winning Sao Paulo theatre arts exhibition (1957).

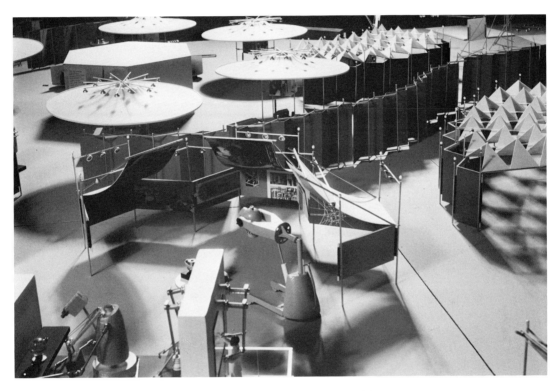

A model of an "Atoms for Peace" exhibition proposed for Moscow in 1957. The exhibition was canceled after the drawings were completed.

On October 17 Nelson was called to Washington for his first meeting with Harold Chadick ("Chad") McClellan, a wealthy Los Angeles manufacturer of paints and chemicals who had been appointed general manager of the exhibition by President Eisenhower.[9] Jack Masey, who was to be the USIA's coordinator of design and construction, wanted Nelson's participation, hoping to repeat their São Paulo success; McClellan wanted the participation of Los Angeles-based Welton Becket & Associates. Nelson's log continues:

> Cooled heels in anteroom. When finally admitted to meeting, took part in lively discussion of possible prefabricated buildings suitable for exhibition purposes. General discussion of budget. Alarmed discussion of time schedule. Ushered out 11:45 a.m. At 1 p.m. message delivered to anteroom by agreeable young official: "You are offered appointment as designer Moscow project, Welton Becket & Associates offered appointment as architects Moscow project. Your answer required by 4 p.m."
>
> Complete confusion. Had been told earlier that project was too large to be turned over to any single design organization. McClellan had reversed this. Had decided apparently that only way to cope with project under the near-impossible conditions was to centralize responsibility.

In the next three hours, Nelson tried but failed to reach his "more cautious associates" in New York. At 4 o'clock he was summoned. The logbook describes this scene:

> Fifty people in a huge room complete with eagles and flags. Looked like MGM set for Grade B political film. Experts in a dozen categories talked briefly. First real idea of complexity of project.

Nelson, of course, accepted the commission:

> Who could turn a project like this down, whatever the risks? . . . Returned to office, announced decision. Mixed feelings, but excitement predominates. Looked at photographs and drawings of Gorky Park buildings in which the bulk of the U.S. exhibition would be housed. Horrified! Not sure buildings would be suitable

for raising of hamsters. Obvious that acceptance of these shoddy containers will put us behind largest eight ball in exhibition history. Communicated opinion to Washington.

Shortly afterward, a large team of U.S. diplomats went to Moscow for a week of negotiations, stayed almost a month, and returned with the good news that the site had been shifted to eight acres in Sokolniki Park, a location both more attractive and more central. Even so, there was the commitment to erect and fill 80,000 square feet of exhibition buildings by summer, and there still were no funds, no budget, no program, and no contract. Amidst this chaos, Nelson devised some guidelines: the Nelson office would design the overall plan, the space allocation and the graphics, would appoint other designers for specific parts of the work, and would specify (but not procure) the items to be shown. Masey suggested that Bucky Fuller, who, in record time, had provided a geodesic dome for the USIA's 1956 exhibition in Kabul, Afghanistan,[10] be asked to join the team. Nelson eagerly agreed and suggested that they also needed Charles Eames.

By the end of November, the budget had been estimated "somewhere between two and a half million and four million dollars" and the possible attendance at "two and a half to three million" Russians, and Nelson flew to Los Angeles to persuade Charles and Ray Eames to take part. There were three days of talk, climaxing in an evening in the Eames house on which all the basic decisions for the fair were made. Present were Nelson, Ray and Charles (the latter occasionally swooping past on a swing hung from the ceiling), the movie director Billy Wilder,[11] and Masey.

It was Nelson, Masey remembers, who first proposed a multi-screen film presentation, with more and larger screens than the Art X experiment for the University of Georgia.[12] "What if we had ten screens?" Nelson asked. The Eameses were the natural choice to undertake such a project. After the Georgia project, they had gone on to develop a number of one-, two-, and three-screen slide shows and a number of films, including the 1955 House—After Five Years of Living, showing their own house and its collection of objects, the delightful 1957 Toccata for Toy Trains, and, most recently and pertinently, a 10-minute animated film, The Information Machine, for IBM's pavilion at the 1958 Brussels World's Fair.

By the end of the evening, Nelson recorded, a basic scheme had emerged:

- A dome (by Bucky Fuller) to be used "as a kind of 'information machine.' No glamor. No things."
- A glass pavilion (by Welton Becket) "as a kind of bazaar stuffed full of things, idea being that consumer products represented one of the areas in which we are most effective, as well as one in which the Russians . . . were most interested."
- "An awareness that 80,000 square feet of exhibition space was not enough to communicate more than a small fraction of what we wanted to say," which suggested the use of films "as a way of compressing into a small volume the tremendous quantity of information we wanted to present."

There would also be supplementary areas for the display of a house, automobiles and farm equipment, and the USIA had already contracted for the reprise of Walt Disney's "Circarama," a wrap-around movie projection about the American scene that had been popular at Brussels. Returning to New York, Nelson consulted with the prefabrication-canny architect Carl Koch, with *Industrial Design* editor Jane Fiske McCullough, and with Peter Harnden, a Paris-based designer of previous USIA exhibitions. He added to the staff a young designer named Philip George, who had worked for Harnden and, before that, for Raymond Loewy. With assistance from the Chicago architect Richard Barringer, the Nelson office devised for the large glass pavilion a "jungle gym" structure, "permitting the building to be filled from floor to ceiling with consumer products."

The plans for the dome were controversial, however. In early December, Nelson recorded Washington's "general alarm at proposal that dome be set up as an 'information machine'" and "fear it would not be sufficiently dramatic":

> Considerably greater alarm and disapproval of the idea of a multiple-screen presentation in the dome as its major exhibit. Considerable pressure to follow conventional exhibition procedures, which would mean glass pavilion would be stuffed with one set of objects, dome equally stuffed with another. Our contention: If acts one and two are identical, people leave the theater. . . .

The crucial meeting occurred in Washington on December 22, 1958. George V. Allen, head of the USIA, was present. Nelson noted:

For the dome two schemes were presented: one a plan based on the use of things mostly of a scientific nature, the other based on the use of multiple screens. The former was presented as badly as we knew how to do it, and this was convincing, but what finally turned the tide was Allen's conviction that the multiple-screen presentation was the one really effective way to establish credibility for a statement that the products on view were widely purchased by the American public. An automobile, for instance, might be looked upon, if the Russians chose to do so, as a prototype made for display purposes. Twenty to thirty shots of the parking lots surrounding factories and shopping centers, traffic congestion in cities, and car movement on express highways could leave no possible doubt in the visitor's mind.

By Christmas Eve 1958, Nelson could write: "From here on there is nothing to do but work. We have January, February, March, and a part of April to put together the most important of all United States exhibitions."

A minor detail of the work shows Nelson's way with words, and with ideas. Don Ervin, then in charge of graphic design for the Nelson office, had been asked to work, in Nelson's absence, on the emblem or logo needed for exhibition literature, correspondence, posters and guides' uniforms. On Nelson's first morning back there was a presentation to the USIA, and Ervin's effort, never before seen by Nelson, was presented. The officials expressed mild approval but asked what the emblem meant. Just as Ervin was about to confess that it was simply an abstract design without specific meaning, Nelson began to explain it: the circular form, he said, represented the world; the blank stripe down its center, the fact that the world was not united; the red half, communism; the blue half, the free world; and the central position of "USA" signified that the United States, by means of this exhibition, was attempting to bring the two factions together. The design was accepted.[13]

Other pieces began to fall into place. Inside the dome, in addition to the Eames film, there would be an IBM computer installation and a suspension system, devised by William Katavolos of the Nelson office, that would enable screens and other objects to be hung from the sides of Fuller's dome. As Aline (Mrs. Eero) Saarinen would explain in the *New York Times,* "by means of this mechanized information center a visitor can get quick answers to literally millions of questions, ranging from the number

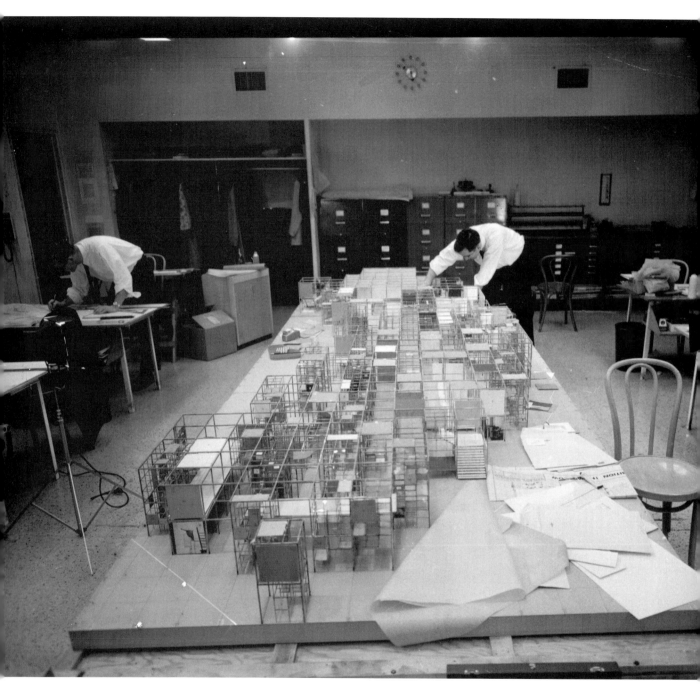

In the Nelson office, work progresses on the model of the "jungle gym" part of the 1959 Moscow exhibition.

of automobile workers belonging to trade unions to the number of students studying Russian in American universities or the number of babies born every minute in the United States."[14]

Outside the two main buildings, there were to be several other elements: an architecture exhibit, to be curated by Peter Blake of the *Forum* and of the architecture firm Blake and Neski; a fashion show, to be curated by Eleanor Lambert and designed (with an accompanying fabrics display) by Tom Lee; a packaging exhibition by the Museum of Modern Art's Associate Curator of Design, Mildred Constantine; and Edward Steichen's touring photographic exhibit "The Family of Man." To shelter these, Nelson proposed what may have been the decade's most ingratiating architectural forms: irregular clusters of translucent fiberglass umbrellas on columns like giant golf tees.[15] While Nelson certainly knew that his old friend Yamasaki was beginning to experiment with umbrella-like forms,[16] the Moscow umbrella clusters have a jaunty personality of their own. The use of plastic not only met the time schedule and demonstrated the virtues of assembling prefabricated parts; it also allowed the structures a rare and exhilarating lightness.

The Nelson office also devised subsidiary canvas-roofed pavilions to cover displays of paperback books and magazines, food stalls, and a working beauty shop. Elmer Bernstein was asked to provide a musical score for the Eameses' film, as he had for their film at Brussels, and Robert Zion of Zion and Breen was given the landscaping commission. There was a model apartment, designed by the Nelson office (with a number of modern features: a combination living-dining room,[17] a pass-through from the kitchen to the dining area, and a children's play area that could be converted into a sleeping area by means of folding partitions), and a model house (for which the Nelson staff chose furnishings and equipment[18]).

As late as May, even with the opening date slightly extended to July 25, Nelson was complaining that "the stakes are high, the budget low, the deadline impossible."[19] Living and working conditions in Moscow were often difficult, although the arrival of a refrigerator with a large ice maker, intended for the model house, facilitated nightly martini mixing. Other pleasures included working lunches taken every day at an elegant turn-of-the-century pavilion on the fairgrounds and, as Jack Masey remembers, invariably consisting of a bowl of caviar, a bowl of tomatoes covered with chopped onion, and a bowl of ice cream. These were at-

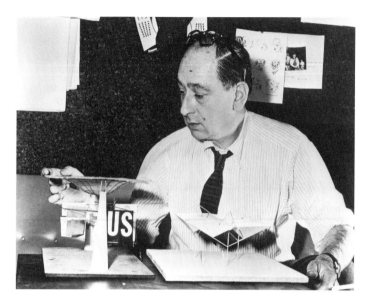

Nelson with early models of the umbrella pavilions.

Fuller and Nelson at the site of the Moscow exhibition.

As the jungle gym is assembled, Nelson finds a moment (and a coconut chair) for writing in his job diary. At left is a tower of Eames's 1955 stacking chairs. The magnesium-frame chair directly in front of Nelson was designed by Jack Heany for Treitel-Gratz and distributed by Herman Miller.

tended always by Nelson, Philip George and Masey, often by Peter Blake, and sometimes by a Foreign Service staff officer named Jacqueline whom Nelson had met in connection with earlier USIA work and who would eventually be his second wife. During one of these three-bowl lunches, Nelson doodled on the back of a plate an amply proportioned nude woman. Found after lunch by a dishwasher and turned in to the Russian authorities, the sketch created a scandal. Not only was it obscene, the authorities declared; it also ridiculed Russian womanhood. (It is possible, however, that the sketch was inspired not by Russian womanhood but by Gaston Lachaise's monumentally robust "Standing Woman," which was to be installed on the grounds of the exhibition and may have already arrived on site.) The Russians protested angrily to the U.S. ambassador, who protested angrily to Chad McClellan, who protested angrily to Nelson: unless the culprit were found and made to apologize, the Russians would cancel the exhibition. Nelson replied coolly that the American designers were all thoroughly professional and that he would not dream of asking them insulting questions. Frustrated, the Russians dropped their threats of cancellation.[20]

There were design problems, too. Particularly difficult was the problem of fitting the product exhibition into the awkward shell designed by the Welton Becket office. Asked pointedly by Nelson why the building was so narrow and long, why it was curved and why its ceilings were so low, the Becket representative replied that aesthetic concerns were the reason. "Your aesthetics department," Nelson said, "must have been out that day."[21]

And there were construction problems as well. Improperly cured concrete earned the dome (which during the planning stage had been called "the bagel") a new name: "the dust bowl." Nelson later recalled "concrete slabs so bad you could have gone through them with a teaspoon" and "walls plastered by women workers who could not possibly have seen a trowel before."[22] Peter Blake remembered that in the final days of preparation "asphalt walks sank into the primeval ooze, lightbulbs exploded, paint peeled, hammers, nails, screwdrivers, saws, pliers and wrenches disappeared as soon as they were uncrated."[23]

But somehow it all got done. According to Blake, Nelson "orchestrated the whole shebang brilliantly and seemingly without effort. His frenetic troubleshooter, the designer Philip George, ran interference for him around the clock, creating an astounding exhibit out of virtually nothing

Lachaise's "Standing Woman" among the Muscovites.

but a sea of mud."[24] The Eameses flew into Moscow the evening before the opening clutching their film, and that night it was projected in the dome for the first time. It worked. Perfectly synchronized on seven 20-by-30-foot screens, 2200 still images, including photographs by Ezra Stoller and Eliot Noyes, were projected in 10 minutes. Beginning with seven early-morning scenes of milk bottle delivery, the show progressed to automobile traffic on cloverleafs, family dinners, and a seven-screen Marilyn Monroe wink (from Billy Wilder's *Some Like It Hot*). A few weeks earlier, stumped for a closing, Ray Eames had asked Nelson how to end the show. "With love," Nelson had said.[25] It ended with a single-screen shot of a bunch of forget-me-nots.

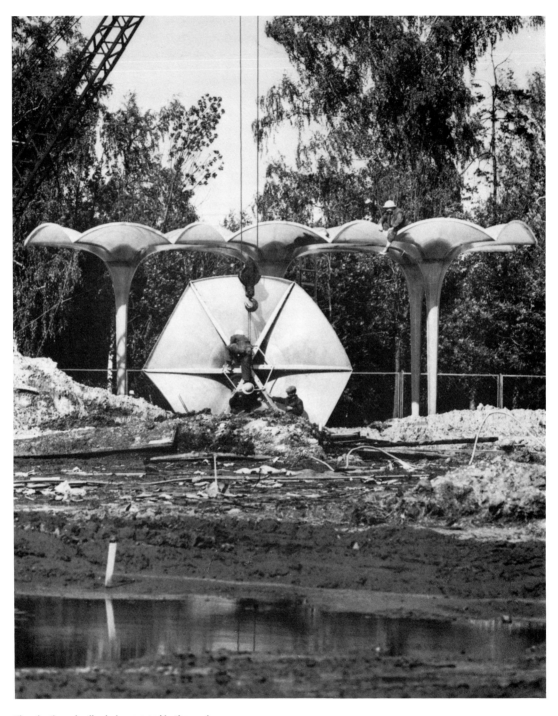

The plastic umbrellas being erected in the mud.

This first major American exhibition ever held in Russia drew 3 million visitors in only 6 weeks (150,000 of them on the last day, after many of them had stayed in line all night for tickets), and was an international sensation. "Primarily," Nelson had said, "we want to make a simple, sincere statement about American life."[26] And they had.

There were a few cavils, naturally. At home, the American electronics industry complained (accurately) that fewer electronics goods were shown than in the Soviets' simultaneous exhibition (a heavy-metal spectacle of weaponry and engineering that had opened in the New York Coliseum three weeks earlier), and the chairman of the board of General Mills complained that Russian officials, fearing disorder, had forbidden the distribution of free cake samples.[27]

More attention was paid to President Eisenhower's disapproval of the hugely popular[28] contemporary art exhibit. Eisenhower was particularly offended by Jack Levine's portrait of an unkempt general, "Welcome Home," which he called "a lampoon." Curator Edith Halpert countered: "Some people think the President's paintings aren't so good either."[29]

And, not surprisingly, the official Russian press seemed less impressed than the Russian visitors, questioning the affordability of the goods and housing shown and imputing a cover-up of American social inequities. Of Fuller's gold-anodized aluminum dome, *Pravda* said: "A beautiful golden half apple. But what about the rotten half the Americans are not showing us?"[30] The dome's technology, however, was impressive enough to soften the heart of Soviet Premier Nikita Khrushchev, who said he "would like to have Mr. J. Buckingham Fuller come to Russia to teach our engineers."[31]

The exhibition ended a long period of almost total cultural estrangement between the United States and the Soviet Union, and ended it with a smile. It also happened to come at a time of American self-doubt (the Russians having launched the first Sputnik in the autumn of 1957) and self-examination. This last was aggravated by a recession year in the midst of general prosperity—the paradigmatic failure of the time being that of the Edsel.[32] The state of the country was given written expression in John Kenneth Galbraith's 1958 best-seller *The Affluent Society* (tentatively titled *Why People Are Poor* by the author),[33] which called attention not only to U.S. affluence but also to coexistent U.S. poverty: there *was* another side to the apple. Although Eisenhower's vice-president, Richard Nixon, who opened the Moscow exhibition, bragged of American consumerism

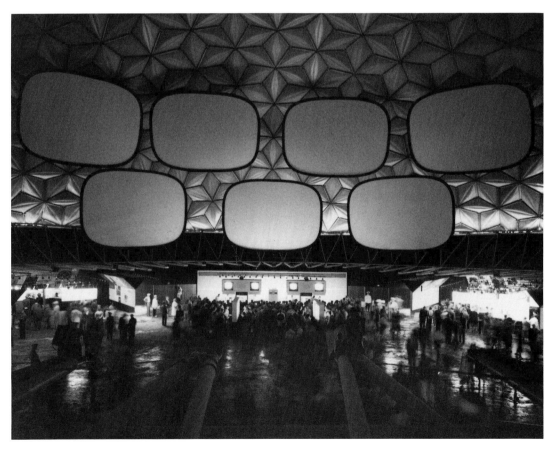

Inside Fuller's dome, the seven screens for the Eameses' film.

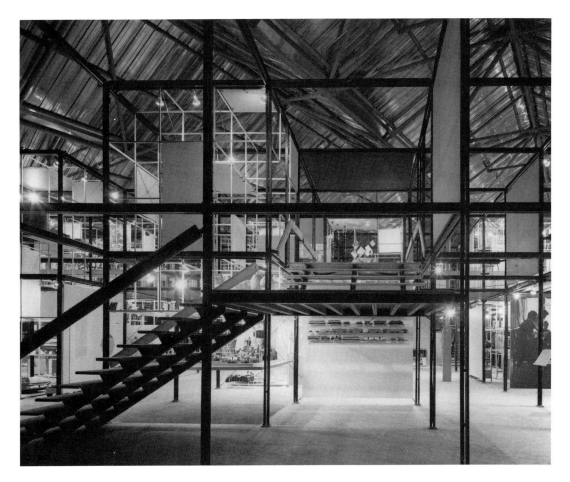

The jungle gym, completed.

(44 million families with 50 million television sets and 56 million cars, approaching, despite the recession, "the ideal of prosperity for all") and staged his ostensibly impromptu "kitchen debate" with Khrushchev there,[34] the tone of the exhibition itself was not Nixonian braggadocio and muscle-flexing but a modest presentation of Americans as fallible humans, not really all that different from Russians. *Industrial Design* termed it "the soft-sell on the cultural exchange,"[35] and Fuller's exuberant dome, the Eameses' seven-screen look at daily life, and Nelson's light and light-hearted plastic pavilions—along with the pointed absence of arms and heavy machinery—must have constituted a near-ideal manifestation of Nelson's humanistic concept. As Nelson had proposed in 1936, the exhibition had shown not the machine but its social implications.

Although the Moscow fair made unprecedented demands on the Nelson staff, the office somehow managed to work simultaneously, for the Museum of Modern Art, on an exhibition called "Design Today in America and Europe," which opened in New Delhi in February 1959 and then traveled in India for two years.[36] The contents of the show were chosen by the museum, but they were housed in Gordon Chadwick's handsome, rather Miesian shell of plywood-panel pavilions around a central courtyard, all—as if in rehearsal for the Moscow main event—within a relatively small geodesic dome.

After the deserved success of the Moscow venture, the Nelson office was much in demand for exhibition design—a field in which the office excelled as a result of its interdisciplinary mix of structure, graphics, circulation, lighting, architectural space, and advertising psychology.

For the 1964–65 New York World's Fair, the Chrysler Corporation commissioned the Nelson office to design its display,[37] meant to compete with General Motors' Futurama (a new version of the original Futurama, designed by Norman Bel Geddes for the New York fair of 1939) and Ford's pavilion (designed by Walt Disney), both of which featured "tunnel of love" rides through highway-intensive visions of the future. Nelson tried a touch of humor, turning auto parts into a surreal six-acre playground.

The architectural historian Vincent Scully, writing in *Life,* found the fair generally disgusting: "I doubt whether any fair was ever so crassly, even brutally conceived as this one."[38] He found little to praise in the very popular IBM building (by Eero Saarinen and Charles Eames), calling it "a huge eagle's egg, heavily laid on a thicket," even though inside the egg Eames had expanded the "information machine" concept into a film

Nelson's conceptual sketch of a giant automobile for the 1963 Chrysler pavilion.

THE 64.ft CHRYSLER '64.!
(in a pit, perhaps, with gangplanks).

—SHAPES OF THE OLD WOMAN WHO LIVED IN A SHOE...

extravaganza (called "Think") shown on 22 screens of different shapes and sizes. Scully found Charles Luckman's U.S. pavilion a "pompous pile of absolutely nothing." He called Philip Johnson's New York State pavilion "almost great." But he was delighted by Nelson's automotive antics:

> The Chrysler exhibit, designed by George Nelson, is the surprise of the Fair. It is pop art at its best, and presents Detroit with welcome wit and irony. There is a "working" engine you can walk into and a demented mock-up of a car of the future you can examine from below—the bucket seats are buckets. There is also a zoo of rickety and noisy animals made out of auto parts, some of them looking absurdly like the Port Authority helicopters clattering about next door.

On the whole, Scully's judgment of the fair was one Nelson must have agreed with:

> [This] Fair is exactly the kind of world we are building all over the U.S. right now. It is a world created by and for the automobile in which everything permanent and solid melts away in favor of fugitive constructions bedizened with flapping pennants, neon signs,

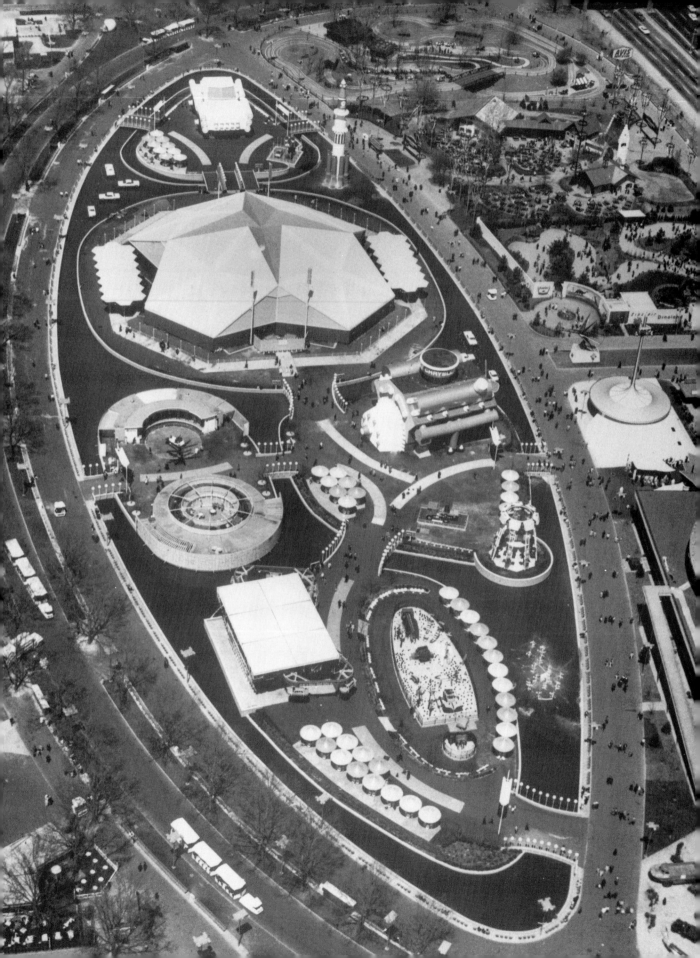

The site of the Chrysler
pavilion— a network of
islands and bridges in an
artificial lake.

and screaming colors—our real-life tunnel of love to catch our at-
tention as we skid and rocket by. The Fair is nothing but the con-
centrated essence of motel, gas station, shopping center, and
suburb. Why go to New York to find it, then, when we have it all
at home?[39]

Throughout the 1960s and the 1970s, exhibition design continued
to be an important part of the work of the Nelson office. In 1967 there
was a return to Moscow's Sokolniki Park with a product exhibition called
"Industrial Design USA," later shown in Leningrad, Kiev, and other Soviet
cities and then in West Berlin. In 1970 there was a show of U.S. research
and development that went to Hungary, Poland, and Rumania as well as
Russia. In 1976 there was a traveling exhibition for the American Revolu-
tion Bicentennial Administration, and a Latin American exhibition for
Miami's Inter-American Cultural and Trade Center.

In the early 1980s, Nelson began a series of discussions about a
design exhibition that would open a new wing of the Jerusalem Museum.
Although this never materialized, Nelson reported that, at a time when
work in his office was diminishing, talking about his "client in Jerusalem"
was good for his ego. He was delighted with his incidental discovery of
pita, "the best sandwich design for at least 3,000 years."[40]

The firm's last major exhibition design opened at the Philadelphia
Museum of Art in the fall of 1983. It housed "Design Since 1945," a selec-
tion of 425 modern objects representing four decades of design. The
choices were made by Kathryn Hiesinger, the museum's curator of Euro-
pean Decorative Arts after 1700.[41] they were limited to products that had
been (or were still) in actual production, and they included four by the
Nelson office: the 1949 ball clock, the 1952 bubble lamp, the 1955
"Florence" line of melamine dinnerware, and the 1964 sling sofa. Thomas
Hine wrote in the *Philadelphia Inquirer:* "It is possible to sit in a George
Nelson sofa, reading, by the light of a George Nelson lamp, a book of
George Nelson essays. And [now it is] possible to see the Nelson sofa and
the Nelson lamp in an exhibition Nelson has designed."[42] Jeffrey Meikle,
reviewing the catalogue in *Design Issues* (fall 1984), found the show "am-
bitious, visually stunning" and "blessed by George Nelson's imaginative,
unobtrusive installation."

A walk through "Design Since 1945" began with a crescent of
lamps, only some of them lit, seen against purple walls. As the observer

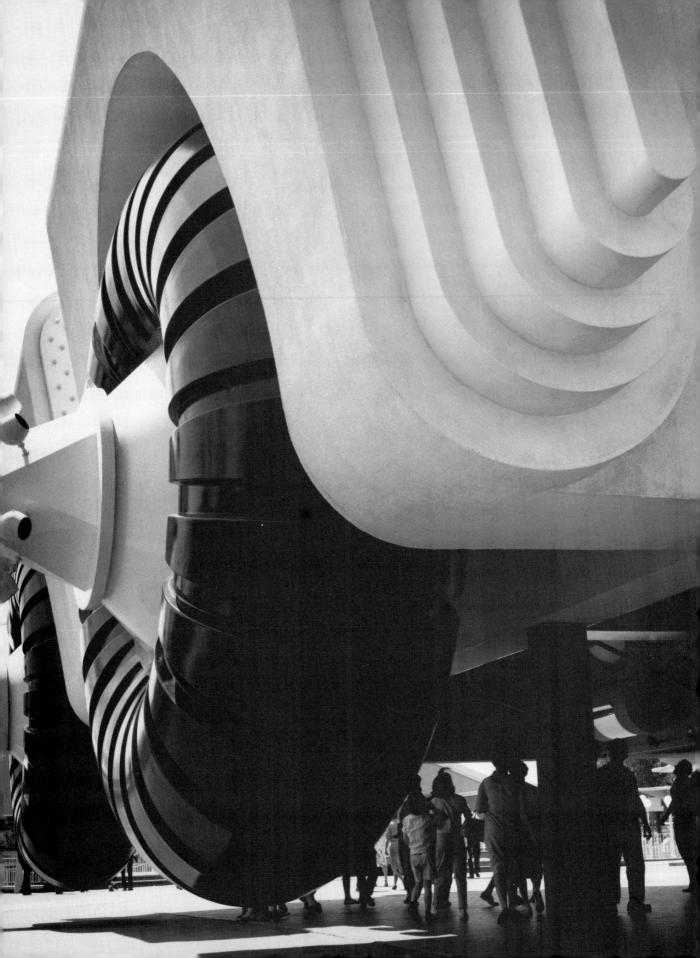

A drawing by the author based on Nelson's 1980 plans for a motorized exhibition for Herman Miller. Looped messages were to be reeled between rotating wheels.

The wheel of a giant car.

moved through the gallery, some lamps would switch off; others would switch on; still others would blink intermittently. Two other major features were a hundred-foot-long undulating red "snake" holding household objects and a cluster of tall black pylons with yellow niches holding advanced electronics and appliances.[43] Overhead floated larger products—the white fiberglass body of a new Corvette, a model of a communications satellite, a hang glider. Occasional alcoves highlighted the work of seven design heroes selected by Hiesinger: Nelson, Ettore Sottsass, Jr., Charles Eames, Dieter Rams, Tapio Wirkkala, Marco Zanuso, and Arne Jacobsen. It was an exhibition that attempted much and achieved much. Even so, Nelson had ideas for which no space could be found: "Beside the best-designed, prizewinning chair of 1948, I would have liked to see a photograph of the chair that sold the most in that year, but I guess that wouldn't really fit the museum's purpose, would it? Oh, well, maybe next time."[44]

　　　"Design Since 1945" was graced by an opening symposium featuring designers Ettore Sottsass, Jr., Dieter Rams, and Victor Papanek. It was graced as well with an unusually large and serious catalogue,[45] which Suzanne Slesin of the *New York Times* predicted would be "the design reference handbook of the decade."[43] The catalogue contained examinations of the nature of product design by the sociologist Herbert Gans and the designers Niels Diffrient, Olivier Morgue, and Marco Zanuso, among others.

Two views of "Design Since 1945" (Philadelphia Museum of Art, 1983)—the Nelson firm's final exhibition design. (photos: Will Brown)

There was also a spirited double interview, "Design and Theory," in which the designers Ettore Sottsass and Max Bill met, predictably, head on. Asked how the qualities of good design could endure in the face of changes in technology, Bill answered: "Technological change should help to make the object better and more harmonious in form and function, as well as cheaper." Sottsass answered: "They don't endure at all. . . . In design what endures is man's curiosity toward existence and the drive to give a metaphoric image to it."[47] One imagines that Nelson's own opinion would have been closer to Sottsass's idea of change than to Bill's idea of perfectibility.

Best of all, there was an essay by Nelson in which his lifetime of thinking about design was distilled to a few simple, crystalline statements:

. . . the steady movement [throughout the design process] is in the direction of a solution that is ultimately seen, not as beautiful, but as *appropriate.* The creation of beauty cannot be an aim; beauty is one of the aspects of appropriateness, and it still lies pretty much in the eye of the beholder, which makes it a by-product rather than a goal.

The aim of the design process is always to produce an object that *does something.* . . .

The one absolutely irrefutable thing that can be said about design is that it *evolves.*[48]

8 The City

George Nelson to Ivan Chermayeff, viewing the excavation for a building in New York: "Ivan, did you ever see a new building that looked as good as a hole in the ground?"[1]

Nelson's interest in cities and his dislike of what large buildings did to them date from early in his career. Upon his winning the Rome Prize in 1932, a New York newspaper reported: "When Mr. Nelson goes to Rome he will devote himself to the subject of town planning, both from classical and contemporary European life. He is interested particularly in town planning and does not expect to enter into competition with architects designing skyscrapers. 'The skyscraper is fine to look at,' he said yesterday, 'but it demands too high a price in congestion.'"[2]

Nelson's view was certainly at odds with the damn-the-consequences modernism of Le Corbusier, who in 1937 declared "The Skyscrapers of New York Are Too Small!"[3] But a well-read young man in the 1930s would have found a great deal of supportive precedent for a mistrust of the skyscraper city and a romantic attachment to the countryside—Ruskin, for example, and all his followers, including the garden-city pioneer Ebenezer Howard, the planner Patrick Geddes, the urban historian Lewis Mumford, and, of course, Frank Lloyd Wright.

Wright's sprawling, low-density Broadacre City scheme had first been proposed in 1930, his 1932 book *The Disappearing City* had supported the scheme's premise with passionate rhetoric (". . . to look at the plan of any great city is to look at the cross section of some fibrous tumor. . . . A parasite of the spirit is here. . . ."), and a dramatic 12-foot-square model of the scheme, built by Taliesin apprentices and paid for by Edgar Kaufmann, Sr., had been displayed in 1935 in New York.[4] (It was shown, ironically, in Rockefeller Center, the epitome of the large-scale urbanism it was meant to combat.)

Nelson must also have been exposed to the ideas of planner Henry Wright (1878–1936), no relation to Frank Lloyd but the father of Nelson's *Forum* colleague and co-author Henry. The elder Henry Wright, as a partner of the like-minded Clarence Stein, had participated in a number of exemplary new town designs—Radburn, New Jersey; Sunnyside

Gardens, Queens; and Pittsburgh's Chatham Village—with integral garden areas and segregated traffic patterns.[5] His 1935 book *Re-Housing Urban America*[6] was influential, and Lewis Mumford called his site plan for Chatham Village "one of the timeless masterpieces of contemporary urban design."[7]

Nelson's response to such pedestrian-centered and anti-urban attitudes took the form of a prophetic proposal, titled "Grass on Main Street," that was published in 1943 as a two-page advertisement sponsored by Revere Copper and Brass in the *Saturday Evening Post* and, in greater detail, in a 12-page booklet distributed by Revere and a 20-page one issued by *Architectural Forum*.[8] The proposal was based on Nelson's perception of the general pattern of urban decay. He later recalled:

> One of the projects I was handed as a beginner at *Forum* was to look at a pile of airviews of cities with about 150,000 to 200,000 people. They all showed the city center—the business district—and what was called in those days "the ring of blight." This was made up of the houses of well-to-do people, abandoned by their owners as business pushed out, now rooming houses, Chinese laundries, marginal business places.
>
> I don't remember what the assignment was, but as I looked at one city after another, I got curious; the blight was always in the same place. The city center was always roughly the same size. And it was the first time that I got a dim perception of the city, not as a product but as an organism. In nature, when an organism dies or decays, it marks the beginning of a new cycle of growth. What about this ring of blight? What is it going to become? It has to grow into something else. And for no reason I could understand, I started measuring downtown areas. What I discovered was that the whole area was walkable. . . .[9]

He then visualized a transformation of the decayed inner city. The "ring of blight" turned into "a ring road and parking, with a pedestrian precinct on the inside. Suddenly the old downtown began to look humane and interesting and lively."[10]

More specifically, Nelson's proposal was to close the heart of the city to vehicular traffic and to create a "park-like promenade for shoppers." Automobiles and pedestrians would be separated, and parking would be provided close to the shops. The most remarkable feature of this

precinct, however, was to be Main Street: "Instead of honking cars and clanking trolleys there are now lawns, fountains, trees, benches, and playgrounds for children." As for the commercial structures served by this amenity, "a number of the old buildings were left, others were remodeled, some are new."[11] For the new buildings, Nelson had a complementary vision, this one called the "Store Block" and developed with New York architect Morris Ketchum for *Architectural Forum*'s "Design Decade" issue of October 1940. Rather than being divided conventionally into deep, narrow commercial spaces, "rather like bowling alleys,"[12] each space having its own window on the street, the block was conceived as a solid penetrated by a wandering internal pedestrian path around which shops of various sizes and shapes could be freely disposed.

Together, "Grass on Main Street" and the "Store Block" constitute a precise anticipation of the postwar regional shopping center. At the time, however, little attention was paid. "Out of seven million readers," Nelson reported in 1980, "I think I received one letter expressing interest: timing has a lot to do with the way things happen."[13]

But although there were few responses in the mail, there were soon to be built examples all over the country. The first of these large enough to serve an entire region[14] was John Graham's 50-store Northgate development in the north end of Seattle, built in 1950. Another early one was Victor Gruen's 1954 Northland Center, outside Detroit (which would be shown by Peter Blake in his section of the 1959 Moscow exhibition); it was followed two years later by Gruen's Southdale Shopping Center in Minneapolis. A more complete realization of Nelson's vision, however, was Gruen's highly publicized 1955 scheme for a traffic-free 270-acre multi-use center for Fort Worth. As Texans of the mid 1950s were unwilling to get out of their cars more than a few feet away from their shops and offices, the scheme was not, in the end, built in Fort Worth. Just everywhere else.[15]

Nelson's idea, it is important to note, was intended for downtown, not for the suburbs, and directly supported the notion of transforming streets into pedestrian malls. The first U.S. proposal for such a mall seems to be one put forth in 1946 by Morris Ketchum's firm for Main Street in Rye, New York.[16] The citizens of Rye voted against it, but the idea was later employed with great success in other American cities (most notably in Minneapolis) and with dismal failure in others. Today it is being tested widely in the centers of European cities, including Prague, Cologne, Strasbourg, Turin, and Amsterdam.[17] However, most of the offspring of

"Grass on Main Street" were located not on Main Street but in the suburbs, where they brought more urban problems than solutions. "Suburbs exist," Nelson wrote, "because we let our center cities decay, and the center cities have decayed because people who could pay taxes left them for the suburbs."[18]

Nelson later found another ally in his views of the city in the Berlin-born architect and urban historian E. A. Gutkind, two of whose books (*The Expanding Environment* and *Community and Environment*, both published in 1953), extensively underlined, were in his library. Nelson admired Gutkind's arguments for decentralization, found him "irascible and prophetic," and, re-reading the books almost 20 years later, still found his views "fresher than springtime."[19]

Nelson went public with his disapproval of the American city in a 1961 presentation at the Museum of Modern Art.[20] Called "U.S.—Us," it began with hundreds of unflattering slides of American towns and cities, shown on three screens and accompanied by patriotic songs and radio commercials. Then Nelson appeared, denouncing the quality of the goods in which the country seemed to be drowning: "The product is our great achievement, the crowning glory of our civilization. The product is with us everywhere—at home, on the road, in outer space, on the beach—weak in design, imitative, derivative, highly styled but rarely well designed, lacking in integrity."[21] Today's product designers, he continued, have fouled our habitat and failed our expectations because they have eliminated people; whereupon, in an impressive *coup de théâtre,* he disappeared and was replaced onstage by a bright green robot which continued the lecture in a mechanical voice, declaring that the American society had a symbol as clear as the pyramids, the Parthenon, and the medieval cathedrals. "Our symbol," the robot said, "is junk." Next came a film (which the *New York Tribune* found "breathtaking . . . impressive and spellbinding") called "Elegy in a Junk Yard" and showing the potential beauty in details of rusting automobiles, scrap heaps, and other urban detritus. "No robot," the *Tribune* concluded, "can replace designer Nelson."[22]

The problems of urban life were particularly severe, Nelson thought, in New York, where they were not mitigated by the occasional triumphs of modern architecture:

> Working in New York, I am constantly exposed to the suspicion
> that many of the most handsome new buildings are distinctly
> anti-social in their effects on the streets and the transportation

system. Is it possible for a building to be accepted as a good design if it has such an effect? I am inclined to doubt it, for I am coming to believe that meaning, for contemporary man, resides less in the esthetic qualities of individual structures than in the tensions set up by their various relationships.[23]

He found some other cities equally troubled, though. In 1966 he wrote an article for *Holiday* praising the urban renewal plans of Richard Lee, the mayor of New Haven, and he introduced it with an explanation of why New Haven *needed* to be renewed:

> I entered [the city] on Whalley Avenue behind a bread truck stuffed with loaves of "batter-whipped" bread. It carried a second sign: "Don't litter Connecticut. It's a beautiful state."
>
> The section of beautiful Connecticut through which we were moving at that moment contained a batter-whipped assortment of motels, second-hand-car lots, overburdened telephone poles, and block after block of two-family houses bulging with shingled cupolas, bay windows, and sagging porches. Into many of these, glassy stores and automobile showrooms had been forcibly inserted, rather like the clocks an earlier generation installed in the bellies of naked bronze ladies. On both sides of the street it was open war waged by batallions of shop fronts and illuminated signs, all executed with a polychrome violence. Delicatessens charged supermarkets; drugstores strafed gas stations; instant dry cleaners dropped neon bombs on bar-grilles, candy stores and housewares establishments. . . . Clogged traffic honked indignantly and uselessly, like elephants caught in a sudden explosion of tribal feuds.
>
> Whalley Avenue was not precisely the place a chamber of commerce would recommend for the start of a tour of the "new" New Haven, but there is nothing unusual about it. The same is to be seen in thousands of streets across the nation. "God's Own Junkyard," an observer [Peter Blake] recently named it, living testimony to modern man's ability to put up with practically anything.[24]

Nelson himself was one of those able "to put up with practically anything." Acutely as he saw the visual and functional chaos of the city,

he was nevertheless, all his life, a city dweller, even though there were sporadic attempts to escape. One of these attempts was a short-lived scheme for moving his office to a remote site in the Rockies. where it would be convenient to Aspen. The exact location was to be determined by Bucky Fuller's complex calculations of the continental areas most likely to survive a nuclear war.[25] Later, there was an attempt to remodel a chalet in Switzerland into a latter-day Bauhaus that Nelson would direct, but neither of these schemes proved practicable.

Around 1940 Nelson began two decades of weekend escapes from Manhattan by buying a "cumbersome old Victorian firetrap"[26] in Quogue, on the south fork of Long Island. Formerly the annex of a nearby inn, it came still furnished with dozens of sturdy maple bedsteads—a handy source of hardwood. Some of the furniture pieces Nelson built for the house served as prototypes for designs later manufactured (the 1950 Herman Miller daybed, for example). For a bit of extra income, Nelson practiced his photography skills on some of the local children and tried his hand, with less success, at writing whodunits.[27]

In 1947 Nelson fixed up the house so it could be lived in through the winter and tried spending more time there. He had once written about Frank Lloyd Wright's "acting on his conviction that living in cities was a contradiction in terms, [and moving] out to southern Wisconsin [to build] the house he named Taliesin."[28] Now he wrote to Wright:

> Since I can see traces of your fine Wisconsin hand all through this new pattern we are trying to create, the least I can do—or so it seems to me—is to tell you about it.
>
> The first move was to get my family[29] out of New York. . . . Because I shall have to depend on New York for a few more years, I've worked out a schedule of three days in town and two out here.
>
> The results have been wonderful. I should have known this, just from the visits to both Taliesins, but a dozen years under the benevolent dictatorship of Time, Inc. do not make one particularly courageous. Now that we have taken our first step towards a life that is for us, I wonder why I was so scared for so long. . . .
>
> I doubt if I would have come this far had it not been for *Forum* and the assignments involving the visits to you. The trips out taught me so much—not in the sense that the wonderful and monumental pattern you have created is for me or anyone else,

but that a full and creative existence for oneself inevitably creates its own appropriate shape. . . .

Because you taught me this, and because you did it by example and not precept, I have come to feel that you have been the only real teacher I ever had. I like having come to feel this way.[30]

Nelson's suburban sojourn would not last long, however, and he came to consider the obvious problems of the city preferable to suburban complacency:

It takes more than . . . immaculate dormitories to foster the conditions which produced the poems of Villon or the comedies of Aristophanes. The city is a big pot, and it does not come to a boil unless people are able to light a fire under it. Suburbia—the dormitory community—is not a stove but a refrigerator. Refrigerators have desirable uses, but to cook a great meal other equipment is needed.[31]

From the 1950s on, Nelson traveled more and more. He toured the major cities of West Germany in the company of Charles Eames, the sculptor Richard Lippold, the painter Robert Motherwell, and the architect Richard Neutra—all guests of the German cultural exchange program. (*Interiors* published some of Nelson's "souvenirs of travel in Germany, Ireland, Georgia, and Massachusetts," mostly photographs of street signs.)[32] He went to Mexico to visit Erich Fromm. He evaluated new architecture in Switzerland for the *Forum*.[33] He went frequently to Paris, where from 1968 on he was the sole American on France's newly-formed industrial design board, the Conseil Superieur de la Création Esthétique Industrielle. He photographed Venice—repeatedly.[34] He went to Tbilisi with Edgar Kaufmann, jr., Mildred Constantine, and Henry Dreyfuss for a UNESCO design conference,[35] sleeping on beds he thought to be "originally billiard tables" but admiring the "spanking new subway."[36] He went to London, where he was named a Benjamin Franklin Fellow of the Royal Society of Arts. He visited Port of Spain to advise on the future of Trinidad crafts, liking the costumes of Carnival and some trays and bowls made from exotic local woods, but not a great deal more.

Japan was another matter, Tokyo in particular; he loved it. He was there in 1951, with war recovery efforts underway, and was back

Music lessons from the Japanese.

again in 1957 as part of a two-month Japanese tour planned for him by Japan's Ministry of International Trade and Industry. One result of this last trip was an article in *Print* showing examples of Japanese packaging that Nelson had brought back; another was an illustrated article, syndicated in at least a dozen U.S. newspapers, called "What I See in Japan" (including the hibachi, the shoji screen, traditional tools, and toys) and introduced by a statement that Nelson was "adapting many Japanese designs for living to American life." In 1959 his collection of Japanese advertisements, calendars and posters was shown by the American Institute of Graphic Arts, and his "Impressions of Japan," illustrated with his own photographs, was published in *Holiday* the following year.[37] A further appreciation of things Japanese came in Nelson's introduction to a book titled *How to Wrap Five Eggs:*

We have come a long, long way from the kind of thing . . . presented in this book. To suit the needs of super mass production, the traditional natural materials are too obstreperous—too uneven, too resistant to automation—and one by one we have replaced them with the docile, predictable synthetics, and these are now, for better or worse, the larger part of our environment.

What we have gained from these excellent materials and wonderfully complicated processes to make up for the general pollution, rush, crowding, noise, sickness and slickness is a subject for other forums. But what we have lost for sure is what this book is all about: a once-common sense of fitness in the relationships between hand, material, use and shape, and above all, a sense of delight in the look and feel of very ordinary, humble things.[38]

In 1960 Nelson reported on Brazil's new capital city, Brasilia, for *Saturday Review,* finding "the breathtaking sweep of [Brazilian President] Kubitschek's vision . . . matched by the architects."[39] Some of the current criticism of the city he found justified: "In one sense the town is all exterior, from the viewpoint of interest. . . . Many of the most important buildings, inside, look as if nobody quite knew what to do with what the architect left behind him." But he found, to an unprecedented degree, a built example of the separation of vehicles and pedestrians, which had long been one of his concerns:

I could imagine someone finding Brasilia's architecture far from beautiful, and still sensing the excitement it generates. My best guess is that the impact lies in the force with which an image of modern life has been presented. . . . For example, a town designed to let motor vehicles move around cannot have close-packed buildings on narrow streets: the workable answer puts high buildings in parks, leaving plenty of room for cars. In this sense, Brasilia naturally looks "modern" because it is. . . .

It is hard to believe that anyone could visit it and come away without some modifications of attitude, whether with respect to modern architecture, to city planning, or to the emerging shapes of contemporary life. If I were a tourist and had my choice of visiting Brasilia or, say, the Taj Mahal, I would pick the former. At this point . . . it has much more to say, and it says it with great power and beauty.[40]

Nelson on a return visit to Brazil in 1980.

In the mid 1960s it seemed that Nelson might be able to put his urban design ideas into practice. Although his plans for a large resort development in Portugal were not carried out, they promised an unusually civilized environment, an idealistic response to an ideal site, and it is interesting to imagine what the resort might have been like: a group of new Main Streets built with their grass already in place.

Troia, the site, was then a wild peninsula between the Atlantic and the Sado estuary, only 25 air miles south of Lisbon and across the river from the town of Setubal. Edged by 20 miles of sand beaches, Troia had been virtually uninhabited for centuries, visited only by tuna fishermen and weekend bathers. Now, having been purchased by a Brazilian banking group,[41] it was to be transformed into a profitable resort community. As Nelson described it in a memo, "Our job is to transform this seaside wilderness into a place for about 80,000 people without destroying those natural advantages which caused people to select it for development. The problem, in effect, is that of planning and designing a new little world."[42]

Nelson was approached about the project in early 1964. in April he wrote: "I have been asked to give thought to my own role. Its most important aspect, in my opinion, is one of helping to establish the concept and the general program."[43] He was not formally retained until September,[44] with the title of Consulting Director of Design, but he was enthusiastically at work long before.

In a meeting during the summer of 1964 at "Lisbon's frigidly lavish Ritz,"[45] Nelson was shown initial plans prepared by a Lisbon architect. With characteristic candor, he told the development team's chief partner that "the Lisbon plan lacks ideas, and what is presented is essentially a petit bourgeois suburb."[46] To Henrique Mindlin, the Rio architect who was directly in charge of planning, he was more specific:

> One note on the sketch plans alarmed me greatly. This was the suggestion that the open spaces might gradually become sprinkled with villas on small lots and other facilities. I feel as strongly as I can possibly tell you that unless the clusters have tightly defined limits, which are permanently respected, the scheme will be disjointed. . . . I have been studying cluster design and everything I can find in the way of plans and air views of old towns and villages. The one constant distinction between these old and completely successful urban designs and the new city, characterized by formless sprawl, has to do with the treatment of the edges. The minute you permit them to be blurred in any way, whatever virtue there is in the village scheme is gone, and you simply get a repeat of the disasters occurring everywhere.[47]

Nelson was able to effect a change of plans, apparently, for the prospectus later written and designed by his office (with a jolly cover of dolphins at play) offers this description:

> A conventional approach to the planning of Troia would probably envisage seaside villas, each on its half acre of ground, scattered through the entire length of the peninsula. It would include some urban clusters as well, primarily for hotels, apartments and shopping centers. Had this easy, familiar approach been adopted, those things which now make Troia so attractive in its wild state would have been completely lost. . . .

The scheme adopted for Troia was to eliminate, in large part, the freestanding houses, and to return to the ancient pattern of the Mediterranean village, where houses share common walls, with each enjoying the privacy of its own walled garden or patio.

This more compact housing model would then allow the builders "to leave great areas of the peninsula untouched." This would be a step toward the creation of settlement patterns appropriate to Portugal, "essentially a country of villages." But it would be only one step:

> A modern village, to be sure, must differ in many significant ways from the old ones; and the greatest single difference has been created by the automobile. Thus the problem of the automobile was confronted as a major factor in the planning process. The automobile, as we have all learned, is a mixed blessing, and the objective in Troia has been to eliminate those aspects of a motorized existence [that] wreck cities, pollute the air, and destroy the tranquility of their inhabitants.

The cover of the 1964 Troia prospectus.

One way to eliminate these negative aspects, according to the prospectus, might be "the amusing contradiction of a village with much of the quiet charm of ancient Mediterranean communities—and a modern garage hidden under the main square." Cars, Nelson had come to think, should be seen only when moving, and, even then, seen as little as possible.

Another way might be the use of a monorail system, such as the one that had recently been developed for Lausanne. Or horse-drawn carriages might be employed. High-speed traffic between villages would, of course, be separated from slower local traffic. Another possibility considered was banning conventional automobiles and renting small electric cars to residents and visitors.[48]

New technology was to have served Troia in other ways as well, perhaps in the form of prefabricated kitchen and bathroom units designed by the Nelson office, perhaps in the form of complete prefabricated houses. Investigation into this last possibility, a recurrent interest of Nelson's, happened to be underway in the form of a study labeled Project Athena and conducted jointly by the Nelson office and the Chicago industrial design firm Latham-Tyler-Jensen, headed by Nelson's friend Richard Latham. The project's aim was the production of "a kind of Volkswagen for the housing field," a product that might "be a little funny to look at, at the outset, but so overwhelmingly competitive that it establishes a foothold everywhere."[49]

Troia was not envisioned as a technological fairground, however. Nelson insisted that the traditional crafts of Portugal play an important part in establishing the resort's character. At his urging, Soltroia hired Mildred Constantine to travel through Portugal surveying crafts production and possible applications for rugs, wall hangings, furniture and other products.[50] Her report, dated January 7, 1965, also considered the development of arts and crafts centers in Troia itself and the creation of a Cultural Committee to advise on Troia's development.

In early 1965 Nelson complained that his Lisbon colleagues had "established a record as the world's most dilatory correspondents."[51] Although in March a crucial approval of the project came from the Portuguese government,[52] the following months brought little news. By October, Nelson was pleading for drawings and information that could be given to inquisitive editors at *Interiors* and *Fortune*,[53] and by March 1966 he was asking if construction were going ahead on guest quarters.[54] On April 15 Nelson received a telegram advising "paciencia,"[55] and an accom-

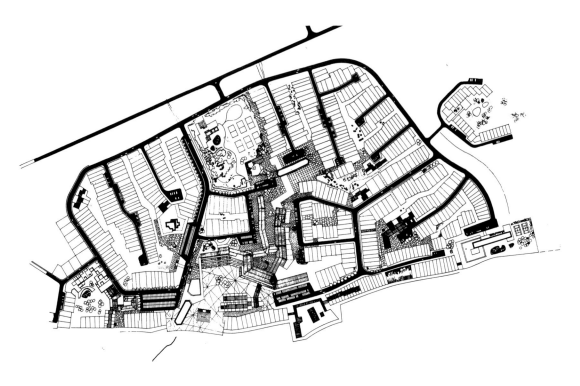

A site plan for one of the village clusters in the Troia development. Vehicular traffic was to be limited to the roads shown in black, with major open spaces reserved for pedestrians.

panying letter was almost as vague, referring to a "new financial structure now being outlined" and saying that discussions "concerning the investment picture . . . require us . . . to go through a period of waiting."[56]

The project was virtually over, although as late as July of 1968 Nelson was asked for his opinion of a design for a water-storage structure and restaurant for the peninsula. He found the design pretentious.

The Troia experience must have reinforced Nelson's frustration with the possibilities of effecting intelligent urban design. In his 1974 article "The Hidden City" he wrote the following:

> One of the real difficulties in dealing with urban problems is that they have a very low social priority, which in turn means that the money they need is spent elsewhere. As a broad generalization, one can say that any problem intimately related to people gets a relatively low priority in any of the advanced industrial societies,

which are much better at dealing with physical things than with living organisms. One result of all this is that we tend to see city problems as operational rather than human, and yet any city, whatever its physical plant, consists essentially of living, interacting organisms. The central cities all over the country are dying, not because the power has been shut off or the buildings are falling apart, but because those people who can afford to do so are running away from them.

Paris, in the time of François Villon, was a stinking medieval pesthole, crawling with pimps, whores, thieves, con men and murderers. And yet this drunken rascal produced some unforgettable poems about the city he loved, and especially about the women of the city. Have you read any poems lately about the women of Chicago?[57]

Nelson also saw clearly that whatever *was* accomplished in the field of urban design was often the work of the unqualified: "Urban design is not unlike baseball, in that anyone in the bleachers is convinced he could do it better. Obviously this could not be the case with pro baseball, but I am no longer so sure about urban design."[58] But he persisted in seeing the condition of the city as central to the struggle for a humane existence:

> . . . life is the only anti-entropic force in the universe, which means that it is the only known antidote to death, that the essence of civic life is people in numbers, around the clock, that people like city living when it is livable, that cities have reasons for existence apart from maintaining employment in Detroit, that the reason for urban sprawl is that nature abhors a vacuum. While there are many reasons for the flight to the suburbs, the central cause is that the ordinary values of ordinary families could no longer be satisfied within the central city. The whole thing can be turned around. It has to be turned around. The alternative is an entire nation as one vast, dirty backyard littered with dead cats and dead cars.[59]

More thoughts on cities were expressed in 1976 when Nelson helped with opening celebration plans for the Cooper-Hewitt Museum,

which had moved to a new location and had recently been designated the Smithsonian Institution's National Museum of Design. His official duties were to design the catalogue and to write its introduction and an essay, but he also influenced the opening exhibition (called MAN transFORMS), designed by Hans Hollein and containing sections by Ettore Sottsass, Jr., Arata Isozaki, Richard Meier, Bucky Fuller, and others. Nelson's essay, "The City as Mirror and Mask," extended some of the thoughts he had presented in "Grass on Main Street" 33 years earlier. More than ever, it was clear to him that movement was the key to the city's problems and its future:

> A city is the most complex artifact produced by mankind, no longer "architecture" but an organism that lives, breathes and dies. If more and more cities have bad breath these days, this is merely another example of getting what we pay for. What we want is unlimited private mobility: the price is congestion and pollution. . . .
>
> A striking difference between U.S. cities and those in Europe is the appearance of our central areas, best observed from the top of the local highrise tower. Spreading out from the base on all sides is a vast checkerboard made up of parking lots and beat-up old buildings, usually one or two stories, their sides covered with billboards.
>
> Beyond the center lies a mixed area of light industry, warehouses, and old residential neighborhoods, many of them already at the slum stage. This scene, duplicated with variations in one city after another, makes it clear that wherever the affluent citizens may live, it is not in the center. There is also fresh evidence, visible from the towers, that the tendency to run away from the city core is beginning to reverse itself. Slowly. . . .
>
> The new buildings in the city cores, stuffed with mechanical and electronic equipment, are much more expensive than their ornate but essentially modest predecessors, and this brings other levels of meaning into view. These sealed cages become a terminal statement about the dead end which now punctuates our long struggle to dominate Nature, for they can keep their occupants alive only by the consumption of very large quantities of energy. . . .

Meeting in Paris, 1977: Lisa Taylor (director of the Cooper-Hewitt Museum), Gilles De Bure (a curator at Centre Pompidou), Ettore Sottsass, Jr., and George Nelson.

Mobility is a dominant theme in the view of downtown. Here again, as in the design of the old and new skylines, we see the parking lots as the first phase, with expressways, interchanges and parking ramps as the second. These are perhaps the most dramatic examples of the violent metamorphosis going on in the cities, for in one aerial view we can see the old city, with its pedestrian scale of blocks, ripped from throat to pelvis, so to speak, by the great concrete ribbons slashed through the old fabric, separating one neighborhood from another as effectively as a Chinese wall. . . .

There is no question here of good or bad, but rather the observation of a transformation unprecedented in its scope and violence. The image presented by this aspect of the city is that of a society completely materialistic in its values, fundamentally uninterested in planning, wasteful in its handling of resources (the city is a vital resource), and oblivious of such concerns as quality of life.

There is a difference between this kind of observation and taking a Cassandra-like view of what is going on. Transformations go on all the time in the natural world, and change does not always carry with it the idea of something bad. . . .

It cannot be disputed that the city is transforming itself into something new and not yet identifiable. And there is no indication yet that this acclerated evolution has removed the possibility of humane urban environments.[60]

In 1977, *How to See* was published.[61] Ostensibly Nelson's call for greater attention to the visual aspects of the whole man-made world, it dealt primarily with visual aspects of the urban experience and with his own methods of turning them—by means of comparisons, shifts of focus, and attention to often-neglected details—into instructive games, some of which had been played in the Art X classroom experiment a quarter century before. The book might have been titled *How to See the City* or even *How I See the City.* (For all the visual treasures among its illustrations, this was, ironically, the one book of Nelson's that suffered from a book design beyond his control; its own appearance was a severe disappointment.)

Earlier, Nelson had outlined the opinion that had led to the writing of *How to See:*

> We are all taught to read and write and add and subtract, but we are not taught to see except in the sense that a seeing-eye dog sees. You can see a curb so you don't fall and trip in the path of traffic; you can see the difference between a red light and a green light; and you can see a Shell or Esso sign as you're driving along the highway. I would suspect this is about the limit of most people's seeing as a result of [our] curiously crippled educational process.[62]

One wonders if Nelson today might see hope for greater visual acuity (even if without greater mental agility) among the generation that has grown up with the multiple images of television as its primary information source, and if, indeed, he might agree with Moholy-Nagy's 1937 prediction that "the illiterate of the future would not only be the man ignorant of holding a camera, it also would be the man without a color and space concept."[63] Nelson might also detect an increasingly brief attention span for the printed word, of course, something he would abhor.)

More furniture for Herman Miller: the Marshmallow sofa (1956), the Swaged-Leg Group (1954), and the Pretzel chair (1950).

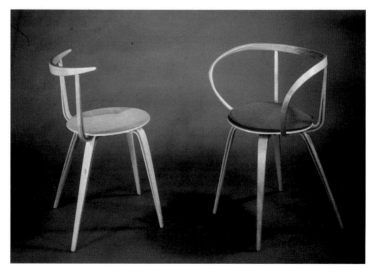

**The 1959 American National Exhibition in Moscow: the translucent umbrella pavilions in place,
and a general view of the exhibition grounds, with Bucky Fuller's dome in the center.**

A "zoo" of creatures built from auto parts for the Chrysler exhibition at the 1964 New York World's Fair.

Nelson's "Junkyard" observations, shown at the Museum of Modern Art in 1962.

Some of Nelson's photographs of Venice, a favorite subject.

From the "Countdown" series: discovering a hundred numerals in the urban fabric.

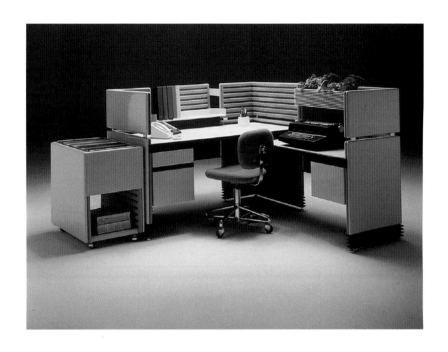

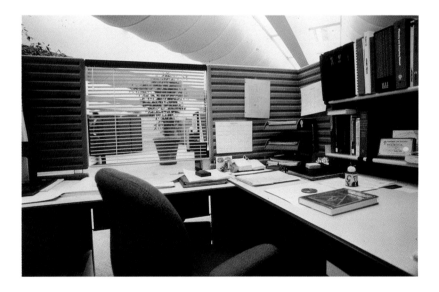

A prototype of Nelson Workspaces, and an actual installation at the office of the Aid Association for Lutherans (1976).

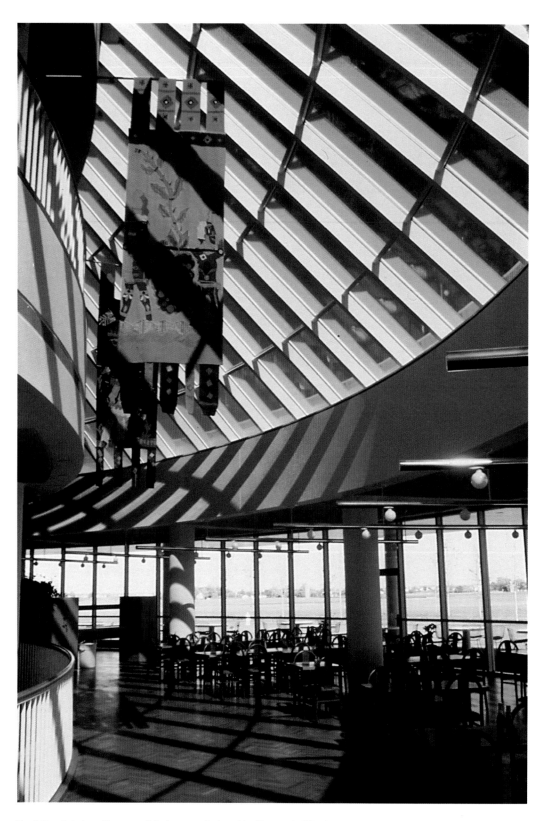

The AAL cafeteria, with some of the banners designed by Norman La Liberte.

Nelson and his good friend Rolf Fehlbaum in France, 1983.

Also indicative of the attitude that compelled Nelson to write *How to See* is this passage copied into one of his notebooks.

José Ortega y Gasset, *The Revolt of the Masses:*
To be surprised, to wonder, is to begin to understand. This is the sport, the luxury, special to the intellectual man. The gesture characteristic of his tribe consists in looking at the world with eyes wide open in wonder. Everything in the world is strange and marvelous to well-open eyes. This faculty of wonder is the delight refused to your football 'fan' and, on the other hand, is the one which leads the intellectual man through life in the perpetual ecstasy of the visionary. His special attribute is the wonder of the eyes.

Not that Nelson ever claimed that such "wonder of the eyes" was his own attribute to any exclusive degree. For example, he told this admiring story about Le Corbusier, years after their interview in Paris:

> I remember having lunch one summer day in somebody's place in Long Island[64] with Le Corbusier . . . and Corbu was then in his middle sixties. He had just come out on the Long Island Railroad, which is an interesting experience, and was chattering like a kid about the number of birds he'd seen out of the car windows. Mostly, when I went on that train, all I saw was the soot and the stench of these cars which never got maintained. Here was Corbu seeing all the birds, and then when he got there he started making some sand sculptures within fifteen minutes of putting his bag down.[65] He was just busy as a teenager, a kid having a wonderful time.[66]

The same celebration of discovery lies behind "Countdown," Nelson's series of slides discovering the numerals 99 to 0 hidden in urban scenes. But, while capable of observing the city sharply, Nelson was never able to wholly admire it. His disenchantment with what the city had become was, in part, a disenchantment with the modernist revolution that had transformed it and obliterated some of its local character. In 1967 he complained:

> You can now be identically and modernistically air-conditioned, balconied and twin-bedded in Bali, Brasilia, and Bimini. There are still some places to hide if you don't go for this kind of thing, but not for long. The universal architectural response to mass travel is mass modern. One could do an article about a quick trip around the globe and use only two photos, one showing a glass air terminal and the other a glass and concrete hotel stuffed with cells. While the story would not be entirely true, it wouldn't be completely false, either.
>
> When it comes to hotels I find I avoid the Hiltons and the Inter-Continentals, although I have nothing in particular against them. I like has-beens, like the Regina in Paris, with its delicious open elevator and monstrous bathtubs and good service, the Euler in Basel, the Carlton Senato in Milan, the Japanese inns

(rather than hotels) in Japan, and so on. To what extent these re-actionary tastes base themselves on snobbery or nostalgia I have no idea and I do not have much interest in finding out. Apparently one gets one's fill of fine things like polished escalators, shiny coffee shops, fluorescent lighting, plate-glass windows, and all the rest of the contemporary package one gets living in any big city, and an escape from 100 per cent modernity is agreeable from time to time. As a designer I have contributed my mite to the modern look over the past two decades, and since modern is a mass style essentially, it is sometimes refreshing to walk back into an older world where the individual is more visible, particularly since it is disintegrating at a high rate of speed.[67]

Nelson also became disenchanted with the advocacy of *any* popular movement, such as modernism had become. In the 1984 Charles Eames Memorial Lecture at the University of Michigan, he had this gentle advice for the students:

> The Eames Memorial Lectures are not supposed to be sermons, as I understand it, and, anyway, I have never believed in the virtues of missionary work, which historically has succeeded only in putting Mother Hubbards on all those beautiful Hawaiian bodies and in hacking paths through the jungle for the advance troops of Empire. If I did believe in giving advice, however, I think that what I would suggest is trying the interesting experience of being out of style, or maybe just getting out of step once in a while. It can be nervous-making at first, but who knows? You might learn to love it.[68]

9 The Office

A number of seemingly unrelated lines of thought converged, during Nelson's career, to produce the most ubiquitous feature of our present commercial interiors and the Nelson design that would alter more behavior patterns than any other: the open-plan office system. Nelson had not fully foreseen this result, was not fully satisfied with it, and he spent his last years trying to make its effects on office life more benign.

Some of these lines of thought seemed at first to have no application to the office. Storagewall was meant for the postwar house,[1] and the pole systems the Nelson office produced—StrucTube, Omni, CSS, the Moscow fair's "jungle gym," a "House on Poles" for Herman Miller's Chicago showroom[2]—were all designed with either exhibitions or residential applications in mind.

A more obvious forerunner of the open-plan office was Nelson's L-shaped desk, designed as the heart of his 1947 Executive Office Group (EOG) for Herman Miller. Its most important aspect was not its shape—desks and typing tables had often been placed in right-angle configurations, and Gilbert Rohde had designed desks for Herman Miller in both L and U configurations (but with all their surfaces flush)—but its comprehensiveness. More than a desk, it was described in the catalogue as a "work center." In addition to its two levels of work surfaces, it offered storage elements both above and below those surfaces,[3] a typewriter storage compartment, a desk-height file, and even built-in lighting. Nelson called it "the first step in breaking up the old two-pedestal desk configuration,"[4] London's *Design* magazine called it "possibly the most significant early event in the whole modern office movement,"[5] and Lance Knobel, more recently, called it "the first example of what came to be called a workstation."[6]

The possibilities inherent in these experiments for flexible, multipurpose dividers of office space might never have been recognized, of course, without the emergence of office space that needed them. Before the war, large open areas were limited to secretarial pools and the clerical staffs of insurance companies and banks; after the war, with the great proliferation of "white-collar" work to be done, and with new capacities

Ernest Farmer, Nelson's first employee in 1945, working on Herman Miller's Executive Office Group two decades later.

for air-conditioning and lighting making possible large work areas remote from exterior walls, they were everywhere.

Architecturally, there had been little progress, since Howe & Lescaze's 1932 Philadelphia Savings Fund Society tower, toward building a modern expression of the skyscraper form. This had had to wait for two New York towers of the early 1950s: Wallace Harrison's dilution of Le Corbusier's scheme for the United Nations Secretariat, and the more rigorous design of Lever House by Gordon Bunshaft of Skidmore, Owings & Merrill.

Appropriate interiors for such buildings had to wait even longer, except for rare individual efforts. Perhaps the best of these—certainly, the most consistent and thoroughly considered—was in Skidmore, Owings & Merrill's Union Carbide building, finished in 1960 (but depressingly replaced by the same architects in the mid 1970s with ersatz eighteenth-

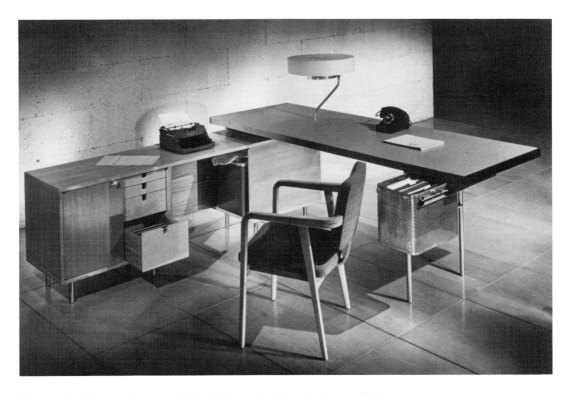

The Executive Office Group's L-Shaped Desk (1947)—not simply a desk, but a workstation.

century decor). Its ceiling-high metal partitions, its luminous ceiling with plastic air diffuser panels, and the building's structure and window mullions constituted a unified, pervasive modularity. But this was all custom work; there was nothing then on the market for furnishing the open office.

Around the same time, a change in the whole nature of office planning was being hatched in the Hamburg suburb of Quickborn by the brothers Eberhard and Wolfgang Schnelle, who ran a management consulting firm. Their notion was that the distribution of office furniture should be based on actual patterns of communication between workers rather than on rank, organization charts or departmental divisions. Furthermore, they imagined such distribution in apparently random groupings rather than in regimented rows. The results, to most who saw them for the first time, looked ridiculous, "like the tracks of little animals in a meadow, . . . going on their way here or there,"[7] but they seemed to work. The Schnelle brothers' design group was called the Quickborner Team, and its method *Bürolandschaft* (office landscape). After some late-1950s experiments and some early-1960s installations in Germany,[8] the first American trials followed in 1967 and 1968.[9] With those successes the open office was given new vitality and a new look, but it still lacked adequate furniture. (The Quickborner Team had made do with lightweight tables, potted plants, and folding screens. As Nelson later explained, "they were restricted to furniture designed to fit into smallish offices with square corners."[10])

At this point, Robert Propst entered the story. Propst had been in Colorado, inventing playground equipment, airplane parts, heart valves, timber harvesters, and livestock-tagging machines. At some point in the mid 1950s he had called on D. J. De Pree at Herman Miller, trying to interest him in a piece of wood joinery equipment he called a fishbone connector. De Pree had not been interested in fishbone connectors just then,[11] but the two men kept in touch, and a few years later D. J.'s son Hugh hired Propst to investigate ways the company might expand into other fields. In 1960 the Herman Miller Research Corporation was formed in Ann Arbor, with a staff of four headed by Propst.

Although, as Ralph Caplan has written, "Propst's mandate was to explore problems for which 'a product not necessarily furniture' might be the solution,'"[12] the first general problem Propst considered was that of accommodating his own work habits. "I was changing my . . . foot patterns," he reported, "tasks were migrating to the drafting table and all the walls were becoming areas for display."[13]

The Herman Miller researchers sent office workers a ten-page survey, its 105 questions including these: "Can you take a nap in your office without embarrassment?" "Can you keep your papers visibly available?" "Who can overhear your 'phone conversation? Does it matter?" "What percentage of your working day is spent in these positions: sitting, standing, walking, perching, supine, sleeping, other?"[14] They also consulted a large number of specialists, including the Michigan State psychologists Terry Allen and Carl Frost; Joan Evans, a British scholar of ornament and pattern; Robert Sumner, an investigator of the effects of different spaces on mental health; and anthropologist Edward Hall, whose book *The Silent Language* had been published in 1959.[15]

The study led Propst's little band to some further conclusions: for example, that "people like to support their extremities" and that "body motion" is related to "mental fluency and alertness." More concretely, Propst was coming to feel that office walls should be used for visual messages, that desk surfaces should be attached to walls but supplemented by flat work areas, and that workers should be encouraged to move about rather than just sit. He also deplored deep drawers where stacks of paper could be stuffed and forgotten, forming "vertical paper bottle necks,"[16] and he declared that "the tidy desk top is a waste of time."[17]

This was all very interesting, but it was hardly anything Herman Miller could market. Nelson was called. At first he was a bit skeptical of Propst's research ("My own experience with surveys is that they often get all the information except the essentials"[18]) and more than a bit wary of being the stylist for *anyone* else's ideas, but then he saw the possibilities in the proposals and their affinity with his own earlier notions. He put Ronald Beckman in charge of the project, and the Propst-Nelson collaboration (never a close one, geographically or temperamentally) began. According to a report in *Interiors,* "Propst sent the Nelson office highly unorthodox memos full of questions and suggestions but not answers. He also made drawings and models of the *kinds* of furniture he envisioned for 'mind-oriented space—a place for translating abstractions.'"[19] Somehow Nelson, Beckman, and the others were able to take these unanswered questions, generic models, and unrealized visions and embody them in a new kind of office furniture. Herman Miller's Action Office, introduced in 1964, revolutionized the field of office design.

Cantilevered from die-cast polished aluminum legs that hugged the floor, and braced with chrome stringers that doubled as footrests (com-

Nelson with the Action Office products introduced in 1964.

pared by one reporter to "the brass rail in a saloon"[20]), the Action Office units looked nothing like conventional desks. They were high and shallow, with rounded corners and rubber edges. They had plastic-laminate work surfaces[21] and molded-wood side panels, file bins suspended along the back edge (a part of the desk Propst thought generally wasted), and, perhaps most novel of all, covers of rolled canvas or wood tambour that could be pulled down every evening like the roll-tops of half a century before (but allowing only a 3-inch-high pile of papers). Workers at the tall units could stand or slouch, or could perch on tall, narrow stools. In addition to these main pieces, Action Office offered a lower desk with a flipper top and a built-in electric outlet, a tall unit that seemed a movable slice of Storage-wall, and an acoustically insulated "communications center" for telephone and dictaphone use. And all in color: olive green, electric blue, dark blue, black, or pale yellow. Its novel forms and colors linked Action Office with other advanced designs of its day and with some that were soon to follow.[22]

The press, starved for genuine innovation, did cartwheels. "Seeing these designs," *Industrial Design* said, "one wonders why office workers have put up with their incompatible, unproductive, uncomfortable environment for so long."[23] *Esquire* noted "a new liberality in the use of space" and an acknowledgment of "the idea that an office should get work done, not stored away."[24] *Business Week* lauded Herman Miller's "sense of daring in design,"[25] and the *Saturday Evening Post* warned: "So, office workers of America, beware! The action office is coming! We are in real danger of being enabled to work at 100 percent efficiency."[26] And, naturally, Nelson himself had a few words to say: "These are not desks and file cabinets. This is a way of life."[27]

Well, yes, but would office designers and furniture dealers, accustomed to buying desks and filing cabinets, make the radical switch to buying a way of life—and at the rather steep price necessitated by Action Office's expensive tooling and manufacturing? As it turned out, not many of them would. No doubt there was also the problem, not fully overcome even today, that for many clients the big, heavy, dark mass of a hardwood desk, practical or not, seemed to bestow more status than some curious blue object with shiny legs.

Although the first Action Office was a commercial disappointment, it still earned Propst respect for his thinking, the Nelson office a couple of awards (one from Alcoa and one from the American Institute of Interior Designers) for its design, and the Herman Miller Company a great

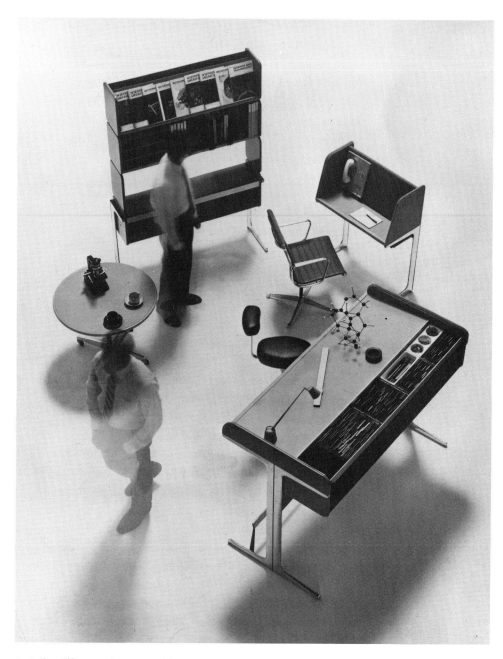

An Action Office grouping arranged for a Herman Miller advertisement.

The Action Office's stand-up desk with roll top and chrome footrest.

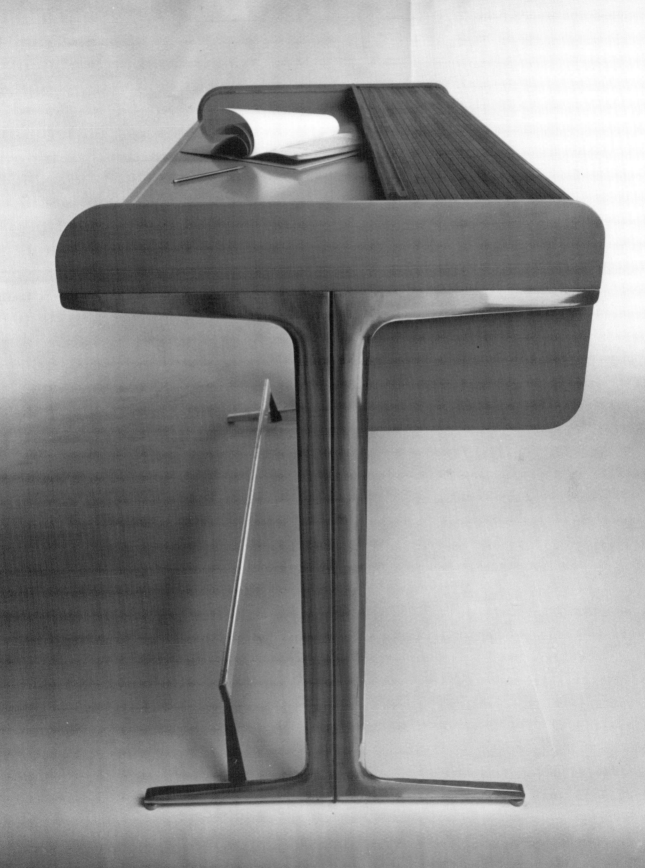

deal of admiration for its nerve. It was a failure on only the shortest of terms. It also accelerated a shift in Herman Miller's business from residential to commercial furniture.[28] In the first year after Action Office's introduction, residential furniture at Herman Miller, already down to 13 percent of output, dropped to 10 percent; a decade later it had disappeared entirely.[29]

And Action Office was a near-perfect solution to the problem of furniture for the new office building's deep space and for the configurations of the office landscape. What was still needed was to free the furniture components from their traditional dependence on the built envelope by providing them with their own structure. Already, panels had been attached to the structure of Nelson's CSS pole system, and Herman Miller had begun a collaboration with the Hauserman Company, manufacturers of movable partitions. Precedent for a new sort of office system might even be seen in the floor and wall panels clipped to the aluminum cages of Nelson's 1957 Experimental House.

A more explicit antecedent for the panel-hung system had been built first in model form: in that same Experimental House project, a desk (as well as a clock and other objects) was supported from tracks set into the walls. The idea was finally realized in 1961 when Hugh De Pree, then president of Herman Miller, hired Nelson and Gordon Chadwick to design an addition to his Michigan house; set into the new walls at regular widths were sections of CSS standards.

Soon the Nelson office was at work on office interiors for the Federal Reserve Bank of New York, completed in 1963. For these the office designed (and Herman Miller built) pinwheels of partitions incorporating CSS track and supporting all manner of work surfaces, storage compartments, lighting, and accessories. CSS had begat CPS (the Comprehensive Panel System).[30] The Nelson office repeated the idea in 1964 for the Woman's Medical Clinic in Lafayette, Indiana; here a free-standing multi-panel screen outfitted with CSS extrusions supported all workstation needs, and there was a provision for keeping all electrical and telephone wiring neatly bundled and out of sight.[31] And in Nelson's own New York office at about the same time, a free-standing row of CSS standards running down the center of the drafting room supported shelving and storage elements on both sides, and a wall of CSS in the reception area could also support furniture.[32]

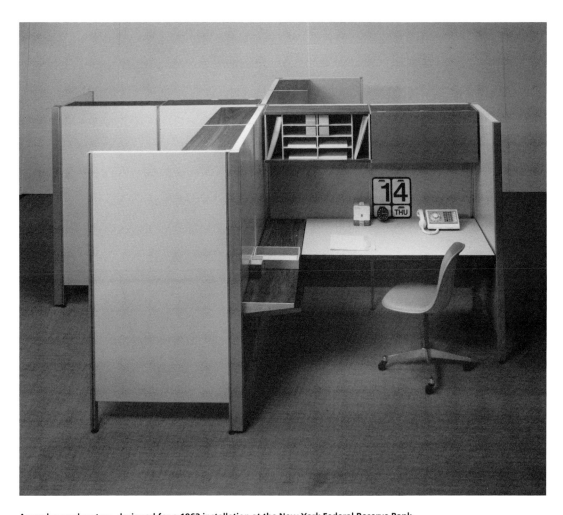

An early panel system, designed for a 1963 installation at the New York Federal Reserve Bank.
(photo: Grafék Arts)

The next major step was called "Skiddable Walls."[33] This was an experiment put together in 1965 by Nelson's office (with Ronald Beckman again in charge) for the adventurous new dean of the University of Tennessee's architecture school, Bill Lacy. Its head-height panels could be easily separated, skidded along the floor by the students, and—at last using Propst's fishbone connector—reattached in new configurations. From the connecting strips between the panels could be hung drafting tables, desks, racks, shelves, and lamps. "Our landscape for Tennessee goes from calm to wild," Beckman said, and "the kids themselves, in a half hour, can change their environment. . . ."[34]

At the same time, Nelson was toying with a thoroughly different office concept for the Rosenthal China Company. Rosenthal's nineteenth-century brick building in Bavaria was being renovated for administrative offices. Nelson described the project in the November 1965 *Interiors:*

> So what do we have? On the top floor as much as eight or ten thousand feet, which could be used for top management, with their administrative departments on the floor below.
>
> As Philip Rosenthal described his operation, the most crucial thing is the rapport between his top five men. He wanted a symbol of a thing that was real. So I began to think . . . with 50 or 60 feet between each man, you begin to have privacy without doors or offices. As we talked, I began to visualize the working spaces less as offices and more as free-form clearings in a forest. Rosenthal, as a Bavarian, has all kinds of special connotations with a forest. . . . Then, why not real trees and sun through a skylight? Why not make huts—a sort of pavilion for storage, files, coats, to make coffee in. . . .
>
> The whole concept made me think: What is a proper office? The forest revealed the limitations of a typical private office that is totally undifferentiated. Who sits, eats, sleeps, makes all his phone calls in one place? Isn't working in a non-geometric world a helluva lot less tiring than in a box?
>
> This is not a romantic game, . . . but an extraordinarily efficient operation for think-type guys. Obviously it costs more, but here is another example of a *real* choice made possible by affluence.

For all its charm, the office-in-a-forest was obviously too extravagant to enter the mainstream of office design. Action Office and Skiddable Walls were more promising. Conceptually, if not practically (for some cost-saving changes in production technique were necessary as well), it was no distance at all from Skiddable Walls to the panel-mounted version of Action Office that was introduced in 1968. Herman Miller called it Action Office 2, even though Miller's Joe Schwartz complained that this was "like calling a car Edsel 2."[35]

Though responsible for most of the ideas that contributed to it, Nelson had nothing directly to do with the final design of Action Office 2, and was not enthusiastic about it. In a letter to Robert Blaich, who had become Herman Miller's Vice-President for Corporate Design and Communication, Nelson complained of the system's "dehumanizing effect as a working environment." He continued:

> This characteristic is not an accident, but the inevitable expression of a concept which views people as links in a corporate system for handling paper, or as input-output organisms whose "efficiency" has been a matter of nervous concern for the past half century.
>
> People do indeed function in such roles, but this is not what people *are,* merely a description of what they *do* during certain hours. . . .
>
> One does not have to be an especially perceptive critic to realize that AO II is definitely not a system which produces an environment gratifying for people in general. But it is admirable for planners looking for ways of cramming in a maximum number of bodies, for "employees" (as against individuals), for "personnel," corporate zombies, the walking dead, the silent majority. A large market.[36]

Scornful as Nelson may have been, he was right in at least one regard: it *was* a large market. Action Office 2 was an immediate and immense success; along with its later revisions, it boasts more installed units than any other system and its total sales have been more than $5 billion.[37]

Typically, when Action Office 2 sales were beginning to soar, Nelson had already begun work on a quite different and potentially competitive idea: Basic Office, a more informal "bullpen" concept, similar to a grouping of library carrels. Herman Miller's financial officers advised that

it was impossible for the company to investigate both directions at once, and, with Action Office 2 flourishing, Basic Office was abandoned.

Soon, though, Nelson had an opportunity to test his maverick ideas about where office design should be heading. In 1971 the Aid Association for Lutherans, a non-profit life insurance company in Appleton, Wisconsin, began making ambitious plans for a new headquarters building and hired Total Concept Inc., then headed by G. Ware Travelstead, to prepare a building program. Total Concept's presentation included a program calling for half a million square feet of office space, a helpful explanation of open and conventional office planning, and a suggestion of what sort of talent would be needed to do the job.

John Carl Warnecke & Associates were hired as architects, with William Pedersen[38] the designer in charge, Joe Baum as food service planner, Zion & Breen as landscape architects, and George Nelson Associates as space planners and interior designers. The AAL's mandate to the designers was "the most humane working environment you can think of."[39] A major factor, clearly, would be the character of the work stations, almost a thousand of which were needed, and their importance became even more apparent as Pedersen's design developed. Nelson thought the young architect "did a lot of things . . . better than OK,"[40] but the low, six-acre loft building, with partition-free interior spaces up to 400 feet across, was not easy to furnish. The problem, Nelson wrote to his friend Theo Crosby, was how to "keep it from looking like a parking lot."[41]

The AAL executives asked Nelson to investigate the more than two dozen similar systems that had quickly followed Action Office 2 onto the American market. Nelson pronounced the selection "a scene of almost unrelieved monotony."[42] Although he chose three systems for full-size mock-ups in a test space, none seemed exactly right. Even Action Office 2 had lost its "skiddability" and shared with the others an inability to be moved easily. With work surfaces panel-hung, there could be no work surfaces *without* panels, yet Nelson estimated that for 65 percent of AAL's employees a simple desk would suffice. His major complaint, however, was of the systems' failure to provide the mandated humane environment. He thought the panels tended to form a labyrinth of blank surfaces and, far from creating a landscape, offered their users only "an all-day view of a fluorescent ceiling."[43]

If nothing on the market would meet the criteria, the obvious next step was for Nelson to design something that would. The result, later marketed as Nelson Workspaces by Toronto-based Storwal International,

One of the first sketches for Nelson Workspaces (1970).

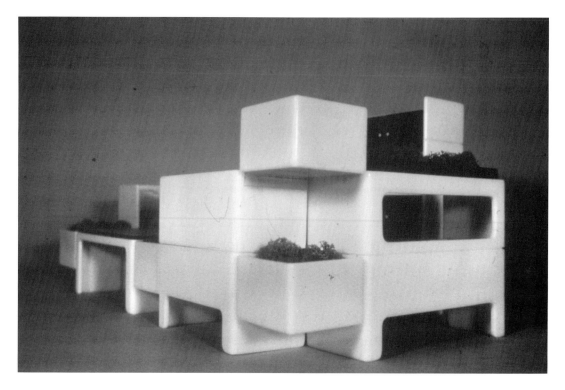

A rough study model, at the scale of 1:12.

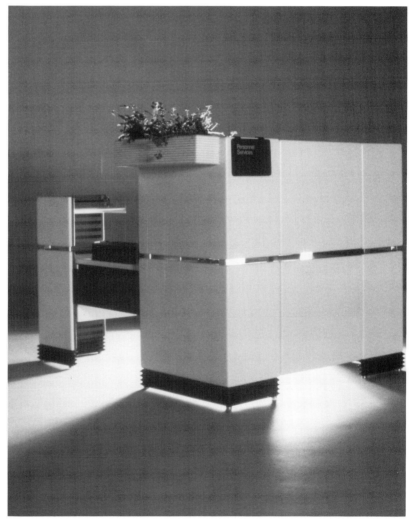

A more finished prototype at full size.

was a system with several innovations. The basic element was not a panel from which other elements could be hung but a desk on which other elements could be stacked. These elements included L-shaped corner panels with hard outside surfaces and soft inside ones, a telephone stand, a flexible lamp, a "book bulge" extending beyond the desk top (and therefore varying the units' profile), and a little planter that could be over the edge of the desk.[44] At the back edge of the desk, the area Propst thought wasted, was a slot opening over a trash box that could be tilted out for emptying; the box served as a "modesty panel" and eliminated wastebaskets. At its base the desk had rubber bumpers, resistant to cleaning equipment and kind to ankles and stockings. Most important, there was an inch-wide gap between the elements. This, according to Nelson, "gives you a kind of psychological air movement—not a very real thing, but you won't feel quite closed in as you sit there. The crack idea is repeated with this completely open central space left by the . . . side screens. You can fill it with lace or gauze or a solid or whatever you like."[45]

Nelson's own favorite filler, offered as an option by Storwal, was a venetian blind, which provided some control of privacy. Like the highly adjustable Luxo lamps that had been clamped onto the desks during the mock-up tests, the blind offered workers a welcome touch of authority over their environment:

> We learned that if you put a Luxo lamp on [people's desks], they live in a state of high excitement for two weeks. Why? The only thing you can imagine is that here's a little lamp that will do what you tell it to do. So you say: Ah! People like to be able to tell lamps what to do. Or they like to be able to control this or that. Well, if you take this far enough, you will end up with a pretty good office.
>
> If the venetian blind starts doing this for you, and the lamp starts doing it, you are on the way to a decent environment. . . . You really are dealing with very primitive emotions in these things: territoriality, personal space, controllable privacy.[46]

There were full-height panels, too, that could be joined to the edges of desks or joined to form cylindrical conference areas, roofed with giant umbrellas. Overall, the AAL installation was far from monotonous, but there remained an orientation problem in the vast spaces. A program

Four details of the finished product. Left to right: installation of an L panel above the desk; storage drawer facings; wiring connection to attached task lighting; the resilient corrugated bumper base.

of hanging banners added not only color but directional aids. Other strategic parts of the art program were cafteria hangings with a biblical theme by Norman La Liberté and "The Journey," a 50-foot-long lobby tapestry by Helena Hernmarck. It was altogether a handsome, interesting installation. Nelson Workspaces was a system rich in civilizing details, but those very details—cracks, bumpers, blinds, planters, umbrellas—seemed a bit kinky and not quite corporate or serious. What made the stations work well did not make them sell well, and Storwal soon discontinued the line. In any case, Nelson was already thinking of other avenues, most of them even more idiosyncratic, even less institutional. Perhaps the best answers, he had come to think, were not to be found in the vocabulary of systems at all.[47]

Nelson's next line of investigation was something he called Pad. As this began to take shape in 1978, he jotted down these fragments:

> Maybe packages, not system . . . carrel . . . hideout . . . gauze dividers . . . acoustically treated hood with a viewport . . . The Pad is: 1. Japanese screen, 2. Tables, 3. Roller boxes plus accessories.[48]

Later, Nelson wrote to Hugh De Pree that the idea behind Pad was "that a casual, lively and easy approach to the office might have takers." He continued:

> The character we had in mind was that of an architect's or designer's office, or a newspaper or magazine, or perhaps a research facility. All such places look less "designed" than corporate office interiors and almost invariably more interesting to be in, partly because of the informal atmosphere, partly because the work *shows*. . . . Scattering potted plants is OK, but hardly a real answer to the need for better working environments.[49]

One key element of the Pad idea was, literally, a pad, fabric-faced, acoustically absorbent, and "attached to screens (or screen frameworks) like mats in elevators."[50] These would serve for sound control, for decoration, for visual privacy or, when more gauze-like, for visual semi-privacy and for marking departmental territories. The proposal, Nelson said, "hints that a system can become too systematic. That the do-it-yourself approach could be built into the design criteria."[51]

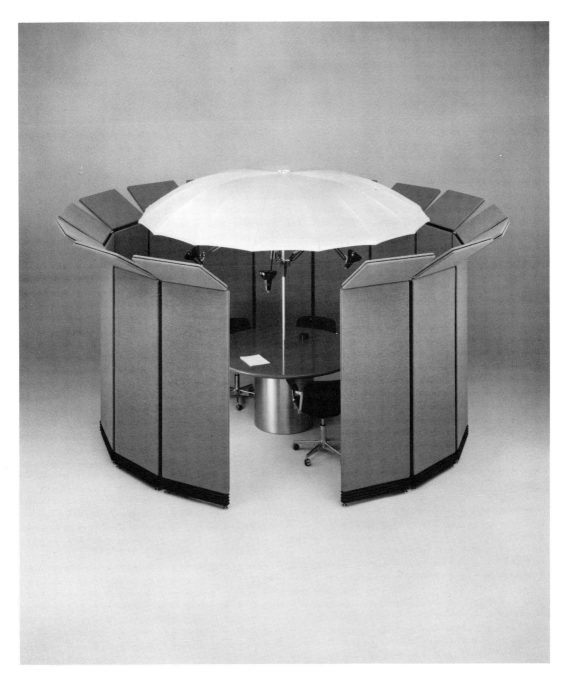

A ring of panels forms the Nelson Workspaces conference room.

Other investigations that followed were The Soft Wall, an elaboration of Pad's fabric hangings, and The Shared Office, a recognition that a personal, immobile work station for each employee was often an unnecessary waste of space and could be replaced with personal, movable storage cabinets wheeled around to whatever desk was available.[52]

Pad, Soft Wall, and Shared Office were not without promise, but their pursuit would have required more adventurousness than was in the air at the time. It was probably also true that the relationship between Nelson and the Herman Miller Company was less idyllic than it once had been. Nelson had begun to feel that, gradually, he had become remote from the decision-making in Zeeland; the company, as Nelson had both predicted and made possible, had grown enormously, needing increasing numbers of executives (not all of them Nelson's friends or even his acquaintances) and also needing an in-house design department. The market had changed, too. Having grown enormously in both size and sophistication, the demand for modern furniture could no longer be guided by Nelson and a handful of other designers; gone were the years when Miller could profitably offer for sale whatever its designers dreamed up.

In the last years of his life, Nelson began to organize his thinking about office design as the foundation for something he saw was missing from all attempts (even his own) to shape the modern office: a theory of the workplace. One form in which this was expressed was in a long memo to Arthur Gensler,[53] who had hired Nelson as a consultant for his large design firm's future planning. It also appeared in long papers written for Max De Pree, who had succeeded his brother Hugh as president of Herman Miller, and for Joe Schwartz, who had earlier, and for a short time, succeeded Robert Propst as head of Miller's research wing. And if Nelson had lived longer, these scattered writings might have coalesced into a book.[54]

In still another form, the search for a theory played a major part in Nelson's long, rambling, prolific, sometimes very personal correspondence with Tom Pratt, a respected friend among the Herman Miller executives.[55] It had been Pratt who, after a chance meeting with Nelson at the Pacific Design Center in West Hollywood, had brought him more firmly back into the Herman Miller fold as consultant and senior statesman. As Nelson described this new role, it "led to the transformation and apotheosis of Nelson as a Living Legend, a euphemism which simply means that nobody knew what the hell to do with him, which led to his being wheeled out, well dusted off, for occasional viewings on ceremonial occasions. A sort of Disneyized . . . Lenin, though not as well preserved."[56]

In whatever form, Nelson's theory of the workplace had little in common with the plentiful contemporary predictions for the office of the future, which he found "remarkably uniform." He continued: "There are going to be a lot of electronic assists, and the office will consist of purring robots tended by sanitized boys and girls. This will make the office productive and we will finally be able to beat the Japanese and live happily ever after."[57]

A major flaw of this picture was that it was boring, and Nelson thought a successful theory would have to deal with the problem of monotony and its causes:

> The workplace exists in a social environment. This environment can be described as a mass, technological, capitalist society. . . . One of the main criticisms of the modern office has to do with its prison-like monotony. The same criticism, incidentally, has been leveled against the modern city. A mass technological society, apparently, is so structured that monotony is an almost predestined result.[58]

And to combat monotony, office design would have to accept, rather than deny, the natural variety that an office harbors:

> What goes on in the workplace, presumably, is work. This would be true in an automatic factory, but it does not seem to be entirely true for people. There is a great deal of intermittent socializing; there are the struggles for status and power. There are kinds of people and kinds of work. There are people who file and people who pile. There are doers and dreamers.
>
> In all this apparent simplicity of 9 to 5 office work there are endless complexities. Design, in such a situation, does not necessarily have to be complex as well, but it does have to be *accommodating.*
>
> A major aim of the effort to develop a theory is the creation of *accommodating* workplaces. It is possible that such a design is a system, since that is one of the familiar responses to complexity, but it is also possible that the present "open landscape" systems are not accommodating enough, and are at the same time too complex.

Traditionally, designs for the office are created and produced by the furniture industry. Now, alongside all this furniture, there are all the products and systems provided by a swiftly evolving electronics industry.

There are questions: Will the workplace of the immediate future continue to be an assembly of furniture? If not, then what?[59]

Throughout these last writings about the office, and fundamental to them, is a humanism that seemed to have become increasingly passionate as Nelson saw it increasingly threatened. For example:

The rest of my theory is that, if one wants to break through existing problems in office planning and design, the answers are to be found in the *people, not the hardware*. You can also add an aim on to the theory, which is that the office should *become a more humane workplace*.[60]

Nelson's last years brought a number of medical problems but no diminution of intellectual energy. Delivering the Eames Memorial Lecture in 1984, he described himself as being left "with the apparently obsolete conviction that learning, trying to expand one's vision and understanding, is one of the most deeply satisfying experiences a human being can enjoy." "One result," he continued, "is that you find yourself feeling, at an age when one is supposed to be sitting in a rocking chair on a porch in St. Petersburg, waiting for the batteries to run down, that life was never so beautiful, mysterious, or exciting."[61]

Even so, the adventurous years of modernism's development had passed, and many of Nelson's fellow adventurers were disappearing, too. At one of the last Aspen design conferences he attended, Nelson and his wife Jacqueline were about to descend a path to a big cookout in the meadow when a young reporter, pounds of camera equipment strapped to her back, ran up to them, surveyed the scene below, and asked "Is anyone important there?" Nelson thought for a second, then told her, "No, everyone important is dead."[62] Just a joke, perhaps, but Charles Eames had died in 1978, Erich Fromm in 1980, and Bucky Fuller in 1983. On February 11, 1986, Nelson wrote to Tom Pratt:

Had word from Yamasaki's secretary last week that Yama had died. It came as a real shock, for I had heard nothing. I lunched with him in Detroit perhaps five or six months ago, and he was very frail indeed, but otherwise as full of life, curiosity and enthusiasm as ever. We had an odd relationship. We were best friends in a way, but saw each other only at the most irregular intervals, and we practically never wrote to each other. Still, when the news came, it was a large shock, . . . as if a pair of great doors which had been open for the better part of a lifetime had suddenly been closed, never to open again. He was a very good guy, endlessly searching in his projects for a kind of richness the standard modernists hated, and he was not well treated by them because of his refusal to conform.[63]

Three weeks later, after suffering medical attention from (he complained) Drs. Tweedledum and Tweedledee, and with much potential still unrealized, Nelson himself was dead.

10 Some Common Themes

One telling aspect of Nelson's "Theory of the Workplace"[1] is that this last project remained unillustrated. There were no plans, no sketches. The project was never finished, of course, but a more interesting explanation is that Nelson *did not care* what his theoretical workplace looked like. He had traveled from an awakening to the visual world (stirred by images of gateways), through a long process of learning and then teaching how to see, to an end when visual characteristics no longer seemed important.

His career had taken him—or, more exactly, his mind had taken his career—on a long arc of development that had begun with concern for specific problems and solutions: a house, a clock, a lamp—design in the conventional manner, even if some of the solutions were of more than conventional inventiveness. Early on, this concern was accompanied by— and later it was supplanted by—a concern for more universally applicable design: for the concept of the Storagewall, for example, rather than the accommodation of items to be stored in one client's house; for the principle of modularity in furnishings rather than unrelated units; for reproducible master courses in art education rather than redundant individual lectures; and for prefabricated housing systems, not just single houses. And in his final years this second sort of concern seems to have been surpassed in his thinking by a third sort: concern for design principles rather than for their visual expression.

This development may be seen (although it is too early to tell with what accuracy) as an abbreviated and precocious journey paralleling the progress of modern design from its early stage (when the invention of a new chair design, for example, could be an important and informative achievement, embodying fresh attitudes towards form, materials, and use) to its present stage (in which new chair designs satisfy and also partly provoke a restless search for novelty but lack their former power to enlighten) and on to a possible future stage (when, in the context of grievous social and cultural problems, a new chair design will be seen as an irrelevance).

In such an evolution, we should not deduce, nor did Nelson deduce, a weakening of the importance of design. Rather, Nelson saw the

opposite: the maturation of design and the broadening of its application from goods to principles. In an article that he submitted to *Interior Design* three weeks before his death, he wrote that "more and more of the world is seen as a place in need of increasing exposure to the design process."[2]

And what, in Nelson's opinion, *was* the design process?

Design is an unsatisfactorily vague pursuit—vague in the way it is accomplished, vague in the way it is evaluated. In the postwar years, when the glorious certainty of the scientific method was at the height of its appeal, it was natural that Nelson coveted some of that quality for the process of design. ("Physics envy," Denise Scott Brown has called this covetousness.[3]) How the scientific method might be appropriated and applied was a matter of long investigation that never ran along a straight track (Nelson never cared a hoot about consistency) or yielded a clear answer. "Design is not science," Nelson said,[4] but perhaps, he apparently kept thinking, design might somehow learn from science. There was no question in his mind that, in the development of man's skills for dealing with the world, science was an advance beyond philosophy, which was an advance beyond religion.

Nelson therefore sought, more than most designers, to abet the customary design process with elements of the scientific process. This was manifest in three ways:

First, in his application to design at both furniture scale and building scale of the principles of modularity. The orderly repetition of units had an appeal beyond the obvious simplifications of manufacture, stocking, and use: the appeal of a logic fundamental to the design result, as mathematics is fundamental to a result in physics.

Second, in his testing of variables and his matching of the previously unmatched: plastic cocooning with lamps, grass with Main Street, cavity walls with closets. This matching process was never performed with scientific rigor, obviously. As Carl Jung wrote, "Many artists, philosophers, and even scientists owe some of their best ideas to inspirations that appear suddenly from the unconscious. The ability to reach a rich vein of such material and to translate it effectively into philosophy, literature, music, or scientific discovery is one of the hallmarks of what is commonly called genius." Even so, the creative matching, the "finding" rather than the "doing" of new combinations, is fed by knowledge. If it is true that Nelson's "peak experiences" sometimes came unexpectedly, it does not necessarily follow that his design process must have been wholly intuitive and therefore intellectually blind. The design genius, as much as the scien-

tific genius, relies on preparation and application, never just on accident, and a searching curiosity considerably increases the incidence of "finding." The ability to make connections, Nelson said, "depends on the homework you've done":

> . . . You can look at a printed circuit, for instance, which is always a fascinating thing to look at, and say: "My goodness, that looks like John Cage's music." Because you know John Cage's music; you could never make that improbable connection otherwise.[5]

His third emulation of the scientific method was in his skepticism for the accepted but unproved. Using his eyes independently of common perceptions, Nelson acted very much like a scientist observing data without prejudice or partiality. In an unpublished text titled "The Design Process" he wrote:

> The businessman who is weighing the pros and cons of a merger, the scientist setting up an hypothesis and tracking it down, the mathematician constructing an elegant model—these people are all going through steps similar to those taken by a man feeling his way towards a suitable shape for a pitcher.[6]

About science's offspring technology Nelson felt some hope (in connection with education, for example) but less enthusiasm. He saw technology's toll on cities in the form of too many buildings and too many cars, and he also saw its toll on the workplace in overstructured office interiors. But he never turned to the past for solutions. He would not have agreed with Thoreau that it was better to walk from Concord to Boston than to spend the same time earning the train fare; he agreed instead with Bucky Fuller that technology, for all its faults, was the best basis for future improvement.

But were Nelson's admiration for science and his hope for technology not, at times, at odds with his humanism? No more, probably, than was his belief in design. Nelson saw that if science, technology and design were to effectively serve the people they would have to operate at full strength, unfettered by populism. Ortega's masses (or, in Wright's term, "the mobocracy"[7]) with "no desire to be told anything they don't already know,"[8] must not be given control of the design process, even though they were meant to be the beneficiaries of that process.

While he deplored the democratization of design, Nelson also deplored its opposite extreme, the mystification of design, as well as the narrow definition of the design professions. In one of his letters to Tom Pratt he wrote of the "mistake in confusing the word 'design' with the activities of an exceedingly limited group of professionals, such as graphic, interior and product designers":

> The fact is that the modern world is constantly being designed and redesigned, not by these over-publicized specialists, but by literally millions of people, most of whom do not think of themselves as designers, but who nonetheless are primarily responsible for the shape of the world.[9]

For example, anticipating the launching of the proposed NASA Space Telescope, Nelson said

> . . . we will be watching a composite event—ship and cargo—which might be characterized as one of the major design accomplishments of the 20th century, and one for which the design professions as we think of them have no responsibility. The credit goes to a multitude of people we do not know, have never met and have never even talked to. In other words, the world has been changing while we have been going about our business, and we are seeing the idea of design expanding to include immaterial, abstract things . . . as well as solid objects.[10]

One lesson of this changing world was that, even though design would have to stay in the hands of the designers, those designers would be an increasingly interdisciplinary group. In 1983 Nelson detected in 1983 "a major trend in a society up to its eyebrows in large problems":

> A clear indication of this trend is the growing awareness worldwide that the designer's responsibility is to become more effective on an enlarging scale, *but also that he hasn't a prayer of doing it on his own.* Collaboration, in whatever forms make sense, seems to be the only workable answer. The effects of such mergers are clearly visible in the sciences, so many of which are

now hyphenated: astrophysics, biochemistry, molecular biology—all involving the removal of barriers between once-separated disciplines.

There could be some very interesting times ahead for all of us.[11]

An evaluation of Nelson's work and a measure of his success cannot be based, as it can with most design professionals, simply on the beauty or the originality of his designs. Nor can it be quantified in terms of popularity or sales. Although, naturally, he would have been pleased if his practice had been more profitable, Nelson saw clearly the dangers of easy routine, security, and affluence. In one of the books found in his library, Richard Sennett's *The Uses of Disorder: Personal Identity and City Life,* he had marked the following Veblenesque passage:

> The peculiar character of a secure, affluent routine is that it does not arise from the needs of adaptive survival with the environment or with other members of the race. It arises instead out of the fact that affluence permits men, through coherent routines, to hide from dealing with each other. Rather than face the full range of social experience possible to men, the communities of safe coherence cut off the amount of human material permitted into a man's life, in order that no questions of discord, no issues of survival be raised at all.
>
> It is this "escape from freedom," in Erich Fromm's words, that ultimately makes a man quite consciously bored, aware that he is suffocating, although he may refuse to face the reasons for his suffocation. The boredom that rises out of this hiding is quite natural, for it is, as Nietzsche said, the voice of the creature in each man trying to make itself heard. . . .
>
> Our affluence in its present form is becoming an intolerable weight to those who supposedly enjoy it.[12]

As Bucky Fuller had phrased it, modern man was "chained to ponderous thingness."

That material values are not final values was, of course, a belief that Nelson shared with D. J. De Pree. While the two men disagreed about the nature of those final values, they agreed passionately that the most important ideas transcended metal and wood. This attitude could have

been the source of Nelson's impatience with the resolution of technical details, as well as of his impatience with consumerism. It was probably the source, also, of De Pree's trust in such a designer and his willingness to take financial risks on the basis of that trust. The mutual admiration of these two men had blossomed at their first meeting and had only grown stronger through the years; it was a fortuitous (D. J. would have said a blesséd) pairing.

In comparison with the careers of other designers, Nelson's seems not only interestingly unconventional and appealingly uncommercial but also, at times, perversely negative, even self-destructive: it is the career of an architect who advocated the end of architecture, a furniture designer who imagined rooms without furniture, an urban designer who contemplated the hidden city, an industrial designer who questioned the future of the object and hated the obsession with products.

Nelson was not interested in design as a temporary, cosmetic palliative for the problems of a far-from-perfect world. His hope was not for a world that would have more design but for a world that would need less. Most designers are able to offer human relief by adding artfully to the quality of the human experience. Nelson could do that, too; however, his valuable vision was not of a cultural situation ameliorated by the seeing of art but of a human situation liberated by the art of seeing—and, in his own case, by the ability to tell what he saw.

Nelson was not an ordinary designer. He focused on problems of a larger scale, with more serious implications and more lasting significance. For the modern world, which came to maturity in his lifetime, he wanted to find convincing principles rather than just produce satisfying artifacts. He cared for the improvement of the experience of life as an end result, but he was no more wedded to art than to science as the proper means to that end. He tried, often successfully, to provoke a profoundly critical examination of artistic conventions, established design professions, and accepted practices. What George Nelson spent his most creative talents designing was nothing less than design itself.

Appendixes

compiled by Judith Nasatir

Biographical Chronology

born May 29, 1908

June 21, 1924: graduation, Hartford Public High School

June 1928: Bachelor of Arts degree, Yale University

1929–1931: instructor at the Yale School of Fine Arts; renderer for Adams and Prentice, Architects, New York

1931: Bachelor of Fine Arts degree with honors, Yale School of Fine Arts

1931–32: graduate work, Catholic University, Washington, D.C.

1932–1934: at American Academy in Rome, on Rome Prize

1932–1941: William Hamby + George Nelson, Architects, New York

1933: marriage to Frances ("Fritzi") Hollister

1935: joined *Architectural Forum* as editorial staff writer

1935: associate editor, *Architectural Forum* and *Fortune*

1935–1936: worked for Adams and Prentice

1936–1941: partnership with William Hamby

1938: registered architect, State of New York

1941–1944: design critic, Columbia University School of Architecture

1941: member, Committee on Architecture, Museum of Modern Art

1941: member, Architectural Advisory Committee, U.S. Housing Authority

1941: on faculty, Yale University

1943–1944: co-managing editor, *Architectural Forum*

1944–1945: head, *Fortune–Forum* Experimental Department

1944–1949: consultant, *Architectural Forum*

1945–1948: special contributor, *Fortune*

1946–1972: Design Director, Herman Miller, Inc.

1946: member, Corporation Visiting Committee for School of Architecture and Planning, Massachusetts Institute of Technology

1946: consultant on interior design, Parsons School of Design

October 1, 1947: George Nelson & Co., Inc., office temporarily at Herman Miller's New York showroom; also working out of his home on the Upper West Side

1947: George Nelson & Co., 343 Lexington Ave., New York

1948–1956: contributing editor, *Interiors*

1949–1953: George Nelson and Associates, 20 West 55th St., New York

1952–1955: design consultant, School of Fine Arts, University of Georgia, Athens

1953–1956: George Nelson and Associates, 30 West 57th St., New York

1953 on: George Nelson and Gordon Chadwick, Architects

1956–1962: George Nelson & Co., Industrial Design, 18 E. 50th St., New York

1958: member, board of directors, Design Center, New York

1959: marriage to Jacqueline Griffiths

1960: Benjamin Franklin Fellow, Royal Society of Arts, London

1961–1965: member, Corporation Visiting Committee for Department of Architecture, Massachusetts Institute of Technology

1962–1973: George Nelson & Co., Designers and Planners, 25 E. 22nd St., New York

1963: Fellow, American Institute of Architects

1964: member, Advisory Committee on Arts and Architecture for John F. Kennedy Memorial Library

1965: member of Visiting Committee, Boston Museum School of Fine Arts

1965: chairman, International Design Conference, Aspen, Colorado

1965 on: member, Board of Directors, International Design Conference, Aspen

1967: advisor, New York State Council on the Arts

1968: advisor, proposed department of interior design, School of Architecture, Texas A&M University

1968: Fellow, Industrial Designers Society of America

1968–69: consultant, Boston Museum School of Fine Arts

1968–1973: editor-in-chief, *Design Journal*

1968 (1971)–1975: member, Conseil Superieur de la Creation Esthetique Industrielle, Ministere du Developpement Industriel et Scientifique, Paris

1968–1975: member, Board of Overseers, Committee on Visual and Environmental Studies, Harvard College

1969: member, Traveling Exhibitions Panel, New York State Council on the Arts

1969: member, Executive Committee, Yale Arts Association

1969–1970: member, Visiting Committee for Visual and Performing Arts, Board of Overseers, Harvard College

1969–70: member, Visiting Committee, School of Museum of Fine Arts, Boston

1969–1975: member, New York State Council on Architecture

1969–1976: member, Board of Directors, Industrial Designers Society of America

1970: member, Comite de Patronage, Centre de Creation Industrielle, Paris

1970: Honorary Fellow, American Institute of Interior Designers

1970: member, Advisory Panel, Washington Center for Metropolitan Studies Department of Housing and Urban Development study)

1971–72: member, Committee for Visual and Environmental Studies, Board of Overseers, Harvard College Visual and Environmental Studies

1972: Visiting Critic in Architecture, Harvard University

1973–1979: George Nelson & Co., Designers and Planners, 251 Park Ave. South, New York

1973: member, Systems Committee, American Institute of Architects

1973: Visiting Critic in Architecture, Harvard University

1974–75: member, Committee to Visit the Department of Visual and Environmental Studies, Board of Overseers, Harvard College

1974: Visiting Lecturer in Architecture, Faculty of Design, Harvard University Design, Harvard University

1975–76: Lecturer in Architecture, Faculty of Harvard University Design, Harvard University

1975–1977: Visiting Distinguished Professor, Pratt Institute School of Architecture Architecture, Brooklyn, NY

1982: chairman, International Design Conference, Aspen

1982 on: advisor, Visual Technology Center, Massachusetts College of Art, Boston Boston

1984: Scholar in Residence, Cooper-Hewitt Museum, New York

1984: member, Presidential Design Awards Jury, National Endowment for the Arts

1984–1986: Professor of Design Research, University of Michigan, Ann Arbor

died March 5, 1986

Chronology of Work

Products are dated (wherever possible) to inception of design work, not by date of production. Exhibitions are dated by their openings. Some dates are inexact. No completely accurate record exists—in either the Nelson or the Herman Miller archives—of all the work done or all the designs not produced. Wherever possible, names have been included of the designers in the Nelson office who were primarily involved in the work, all of which was directed by Nelson.

1932

Competition-winning drawings, Prix de Rome

1932–1941

Exhibit, Chicago World's Fair, General Foods (in partnership with William Hamby?)

Penn Drug stores, New York

Prefabricated house, Long Island

1933

Penn Drug stores, Long Island

House, A. S. Dwight

1934

Hamby worked on designs for the "China Clipper" for Norman Bel Geddes; Nelson worked for the architecture firm Adams and Prentice.

1935

(part of year as above)

Basic house planning and research, *Architectural Forum*

Penn Drug stores, New York

1936

Offices, John Brotherhood, New Canaan, Conn.

House, John Hamilton, Greenwich, Conn.

House, R. Girdler, Greenwich, Conn.

House, Jules Singer, Long Island

1937

Article and house, *House & Garden*

Article and house, *Collier's Magazine*

Offices, Laird & Co., Wilmington, Del.

Apartment interior, M. Bourjaile, New York

Offices, United Features Syndicate, New York

House, William Harris, Greenwich, Conn.

1938

Remodeling, D. McKeon, Ridgebury, Conn.

House, M. Griffin, Yonkers, N.Y.

Remodeling, R. Douglas, L.I.

Articles and houses, *McCalls Magazine*

Remodeling, M. Lauria, Central Valley, N.Y.

Stores, William Berri, Miami, Fla.

House, J. Kauffman, New Brunswick, N.J.

Houses, A. Woodard, Clinton, N.J.

House, G. Meissner, L.I.

House, P. Deisroth, Suffern, N.Y.

Remodeling, S. Fairchild, L.I.

House, G. Borgerson, L.I.

Store, Lehman Radio Shop, New York

Offices, *March of Time,* New York

1939

Prefabricated house, A. S. Dwight, Conn.

House, E. White, Fla.

Park, Great Neck, N.Y.

Various buildings and offices, L.I.

Photo office, H. Herbert, New York

Photo offices and laboratory, Pavelle Laboratories, New York

House, W. Little, L.I.

"Yale-Life Conference on Housing" exhibit, New Haven, Conn.

1940

Remodeling, A. S. Dwight, Conn.

Laboratories, *McCall's Magazine,* New York

House, A. Guevjian, Conn.

House, H. Whitman, L.I.

Speculative houses, Palcolini Co.

"40 under 40" exhibit, Architectural League, New York

House, Sherman Fairchild, 17 East 65th St., New York

Cover design, Beaux Arts Diamond Ball program

1941

Farm buildings, A. D. Dwight, Conn.

Cottages, B. Whitman, Cape Cod

Cottages, J. Crane, Cape Cod

House, W. Taylor, L.I.

House, H. L. Gage, Mass.

Remodeling, B. Stevens, Oscawanna, N.Y.

House, W. Zerbo, Conn.

House, W. Brown, Conn.

Gas stations, Socony Vacuum

Offices, *Fortune Magazine,* New York

School and gymnasium, Virginia Union University, Richmond

"Versus" exhibit, Architectural League, New York

1944

Nelson's own office at *Fortune*

Storagewall (with Henry Wright)

1945

Work for Dr. Frank Stanton (with Henry Wright)

1946

Work for Fenton Glass Co.

Furniture for Herman Miller, Zeeland, Mich.: first collection, designed with Irving

Harper and Ernest Farmer, totaling approximately 80 pieces and including slat/ platform bench, bench pads, 4600 cases, storage headboards and matching bedside units, suspended vanity, additional vanities and mirrors, beds and bedside tables, dining tables including gateleg, occasional tables, 4658 home desk, 4753 drop-leaf desk and other 4700 series desks, radio cabinets and chests, coffee table with extensions, sectional seating, occasional seating, and door/drawer pulls.

Logo and graphics (designed by Irving Harper) for Herman Miller

Herman Miller advertisements (designed by Irving Harper)

1947

Offices, George Nelson & Co., 343 Lexington Ave., New York

Lighting fixtures, including table lamps and wall sconces, General Lighting

Exhibit of prize-winning greeting cards, "The Artist in Social Communication," and accompanying brochure, Gartner and Bender

Advertising and graphic design for Herman Miller

Display, Flexalum Blinds, Hunter Douglas

Rib-Strut system, a demountable frame for exhibits, graphics and interiors, marketed under the name Struc-Tube and used for the Gartner and Bender-sponsored show at the Brooklyn Museum as well as the Nelson office on Lexington Avenue.

The Nelson office also designed a traveling display of cards and a box to hold samples for dealers. It also organized a new business for Gartner and Bender, called Artifax and launched in 1950, consisting of art reproductions on cards that were packaged for sale in book stores. Irving Harper designed the graphics for the system and for Artifax.

Furniture for Herman Miller, including 4663 chair, 4669 chair, 4671 chair, and vanity and dressing room stools

Series of wall and table clocks, including 4755, called the Ball clock and designed primarily by Irving Harper, Howard Miller Clock Company, Zeeland, Mich.

1948

Vertical blinds, Flexible Blind Company (Hunter Douglas)

Showroom interiors, Grand Rapids, Mich., for Herman Miller

Showroom interiors (designed by Irving Harper with Jack Dunbar), Chicago, for Herman Miller

Advertising and graphics for Herman Miller

1949

Collection of table and wall clocks, called Modern Clocks, for Howard Miller

Tableware, Pickard China

House, Sidney Johnson, East Hampton, N.Y.

Store interiors, Liebermann Trunk Company, Mich.

Jewelry designs, Ciner Manufacturing

One interior and catalogue design for "Exhibition on Modern Living," Detroit Institute of the Arts

Furniture for Herman Miller, including Basic Storage Components (BSC), Executive Office Group (EOG), Steelframe desks, executive desk and chair, office swivel chair, highback executive tilt swivel chair, Swaged-leg desk

Advertisements and graphics for Herman Miller

1950

Fabric designs, Schiffer Prints

Armchair, occasional table, coffee table, Arbuck, Brooklyn

Axe with vinyl plastisol-coated edge, Collins Co.

Wallpapers, Concord Wallpaper Co.

Corporate image program, including packaging, truck signage, and stationery, for Aluminum Extrusions, a division of Aluminum Manufacturers, Charlotte, Mich. Drawings for the company's later-introduced Omni System, brochure, advertising, sales bulletins, merchandising programs, exhibit design, first showroom, work continued through 1959

Factory plan and model, Ansul Chemicals

Centrifuge with timer, called Adams Sero-Fuge, Clay Adams

Furniture for Herman Miller, including 5088 daybeds, 5400 group padded storage headboards, 4200 steelframe series headboards, bedside units, 5500 cane series headboards and units, 5068 Steelframe seating system including Angle-iron chair, 5063 Tubular chair, Lazy Susan dining table, Memphis Townhall seating, original flexibile radius seating, Laminated chair (later known as Pretzel)

Advertising and graphics for Herman Miller

Holiday House, interiors and exterior, *Holiday* magazine, Quogue, N.Y.

House, Rev. and Mrs. Woodroofe, L.I.

1951

Designs for the Experimental House, with Gordon Chadwick et al., continued in the Nelson office through 1957

Logo, graphic applications for labels, bottles, display unit, Lexol

Furniture for Herman Miller: continued work on Basic Storage Components initiated in 1949

Advertisements and graphics for Herman Miller

Fireplace accessories for Howard Miller

Stationery and logo, Price Brothers

1952

Designs for molded melamine dinnerware, called Prolon Dishes, Pro-Phy-Lac-Tic Brush Company

Designed logo for new imprint, Interiors Library; designed, wrote, and edited *Living Spaces* (Whitney Publications)

Designed corporate identity program and product (continuing through 1957) for Aluminum Extrusions, a division of Aluminum Manufacturers, Charlotte, Mich., including a proposed highway billboard with the AE trademark by Carl Ramirez, sales promotion and job estimate brochures by George Tscherny and Irving Harper, industrial and institional advertisements by George Tscherny, Irving Harper, Tobias O'Mara, and Don Ervin, the company's Steady Customer Calendar for (1956, 1957, 1958) by Tobias O'Mara, Don Ervin, and George Tscherny, exhibits for trade shows by Robert Gargiule, giveaway folder for trade shows by Don Ervin. George Tscherny designed the AE trademark applications. Irving Harper was associate in charge of design direction. Don Ervin was in charge of graphics.

Designed corporate identity program and product, called Omni, for Structural Products Inc. (SPI), another offspring of Aluminum Extrusions, a division of Aluminum Manufacturers, Charlotte, Mich. Trademark, trademark applications and standard parts catalog were designed by Fred Witzig. Brochure for Omni was designed by Don Ervin. Omni trademark was designed by Herbert Lee. Work continued through 1959.

Office interiors, Chicago and Milwaukee, CBS, New York.

Store interiors, Liebermann's, Lansing, Mich.

Model interiors for R. Buckminster Fuller's geodesic dome

Nelson and Gordon Chadwick designed the master plan for a four-building factory complex/furniture manufacturing facility, arranged around a central courtyard, for Herman Miller. The facility was built in stages.

Furniture designs for Herman Miller, included miniature cases, Rosewood case group 5200 series (later called the thin-edge group and including a series of cabinets and bed), and nursery chest

Graphics for Herman Miller

Bubble lamps, Howard Miller

Model kitchen designed for advertising purposes, Tile Council of America

Tableware, Walker China

1953

Designed exterior and interior of model house, American Homes.

Residence, Sidney Robbins. work continued through 1955

Nelson was retained by General Electric Corporation to support the activities of its internal design staff for major appliances. Nelson brought in Latham, Tyler and Jensen of Chicago. Two results of the venture were the Mini-Max kitchen and the Mechanical Storage Unit, which were shown in model form at Appliance Park in Louisville. The consultancy lasted through 1962.

Furniture designed for Herman Miller, including thin edge beds and vanity, chrome-based chaise longue designed by Irving Harper, cast-leg table, 5559 pedestal tables, 5496 roll-top desk, 5260 and 5464 X-leg Extension tables, 5259 Oval soft-edge dining table, and a never-produced folding chair

Advertisements and graphics for Herman Miller

China clocks, Howard Miller

Model for plywood house

Residence, Gerard Spencer, Sea Cliff, N.Y.

Designed, wrote, and edited *Chairs* and *Display* (Interiors Library, Whitney Publications)

1954

Designed decorative laminated safety glass, marketed as Saflex by Monsanto

Designed Information Center for *New York Times,* Cross County Shopping Center, Yonkers, N.Y.

Store interiors, Style Shop, Grand Rapids and Lansing, Mich.

Designed Carvel Hall, a stainless steel flatware pattern, plus packaging, other flatware and an electric knife sharpener for Chas. D. Briddell Inc. Steelsmiths

Spotlight fixture (never produced, projected for CBS Television), Century Lighting

Kitchen interior, Leopold residence

Furniture designs for Herman Miller, including the 4000 series Steelframe case group, Flip-top dining table, Modular conference table, Sectional seating, Deep seating, Modular steel bench, 5468 Dining chairs, Swaged-leg chairs with fixed or flexible backs, Swaged-leg table, and Lounge chair

Advertisements and graphics for Herman Miller

Birdhouses, cabinets, calendar, Howard Miller

Designed, wrote, and edited *Storage* (Interiors Library, Whitney Publications)

1955

Interiors, Milwaukee and Chicago offices, CBS Television

Work for Inland Steel

Adams Sero-Fuge, Clay-Adams Inc., New York

Interiors, Kellog Center for Continuing Education, University of Georgia, Athens

House by Nelson and Chadwick, Architects, Mr. and Mrs. J. T. Kirkpatrick, Kalamazoo, Mich.

Interiors by George Nelson and Company, Mr. and Mrs. J. T. Kirkpatrick, Kalamazoo, Mich.

Bottles and packaging designs, Calvert Distillers

Designed a series of new metal meshes, known as Expanded Metals, and an explanatory brochure for United States Gypsum

Trademark applications, Gulf Oil Company

Furniture for Herman Miller, including Modular seating group with daybed, Occasional tables, Home desk, MMG (Middle Management group) basic components begun, High-back chair, Coconut chair and ottoman, Flying Duck chair, Sectional seating, and H-Leg tables

Advertisements and graphics for Herman Miller

Product designs for Omni system, graphics, advertising, SPI (Structural Products Inc.), a spinoff company of Aluminum Extrusions, a division of Aluminum Manufacturing, Charlotte, Mich.

1956

Renderings for a residence, Pease Woodwork

Interiors and exhibition, Visitors' Information Center, Colonial Williamsburg (work continued through 1959)

Furniture for Herman Miller: Steelframe modular seating system, Loose cushion seating group (chairs, sofa), Marshmallow sofa/love seat, Occasional pedestal tables, High EOG, Swaged-leg chair and home desk, Thin edge cases, 0200 group, Miscellaneous deep seating, Caned-back group (chairs and settees), High-back lounge chair, Black frame group, Sculptured group, Kangaroo chair (5672)

Advertising and graphics for Herman Miller

Clocks and chair lights for Howard Miller

Glassware and vases, Morgantown Glass

House and interiors (Nelson and Chadwick, Architects), for Otto Spaeth, L.I.

1957

Complete corporate image program, including new logo, letterhead, packaging, building signage, literature, for Abbot Laboratories

George Nelson and Company, with Lucia Neumann as design coordinator, designed a bedroom for the exhibit "Home Furnishings Old and New," at the Brooklyn Museum

Decorative surface designs, Pioneer Plastics Corp.

Designs for a turntable, turntable case, and packaging for Audax speakers (Ronald Beckman, designer in charge) for Rek-O-Kut

Work for American Telephone and Telegraph Co.

Exhibit on communications and creativity, McCann Ericson, New York

Residential interiors, William Dunlap, Mich.

Furniture for Herman Miller, including Multi-service cases, Round tube base conference table, 5770 Swivel desk chair, 5774 Swivel desk chair, CSS (Contemporary Storage Systems) see also 1962/1963, and finalized MMG

Advertising and graphics for Herman Miller

Prototypes for various equipment cases, IBM

Interiors, Irving Richards

Work for Treasurer of the United States

Clocks to which advertising could be attached, for installation in subways, for Time Control. Produced by Clock Spectacular Division of Self Winding Clock Co. "Atoms for Peace," an early, never-realized proposal for the American National Exhibition in Moscow, U.S. Information Agency

"U.S. Education for Design in the Theatre" for São Paulo (USIA)

1958

Three fire alarms and an interior manual coded fire alarm station, Acme Fire Alarm Co.

Furniture for Herman Miller: Black Frame Group cases and tables, CSS (Comprehensive Storage System) with desk, 9000 Black frame desk group, stick chairs, Contract bench system, executive swivel chair, Swaged-leg desk, modular seating, Pretzel chair (bentwood or laminated wood, side and arm chair versions), High EOG, Swaged-leg group (chairs, desk, tables worked on by Charles Pollock under the supervision of John Pile; chairs went through several versions, one of which was constructed of two pieces of molded fiberglass)

Advertising and graphics for Herman Miller

"Atoms for Peace," an exhibit on atomic energy in Cairo, for USIA

"Chairs from Machines," traveling exhibit, Herman Miller

Interiors for model house in St. Louis, General Electric

Desk and executive accessories, Giftcraft Leather Company

Designs for sink, bathtub, and toilet, Ingersoll Humphries

Interiors and signage, Miller's Bootery, Tallahassee

"Design Today in America and Europe," an exhibit designed for the government of India based on the Good Design shows of New York's Museum of Modern Art

Four rugs, V'Soske, New York

1959

"Atoms at Work/Atoms for Peace," an award-winning exhibit in Cairo that included a section called "Isotopes for Industry," designed for Atomic Energy Commission, sponsored by USIA

"American National Exhibition in Moscow," the first U.S. exhibit in the Soviet Union, for USIA

Furniture for Herman Miller, including Individual conference desk and Flexible radius seating.

Advertising and graphics for Herman Miller

Design of a model warehouse for article in *House & Garden*

Interiors, under the direction of Dolores Engle, for Loeb Student Center at New York University

1960

Restaurant interiors and graphics for Tower Suite and Hemisphere Club in Rockefeller Center, for Restaurant Associates, New York.

Corporate image program, from logo to trade show booth, for Everbrite Electric Signs

Four pattern designs for ceramic tiles (Lucia De Respinis, designer in charge), for Pomona Tile

Ongoing programs for graphics, signage, and interiors (through 1968) for Rosenthal China Corp., New York

Outdoor light fixture with pivoting lens, Nessen Studio Inc., New York

Corporate identity program for Custom Truck Truck Rental Corp., a division of U.S. Freight, New York (work updated 1967–68)

Hospital corridor light, interior signage, Auth Electric

Record covers and point-of-purchase display, Columbia Records, New York

Furniture for Herman Miller, including folding and boat-shaped conference tables

Advertising and graphics for Herman Miller

Interiors, Living for Young Homemakers House, sponsored by *Living Magazine,* Seattle

Logo and letterhead, Huntington Park First Savings and Loan Bank

Model for proposed building, Institute of Life Insurance, for New York World's Fair (not built), Traveler's Insurance Co.

Design for portable record player, RCA, New York

Poster and graphic design, under direction of Don Ervin, for the John Huston film *The Misfits* (Seven Arts Productions)

Designs for a demountable structure for traveling exhibits, USIA

1961

Interiors, including public spaces and council chamber, as well as a chair later produced by Herman Miller, Memphis City Hall

Design for an exhibit in Germany, "Aid to African Nations," USIA

Portable slide projector, Airequipt Manufacturing Company, New Rochelle, NY

Logo design, building signage, and logo applications, American Express

Logo applications, wrapping paper, and packaging, Champion Paper

Residential interiors, Elliot Erwitt

Furniture prototypes for Herman Miller, including Net seating and Prestressed chair

Advertising and graphics for Herman Miller

Casserole pot and an all-in-one cooking appliance called the Roman Kitchen, Designs for R/A

House and interiors (George Nelson and Gordon Chadwick, Architects), for O. R. Johnson, L.I.

Logo and graphic applications, Scott Paper

Traveling exhibit to Soviet Union, "Transportation," USIA

1962

Kitchen interior for Hugh DePree

"Abbott Medical Exhibition," Seattle World's Fair, Abbott Laboratories

Mini-Max, a kitchen unit designed for the compact spaces of mobile homes, trailers, and small apartments, General Electric

Furniture for Herman Miller: Catenary group, CSS (first use as space divider; storage components hung in front of poles, not backs), Flexible Radius (not produced), and Milan Group (not produced)

Advertising and graphics for Herman Miller

Interiors, designed but not built, Huntington Park Savings and Loan Association

Office interiors, George Nelson Associates, 25 East 22nd Street, New York

Residential interiors, George Nelson, 25 East 22nd Street, New York

Map of New York State, built of mosaic and designed for the New York State Pavilion at the 1964 World's Fair

Typewriter, model 108, Royal McBee

Office interiors for Tokyo, Sidney, Paris, Mexico City, London, and Frankfurt, U.S. Travel Services

Exhibit design, installed in Kalamazoo, Mich., U.S. Travel Services

Logo applications, packaging program for PhisoHex and NeoSynephrine, Winthrop Laboratories

1963

Renovation of brownstone structure and interior design, William Alanson White Institute of Psychiatry, Psychoanalysis and Psychology, New York

Exhibit designed to represent the Frick Museum at the 1964 New York World's Fair

New York and Chicago showroom exhibits of 3300 product line, Herman Miller

Furniture for Herman Miller: 3300 cases, Sling sofa (three- and four-seat versions), Fair chair, Granite top table, Modular conference tables, UAL chair (for United Air Lines, never produced), CSS (free standing, away from walls to create islands in large spaces), Seating for Memphis City Hall, Action Office I, and Catenary Group

Advertising and graphic design for Herman Miller

"Showboat," a prototype for a floating Herman Miller showroom on the Mississippi River

Multi-colored tear-shaped dispenser for typewrite eraser tape, Joseph Dixon Crucible Company

Royalite Portable typewriter, Royal McBee

1964

Designs for a resort community in Portugal, Soltroia, S.A.R.L., work continued through 1965 but the project was not built as planned by Nelson

Proposal (not built) for Expo '67 in Montreal, Canada, Alcan Aluminum Company of Canada

Exhibit design for Chrysler Pavilion site, 1964 New York World's Fair

Furniture for Herman Miller: Action Office Group (designs finalized and product introduced), CPS (Comprehensive Panel System), Cube Group, Octagonal Basic Office (never produced), Light Seating, Starter Set (never produced), Vacuum Form chair (never produced), United Airlines Chair (never produced), Wall hung CSS, and Cylinder chair (prototype only, never produced)

Advertising and graphic design for Herman Miller

Interior of Washington showroom, Herman Miller

Interiors, exhibit design, Irish Pavilion, 1964 New York World's Fair

In-store display units for Hudson's (Detroit), Kaufmann's (Pittsburgh), Woodward & Lothrop (Washington, DC), Lenox China

Store interiors, Liebermann's, Lansing, Mich.

GB/MN typewriter, Royal Turtle typewriter, and Royal Safari typewriter, Royal McBee

"Hall of Presidents Exhibit," Federal Pavilion, 1964 New York World's Fair

1965

Graphic Design, Ford Motor Co.-Training Aides Catalog

Surface patterns for Darvyl, sketches and prototypes for a modular shower and vanity, Du Pont, Wilmington, Del.

Residential interiors, Julian Falk, New York

Office interiors, fifth floor, Federal Reserve Bank of New York

Furniture for Herman Miller: EOG 5000 series, EOG 9000 series, Conference table, "Action Wall" space divider, Library group, and CPS (Comprehensive Panel System)

Graphic design for Herman Miller: catalogue pages for Comprehensive Storage System

Packaging and trademark applications, Holt, Reinhart, Winston, New York

Store interiors, Liebermann's, Lansing, Mich. (redesigned in 1971)

New seal design, U.S. Department of Commerce

Interior and exterior signage for White House

1966

Editor II typewriter (introduced in 1969), Olivetti-Underwood

Underground factory, designed but not built, Olivetti-Underwood

K-3000 copier, models, signage, wall clip for Branch Office Display, DE520 Video Display System, truck signage applications, Olivetti (ca. 1966–1968)

Office interiors, ninth floor, Federal Reserve Bank of New York

Trademark applications, Gulf Oil Company

Furniture for Herman Miller: work continued (through 1968) on Basic Office designs begun in 1964

Advertising and graphic design for Herman Miller

Factory exterior and interior completed, Herman Miller, Zeeland, Mich.

Office interiors, not built, graphic applications and store interiors, Rosenthal China Corporation, New York (work continued through 1968)

"Industrial Design USA," a USIA exhibit that traveled to Moscow, Kiev, Leningrad, Iasi, and West Berlin

Packaging for an electronic metronome, American Musical Sales Corporation (AMSCO), division of American Music Publishing Co., New York

Interiors, Brenner Clinic, Lafayette, Ind.

Logo and letterhead, New World Home Corporation

"Projection 21," a series of designs and models for devices that act as connectors, as well as graphic symbols representing mechanical systems, to an exhibition entitled "Design and Decoration Show 1965" (Ronald Beckman, designer in charge)

Residence, Sidney Robbins

1967

Children's furniture, packaging designs, models for a store (not built), Creative Playthings

Showroom interiors, Nessen Lighting

Exhibition Hall, James Madison Memorial Library, Washington, DC, by Nelson and Chadwick, Architects, Architect of the Capitol, Washington, DC (work continued, with many revisions, through 1971, 1974–1976, and 1978)

Designs for auto dealership, Bob Ford Inc.

Furniture for Herman Miller: Cube Group

Advertising and graphic design for Herman Miller

Metal pitcher, Legion Utensils Co., Inc.

Refurbished barge housing a Nelson Associates-designed traveling exhibit for the 150th anniversary of the Erie Canal, National Park Service/New York State Council on the Arts

Programma 101 computer stand, Olivetti-Underwood

1968

Model for unknown exhibit, Brooklyn Museum

Office interiors, Chicago, Milwaukee, CBS Television

Advertising, graphic design, color chart, Danskin

Preliminary planning, design, with Paul Heyer as project designer, for Woodbridge Center Shopping Mall, Woodbridge, N.J. (built, but not as designed by Nelson office)

Graphics program, The Children's Place (work continued through 1970)

Store interiors, The Children's Place, West Hartford, Conn.

Advertising and graphic design for Herman Miller

Graphic design, Ford Service Training Aids Catalog and How You Can Profit From Ford Service Training Programs, Ford Motor Company

Office interiors and display system for client's creative department, Ketchum, McLeod Grove, N.Y.

Consultancy with a study that culminated in *Report on the Educational Environment: Pre-Kindergarten through Grade 3,* and prototypes of modular plastic furniture for use in same, Monsanto

Graphic applications, logo, signage, and window grates, New York Telephone

Studio 45 typewriter, Olivetti-Underwood

Drawings, model for Expo '70, George Nelson, Gordon Chadwick, Paul Heyer, architects; Ingeberg August, associate architect; exhibition designers, George Nelson & Company, Expo '70, Osaka, Japan (entry not chosen)

Graphics, signage, store interiors (Paul Heyer, project director) for Rosenthal China Corp.

Marquis design for a Loews theater showing *2001, A Space Odyssey,* W. N. Schneider Co.

Design (by Nelson & Chadwick, Architects) for a model service station and graphic design for a brochure, *George Nelson, FAIA, Enhances Service Station Design with Wood Imaginatively Used,* Weyerhauser Co.

1969

Graphic program and applications, including logo, letterhead truck signage, signage, business forms, publications, advertising, packaging, Hanes

Designs for a service station, Kerr-McGee, Oklahoma City

Store interiors, The Children's Place, Echelon, N.J.

Store interiors, The Children's Place, Willowbrook, N.J.

Self-service model gas station, not built, BP Oil Corp., Atlanta (work continued through 1971)

Packaging program, signage, catalogue from graphic standards designed by Pentagram, BP Oil Corp., Atlanta (through 1971)

Office interiors, BP North America, Atlanta

Designs by George Nelson and Gordon Chadwick, Architects, for pre-fabricated houses, including kitchens, and for a model community, Jonathan Development Corp., Jonathan Minn. (work continued through 1971, but house never went into production and community was never built)

Interiors and store fixtures, by George Nelson and Gordon Chadwick Architects, Barney's, New York (a client until 1980, the store was redesigned several times over the years)

Advertising and graphic design for Herman Miller

Photography and poster for art exhibit in Los Angeles, Foster and Kleiser

Nimbus chandelier with polished acrylic dome and acrylic tubes, Nessen Lighting, New York

Showroom interior at 500 Park Avenue, designed but not built, Olivetti, New York (ca. 1969)

Sycor, Olivetti, New York

Clocks designed for use in public spaces, Time Control

1970

Restaurant interiors, signage, graphic design, by George Nelson and Gordon Chadwick, Architects, Charles Morris Mount, project director, La Potagerie, 554 Fifth Avenue, New York

Exhibit at the Corcoran Gallery and planned travelling museum consisting of inflated modular hemispheres, by George Nelson & Co. and Charles Forberg Associates, National Art Fleet

Designs for a pyramid-shaped branch bank, People's Trust and Savings Bank, Fort Wayne, Ind.

Development of visual standards that evolved into "How to See," the germ for Nelson's later book, Social Security Administration, Washington, DC (again a client from 1974–1976)

Bags, boxes, gift wrapping, and catalogue, Climax Manufacturing Company

Renderings for a proposed visitor's center (never built), New England Electric

Packaging, Pavelle

Portable "communications" center, called Portacom, Stelman

Designs for interiors, furnishings, signage, including development of prototypes for patient seating (never produced), Lincoln Hospital, Bronx, N.Y. (ca. 1970–1976)

"Research & Development-USA," USIA exhibit traveling to Tbilisi, Moscow, Volgograd, Kazan, Donetsk, Leningrad, Hungary, Poland, and Rumania; George Nelson & Company responsible for exhibit, graphics, structural design, and on-site supervision

1971

Prototype for a water-conserving toilet, called Sponder Water Control, Water Control Products Inc. (work resumed 1974–1976)

Ongoing consultancy that, over the years, studied the client's graphic presentation of published research and developed new graphic standards, National Institutes of

Health (work continued 1974–1979, 1983)

Store interiors and signage, Franklin Simon, Atlanta

Furniture for Herman Miller, including Airport Seating (not produced) and Light Office Chairs

Redesign of store interiors, Liebermann's, Lansing, Mich.

Display cases for Costume Institute, Metropolitan Museum of Art, New York

Completion of Pyramid Branch (George Nelson and Gordon Chadwick, Architects, Alan R. Grinsfelder, supervising architect), People's Trust Bank, Fort Wayne, Ind. Signage, Reuters

1972

Logo and letterhead, Institutes of Religion and Health

Consultancy to develop seminars and conferences, Cooper-Hewitt Museum, New York

Interiors (not built), Dayton Hudson Jewelers

Dentist's office interiors, Prescott Epstein

1973

Models and presentation drawings as competition entry for a sports and entertainment complex in Florida, never built, Interama (through 1975)

Office interiors, for which Nelson developed a new office landscape system called Nelson Workspaces ultimately manufactured by Storwal Co., that incorporated a program of fabric art, banners and tapestries designed and woven for the site, Aid Association for Lutherans (AAL), Appleton, Wisc. (project continued through 1978)

Exhibit and case designs for Lexis/Nexis systems, MDC (Mead Data Central)

Model and design program for a hospital, which was built but not as designed by the Nelson office, Fundacion Santa Fe de Bogota, Bogota, Colombia

Audio equipment, Harman Kardon Inc.

Interiors for Garden Restaurant in New York Merchandise Mart, Rudin Management

Original concept drawings, Nelson Workspaces

Designs for an underground city that Nelson directed for a Harvard Student Project, supported by Graham Foundation funds and eventually published as The Hidden City in *Architecture Plus* and in *Harvard Graduate School of Design News*

1974

Monitor enclosure, base and keyboard enclosure for ATEX editing terminal (produced in 1977), Mead Data Central

Restaurant interiors for McDonalds, Third Avenue, New York (Gordon Micunis, project director)

Model, Nelson Workspaces

1975

Graphic design for a brochure written by Brendan Gill for U.S. Custom House and published by New York Landmarks Conservancy; exhibit design for same, called "Public Property," New York Landmarks Conservancy-1976: U.S. Custom House, New York

Light fixtures, known as Half-Nelson and Eyeshade, Koch & Lowy (through 1978)

Logo and graphics program for Schering Plough

Model, Nelson Workspaces

Prototypes, Nelson Workspaces, manufactured and installed at the Aid Association for Lutherans, Appleton, Wisc. (1975–1977)

1976

"USA '76: The First 200 Years," exhibit to tour six American cities, American Revolution Bicentennial Administration in association with the Association of Science and Technology Centers

Designed and edited *Man TransForms,* catalogue for inaugural exhibit of Cooper-Hewitt Museum, New York

Interiors (Katherine Noles, chief designer), Hospital for Joint Diseases and Orthopaedic Institute, New York

Presentation of Nelson Workspaces, Storwal

Latin American Exhibition for Inter-American Cultural & Trade Center, Miami

1977

Material prepared for Goldman Sachs International presentation graphics

Designs for a chair that could be produced by prisoners, Federal Prison Industries

Interiors, Ambulatory Care Center, St. Vincent's Hospital, New York

Lafayette Clinic for Women

1978

Lexis console, Mead Data Central

1979

Proposal for a system, called PAD, with "soft walls" (never produced), Herman Miller

MDC-UBIQ, Mead Data Central

1980

Designed and developed prototypes for Chem Key and Chem Quick, automated teller services, Chemical Bank, New York

Literature for the introduction of Nelson Workspaces, Storwal

MDC-SKP, a calculator-sized supplementary keypad, Mead Data Central

Design for a motorized exhibition for Herman Miller, assisted by Stanley Abercrombie (not built)

1982

Exhibit design, American Cancer Society

Refrigerator unit for executive offices (prototype, not produced), Springer-Penguin

Portable terminal, called MDC-Portable Terminal, Mead Data Central

1983

"Design Since 1945," an exhibition at the Philadelphia Museum of Art (with Kathryn Heisinger et al.)

1984

Post Modern Clocks for Howard Miller

Awards and Honors

1932

Rome Prize

1941

Scarab Gold Medal for Meritorious Work in Architecture

1950

Award for Display Design, Art Directors' Club

Certificate of Merit, American Institute of Architects and Producers' Council

1953

Best Office of the Year prize, *New York Times*

First Award for Excellence in Design, American Institute of Decorators

Gold medal, Art Directors Club of New York

1954

Good Design Award,, Museum of Modern Art

Award for Product Design, Triennale di Milano

Award for Merit, 33rd Annual Exhibition, Art Directors Club

Certificate of Excellence for Fine Craftsmanship in Exhibit Design, American Institute of Graphic Arts

Trailblazer Award for Furniture Design, National Home Fashions League

1955

Certificate of Merit, Art Directors Club

Award for Outstanding Design in Plastics

1956

Certificate of Merit, Art Directors Club

Award for Typographic Excellence, Type Directors Club

1957

Gold Medal, Best Cultural Exhibit, International Biennale, Sao Paulo

Diploma di Collaborazione, Triennale di Milano

1958

Institutions Interiors Award, Georgian University Center for Continuing Education

1959

Trailblazer Award for Most Creative Design in Postwar Years, National Home Fashions League

Certificate of Excellence, American National Exhibition, Moscow American Institute of Graphic Arts

Citation for Outstanding Achievement for Furniture Design, American Institute of Decorators

1960

Certificate of Excellence, Art Directors Club of Philadelphia

Award for Loeb Student Center at New York University, Institutions Award Program

Certificate of Excellence for Outstanding Packaging Design and Certificate of Excellence for Design and Printing for Commerce, American Institute of Graphic Arts

1961

Certificate of Excellence for Superior Concept and Craftsmanship, American Institute of Graphic Arts

Certificate of Excellence, Art Directors Club of Chicago

Award for design of Tower Suite and Hemisphere Club in Time-Life Building, Institutions Interiors Award Program

Certificate of Merit , 40th Annual Exhibition, Art Directors Club of New York

Two Typographic Excellence Awards, Type Directors Club

1962

Certificate of Merit, 41st Annual Exhibition, Art Directors Club of New York

1963

Award for Design Excellence in Typography, Type Directors Club

Award of Distinctive Merit, *CA* magazine

1964

Certificate of Special Merit, Printing Industries of Metropolitan New York

Certificate of Merit, Art Directors Club of New York

Award for Outstanding Achievement in Trademark Design, Society of Typographic Arts

Certificate of Excellence, Society of Typographic Arts

Sling Sofa included in permanent collection of Museum of Modern Art

Honorable mention and Industrial Arts Medal, New York chapter, American Institute of Architects

1965

Alcoa Industrial Design Award

1966

Design Award, American Institute of Decorators

First Award in Business Furniture Design, International Design Award Program, American Institute of Interior Designers

Award for design of Sling Sofa, Schweizer Mustermesses Basel und Schweizerischen Werkbundes

1967

Best Engineering Residential Product, Iron and Steel Institute

Award for contract furniture design, American Institute of Interior Designers

Excellence of Design Award, Art Directors Club of Milwaukee

1968

Olivetti "Editor II" electric typewriter included in permanent collection of Museum of Modern Art

Action Office I selected entry, International Biennal Desinho Industrial, Rio de Janeiro

Certificate of Excellence, American Institute of Graphic Arts

Diploma di Collaborazione, Triennale di Milano

Three Excellence of Design awards, *Industrial Design Review*

1969

Certificate for Outstanding Example of Printing, Printing Industries of Metropolitan New York

1970

Lumen Award for Outstanding Lighting Achievement

Award of Excellence, *Communication Arts*

1971

Interior Design Award, Institutions/VFM 17th Annual Program

Certificate for Outstanding Example of Printing, Printing Industries of Metropolitan New York

Award for packaging, American Institute of Graphic Arts

1972

Outstanding Design in Structural Steel, American Institute of Steel Construction

Excellence in Packaging Award, American Institute of Graphic Arts

1974

Certificate of Excellence, Deco Press, Milan

1975

Award of Excellence for exhibit design, Federal Design Council

1977

Certificate of Excellence, American Institute of Graphic Arts

Excellence of Design Award, Industrial Design Review

Roscoe Award, Resources Council

Gold Medal Award, Institute of Business Designers

1978

Interior Design Award

1980

Excellence of Design Award, *Industrial Design Review*

1984

Molded walnut plywood tray table (model 4950) included in permanent collection of Museum of Modern Art

Writings by Nelson

"Pencil drawings by George Nelson." *Architecture* (New York), ca. 1929.

"St. Etienne Du Mont, Paris, a lithograph." *Pencil Points,* December 1930.

"Two drawings by George Nelson: Yale Daily News Building." *Architecture,* December 1930.

"On the making of pictures and the thumb-nail sketch." *Pencil Points,* January 1931.

"Drawings for Rome Prize—An auditorium building in New England." *Pencil Points,* June 1932.

"Finalists drawings for the Paris Prize." *Bulletin of the Beaux Arts Institute of Design,* August 1932.

"Both Fish and Fowl" (unsigned). *Fortune,* February 1934.

Illustrations for *Horizon's Rim,* by Alexander Brown (Dodd, Mead, 1934).

"The architects of Europe today: Marcello Piacentini, Italy." *Pencil Points,* January 1935.

"The architects of Europe today: Helweg-Moeller, Denmark." *Pencil Points,* February 1935.

"The Architects of Europe today: Gebrüder Luckhardt, Germany." *Pencil Points,* March 1935.

"The architects of Europe today: Gio Ponti, Italy." *Pencil Points,* May 1935.

"The architects of Europe today: Le Corbusier, France." *Pencil Points,* July 1935.

"The architects of Europe today: Van der Rohe, Germany." *Pencil Points,* September 1935.

"The architects of Europe today: Ivar Tengbom, Sweden." *Pencil Points,* November 1935.

"The architects of Europe today: Giuseppe Vaccaro, Italy." *Pencil Points,* January 1936.

"The architects of Europe today: Eugene Beaudouin, France." *Pencil Points,* March 1936.

"The architects of Europe today: Raymond McGrath, England." *Pencil Points,* June 1936.

"The architects of Europe today: Walter Gropius, Germany." *Pencil Points,* August 1936.

"Fairs" (unsigned). *Architectural Forum,* September 1936.

"The architects of Europe today: Tecton, England (Anthony M. Chitty, Lindsey A.T.W. Drake, Michael A.S. Dugdale, Valentine Harding, Lubetkin, Godfrey H. Samuel, and Russell T.F. Skinner)." *Pencil Points,* October 1936.

"Domestic interiors" (unsigned). *Architectural Forum,* October 1937.

"Notes on the monotype: A few experiments with a neglected medium." *Pencil Points,* December 1937.

"Frank Lloyd Wright"(unsigned). *Architectural Forum,* January 1938.

"Where is modern now?" (unsigned). *Architectural Forum,* June 1938.

"Albert Kahn." *Architectural Forum,* August 1938.

The Industrial Architecture of Albert Kahn. Architectural Book Publishing Co., 1939.

"Worlds fairs: New York, San Francisco" (unsigned). *Architectural Forum,* June 1939.

"TVA program." *Architectural Forum,* August 1939.

"The small house grows up." *Parents Magazine,* August 1939.

"When you build your home—The site." *Arts & Decoration,* February 1940

"When you build your home—Learning to read the blueprints." *Arts & Decoration,* March 1940.

"When you build your home—Windows and doors." *Arts & Decoration,* April 1940.

"When you build your home—Floors." *Arts & Decoration,* June 1940

"We've got a place in the country" (with William Hamby). *McCalls,* June 1940.

"Our little house in the country—Watch it grow" (with William Hamby). *McCalls,* July 1940.

"When you build your home—Heating." *Arts & Decoration,* September 1940.

"1930–1940: The design decade" (unsigned). *Architectural Forum,* October 1940.

"When you build your home—Bathrooms." *Arts & Decoration,* January 1941.

"Goodby Mr. Chippendale: Contemporary designers use the materials of today to design for the living" (unsigned). *Fortune,* January 1942

"Your children could romp here while you shop" (advertisement, Revere Copper & Brass, Inc.). *Saturday Evening Post,* February 13, 1943; *Architectural Forum,* March 1943.

"Grass on Main Street" (advertisement, Revere Copper & Brass, Inc.). *Magazine of Art,* 1943.

"Houses for human beings" (unsigned). *Fortune,* April 1943.

"Department Store in 194X" (advertisement, Barrett Division of Allied Chemicals), 1943.

"Building is a happy hunting ground for the predictioneers." *Retailing Home Furnishings,* December 27, 1943.

Planning With You (by the editors of *Architectural Forum*). Time, Inc., 1943.

"Stylistic trends in contemporary architecture." In *New Architecture and City Planning,* ed. P. Zucker (Philosophical Library, 1944).

Tomorrow's House (with Henry Wright). Simon and Schuster, 1945.

"A portfolio of ideas for home planning." *Life,* May 1945.

"Ideas for houses: The U.S. must accept a lot of unfamiliar ones to make its new homes genuinely up-to-date" (with Henry Wright; a condensation of *Tomorrow's House*). *Life,* December 3, 1945.

"Fuller's House" and "Service in a Package" (unsigned). *Fortune,* April 1946.

"Housing." *Architectural Forum,* April 1946.

"Wright's houses: Two residences, built by a great architect for himself." *Fortune,* August 1946.

"Venus, Persephone and September Morn." *Interiors,* May 1947.

"The furniture industry: Its geography, anatomy, physiognomy, product." *Fortune,* January 1947.

"Styling, organization, design." *Arts + Architecture,* August 1947.

"That Hotel Boom" and "Hotel Design." *Fortune,* September 1947.

"What is happening to modern architecture?" (report of symposium at which Nelson was a panelist). *Museum of Modern Art Bulletin,* spring 1948.

"A query." *Interiors,* January 1948.

"*Holiday* houses: An architect suggests new plans for vacation living." *Holiday,* May 1948.

"Problems of design: Ends and means." *Interiors,* May 1948.

"Blessed are the poor. . . ." *Interiors,* July 1948.

"Introduction to Italian design." *Interiors,* July 1948.

"The dead end room." *Interiors,* November 1948.

"Beware of trends." *Interiors,* December 1948.

The Herman Miller Collection. Herman Miller, Inc.,1948 (reprinted 1950).

"*Holiday* convertible: The basic plan of this country place allows for easy adaptation and expansion to suit any changing needs the future may bring." *Holiday,* January 1949.

"New World Xanadu of steel & glass." *Interiors,* January 1949.

"Mr. Roark goes to Hollywood." *Interiors,* April 1949.

"Modern furniture . . . An attempt to explore its nature, its sources, and its probable future." *Interiors,* July 1949.

"Business and the industrial designer: When they lose their fear of each other, they'll sell more goods." *Fortune,* July 1949.

"Modern decoration." *Interiors,* November 1949.

"Homes in the sun." *Holiday,* January 1950.

"The body beautiful: From the business side of the footlights." *Interiors,* June 1950.

"The contemporary domestic interior." *Interiors,* July 1950.

"The new subscape." *Interiors,* November 1950.

"Luxury and the pursuit of comfort." *Holiday,* 1950.

"*Holiday* handbook of the second house." *Holiday,* ca. 1950.

"The enlargement of vision." *Interiors,* November 1951.

"After the modern house." *Interiors,* July 1952.

"A clay tile kitchen" (advertisement, Tile Council of America). *House Beautiful,* August 1952.

"Aspen conference on design." *Fortune,* September 1952.

The Herman Miller Collection. Herman Miller, Inc., 1952.

Living Spaces. Whitney Publications, 1952.

"The individual house." In *Building Types,* volume 3 of *Forms and Functions of 20th Century Architecture,* ed. T. Hamlin (Columbia University Press, 1952).

Chairs. Whitney Publications, 1953.

Display. Whitney Publications, 1953.

Storage. Whitney Publications, 1954.

"Good design: What is it for?" *Interiors,* July 1954.

"Art X = The Georgia experiment." *Industrial Design,* October 1954.

"Storage." *Interiors,* December 1954.

"Developing a communications program that stimulates salesmen." Volume 95 of *Guides to Strenthening the Sales Effort* (American Management Association, 1954).

A Storagewall Designed by George Nelson. Brochure SA-184, United States Plywood Corporation, 1955.

"High time to experiment." *Phillips Bulletin* (Phillips Academy), November 1955.

"Captive designer vs. (?) 'independent' (!) designer." *Industrial Design*, August 1956.

Problems of Design. Whitney Publications, 1957.

"Schools." *Interiors,* February 1958.

"Down with housekeeping." *Holiday,* March 1958.

"*Holiday* handbook of beds." *Holiday,* August 1958.

"George Nelson statement on kitchen trends." *Housewares Review,* 1958.

Plastics in Building. Preprint book for 15th Annual Conference of Society of Plastics Engineers, New York, 1959.

"What I see in Japan." *Jetro* (publication of Japan Trade Council), 1959

"Designer's comments and extracts from log." *Industrial Design,* April 1959.

Memo on American National Exhibition in Moscow. Herman Miller, Inc., October 1959.

"A matter of fluidity." In *This Is Japan 1959.*

Industrial Design. Voice of America Forum Lecture Series, 1960.

"Impressions of Japan." *Holiday,* February 1960.

"Brasilia: Out of the trackless bush, a national capital." *Saturday Review,* March 12, 1960.

"Upside-down in Japan." *Reader's Digest,* April 1960.

"*Holiday* handbook of beach houses." *Holiday,* August 1960.

"Todays planning problems call for bold solutions." *Southern Builder,* September 1960.

"How to kill people: A problem of design" (transcript of appearance on CBS television show "Camera 3," November 20, 1960). *Industrial Design,* January 1961.

"Impressions of Moscow." *Holiday,* January 1961.

"Moscow exhibition in retrospect." *Display World,* January 1961.

"*Holiday* handbook of American architecture." *Holiday,* July 1961.

"People to product relationship." *Industrial Design,* May 1962.

"The passionate arts." *Holiday,* October 1962 .

"French architects renew an old acquaintance." *Architectural Forum,* November 1962.

"Molti libri, molti oggetti: la casa di George Nelson a New York."*Domus,* December 1962.

"Production without consumption." *Stile Industria,* December 1962.

"Production without consumption." *Ulm 7,* January 1963.

"New building abroad: Switzerland." *Architectural Forum,* June 1963.

"Una Baracca molto amata: la casa di George Nelson a Long Island." *Domus,* August 1963.

"Prima dell'apertura, una visita alla Fiera di New York." Domus, May 1964

"Autofriedhöfe." *Du,* October 1965.

Preface to *Graphic Design Manual: Principles and Practice,* by Armin Hoffman (Reinhold, 1965).

"New Haven and its mayor: Their urban renewal plan can serve as an example to the nation." *Holiday,* May 1966.

Japan: A Different Way. Science Research Associates, 1966.

Foreword to *How to Wrap Five Eggs: Japanese Design in Traditional Packaging,* by Hideyuki Oka (Harper & Row, 1967).

"Architecture for the new itinerants." *Saturday Review,* April 22, 1967.

"One world architecture." *Current,* August 1967.

"George Nelson reviews *Designing for People* and *The Measure of Man: Human Factors in Design,* both by Henry Dreyfuss." *Architectural Forum,* June 1968.

"The U.S. at Osaka." *Architectural Forum,* October 1968.

"Don't fire until you see the tops of their roofs." *McCall's,* November 1968.

"Effect on artistic activity." In *Committed Spending: A Route to Economic Security,* ed. R. Theobald (Doubleday, 1968).

"Memo from Tbilisi." *Journal of the Industrial Designers Society of America,* March 1969.

"Working for the government—A designer's view." *Journal of the Industrial Designers Society of America,* June 1969.

"Design, technology, and the pursuit of ugliness." *Saturday Review,* October 2, 1971.

"Design, technology, and the pursuit of ugliness." *Global Architecture,* December 1971.

Making Messages Visible. Social Security Administration, U.S. Department of Health, Education and Welfare, 1972.

"A tribute to Henry Dreyfuss." *Industrial Design,* March 1973.

"Design's great writers." *Harper's,* April 1973.

"The end of architecture." *Architecture Plus,* April 1973.

How to See. Social Security Administration, U.S. Department of Health, Education and Welfare, 1973.

"The designer as social catalyst." *Canadian Architect,* June 1973.

"The humane designer." *Industrial Design,* June 1973.

"The hidden city." *Architecture Plus,* November-December 1974.

"We are here by design." *Harper's,* January 1975.

"Design: The business of survival." *Industrial Design,* March 1975.

"From monuments to bell jars: George Nelson predicts the end of architecture." *RIBA Journal,* October 1973.

"Do small companies need designers?" *Industrial Design,* May-June 1975.

"George Nelson reviews *City Time, City Space,* by Kevin Lynch." *Technology Review,* July-August 1975.

"Interiors: The emerging dominant reality." *Interiors,* November 1975.

Introduction to *Top Symbols and Trademarks of the World,* ed. F. M. Ricca and C. Ferrari (Milan: Deco Press, 1975; distributed in U.S. by Marquis Who's Who Inc.).

Introduction to "Nelson, Eames, Girard, Probst: The design process at Herman Miller."*Design Quarterly* 98–99, 1975.

"About the design of sport equipment." *Du,* July 1976.

Introduction and "The city as mirror and mask." In *Man transForms* (Cooper-Hewitt Museum, 1976).

Learning to See. Catalogue for exhibit at Cooper-Hewitt Museum, sponsored by Johnson Wax, 1976.

How to See: Visual Adventures in a World God Never Made, Little, Brown, 1977.

"Peak experiences and the creative arts." *Mobilia* 265/266, 1977.

The Civilized City, an Illustrated Essay. "Camera 3" (CBS television show), January 2, 1978.

"Organize your living space." *House Beautiful,* April 1978.

"The office revolution at Contract and Architectural Showcase, Toronto." *Canadian Interiors,* June 1978.

"The end of the topless trinities." *The Livable City,* September 1978.

"Tents: A feast for the senses." *Interiors,* December 1978.

"Plagiarism—or how to be creative when no-one is looking." *Mobilia* 280/281, 1978.

The Way We Write. Report, Herman Miller, Inc., 1978.

George Nelson on Design. Whitney Library of Design, 1979.

"The future of the object." *Industrial Design,* March-April 1979.

"Why George Nelson is seduced by woven architecture." *Design Magazine,* April 1979.

"The humane factor: Designs must enhance the quality of human life." *Industrial Design,* May-June 1979.

"A long, cool look at that 'office of the future.'" *Design,* December 1979.

"Mobile seating." *Mobilia* 289, 1979.

"Design and the office in transition: A conversation with George Nelson." In *IDEAS* (Herman Miller, Inc., 1979).

The Way We Write. Second report, Herman Miller, Inc., 1979.

"Tribute to the permissive shell." *AIA Journal,* July 1981.

"Tom Wolfe's fantasy Bauhaus: What's Watts Tower doing in that zigguratrium?" *AIA Journal,* December 1981.

"The age of modern design." *Architectural Record*, February 1982.

"George Nelson reviews *Knoll Design.*" *Architectural Record,* February 1982.

"Those designing Finns." *Signature,* August 1982.

Design and the Corporation. ITT, 1982.

"A tourist's guide to Memphis." *Interior Design,* April 1983.

"A fountainhead in Michigan." *Signature,* July 1983.

"The design process." *Interior Design,* September 1983.

"Vous avez dit Memphis?" *First International Ligne Decoration,* September 1983.

"The design process." In *Design since 1945* (Philadelphia Museum of Art, 1983).

"Design on a small planet." *Industrial Design,* November-December 1983.

"Patent models: Big ideas in small packages." *Smithsonian,* February 1984.

"Technological aspirations." In *American Enterprise: Nineteenth-Century Patent Models* (Cooper-Hewitt Museum, 1984).

'Reflections on home-psych." *Interior Design,* March 1984.

"Winners and losers." *Interior Design,* May 1984.

"Transformations and contradictions." *Interior Design,* September 1984.

"Designing a synthetic planet." *MANAS,* November 7, 1984.

"A 'nice, big book' about the Milan team Memphis." *Architecture,* July 1985.

"High styles." *Interior Design,* February 1986.

"Who designs? An increasing need for exposure to the design process." *Interior Design,* May 1986.

"Design on a small planet." *Industrial Design,* November-December 1987.

George Nelson: Changing the World. University of Michigan, 1987.

Writings about Nelson and His Firms

"Yale-*Life* conference on housing." *Life,* February 13, 1939.

"Fundamentally modern." *House and Garden,* April 1939.

"1930–1940: The design decade." *Architectural Forum,* October 1940.

Geoffrey T. Hellman, "Talk of the town: Sherman Fairchild." *New Yorker,* December 27, 1941.

"Houses for human beings." *Fortune,* April 1943.

"Town house for Sherman Fairchild, New York." *Architectural Forum,* April 1943.

"Men know what they like" and "A bachelor builds a home." *House and Garden,* July 1943.

"The Storagewall." *Architectural Forum,* November 1944.

"The Storagewall." *Life,* January 22, 1945.

"Here is the Storagewall." *Canadian Homes and Gardens,* March 1947.

"Available now: The best furniture in years." *Interiors,* March 1947.

"Herman Miller and stormy petrel George Nelson team up to prove handsome furniture can be had." *Interiors–Industrial Design,* May 1947.

"Reviews: New contemporary furniture offers a wide selection, is designed for volume sales." *Architectural Forum,* May 1947.

"Some furniture to live with." *Harper's,* June 1947.

"There's a new pattern in furniture behavior." *House Beautiful,* June 1947.

"Nelson: Everything in its place and a place for everything." *House and Garden,* July 1947.

"House near Ossining, New York." *Architectural Forum,* August 1947.

"George Nelson, 'bad boy of furnishings,' throws tradition out the window to design a new family of furniture." *Better Homes and Gardens,* August 1947.

Marion Gough, "How to cure your storage troubles." *House Beautiful,* September 1947.

Anne Landor, "Storage space for everything." *Woman's Home Companion,* October 1947.

Harriet Burket, "Furniture for today's living." *Woman's Home Companion,* November 1947.

"Designer at play: George Nelson hits on an oversized Tinker Toy for grown ups." *Interiors–Industrial Design,* March 1948.

"George Nelson joins *Interiors.*" *Interiors,* October 1948.

"New furniture: Top American designers make it simple, slim and comfortable." *Life,* November 15, 1948.

"Three by one (George Nelson designs three showrooms for Herman Miller)." *Interiors–Industrial Design,* May 1949.

"Storage by the yard." *House and Garden,* May 1949.

"Architects design for industry." *Architectural Record,* June 1949.

"Serie Americana." *Domus,* no. 235, 1949.

"Two furniture showrooms." *Progressive Architecture,* April 1950.

"Holiday House incorporates many innovations in design." *Retailing Daily,* August 11, 1950.

"Dali and four fellow modernists meet to introduce drapery fabrics." *Look.*

Carl Biemiller, "Holiday House." *Holiday,* May 1951.

"Holiday House: Quogue, New York." *Architectural Record,* June 1951.

"Casa de Vacaciones Modelo." *Nuestra Arquitectura,* June 1951.

"Designers demonstrate." *Look,* September 1951.

Fritz Neugass, "Architektur künstlerisches Gewerbe." *Werk,* June 1952.

"George Nelson." *Everyday Art Quarterly,* no. 24, 1952.

Ruth Moore and Lucia Carter, "Home, sweet factory." *Colliers,* July 4, 1953.

"George Nelson . . . idea man for today's homes." *Friends,* December 1953.

M. Constantine, "George Nelson and Associates: The projection of industrial design into advertising." *Graphis* 9, no. 49, 1953.

"On George Nelson's Freedom House." *PF,* March 1954.

"Three good planning ideas make three good selling points." *House and Home,* April 1954.

"Above all, people want more space." *House and Home,* May 1954.

"George Nelson designs 'modern' houses for the birds." *Life,* March 7, 1955.

"Diary of a packaging problem." *Printers Ink,* September 30, 1955.

"Do decanters help liquor sales?" *Tide,* January 28, 1956.

"Project design: What the industrial designers are doing." *School Shop,* February 1956.

"George Nelson designs for Lord Calvert." *Spirits,* March 1956.

"Design for merchandising." *Industrial Design,* April 1956.

"Design in the bargain." *New York Times Magazine,* September 9, 1956.

"New continuing education center at the University of Georgia." *Georgia Education Journal* 50, no. 5, January 1957.

"Merchandising with miniatures: George Nelson makes models to make clients." *Interiors,* December 1956.

"Architects' furniture." *Time,* February 18, 1957.

"The grand old shingle: Otto Spaeth house." *Architectural Forum,* October 1957.

"Designers—That extra touch." *Newsweek,* November 25, 1957.

"The George Nelson office: A comprehensive design organization" and "Experimental house by Nelson and Chadwick." *Architectural Record,* December 1957.

Review of *Problems of Design. Interiors,* December 1957.

"Experimental house." *Architectural Record,* December 1957.

Vera Berry, "Japan combines best from East and West." *HFD,* December 23, 1957.

"Story of the Month—196X." *House and Home,* January 1958.

"The industrialized house: An experiment." *Industrial Design,* January 1958.

"Accent on vertical space: Kirkpatrick house." In *Architectural Record Houses of 1958.*

"New York: The taste shaper." *Look,* February 18, 1958.

"Schools: Georgia adults go back to school in unacademic surroundings." *Interiors,* February 1958.

"The approach to Williamsburg." *Architectural Forum,* February 1958.

"The experimental house." *Ekistics* 5, no. 30, March 1958.

"Williamsburg: A comprehensive design program." *Industrial Design,* March 1958.

"Designers: Men who sell change." *Business Week,* April 12, 1958.

Louise Sloan, "Living Areas." *Progressive Architecture,* May 1958.

"Design for the designers: Three interiors George Nelson inhabits and works in." *Interiors,* May 1958.

"What makes a house modern." *House and Garden,* July 1958.

Doris Denisen, "Six feet of entertainment." *American Weekly,* August 31, 1958.

"How many of these famous designers do you know?" *Canadian Homes and Gardens,* September 1958.

"Under all is the land." *Ownership,* September 1958.

Olga Gueft, "George Nelson's Swaged-Leg Group." *Interiors,* October 1958.

"Omni, manufactured by Structural Products of Charlotte, Michigan." *Interior Design,* October 1958.

"The industrialized house." *Architecture and Building,* November 1958.

"Japanese toys as home decorations." *Sunday Sun Magazine* (Baltimore), November 2, 1958.

Emily Heime, "At home in the office." *Du Pont Magazine,* December 1958–January 1959.

"Rek-O-Kut hi fi stereo arm." AIGA Packaging Competition, 1958.

Elizabeth Sweeney Herbert, "A kitchen that's streamlined." *McCall's,* January 1959.

"Business plans a design program: Interview." *Art in America* 47, winter 1959.

"Hi-fi for the lving room." *Record and Sound Retailing,* January 1959.

"A new kind of expandable storage: Plug ins." *House and Garden,* January 1959.

Cynthia Kellogg, "Striking the right note." *New York Times Magazine,* January 25, 1959.

"'Corner of America' is theme of exhibition set in Moscow." *American Metal Market,* Febrary 10, 1959.

"Work on final plans for U.S. exhibit." *Home Furnishings Daily,* February 11, 1959.

"Plastics with built-in muscles." *Chemistry,* March 1959.

"A room grows up." *Glamour,* March 1959.

"Design show opens in India." *Industrial Design,* March 1959.

"U.S. corner in Russia." *Time,* March 16, 1959.

Ernest Mickel, "U.S. in Moscow." *Architectural Record,* April 1959.

"The U.S. exhibition in Moscow: A large design challenge." *Architectural Record,* April 1959.

"Prize winning folding boxes." *Modern Packaging,* April 1959.

"V'Soske 1959 exhibition of rugs: Refinement of technique turns into art." *Interiors,* April 1959.

"Do you know. . . ." *Charm,* May 1959.

"Symbology—Typography USA: High promise, low fulfillment." *Industrial Design,* May 1959.

"On George Nelson and the Moscow exhibit." *New Yorker,* May 30, 1959.

"The urgency of the symbol." *Art Direction,* June 1959.

"Now let me tell you about my corporate design program." *Print,* June 1959.

"Undulating umbrellas designed for Moscow trade fair." *Progressive Architecture,* June 1959.

"Plastics pavilion in Moscow." *Plastics World,* June 1959.

"Another showing for AIGA exhibit of Japanese works." *Printing News,* June 27, 1959.

Cynthia Kellogg, "American home in Moscow." *New York Times Magazine,* July 5, 1959.

"Audax shows new look in loudspeakers." *Billboard,* July 6, 1959.

"Nixon—Will Khruschev get his message? " *Newsweek,* July 27, 1959.

"Möbel der Herman Miller Furniture Company nun auch in Deutschland." *Die Kunst und das schöne Heim,* July 10, 1959.

"George Nelson designs Audax speakers." *Interiors,* August 1959.

"The Moscow–New York exchange." *Interior Design,* August 1959.

Irma Weinig, "Letter from Moscow." *Industrial Design,* August 1959.

"Pravda snorts, but Soviets come to the fair." *Business Week,* August 1, 1959.

"Special international report." *Newsweek,* August 3, 1959.

"When Nixon took on Khruschev." *U.S. News and World Report,* August 3, 1959.

"The Kitchen Summit." *Time,* August 3, 1959.

"Freedom on show." *Time,* August 17, 1959.

"In Sokolniki Park." *Interiors,* September 1959.

Irma Weinig, "American exhibit combines soft sell with hard facts." *Industrial Design,* September 1959.

"Acrylic cloth for hi-fi spreakers 'hangs on' to high notes." *Plastics World,* September 1959.

"Architectural exhibit at Moscow fair." *Interiors,* October 1959.

"Designing the Moscow exhibit." *Architectural Record,* November 1959.

"A is for Abbott." *Modern Packaging,* November 1959.

"Talk, slides on Russians enthusiastically received by members of So. California chapter." *Southwest Builder and Contractor,* November 27, 1959.

"Fiberglas goes to the fair." *Modern Plastics,* December 1959.

Carlos Baxter, "Designs of our times." *Hotel Gazette,* February 13, 1960.

"What time is it?." *Look,* May 24, 1960.

"Una casa experimental de nossa era." *Habitat,* May-June 1960.

"La casa sperimentale di George Nelson." *Domus,* ca. 1960.

"Student center for big city university: The Loeb Student Center, NYU, Washington Square, NYC" and "Product reports: Improved fire alarm." *Architectural Record,* May 1960.

"Sieges edites par Herman Miller." *Au jourd'hui* 27.

"Tomorrow's home: Comfort in cubes." *Science and Mechanics,* August 1960.

"Top designers tell what's ahead in product design." *Dun's Review and Modern Industry,* August 1960.

"Note on Nelson." *Industrial Design,* October 1960.

"Les meubles de C. Eames et G. Nelson." *La Maison Française,* Novembre 1960.

"Two decades of *Interiors:* 1940–1960." *Interiors,* November 1960.

"Secret joints: JG cuts cost of aluminum frame furniture." *Interiors,* December 1960.

"Product review." *Design Quarterly* 47, 1960.

"Abbott hospital series; Audax tonearm and tweeter; Norisodrine sample mailer." AIGA Packaging Awards, 1960.

"Promotion folder for American National Exhibit in Moscow, Don Ervin, designer." AIGA Design and Printing for Commerce Awards, 1960.

"Portrait of a building—Herman Miller, Irving Harper, designer." AIGA 50 Advertisements of the Year Awards, 1960.

"The coming revolution in storage: H&G introduces the family warehouse." *House and Garden,* January 1961.

Enzo Fratelli, "The world of George Nelson." *Zodiac* 8, 1961.

"Moscow exhibition in retrospect." *Display World,* January 1961.

"The new sculptured look." *Institutions,* January 1961.

"Omni display system." *Architectural Design,* January 1961.

"Twelve prominent members of the design world express divergent views on what is the single biggest problem in the design field today." *Print,* January-February 1961.

"New use of wood creates today's new house." *Living For Young Homemakers,* February 1961.

"Herman Miller/George Nelson 0200 Group." *Interiors,* February 1961.

Amy Meier, "Poles poles poles." *HFD,* February 27, 1961.

"More Nelson clocks for Howard Miller." *Interiors,* March 1961.

Robert B. Konekow, "The Abbott redesign story." *Advertising Requirements,* April 1961.

"Tower Suite—Hemisphere Club." *Interiors,* May 1961.

"Designs for living." *Playboy,* ca. 1961.

"Residence for Mr. and Mrs. Elliott Erwitt" and "Wood Research House." *Architectural Record Houses,* 1961.

"The year's work." *Interiors,* August 1961.

Walter McQuade, "The booming office planners." *Architectural Forum*, January 1962.

"George Nelson's space solution with twenty-nine poles" and "Clocks ahead of time." *Interiors,* February 1962.

"Restaurant Associates' new designs." *Industrial Design,* February 1962.

"Sun-dappled platform house: Paul Hayden Kirk's Wood Products Research House." *Interiors,* March 1962.

"Now a reality: H&G's family warehouse." *House and Garden,* April 1962.

"Castellations and ramps add fun to a new shingle style: O. R. Johnson residence." *Architectural Record,* May 1962.

"When the designers design for themselves." *Architectural Forum,* July 1962.

"Kitchen remodelled by Dolores Engle of George Nelson & Company." *Progressive Architecture,* July 1962.

"Revolution in design" (advertisement). *Industrial Design,* August 1962.

"Dunlap residence, Charlotte, Michigan." *Progressive Architecture,* October 1962.

Rebecka Tarschys, "Amerikanska pionjarer." *Form,* June 1963.

"Nelson's way: Furniture for large public spaces by Herman Miller." *Interiors,* November 1963.

"Cat's cradle carries catenary." *Progressive Architecture,* November 1963.

"New furniture from Herman Miller." *Arts and Architecture,* December 1963.

"Showroom design." *Contract Directory,* January 1964.

"Developing the product 3: Contract furniture by Ronald Beckman (George Nelson & Co.)." *Industrial Design,* February 1964.

"On the World's Fair." *Architectural Forum,* May 1964.

Claude Bunyard, "Office design in the USA." *Design,* May 1964.

"Architectural products by industrial designers." *Progressive Architecture,* June 1964.

"Herman Miller—Washington, D.C.." *Interiors,* June 1964.

"Lo Zoo Fantastico di George Nelson." *Domus,* 1964.

Mildred Schmertz, "Architecture at the New York World's Fair." *Architectural Record,* July 1964.

Vincent Scully, "If this is architecture, God help us." *Life,* July 31, 1964.

"Return of the roll-top desk." *Fortune,* October 1964.

"Designers choice" (editorial). *Industrial Design,* November 1964.

Lou Gropp, "Herman Miller's design sociology." *HFD,* November 30, 1964.

"The Herman Miller Action Office: Furniture system based on the needs of the human performer in the modern office." *Interiors,* December 1964.

"Herman Miller's Action Office." *Interior Design,* December 1964.

"Office furniture tailored to the job." *Business Week,* December 19, 1964.

"The Action Office." *Madison Avenue,* December 1964.

Mina Hamilton, "Herman Miller in action." *Industrial Design,* January 1965.

"The System." Lou Gropp, *HFD,* April 19, 1965.

"George Nelson Design for Herman Miller—Catenary Group and Sling Sofa." *Interieur,* May 1965.

"George Nelson on the 'new world' of the mid-60s." *Graphics, New York Graphics, Aspenite,* June 1965.

"The Aspen Papers" and editorial.*Progressive Architecture,* August 1965.

Lou Gropp, "A place for China." *HFD,* September 7, 1965.

William K. Zinsser, "But where will I keep my movie magazines?" *Saturday Evening Post,* November 1965.

"Projections: A look at the future." *Interior Design,* November 1965.

"Connectors unlimited," "Troia—Resort on peninsula in Portugal," "Rosenthal China offices in Bavaria," and "An interview with George Nelson." *Interiors,* November 1965.

"An agreeable office." *Esquire,* December 1965.

Robert Probst, "The Action Office." *Contract Directory,* December 1965.

"The impact of industrial design." *Fortune,* December 1965.

"Designs for the future." *Industrial Design,* December 1965.

"Herman Miller showroom in Washington, D.C." *Contract Directory,* January 1966.

Rita Reif, "Mr. Storage Wall at home." *New York Times Magazine,* January 2, 1966.

Lou Gropp, "Designing spaces." *HFD,* January 3, 1966.

James DeLong, "The renaissance of the wood shingle." *House Beautiful,* March 1966.

"The Sling Sofa." *Architectural Design,* April 1966.

"The men who picked the winners and how they did their work." *Product Engineering,* May 9, 1966.

"Are artists in revolt? An interview with George Nelson." *This Week,* July 24, 1966.

"Hybrid walls." *Progressive Architecture,* August 1966.

"Design display." *Progressive Architecture,* September 1966.

Olga Gueft, "Scientific sell, with sight gags: Nelson, Eames and Girard collaborate on a new Herman Miller showroom in New York." *Interiors,* September 1966.

Stephen A. Kliment, "Is too much comfort worse than not enough?" *Architecture and Engineering,* October 1966.

Elizabeth Brown, "George Nelson." *House Beautiful,* October 1966.

"Nelson enters Bernbach-Lippincott clash; sees true image as sum of firm's activities." *Graphics: New York,* February 1967.

"New Herman Miller showroom: A well-defined group of interior environments." *Contract,* February 1967.

"The urban apartment of an urbane designer." *House Beautiful's Home Decorating,* 1967–1968.

"George Nelson, FAIA, enhances service station design with wood, imaginatively used" (advertisement). *Progressive Architecture,* January 1968; *Architectural Record,* February 1968.

"Furnishings overcome space deficiencies." *Contract,* March 1968.

"Symposium: Prospects and possiblities in the human environment." *Print,* March-April 1968.

Rita Reif, "A tableware shop, periscope included." *New York Times,* September 19, 1968.

"A great wall of China." *HFD,* September 20, 1968.

"The U.S. at Osaka." *Architectural Forum,* October 1968.

"Good design at every level." *Industrial Design,* November 1968.

"A dream world of glass." *RSVP,* December 1968.

"Designer says mass production reduces urge to own products." *Product Engineering,* February 24, 1969.

Enzo Fratelli, "The world of George Nelson." *Zodiac* 8, 1969.

"Where shopping is child's play." *Business Week,* March 8, 1969.

"Product profile: Typewriter woos users to crack U.S. market." *Product Engineering,* March 10, 1969.

"A conversation with George Nelson." *Industrial Design,* April 1969

"Play store." *Industrial Design,* May 1969.

A Report on Issues and Questions in Communication Discussed at the First in a Series of Experimental Seminars on "Environmental Design and the Interaction of Human Behaviour." AT&T Department of Environmental Affairs Advanced Communications Center Project, June 1969.

"A new kind of total house." *Better Homes and Gardens,* September 1969.

George Dudley, "The rest of our lives." *Craft Horizons,* September-October 1969.

"George Nelson & Co. Inc.." *Industrial Design,* November 1969.

"16th annual design review." *Industrial Design,* December 1969.

Samuel Feinberg, "Two men who left industrial gants to open store." *Women's Wear Daily,* December 19, 1969.

"CA-69: Awards of excellence." *Communication Arts* 11, no. 5.

Claudia Deutsch, "A small store for small people." *Stores,* January 1970.

"The children's place." *Interiors,* January 1970.

"Kid's stuff." *Design,* March 1970.

"Schöne Wohnungen: Ein Möbel-Programm, das die Voraussetzung für erfolgreiches Arbeiten schafft." *Schöner Wohnen,* April 1970.

"Vision of design: IDSA annual meeting at Pocono Manor." *Industrial Design,* October 1970.

"Notes for fretless traffic." *Esquire,* December 1970.

"17th annual design review." *Industrial Design,* December 1970.

"The Children's Place is a child's haven." *Profile* 6, no. 12, December 15, 1970.

"Design with the future in mind." *Modern Packaging,* January 1971.

"Barney's is." *Display World,* January 1971.

"Trademarks." *Communication Arts,* vol. 12, no. 6.

"George Nelson: Une polyvalence absolue." *CREE (Creations et Recherches Esthetiques Europeennes)*

"Mr. and Mrs. George Nelson's lunch in New York." *House and Garden,* March 1971.

"Soup's on." *Industrial Design,* April 1971.

"Soup in a Gotham garden" and "Mini-world for small fry." *Interiors,* June 1971.

"Art caravan." *Industrial Design,* November 1971.

"New house in a new town: Great idea for a growing family." *Good Housekeeping,* November 1971.

"Nelson office seating." *Interiors,* November 1971.

"Road show." *Architectural Forum,* November 1971.

"Dollars and sense buy design." *Progressive Architecture,* November 1971.

"The 1971 annual design review." *Industrial Design,* December 1971.

Sidney Abbott, "New hope for new towns." *Design and Environment,* spring 1972.

"Franklin Simon, Atlanta" *Interior Design,* April 1972.

"Designers in America, part 3—George Nelson & Co.." *Industrial Design,* October 1972.

Ilse Meissner Reese, "The Children's Place." *MD,* February 1973.

"George Nelson." *Britannica Encyclopaedia of American Art,* 1973.

"Herman Miller." *Industrial Design,* June 1974.

"NYMMS Eating and Drinking Establishment." *Interior Design,* May 1975.

Olga Gueft et al., "The design process at Herman Miller." *Design Quarterly* no. 98–99, 1975.

"Differing views of the future." *Los Angeles Times,* April 11, 1976.

Ralph Caplan, *The Design of Herman Miller.* Whitney Library of Design, 1976.

Olga Gueft, "Storwall International: Nelson Workspaces." *Interiors,* May 1977.

Olga Gueft, "John Carl Warnecke and Associates, George Nelson & Co.: Aid Association for Lutherans." *Contract Interiors,* January 1978.

Susan Braybrooke, "Fling out the banner." *Print,* March-April 1978.

"George Nelson & Co. designed monitor, display terminal and keyboard for/with ATEX." *Industrial Design,* May-June 1978.

"24th annual design review." *Industrial Design,* 1978.

"Colloquio con il designer americano George Nelson." *Modo,* May 1979.

Alistair Best, "Nelson and the talking office." *Architectural Review,* June 1969.

"A conversation with George Nelson." *Ideas from Herman Miller,* November 1979.

"Long, cool look at that 'office of the future.'" *Design,* December 1979.

Stanley Abercrombie, "Introduction: On George Nelson." *Designers' Choice '80,* 1980.

John Morris Dixon, "Acorns to oaks." *Progressive Architecture,* September 1980.

"Designing for people: Seven of America's best innovators explain the new principles of human-scale technology." *Quest,* September 1980.

Ann Morrison, "Action is what makes Herman Miller climb." *Fortune,* June 15, 1981.

Stanley Abercrombie, "The company that design built." *AIA Journal,* February 1982.

Bryan Ferris, "Aspen 82." *Communication Arts,* September-October 1982.

Rita Sue Siegel, "Introduction." *Communication Arts,* March/April 1983.

"Forms that follow function." *Time,* October 24, 1983.

Sarah Bodine, "Anatomy of an exhibition." *Industrial Design,* November-December 1983.

"George Nelson." *CREE,* ca. 1983.

"George Nelson: The exemplification of total design." *IDEA,* ca. 1983.

William H. Jordy, "The 'big picture' in Philadelphia." *New Criterion,* January 1984.

Peter Blake, "Hype and reality." *Interior Design,* December 1984.

"Is it time for a change?" *Design Today* 11, no. 1, 1985.

Doug Stewart, "Modern designers still can't make the perfect chair." *Smithsonian,* April 1986.

Ronald Beckman, "George Nelson, prophet of the modern office." *Innovation,* fall 1990

"Ralph Caplan on George Nelson." *ID,* January-February 1992.

Notes

Preface

1. The article was "The End of Architecture," which appeared in the April 1973 issue.

2. Preface to "The Office Revolution," in *George Nelson on Design* (Whitney Library of Design, 1979), p. 154.

3. William E. Dunlap, letter to the author, June 8, 1990.

4. In *The Creative Experience,* ed. Stanley Rosner and Lawrence E. Abt (Grossman, 1970).

5. Transcript of interview conducted by Ralph Caplan, January 30, 1981; courtesy Herman Miller, Inc.

6. "Good Design: What Is It For?" in *Problems of Design* (Whitney Publications, 1957), p. 13.

7. "Peak Experiences and the Creative Act," a speech given at the 1977 International Design Conference in Aspen, later published in *George Nelson on Design* (see p. 21).

8. Products and facts are recorded in the appendixes.

Chapter 1: Preparing for an Unknown Career

1. "Button, Button, . . ." (unpublished essay, dated January 1975).

2. His brother Norbert, the main source of this family information, was 18 years younger than George. An intermediate brother, Bill, died in his forties.

3. The family also had a weekend cottage on Long Island Sound.

4. In *The Creative Experience,* ed. Stanley Rosner and Lawrence E. Abt (Grossman, 1970).

5. Commencement address, Minneapolis College of Art and Design, June 10, 1980.

6. Ibid.

7. Rosner and Abt (note 4 above).

8. "Peak Experiences and the Creative Act," p. 12.

9. Ibid.

10. Most notably by Behrens and Poelzig in Germany, by Perret in France, by Voysey and Mackintosh in England and Scotland, and by Wagner, Loos, Olbrich, and Hoffman in Austria.

11. "Peak Experiences and the Creative Act."

12. *Architecture* was published by Charles Scribner's Sons and is not related to the present magazine of that name.

13. *New York 1930,* by Robert A. M. Stern, Gregory Gilmartin, and Thomas Mellins (Rizzoli, 1987), lists one building by the firm, the 1933 Gnome Bakery at 316 East 59th Street, and describes it as a "Hansel and Gretel cottage replete with steep red-tile roof, chimney, and papier-mâché gnome."

14. Rosner and Abt.

15. Richard Buckminster Fuller, Jr., letter to George Nelson, December 14, 1976). Like most of the correspondence quoted (except for letters to the author and those in the Lamar Dodd Archive at the University of Georgia), this letter is in the collection of Jacqueline (Mrs. George) Nelson, and is reproduced here with her permission. Other sources are noted.

16. Rosner and Abt (note 4 above).

17. Ibid.

18. Where he studied under Frederick V. Murphy.

19. He came close enough to winning that his drawings for the competition were published in the August 1932 *Bulletin of the Beaux-Arts Institute of Design.*

20. "Peak Experiences and the Creative Act," pp. 14–15.
 The Rome Prize then offered a stipend of $1,500 per year for two years, a travel allowance of $500, a bedroom, a studio and meals at the Academy. There were 110 competitors for the Rome prize that year. In the last four weeks, seven finalists competed, all working on the same design problem, a community auditorium. Jurors that year included: Charles Adams Platt, designer of the Freer Gallery in Washington and a number of buildings at Phillips Academy, Andover, Massachusetts; Chester H. Aldrich of Delano & Aldrich, designers of the Colony, Knickerbocker and Union clubs in New York; Louis Ayres, a partner in the firm of York & Sawyer; and William Mitchell Kendall, a senior partner in the firm of McKim, Mead & White and credited with the design of the American Academy building in Rome.

21. "Peak Experiences and the Creative Act," pp. 15–16.

22. Although Hewlett was an architect (he had been with McKim, Mead & White from 1890 through 1894 before establishing his own firm; his Beaux-Arts-influenced designs included St. John's Hospital in Brooklyn, the Bronx County Building, New York, and the Westchester County Court House, White Plains, New York), he was better known as a stage designer for the Metropolitan Opera and as the muralist for the ceiling of Grand Central Station.

23. R. Buckminster Fuller, "Universal Architecture," in *T-Square* (the original title of *Shelter*), February 1932.

24. Frank Lloyd Wright, "Of Thee I Sing," *Shelter,* April 1932.

25. Interview in *Interiors,* November 1965. He was then working on plans for Troia, a proposed resort town near Lisbon.

26. The source of the remark is a conversation with Jacqueline Nelson.

27. *Pencil Points,* July 1935.

28. *Pencil Points,* September 1935.

29. None of the nine had been mentioned in Paul Frankl's *New Dimensions* (1928). Henry-Russell Hitchcock had mentioned only Tengbom and Piacentini in his 1929 *Modern Architecture: Romanticism and Reintegration,* and when he published his *Modern Architecture in England* in 1937 he showed seven buildings by the Tecton Group but ignored McGrath. Another important early book on modernism, Sheldon Cheney's 1930 *The New World Architecture,* had shown work by Mies, Le Corbusier, Gropius, Tengbom, and the Luckhardts, but made no mention of Nelson's other seven.

 Gio Ponti was widely known, but primarily as a painter and ceramicist and as the founder in 1928 of the important design magazine *Domus* (almost every copy of which would later be saved by Nelson). At age 43, when Nelson interviewed him, Ponti was just beginning to turn his attention to architecture.

30. After its New York opening, the exhibition traveled to Philadelphia, Hartford, Chicago, Los Angeles, Buffalo, Cleveland, Milwaukee, Cincinnati, Rochester, Toledo, Cambridge, and Worcester (where it closed in December 1933).

31. The catalogue (*Modern Architecture: International Exhibition* [Museum of Modern Art, 1932]), however, did include an essay on "Housing" by Lewis Mumford and Catherine Bauer that focused on functional and social needs rather than style. Mumford was also instrumental in persuading Frank Lloyd Wright to contribute to the exhibition.

32. Letter to John Morris Dixon, editor of *Progressive Architecture,* November 6, 1980.

33. Ibid.

34. According to "Architectural Journalism Analyzed: Reflections on a Half Century," an article marking the magazine's fiftieth anniversary (*Progressive Architecture,* June 1970),

interiors shown at the Metropolitan Museum of Modern Art were published in 1929, including room settings by Raymond Hood, Eliel Saarinen, and Ely Jacques Kahn, but these were said to bear "more of an affinity to the Paris Exposition of 1925 than to Bauhaus developments." The same 1970 article implies that a full appreciation of modernism arrived only with the appointment of Thomas Creighton as Editor in 1947.

35. *Pencil Points,* May 1935.

36. The first of the articles was preceded by this editor's note: "We are definitely not interested in publishing examples of contemporary European architecture for the purpose of encouraging the sort of stupid copying of mannerisms that is unfortunately sometimes done. We do feel, however, that something can be learned from what is going on in Europe today provided we look at the buildings with full knowledge of the men and philosophies responsible for them. With this thought in mind, we commissioned George Nelson, Fellow of the American Academy in Rome, to interview a number of important Continental architects and write for us a series of twelve articles to run during 1935." This warning was repeated three times.

37. The boycott of Jews began in Germany in 1933.

38. *Pencil Points,* March 1935.

39. John Morris Dixon, letter to George Nelson, October 30, 1980.

40. John Morris Dixon, editorial in *Progressive Architecture,* September 1980.

41. Letter to Dixon (see note 32 above).

42. Frances ("Fritzi"), *née* Hollister.

43. Nelson's work for the WPA was described by his brother Norbert in an interview with the author (New York, September 12, 1990).

44. Others represented in the issue included Marcel Breuer, Donald Deskey, Edward D. Stone, William Lescaze, George Howe, Harwell Hamilton Harris, and Henry Dreyfuss. There was also a news article on Moholy-Nagy's New Bauhaus in Chicago and an obituary of neoclassicist John Russell Pope.

45. "The house is shrinking . . . ," *Architectural Forum,* October 1937.

46. This information about the Kahn office and practice is from Daralice Donkervoet Boles, "Albert Kahn," in *Macmillan Encyclopedia of Architects* (Macmillan, 1982).

47. For example, his Italianate residence for Walter Freer in Detroit, 1895, his Tudor residence for Edsel Ford in Grosse Pointe, 1926, his General Motors (1922) and Fisher (1927) towers in Detroit and a large number of buildings for the University of Michigan at Ann Arbor.

48. The factories were not always without decorative touches. As Robert Venturi, Denise Scott Brown, and Stephen Izenour wrote in *Learning from Las Vegas* (MIT Press, 1972), "The fronts of Kahn's sheds . . . were gloriously Art Deco."

49. *Industrial Architecture of Albert Kahn, Inc.* (Architectural Book Publishing Co., 1939). The quoted passage is from p. 14.

50. "Peak Experiences and the Creative Act," p. 16.

51. Howard Myers, letter to Frank Lloyd Wright, November 27, 1936, quoted in *Frank Lloyd Wright: Letters to Architects,* ed. Bruce Brooks Pfeiffer (Fresno: The Press at California State University, 1984), p. 154.

52. Myers letter to Wright, July 28, 1937, quoted in Pfeiffer, *Frank Lloyd Wright: Letters to Architects* (p. 155).

53. Interview with Paul Grotz, New York, January 9, 1990. "Wright's publisher" was Horizon Press, in New York. Hedrich-Blessing is a noted Chicago-based firm of architectural photographers.

54. Talk at The New School, New York, during an evening of tributes to Frank Lloyd Wright in 1980.

55. Wright was also the subject of an article, "Usonian Architect," in the January 17 issue of *Time.*

56. Edgar Kaufmann, jr., "Frank Lloyd Wright," in *Macmillan Encyclopedia of Architects.* The texts of Wright's London lectures, the Sir George Watson Chair Lectures of the Sulgrave Manor Board for 1939, were published as *An Organic Architecture* (Horizon, 1939).

57. Nelson, telegram to Wright, May 2, 1940; Wright, telegram to Nelson, May 7, 1940.

58. *Hartford Times,* November 5, 1941.

59. Nelson, letter to Wright, October 2, 1945.

60. Wright, letter to Nelson, October 9, 1945.

61. Nelson, telegram to Wright, April 17, 1946.

62. Nelson, letter to Wright, August 6, 1946.

63. Wright, letter to Nelson, August 20, 1946.

64. "Wright's Houses: Two Residences, Built by a Great Artist for Himself," *Fortune,* August 1946. Wright may have been remembering the words attributed to John Lothrop Motley by Oliver Wendell Holmes in *Autocrat of the Breakfast Table*: "Give us the luxu-

ries of life, and we will dispense with its necessities." Nelson may have been remembering the quotation from Lao Tzu that Wright had carved over the fireplace at Taliesin: "The reality of the building does not consist in the four walls and the roof but in the space within to be lived in."

65. Winthrop Sargeant, "Frank Lloyd Wright," *Life,* August 12, 1946.

66. Nelson, letter to Wright, August 14, 1946.

67. An early example of that magazine's support of Wright under the editorship of Elizabeth Gordon, an enthusiast for his work (but not for modernism in general). Gordon produced two issues of *House Beautiful* devoted wholly to Wright, one in November 1955 and one in October 1959.

68. Wright, letter to Nelson, August 20, 1946.

69. Nelson, letter to Wright, February 17, 1947. A second special issue of the *Forum* devoted to Wright had first been considered for early 1941 and tentatively planned several times during the war years.

70. Wright, letter to Nelson, February 26, 1947.

71. Nelson, thank-you letter to Wright, May 13, 1947.

72. Wright, letter to Nelson, May 20, 1947: "Will be in New York next week and will go into everything with you and Howard [Myers] then."

73. Nelson, telegram to Wright, September 2, 1947.

74. Wright was then 81. The Royal Institute of British Architects had given him its gold medal a decade earlier.

75. Ralph Caplan, "Circumstantial Evidence," in *International Design* (formerly *Industrial Design*), May-June 1986.

76. Walt Whitman, "Notes on the Meaning and Intention of 'Leaves of Grass,'" in *The Complete Prose Works of Walt Whitman,* ed. Richard Maurice Bucke (Putnam, 1902).

Chapter 2: A New Cause

1. Quoted in Carol Herselle Krinsky, *Gordon Bunshaft of Skidmore, Owings & Merrill* (Architectural History Foundation, 1988), p. 6.

2. Hamby and Nelson published a number of their architectural commissions—all resolutely modern—between 1937 and 1941. Their exact business relationship is difficult to pin down and seems to have varied from commission to commission. A recreation room design from this association was published in *Architectural Forum* (October 1937, p. 279),

the credit reading "Fordyce & Hamby, Architects; George Nelson, Associate." A house in Scarsdale, credited to "Associate Architects: Fordyce & Hamby, George Nelson," was published in the April 1939 *House & Garden.* A kitchen published on p. 268 of the October 1940 *Architectural Forum* was credited to "Fordyce and Hamby and George Nelson, Architects," while another kitchen on the following page of the same issue was credited to Hamby alone. A house in Bayside, N.Y., published in the February 1941 *Architectural Forum,* was credited to "William Hamby, George Nelson, Architects." It could be that Nelson's working relationship with Hamby was as informal and unwritten as his much later relationship, in the last years of his New York office, with the Pentagram group of London.

3. His own 1934 house at 211 East 48th Street and another finished the following year at 32 East 74th Street.

4. Sidebar to article "Houses for Human Beings," *Fortune,* April 1943.

5. *New Yorker,* December 27, 1941. As for the "amoeba-shaped furniture," an article about the house in the April 1943 *Architectural Forum* credits "specially designed furniture and interiors" to Dan Cooper.

6. Beginning in 1943, Marcel Breuer experimented rather steadily with "bi-nuclear" house schemes, their entrance links connecting public/daytime wings and private/nighttime wings. These plans were similar to that of the Fairchild house, but Breuer's were all for open suburban areas and were not concerned with the problems of city sites.

7. The Sidney Johnson house, in East Hampton.

8. During the war Hamby worked as a plant manager for Fairchild.

9. This is from what seems to be an interoffice memorandum, undated and unpublished.

10. "Ends and Means," first given as a speech at the Institute of Design, Chicago (April 8, 1948), then published in *Interiors* (May 1948) and reprinted in *Problems of Design* (Whitney Publications, 1957), p. 38.

11. Telephone interview, September 4, 1990.

12. See Henry-Russell Hitchcock and Philip Johnson, *The International Style: Architecture Since 1922* (Norton, 1932). The patterns identified by Hitchcock and Johnson were three: first, "Architecture as Volume" ("The effect of mass, of static solidity, hitherto the prime quality of architecture, has all but disappeared; in its place there is an effect of volume, or more accurately, of plane surfaces bounding a volume."); second, regularity ("Good modern architecture expresses in its design [a] characteristic orderliness of structure and [a] similarity of parts by an aesthetic ordering which emphasizes the underlying regularity. Bad modern design contradicts this regularity."); and third, "The Avoidance of Applied Decoration."

13. "The Passionate Arts," *Holiday,* October 1962.

14. Interview (note 11 above).

15. Interoffice memorandum (note 9 above).

16. Ibid.

17. Of course, they may have first met outside the university. Yamasaki worked at Shreve, Lamb & Harmon from 1937 to 1943, at Harrison & Fouilhoux in 1943–44, and for Raymond Loewy in 1944–45. Yamasaki's "Postwar Project for a Converted Apartment in New York City" was published in *Architectural Forum* while Nelson was Co-Managing Editor (November 1944).

18. Nelson, letter to Yamasaki, September 7, 1951. This letter proposed three related business ventures:

> (1) G.N. Associates, with you and one or two of the guys as associates;
> (2) Building Design Research, Inc., a private, profit-minded corporation, designed to serve the major companies interested in the building field. BDR Inc. would be jointly owned by you and me. Or maybe we would each own 40–45% with the balance available to key people;
> (3) Yamasaki & Nelson, Architects, a firm related to, but fiscally separated from 1 and 2.
>
> On this basis, I would be front, operating head and chief profiteer on 1. You would be front, operating head and chief profiteer on 3. We would each have to work out something practical in relation to 2.
> Some scheme!

Yamasaki had a similarly complex arrangement at the time. He was principal of Minoru Yamasaki and Associates in Troy, Michigan, a partner in Yamasaki, Leinweber and Associates in Detroit, and also a partner in Leinweber, Yamasaki and Hellmuth in St. Louis. In 1951, the works for which he would become widely known were all still ahead of him; the first of these would be the Lambert Airport terminal in St. Louis, finished in 1956.

19. "Stylistic Trends in Contemporary Architecture," in *New Architecture and City Planning,* ed. P. Zucker (Philosophical Library, 1944). A slightly abbreviated version was reprinted in *Problems of Design.*

20. Ibid.

21. Nelson maintained notebooks for decades, copying into them quotations he particularly admired. These constitute a highly personal sort of chapbook.

22. Eric Gill, *Autobiography* (Cape, 1940), p. 111.

23. "Peak Experiences and the Creative Act (see notes to introduction above), p. 22. A slightly different version of the story was given in the 1980 New School tribute to Wright.

24. Nelson, letter to Wright, February 1, 1949.

25. Chadwick had also collaborated with Herbert Bayer on the design of the Fort Worth Art Center and had worked for Skidmore, Owings & Merrill.

26. Although the name "Nelson & Chadwick" was used on stationery and drawings, the partnership was never quite legalized in any way, according to Jacqueline Nelson.

27. Nelson, letter to the author (undated but written c. January 1, 1980), quoted in the author's brief profile of Nelson in *Designers' Choice '80,* a publication of *Industrial Design*

28. Interview with Graves (note 11 above).

29. Although interior design has subsequently come clearly into its own as an independent profession with its own education, materials, legal recognition and effects on its users, in the 1950s and the 1960s it was still largely subsumed within the profession of architecture, and most architecture firms also designed interiors as a matter of course.

30. Dunbar had worked in the Nelson office for most of 1949, but had been dismissed for being (in Dunbar's own words) "talented but incompetent." He had gone then to *Harper's Bazaar* as assistant to art director Alexey Brodovitch and had designed some book jackets for the Museum of Modern Art. Nelson admired the book jackets and asked Dunbar if he'd like to come back into the office. Later he was an interior designer and associate partner at Skidmore, Owings & Merrill, then opened his own interior design firm in partnership with Lydia dePolo.

31. Interview with Jack Dunbar, New York, November 30, 1990.

32. In a July 6, 1981, letter to John Leppik of IBM Canada, Nelson talked of the benefits of "constant movement of the eye and its muscles" and recalled: "During my years as a young architect, mostly concerned with houses, I speculated on this problem and finally, through a fortunate connection with a client who manufactured dimmers for industry and the theater, I installed some of these primitive monsters in a few living rooms and was rewarded by reports that the owners did use the dimmers during the course of an evening, with very pleasant results."

33. Later Chairman of the Department of Architecture at Pratt Institute, and now President of the New York School of Interior Design.

34. Rita Reif, "A Tableware Shop, Periscope Included," *New York Times,* September 19, 1968. See also "Good Design at Every Level," *Industrial Design,* November 1968.

35. This was Mount's first restaurant design; he later became a leader in the field.

36. The four books, all published by Whitney Publications, were *Living Spaces* (1952), *Chairs* (1953), *Display* (1953), and *Storage* (1954). All four were edited and largely written by Nelson. Suzanne Sekey of the Nelson office was credited with research and layout. Irving Harper shared layout credit for *Chairs* and was credited with jacket designs for all but the first (whose jacket was designed by Kenneth L. Curtis, not a Nelson employee). Additional credit for editorial assistance on *Storage* was given to Madeline Hunt.

37. *Interiors*, November 1948; reprinted in *Problems of Design* (see p. 176).

38. *Interiors*, November 1950; reprinted in *Problems of Design* (see p. 194).

39. "Modern Decoration," *Interiors*, November 1949; reprinted in *Problems of Design* (see p. 193).

40. To choose just three examples from the early 1970s: Louis Kahn's Kimbell Art Museum (finished in 1972), Gwathmey Siegel's Cogan house (1972), and Richard Meier's Douglas house (1973).

41. "Differing Views of the Future," *Los Angeles Times*, April 11, 1976, reporting a panel discussion at the Pacific Design Center in Los Angeles.

42. Nelson, letter to Theo Crosby, October 4, 1981. Crosby was a partner in the London-based design firm Pentagram. Publicly, answering a question after a lecture at the University of Michigan, Nelson evaluated Graves's work more gently: "He worked in my office for a while. Marvelous. Then he went to Rome. Then he went to Princeton and vegetated there for a long time. Then he hitched a ride on the latest star express, and it's okay—I mean, the modern thing was getting kind of tired, and it certainly needed some shaking up, and that was one way to do it." Nelson's lecture, titled "Changing the World," was given while Nelson was Professor of Design Research at the University of Michigan (1984–1986)—a professorship funded by Herman Miller—and was printed under the direction of Colin Clipson as a memorial tribute by the University of Michigan in 1987.

43. "Changing the World" (see preceding note).

44. Ibid.

45. "The Hidden City," *Architecture Plus*, November-December 1974; reprinted in *George Nelson on Design* (Whitney Library of Design, 1979) (see p. 28).

46. Ibid., pp. 31–32.

47. Ibid., p. 28. The idea of a roof garden replacing the land beneath a building was, of course, one of the "five points" of modernism proposed by Le Corbusier in 1927, although Le Corbusier would have been appalled at the notion of making the building disappear. In any case, there had been virtually no garden-covered modern architecture, by Le Corbusier or anyone else. An exception was the Oakland Museum by Kevin Roche and John Dinkeloo (with landscape architect Dan Kiley) finished in 1969.

48. The jury, which included Peter Blake and Jack Masey, chose another minimal scheme: an inflated structure designed by Rudolph DeHarak and Chermayeff & Geismar, with Davis, Brody & Associates, Architects.

49. Source: "The U.S. at Osaka," *Architectural Forum,* October 1968.

50. "The End of Architecture," *Architecture Plus,* April 1973.

51. Autobiographical note for *Contemporary Architects* (St. James Press, 1980).

52. "Design, Technology, and the Pursuit of Ugliness," *Saturday Review,* October 2, 1971. The article was said to be "adapted from [Nelson's] forthcoming book *The Synthetic Garden,* to be published next year by Little, Brown." The book never appeared, however. *Interiors* may have been referring to the same project in November 1965 when it said Nelson was "writing a book for Little Brown & Company, tentatively entitled *Design Life and Death.*"

Chapter 3: A New Profession

1. "Beyond Taste in Product Design," given July 18, 1974. Lacy was then director of the Design Arts program of the National Endowment for the Arts.

2. "Design, Technology, and the Pursuit of Ugliness," *Saturday Review,* October 2, 1971.

3. "Both Fish and Fowl," *Fortune,* February 1934.

4. Nelson continued: "His subject is psychoanalysis. He draws pictures of people's phobias, their recurrent dream symbols, publishes them in books. He designs products to titillate the subconscious of purchasers, to cause them to reach impulsively for their pocketbooks. His Coca-Cola dispenser is an example. The chromium coils at the bottom of the little barrel that sits on the soda counter are there to suggest coolness. But the body of the barrel is made of red and green bands to give a sense of treasure guarded. A persuasive salesman, he can sell psychology and make people like it."

5. "Best Dressed Products Sell Best," *Forbes,* April 1, 1934. Source: Arthur J. Pulos, *American Design Ethic* (MIT Press, 1983), p. 357.

6. See Pulos, *American Design Ethic,* p. 377.

7. Gilbert Rohde, Nelson's predecessor as design director for Herman Miller, produced three exhibitions for this fair. For the opening, in 1939, Rohde designed "Man in the Community" and "Home Furnishings." To fill space vacated by some foreign exhibitors in 1940, he added a "Unit for Living" section to the "America at Home" exhibition. Rohde, in 1935, had been one of the organizers of the fair, along with Walter Dorwin Teague and a number of businessmen. That same year Rohde had been appointed director of the Design Laboratory (later the Laboratory School of Industrial Design) in New York, a short-lived educational experiment supported by the WPA and thus a rare example of federal interest in industrial design. See Arthur J. Pulos, *The American Design Adventure* (MIT Press, 1988), p. 164.

8. Harold Van Doren, *Industrial Design* (McGraw-Hill, 1940); Walter Dorwin Teague, *Design This Day* (Harcourt, Brace, 1940); Raymond Loewy, *Never Leave Well Enough Alone* (Simon & Schuster, 1941).

9. *Art Digest,* August 1940, p. 16.

10. "Business and the Industrial Designer," *Fortune,* July 1949.

11. Nelson, letter to Wright, December 18, 1947.

12. The history of industrial design professional societies in America is a complex one, beginning with the 1927 foundation by Donald Deskey, Frederick J. Kiesler and others of the American Union of Decorative Artists and Craftsmen (AUDAC). In 1938 the American Designers Institute (ADI) was founded by Alfred Auerbach and others, with John Vassos its first president; it later became the Industrial Designers Institute (IDI). In 1944 the Society of Industrial Designers (SID) was founded by Loewy, Teague, Bel Geddes, Russel Wright and others, adding "American" to its name in 1955. In 1965 the ASID and IDI merged with the Industrial Designers Education Association (IDEA) to form the Industrial Designers Society of America (IDSA), which still exists in 1994. Nelson's relationship with the IDSA was sometimes friendly, sometimes disputatious: he was made a director of the society in 1974, a position from which he resigned in 1976.

13. Paepcke had established a design department at Container Corporation of America in 1935 and had been an important supporter of Moholy-Nagy and his Chicago-based New Bauhaus.

14. Including one by José Ortega y Gasset, who praised Paepcke's Aspen Institute for its "cross-fertilization of studies."

15. The members of the first Aspen board are listed in *The Aspen Papers: Twenty Years of Design Theory from the International Design Conference in Aspen,* ed. Reyner Banham (Praeger, 1974).

16. R. Hunter Middleton, in a 32-page pamphlet reporting on the conference: R. Hunter Middleton and Alexander Ebin, Impressions from the Design Conference held at Aspen, Colorado, June 28 through July 1, 1951 (privately printed).

17. "Aspen Conference on Design," *Fortune,* September 1952.

18. The subject of the 1965 conference was "The New World'; the speakers were Stuart Udall, William Lynch, Philip Hauser, David Finn, Robert Theobald, Konrad Wachsmann, Martin Wohl, Philip Rosenthal (president of Rosenthal China—a future Nelson client), James Rouse, and Peter Blake. Nelson was chairman again in 1982, when the subject was "The Prepared Professional." Serving as program director with him was his wife Jacqueline (so that, in her words, "no one would see how disorganized he was"); the participants included not only people from the design disciplines—Ralph Caplan, Ivan Chermayeff, Niels Diffrient, Arthur Gensler, Milton Glaser, Michael McCoy, Jane Thomp-

son, and James Wines—but also people from other fields: Librarian of Congress Daniel Boorstin, author Michael Crichton, retired CBS chairman Frank Stanton, Max De Pree of Herman Miller, and a number of scientists. Nelson was also a speaker in 1969, 1977, and 1980.

19. Jane (*née* Fiske, and later to be Jane Miterachi and Jane McCullough) married architect Benjamin Thompson in 1969. The quote is from her remarks at the George Nelson memorial service at the Players' Club in New York, March 26, 1986.

20. Telephone interview, January 14, 1991.

21. Interview with Alexia Lalli, New York, January 22, 1993.

22. Although, according to designer John Pile (in notes for the author dated July 13, 1990), Drexler had been the designer in Nelson's office for Herman Miller's 4774 chair, an open-arm wood-frame lounge chair. The first digits of the number indicate that the chair was introduced in 1947, but Miller's numbering was not always systematic.

23. On p. 44 of his book *No Place Like Utopia: Modern Architecture and the Company We Kept* (Knopf, 1993), Peter Blake says that he had been hired because of a remark in a letter ("Christmas is here—give!") that had amused Nelson. Before the Second World War he had worked at the magazine briefly. In 1960 he would become managing editor.

24. Drexler left in April 1951. Thompson began as Associate Editor in July 1951.

25. Most prominent of these was Olga Gueft, who had joined Interiors as Managing Editor in March, 1945, and became Editor in January, 1953. The others, besides Thompson, were Associate Editors Jessie Phelps Kahles, Deborah Allen and Marilyn Silverstone.

26. Rudofsky was fierce, but not the founder. *Interiors* had been founded in 1888 as *The Upholsterer;* in 1934 its name was changed to *The Interior Decorator;* in 1940 it became *Interiors.*

　　　Rudofsky joined the magazine in December, 1945, replacing Costantino Nivola as Art Director; the next month, though he was still in charge of art direction, his title was changed to Architectural Editor; in June, 1947, he was named Editorial Director, and in May, 1948, with that same title, his name began to appear on the masthead above that of Editor Francis deN. ("Bunny") Schroeder; he continued with the magazine until February, 1949.

　　　The architect Romaldo Giurgola became the magazine's Art Director in September 1952.

27. Editor of *Interiors* from June 1941 until his death in December 1952.

28. Nelson joined *Interiors* as Contributing Editor in October 1948; in July 1949 his title was altered to Editorial Contributor, a position he held until September 1968.

29. Remarks by Jane Thompson (see note 19 above).

30. The first issue appeared in February 1954, but the phrase "Industrial Design" had appeared on most issues of *Interiors* since October 1943. In 1984 the magazine would change its name to *International Design.*

31. Alvin Lustig (1915–1955) was an important American graphic designer in the 1940s and the 1950s. He studied briefly with Frank Lloyd Wright in 1935. In 1942 he redesigned John Entenza's California-based magazine *Arts & Architecture,* for which Charles Eames was an editorial associate and Ray Eames a member of the editorial board and cover designer. In 1949 Lustig's design work was represented in Alexander Girard's Modern Living exhibition in Detroit, and in 1950 Lustig collaborated with Victor Gruen on the Northland Shopping Center (Detroit). His best-known work, however, may have been a series of jackets of books published by New Directions and by Noonday Press.

32. Remarks by Thompson (see note 19 above).

33. William Barrett, *The Illusion of Technique* (Doubleday Anchor, 1978).

34. Nelson gave the source as "Erich Fromm, *Twentieth-Century Man."*

35. "George Nelson," interview in *Interiors,* November 1965.

36. "Making Messages Visible," U.S. Department of Health, Education and Welfare Publication (SSA)72–10060, 1972.

37. "How to See," U.S. Department of Health, Education and Welfare Publication (SSA)73–10063, 1973. This 71-page booklet led directly to Nelson's much larger book of the same title, published four years later.

38. "The Future of the Object," in *George Nelson on Design* (Whitney Library of Design, 1979), op. cit., p. 149

39. Interview with Peter Blake, New York, December 15, 1989.

40. "How to Kill People," *Industrial Design,* January 1961.

41. "About the Design of Sports Equipment," *Du,* July 1976. Some of the same material was reprinted in Nelson's *How to See: Visual Adventures in a World God Never Made* (Little, Brown, 1977).

42. Interview with Mico Nelson, December 19, 1990.

43. "Great Writers," *Harper's,* April 1973; reprinted in *George Nelson on Design* (Whitney Library of Design, 1979) (see p. 120).

44. Ibid.

45. "The Future of the Object," p. 149. (A closely related observation by Nelson was quoted by *Home Furnishings Daily* in the issue of May 12, 1966: "The American consumer is the most docile creature on earth. He makes a cow look like a tiger.")

46. Ibid., p. 150. In the 1960s and the 1970s, Nelson Foote was the author, co-author, or editor of a number of books on housing and social institutions, including *Household Decision-Making* (NYU Press, 1961).

47. Interview with McAusland, January 10, 1990. He was then director of the Design Arts program of the National Endowment for the Arts.

48. A tentative title for the book was *Interesting Times, A Designer's History of the Universe, with Disproportionate Emphasis on a Minor Planet.*

49. "Design on a Small Planet," *Industrial Design,* November-December 1983.

Chapter 4: The House

1. These articles, outlining such matters as reading blueprints and choosing a heating system, are the most prosaic of all Nelson's writings, but even here there are some graceful moments—for example, this, from May 1940: "Houses have always had walls for a variety of reasons, some of which are still good."

2. "When You Build Your Home: Bathrooms," *Arts & Decoration,* January 1941.

3. "Houses for Human Beings," *Fortune,* April 1943. This article is unsigned. Fortune's credit reads: "The material for this article was drawn from several sources. It particularly represents the ideas of Designers Henry N. Wright and George Nelson. They are associate editors of the *Architectural Forum.*"

4. The sales figures are from a Simon & Schuster advertisement in the April 1946 *Architectural Forum.*

 Although none of them matched *Tomorrow's House* in thoroughness or popularity, there were other books being published on the same subject. F. R. S. Yorke's *The Modern House* (Architectural Press, 1934) had been a prewar British precedent; it had included houses or models for prefabricated housing by Howe & Lescaze, Richard Neutra, and R. Buckminster Fuller. In the U.S., the Architectural Book Publishing Company had published James and Katherine Morrow Ford's *The Modern House in America* in 1940 and their *Design of Modern Interiors* in 1942; T. H. Robsjohn-Gibbings had offered a lighthearted view in *Goodbye, Mr. Chippendale* (Knopf, 1944); the Museum of Modern Art had published Elizabeth B. Mock's *Tomorrow's Small House* in 1945 and her *If You Want to Build a House* in 1946. Reinhold published *Homes* (selected by the editors of *Progressive Architecture*) in 1947; Wiley published Catherine and Harold Sleeper's *The House for You* in 1948.

5. Simon & Schuster ad (ibid.). Wright's own book, *The Natural House,* would follow in 1954.

6. *Tomorrow's House,* p. 9

7. Ibid., pp. 6–7.

8. Ibid., p. 102.

9. "Peak Experiences and the Creative Act" (see notes to introduction above), pp. 17–18.

10. George Nelson, *Storage* (Whitney, 1954), p. 141.

11. *Architectural Forum,* November 1944; *Life,* January 22, 1945.

12. Frank Lloyd Wright's Usonian houses of the late 1930s and early 1940s, some of which Nelson included in *Tomorrow's House,* had made a step beyond conventional closets with their "thick wall" system of storage, but these walls were still permanent parts of the houses' architecture, not the flexible units Nelson and Henry Wright conceived.

13. Olga Gueft, "George Nelson," in Nelson Eames Girard Propst: The Design Process at Herman Miller, *Design Quarterly* 98/99 (1975), p. 13

14. John Fleming and Hugh Honour, *The Penguin Dictionary of Decorative Arts* (Viking, 1989).

15. "Houses for Human Beings," *Fortune,* April 1943. More than 20 years later, Elizabeth Brown would note in *House Beautiful* that "George Nelson set off another storm" with this design, "the single unit that incorporated what is considered today the ultimate in modern kitchens" ("George Nelson," October 1966).

16. *Tomorrow's House,* p. 94. The "ideal" kitchen was developed by the Libbey-Owens-Ford Glass Co. and credited to that firm's design director, H. Creston Doner. The one-piece kitchen was credited to Guyon C. Earle of Forest Hills, N.Y.

17. Arthur BecVar described Nelson's Unit Kitchen to the author in a letter dated September 17, 1990.

18. General Electric's Monogram line of modular units, introduced in 1986, is a good example.

19. "The Future of the Object," in *George Nelson on Design* (Whitney Library of Design, 1979), pp. 146–148.

20. Years later Nelson described his working relationship with Sottsass in the late 1950s. This was in an article rather irreverently reporting a New York design world cult event, the opening of an exhibition of the Memphis furniture collection Sottsass had begun forming in 1981:

Who are all these people crushing each other in this downtown, wrong-side-of-Fifth Avenue loft? There are 1,500 of them in a relatively small space; 500 were turned away.

Everyone stands in a tightly packed circle, all face the vanished center; the works of MEMPHIS form an outer rim in the hard vacuum of space, like the polychrome rings of Saturn. But nobody looks; they press together at maximum density, a Black Hole vibrating at 98.6°F.

The press is there (I think) and the interviewers want to know, "What do *you* think of MEMPHIS?" (For almost two years now they have been asking the same questions all over Europe.) "How do you assess the possible influence of MEMPHIS on contemporary furniture design? Do you feel that the price is right? Who are all these people?"

The interviewers want to know. But who can tell them? And if someone could tell them, how do you capture a Truth whose half-life is measured in nanoseconds? . . .

Ettore Sottsass, Jr. was in a large apartment next to the exhibition gallery, having a late dinner with friends, disciples and the gallery owner. He is the only European I have ever known who is a "Junior," but no doubt there are others. He was born in Innsbruck, which is in Austria, which is in Europe, which is about an hour from the U.S. of A. by ICBM. Ettore's father was an architect, presumably also named Ettore.

Years ago, before Castro took Cuba away from us, Sottsass and his wife came to New York. She was on her way to Cuba to see Ernest Hemingway (hopefully in one of those rare moments when he wasn't pumping iron or fishing for marlin) about translating another of his books into Italian. Ettore stayed in New York while she went off to see Hemingway and to pass the time took a job in my office, where we worked together on a stillborn project called "The Experimental House." All this happened in the late 1950s. The office paid him $125 per week, not a generous stipend even in those far-off days, and, to add insult to injury, the IRS had insisted that this unregistered foreigner kick in $30 every week towards income tax. Our problem in the office was that there was no client for the Experimental House, but even so, while we had a good time together, Ettore never got over this sample of American parsimoniousness. When I got to the gallery and went next door to the apartment, he introduced me to everyone and then promptly told them the story about the miserable $125 per week and the outrageous $30 so callously levied by the IRS. All the young Memphises looked up from their dinners, turning their large liquid eyes reproachfully at me, as if I had been the IRS, and murmured sympathetically in the direction of their guru. ("A Tourist's Guide to Memphis," *Interior Design,* April 1983)

For a short time there *was* a client for the Experimental House," according to Ronald Beckman ("George Nelson, Prophet of the Modern Office," *Innovation,* fall 1990). Bud Hitchcock, a Grand Rapids entrepreneur, had planned to attract attention to a real estate development he was promoting by building three "homes of tomorrow," to be designed by Nelson, Fuller, and Paul Rudolph, but Hitchcock's backers and his ambitious scheme soon disappeared. Nelson, fascinated by the problem, decided to continue work on it without a client.

21. Letter to Minoru Yamasaki, September 7, 1951.

22. *Tomorrow's House,* p. 206.

23. Martin Pawley, *Buckminster Fuller* (Trefoil, 1990), p. 30. In 1970, however, the AIA would award its gold medal to Fuller.

24. Le Corbusier, *Towards a New Architecture,* tr. F. Etchells (Architectural Press, 1946; first published as *Vers une architecture* [Editions Crès, 1923]), p. 210.

25. Ludwig Mies van der Rohe, "Industrielles Bauen," in *G,* no. 3 (June 10, 1924), quoted in Philip Johnson, *Mies van der Rohe* (Museum of Modern Art, 1947), p. 190

26. Title of lecture by Walter Gropius, given during "Bauhaus Week" in 1923. See Howard Dearstyne, *Inside the Bauhaus* (Rizzoli, 1986), p. 69.

27. See, for example, "At Last We Have a Prefabrication System Which Enables Architects To Design Any Type of Building with 3-Dimensional Modules," *Pencil Points,* April 1943; "Miracle House That Grows with Your Family," *Colliers,* June 12, 1943; "Prefabricated Houses," *Architectural Forum,* June 1943; "Prefabricated Panels for Packaged Buildings," *Architectural Record,* April 1943.

28. Gilbert Herbert, *The Dream of the Factory-Made House: Walter Gropius and Konrad Wachsman* (MIT Press, 1984), pp. 306–313.

29. Fuller, letter to Nelson, December 14, 1976.

30. *Architectural Forum,* August 1951, quoted in Hugh Kenner, *Bucky: A Guided Tour of Buckminster Fuller* (William Morrow, 1973), p. 252.

31. Carl Koch with Carl Lewis, *At Home with Tomorrow* (Rinehart, 1958), p. 97. *Life,* in January, 1949, referred to the Acorn house as "handsome, cheap and sensible" but added that "it may never be available."

32. Koch (ibid.), p. 125; Herbert (note 28 above), pp. 312–313.

33. John Neuhart, Marilyn Neuhart, and Ray Eames, *Eames Design: The Work of the Office of Charles and Ray Eames* (Abrams, 1989), p. 155

34. *Architectural Forum,* May 1943; shown in Pulos, *American Design Adventure,* p. 40. Barrett was a division of Allied Chemical & Dye Corporation, and the advertisement was said to show "the first of a series of architectural designs providing greater utilization of roof areas."

35. *Tomorrow's House,* p. 2.

36. "Experimental House," *Architectural Record,* December 1957; "The Industrialized House: An Experiment," *Industrial Design,* January 1958. See also "Experimental House," *Ekistics,* March 1958; "Could This Be Your Next House?" *Ownership,* September 1958; "The Industrialized House," *Architecture & Building,* November 1958.

37. Gropius had been scornful of the idea of repetitive identical housing units: "The true aim of prefabrication is certainly not the dull multiplication of a housing type ad infinitum. . . . More and more the tendency develops to prefabricate component parts of buildings rather than whole houses. Here is where the emphasis belongs." (Walter Gropius, letter to editor, *New York Times,* printed March 2, 1947, quoted in Sigfried Giedion, *Walter Gropius, Work and Teamwork* [Reinhold, 1954], pp. 76–77)

38. "Experimental House," *Architectural Record,* December 1957.

39. Ibid.

40. Ibid.

41. Ibid.

42. "Beware of Trends" (originally a speech to the Home Furnishings Division of the Fashion Group, New York, October 28, 1948), *Interiors,* December 1948.

In Europe, the industrialized-building movement enjoyed some successes in the form of prefabricated panel systems used to build large housing and office blocks. In the United States, its only success was in the form of mobile homes, most of which, despite their name, never moved an inch after being deposited in their "mobile parks."

According to Charles Abrams's book *The Language of Cities* (Viking, 1971), "The industry says that in 1968 mobile homes accounted for 75 percent of all new [U.S.] housing selling below $12,500 and for mroe than a quarter of total new single-family sales. . . . The mobile-homes industry has made the greatest strides in the industrialization of housing" See also Pulos, *American Design Adventure,* pp. 31–34.

There were, of course, other contemporary efforts at prefabricated housing, including the Consolidated Vultee house, designed by Henry Dreyfuss and Edward Larabee Barnes (1947); a house commissioned by *Look* magazine, designed by Walter Dorwin Teague (1948); Frank Lloyd Wright's Usonian House prototype, built on the future site of the Guggenheim Museum (1953); Monsanto's cruciform house, designed by MIT's Richard Hamilton and Marvin Goody (1954); B. F. Goodrich's "House of Today" (1956); and Alcoa's Care Free House, designed by Charles Goodman (1958).

43. "Impressions of Moscow,"*Holiday,* January 1961.

44. Ibid.

Chapter 5: Furniture

1. In 1919 Dirk Jan De Pree, who had started at Star in 1909 as a clerk, became president and changed the name to Michigan Star. In 1923 De Pree acquired 51 percent of the stock

(using money borrowed from his father-in-law, Herman Miller) and renamed Michigan Star the Herman Miller Furniture Company. In 1969 it would become Herman Miller, Inc.

2. Rohde had also designed for the Herman Miller Clock Co., which was also headed by D. J. De Pree.

3. Interview with D. J. De Pree, Zeeland, June 1, 1989. (Similarly, Penny Sparke, in *Furniture: Twentieth-Century Design* [Dutton, 1986], says that De Pree called Rohde's designs "vocational school furniture.")

Although Nelson was on the Architectural Forum staff in those years, De Pree's memory in June of 1989 was that Nelson himself had never been responsible for publishing any of Rohde's work, considering it "too crude." As already noted, however, Rohde's work had been included in the October, 1937, issue of Architectural Forum devoted to the subject of "Domestic Interiors;" Nelson was listed on the masthead of that issue as Associate. Before 1944 Rohde's designs for Herman Miller were also shown in *Arts and Decoration, Art & Industry,* and *Architectural Record.*

4. Ibid.

5. Quoted in Ralph Caplan, *The Design of Herman Miller* (Whitney Library of Design, 1976), p. 27.

6. Interview with De Pree (note 3 above).

7. After fleeing Germany in 1933, Mendelsohn had shared a successful London practice with Serge Chermayeff for several years. Mendelsohn would move from New York to California the following year.

8. Wright's wife Mary is said to have coined the phrase "blonde wood" for American Modern. The phrase and the furniture became clichés in the next two decades. Wright's earlier collection for Heywood-Wakefield had not been successful. See William J. Hennessey, *Russel Wright* (MIT Press, 1983), pp. 31–35.

9. Ibid., pp. 38 – 42. Also called American Modern, this may have been the most popular dinnerware ever designed, with 80 million pieces being produced in the 20 years after its introduction. A decade later, Edgar Kaufmann, jr., would include it in his first "Good Design" show at the Museum of Modern Art.

10. Herman Miller Co. oral history, undated. Wright's demand that Herman Miller hire no other designer was reported in a memo from D. J. De Pree to J. M. Eppinger dated December 5, 1944.

11. Herman Miller Co. oral history, n.d.

12. "Stylistic Trends in Contemporary Architecture" in *New Architecture and City Planning,* ed. P. Zucker (Philosophical Library, 1944).

13. Interview (note 3 above).

14. Ibid.

15. D. J. De Pree, memo to J. M. Eppinger, November 29, 1944.

16. Eppinger, memo to De Pree, December 19, 1944.

17. Eppinger, memo to De Pree, December 8, 1944.

18. Eppinger, memo to De Pree, December 19, 1944.

19. Eppinger, memo to De Pree, December 1, 1944.

20. Eppinger, memo to De Pree, December 19, 1944.

21. De Pree, memo to Eppinger, December 13, 1944.

22. De Pree, record memo, February 13, 1945.

23. From De Pree's record memo dated June 11, 1945: "We also discussed his partner, Yamosaki. This is an American-born Japanese architect whom Nelson has chosen from many that he could select to be his partner. They expect to set up their partnership in architectural offices in September. Yamosaki is with Nelson on the faculty of Columbia University. They have been working together on a number of projects for Time, Inc." In a letter to De Pree dated June 27, 1945, Nelson states that he has "discussed the matter of fees with Mr. Yamasaki."

24. Nelson, letter to De Pree, June 27, 1945. Noguchi's first version of the glass-topped coffee table, with a more complex base than the popular version, had been designed in 1939 for the house of A. Conger Goodyear, then president of the Museum of Modern Art. According to Noguchi, he was then asked by the designer and author T. H. Robsjohn-Gibbings for a coffee table design, and presented him with a plastic model of the table. When this turned up in a Robsjohn-Gibbings advertisement without credit to Noguchi, the sculptor was furious. "In revenge," he wrote, "I made my own variant of my own table, articulated as the Goodyear Table, but reduced to rudiments. . . . This is the coffee table that was later sold in such quantity by the Herman Miller Furniture Company." Herman Miller manufactured it from 1947 through 1953. In 1980 a limited edition of 400 was made available to Herman Miller stockholders, and the company again put the table into production in 1984.

25. De Pree, letter to Nelson, July 2, 1945.

26. Nelson, letter to De Pree, June 27, 1945.

27. Herman Miller Co. oral history, n.d.

28. Ibid.

29. "The Furniture Industry," *Fortune,* January 1947.

30. Ibid.

31. Eliot F. Noyes, *Organic Design in Home Furnishings* (Museum of Modern Art, 1941).
 The competition was organized and the catalogue written by Noyes, director of the museum's department of industrial design. The jurors were Marcel Breuer, Alvar Aalto, Alfred Barr, Edward Durell Stone, and Frank Parrish. Two of the competition's sponsors were Edgar Kaufmann, jr. (then in charge of home furnishings for the Kaufmann department store in Pittsburgh, but about to join the museum's staff) and the department store Bloomingdale's. Among the other competition winners were Bernard Rudofsky, Antonin Raymond, the team of Oscar Stonorov and Willo von Moltke, and the team of Harry Weese and Benjamin Baldwin; honorable mentions went to Carl Koch and Hugh Stubbins, among others.
 Noyes offered this explanation of "organic" on the inside front cover of the catalogue: "A design may be called organic when there is an harmonious organization of the parts within the whole, according to structure, material and purpose. Within this definition there can be no vain ornamentation or superfluity, but the part of beauty is none the less great—in ideal choice of material, in visual refinement, and in the use of rational elegance of things intended for use."
 In 1939, before the Organic Design competition, Eames and Saarinen had collaborated on the design of an exhibition of work by the faculty of the Cranbrook Academy of Art; see R. Craig Miller, "Charles Eames," in *Macmillan Encyclopedia of Architects* (Macmillan, 1982).

32. On Eames's days at Cranbrook, see David G. DeLong, "Eliel Saarinen and the Cranbrook Tradition in Architecture and Urban Design," in *Design in America: The Cranbrook Vision, 1925–1950* (Abrams, 1983).

33. Except that, in all of Eames's work since their marriage in 1941, there was the collaboration of his wife Ray.

34. In 1943, Evans Products had begun to manufacture Eames-designed splints and body litters made of molded plywood. Many of these were sold to the U.S. Navy for wartime use. In the 1970s the Barclay was renamed the Intercontinental New York.

35. John Neuhart, Marilyn Neuhart, and Ray Eames, *Eames Design: The Work of the Office of Charles and Ray Eames* (Abrams, 1989), p. 56

36. Interview with De Pree (note 3 above).

37. In calendar year 1991, Herman Miller's sales were over $800 million.

38. Interview with De Pree.

39. Head of Alfred Auerbach Associates, New York-based marketing, advertising and public relations consultants, who had been hired to represent Evans Products. In 1938 (as mentioned in note 12 to chapter 3) Auerbach had been a founder of the American Designers Institute, a professional organization for industrial designers.

40. See Neuhart et al., *Eames Design,* pp. 75, 79–80.

41. Transcript of interview conducted by Ralph Caplan, January 30, 1981; courtesy Herman Miller, Inc. In a letter to D. J. De Pree dated March 25, 1946, Nelson wrote: "Ernest . . . is out of the Army and I have engaged him to work full time for me until the end of May. This will, of course, greatly speed up production of the required designs." Farmer's employment continued much longer, however.

42. Nelson, memo to De Pree dated "Summer, 1945."

43. Interview with Irving Harper, Rye, N.Y., June 4, 1990.

44. The slat bench would become ubiquitous in the next few years, with sculptor Harry Bertoia introducing his own version (walnut slats on a black metal frame) for Knoll; it was included in the 1951 "Good Design" show at the Museum of Modern Art. Paul McCobb would also include a platform bench in his 1949 "Planner Group" of furniture components for Winchendon, and Edward Wormley would design his own version, a foam rubber slab on a wood base, for Dunbar.

45. Noyes, *Organic Design* (note 31 above), p. 9.

46. Such as the stacking glass-fronted "Elastic Bookcase" units manufactured and sold in great numbers by the Globe-Wernicke Co., Grand Rapids, beginning about 1898.

47. The Casiers Standard were available in a single height (75 cm.), two depths (37.5 and 75 cm.) and three widths (37.5, 75 and 112.5 cm.). They were reproduced by Cassina in 1978 and sold in the United States by a.i. (Atelier International).

48. I am grateful to Harvey Probber (himself a pioneer in the application of modularity to seating) for a conversation on the significance of the Breuer design.
 The Breuer units were based on a 33-centimeter module. Its units could be free-standing, set on legs, or wall-hung, and were used in a great number of his interiors, perhaps first in the 1926 Wilensky apartment and 1927 Piscator apartment, both in Berlin, then (executed in enameled sheet metal) in the Stam house at the 1927 Weissenhof Siedlung in Stuttgart. (Soon after his development of modular furniture components, Breuer carried the idea of modularity an important step further by extending it beyond furniture units to the enclosing building units. The first of these extensions, dating from 1925, was the *kleinmetallhaus,* to be built of lightweight prefabricated metal parts. He elaborated on these sketches in 1926, and in 1927 he proposed a row of prefabricated houses for the Bauhaus masters Bayer, Albers, Mayer, Breuer, Otte and Schmidt (hence their acronym, the BAMBOS houses). (See Noyes, *Organic Design,* p. 9.) They were to have been built of steel skeleton construction with infill of cement-asbestos panels. At about the same time, Gropius was also designing prefabricated row housing for the school. None was built.

49. *Tomorrow's House,* p. 116

50. Herman Miller Co. oral history 33, 1985.

51. Opening sentence of a manuscript titled "The Design Process," undated but probably written c. 1975.

52. Herman Miller oral history 33.

53. "Nelson enters Bernbach-Lippincott clash; sees true image as sum of firm's activities," *Graphics: New York,* February 1967.

54. Interview with Harper (note 43 above).

55. Ibid.

56. Herman Miller Co. oral history, not dated.

57. Three dollars had also been the price of *Tomorrow's House,* a much larger book.

58. "Peak Experiences and the Creative Act," p. 20.

59. *The Herman Miller Collection* (Herman Miller Furniture Co., 1948), p. 4

60. Nelson, letter to Charles Eames, April 30, 1948.

61. Nelson, lecture to members of American Institute of Architects, Detroit, March 22, 1951.

62. Beginning in 1948, some of the Herman Miller ads were designed by Ray Eames and Charles Kratka of the Eames office. See Neuhart et al., *Eames Design,* p. 89.

63. *Interiors,* March 1947. The 1938 company was the Hans G. Knoll Furniture Company. An important shift into the commercial design field came in 1945, when Knoll and his wife were given the commission for Nelson Rockefeller's office in New York. In 1946 Knoll and his wife established Knoll Associates.

64. Text accompanying Eames's competition entry, quoted in Arthur Drexler, *Charles Eames Furniture from the Design Collection* (Museum of Modern Art, 1973), p. 60.

65. In the seating category, first prizes went to Donald Knorr and George Leowald, the other second-prize winner was Davis Pratt, and a third prize was given to Alexis [Alexey?] Brodovitch, according to Pulos (*American Design Adventure,* p. 86).

66. Neuhart et al., *Eames Design,* p. 99.

67. Herman Miller Co. oral history, undated.

68. Ibid. The same story is repeated, at slightly greater length, in Ralph Caplan's interview with Nelson (note 41 above).

69. Herman Miller Co. oral history, undated.

70. Edgar Kaufmann, jr., *Prize Designs for Modern Furniture from the International Competition for Low-Cost Furniture Design* (Museum of Modern Art, 1950).

71. Girard's radios were shown in the 1946 "Ideas for Better Living" exhibition at the Walker Art Center in Minneapolis.

72. See Neuhart et al., p. 55.

73. The Eames furniture was also being sold at Baldwin Kingrey, a Chicago shop run by Kitty Baldwin Weese, sister of designer Ben Baldwin and wife of architect Harry Weese. Baldwin and Weese had both been at Cranbrook with Charles and Ray Eames.

74. Between the war's end in 1945 and the end of the decade, there were a number of American exhibitions of new domestic products. These included: "Ideas for Better Living" (Walker Art Center, 1946), "Useful Objects for the Home" (Akron Art Institute, 1946 and 1947), "Good Design Is Your Business" (Albright Art Gallery, Buffalo, 1947, later restaged at the Addison Gallery of American Art in Andover, Mass.), "Decorative Arts Today" (Newark Museum), "The Modern House Comes Alive" (Munson-Williams-Proctor Institute, Utica), "Furniture of Today" (Rhode Island School of Design), and, in 1949, four product-design exhibitions at the San Francisco Museum of Art, each devoted to a different part of the house.

75. George Nelson, *Display* (Whitney Publications, 1953), p. 144.

76. In 1927, four years after D. J. De Pree bought a furniture company with money supplied by his father-in-law, Herman Miller, Miller gave de Pree money to start a clock company. It was originally called the Herman Miller Clock Co., but in 1937 it was turned over to Miller's son Howard and given his name.

77. Edgar Kaufmann, jr., in *An Exhibition for Modern Living,* ed. A. H. Girard and W. D. Laurie (Detroit Institute of Arts, 1949), p. 27. Almost immediately after the Detroit exhibition, Kaufmann asked Girard (along with Meyric Rogers, curator of decorative arts at the Art Institute of Chicago) to help him in jurying the first (1950) Good Design show for the Museum of Modern Art and Chicago's Merchandise Mart. Kaufmann would also ask Girard to design the 1953 and 1954 Good Design shows.

78. Ibid., p. 82.

79. Transcript of taped conversation between Nelson and Mildred Friedman, October 15, 1974; courtesy of Herman Miller Co.

80. Alexander Girard, letter to D. J. De Pree, July 5, 1951: "Am greatly looking forward to collaborating with Herman Miller Company on fabrics. I have thought quite a lot about procedure the last week, and discussed it with George." De Pree forwarded Girard's letter to Nelson for his comments and suggestions.

81. Jack Lenor Larsen, "Alexander Girard," in Nelson Eames Girard Propst: The Design Process at Herman Miller, *Design Quarterly* 98/99 (Walker Art Center, 1975). The same publication includes an introduction by Nelson and an essay about Nelson written by Olga Gueft, longtime editor of *Interiors*.

 Some sprightly modern fabric design had preceded Girard's, of course, including "Incantation," a highly publicized 1948 print by Alvin Lustig for Laverne and, a year later, a collection for the Schiffer Prints Division of the Mil-Art Company (see *Interiors*, July 1949), for which the six designers were all previously inexperienced in the textile field. They were: Nelson himself, who put Irving Harper in charge of the project, producing an abstract print called China Shop and five others; Ray Eames; Edward Wormley; Abel Sorensen; Salvador Dali; and Bernard Rudofsky, who claimed not to have designed but rather "edited" his fabric patterns, all based on arrangements of typewriter characters.

 For the Schiffer collection, the Nelson office also designed a display at New York's Architectural League as well as stationery, bills, sample tags and shipping labels. The Schiffer fabrics were later translated into wallpaper patterns by the Concord Wallpaper Co.

 Another printed fabric from the Nelson office, called "Terrain" and manufactured by Schiffer in the 1950s, is in the Twentieth-Century Art collection of the Metropolitan Museum of Art.

82. Most notably, in San Francisco, his 1959 transformation of a turn-of-the-century music hall into a showroom. Keeping some elaborate ornament and adding more, it presented a "postmodern" image long before the style became labeled.

83. La Fonda del Sol, located on the ground floor of the Time-Life building, was enlivened by pieces from Girard's collection of Latin American folk art. The main product of the Eames-Girard collaboration, the La Fonda chair, can still be ordered from Herman Miller, Inc.

84. Nelson, letters to De Pree, May 22, May 27, June 19, and August 29, 1946.

85. In September of 1952, De Pree wrote Nelson that he had "received an inquiry from Paul László stating he would like to regain his right to the designs of the table and the easy chair since he assumes that we are no longer selling them. How do you feel about this?" Nelson replied: "It would seem fair to restore László's rights in the circumstances."

86. Nelson had probably bought his Aalto furniture from Clifford Pascoe, an early New York importer of the furniture. In San Francisco, the Aalto furniture was being imported by the landscape architect Thomas Church. In 1940, the Aalto furniture began to be manufactured in the United States by The Eggers Co. in Wisconsin, with sales handled by Pascoe.

87. Mr. and Mrs. George Nelson are thanked in the catalogue (*Aalto: Architecture and Furniture* [Museum of Modern Art, 1938], p. 4). Other lenders included Henry-Russell Hitchcock, Mr. and Mrs. William Lescaze, Herbert Matter, and the Kaufmann store in Pittsburgh.

88. Less than a year after the first Miller catalogue appeared, Knoll had issued one priced at $5.

89. De Pree, letter to Nelson, May 29, 1952.

90. Arthur Drexler, *Problems of Design* (Whitney Publications, 1957), p. ix.

91. *Fortune,* April 1946.

92. For Fuller's support of the currency-reform ideas of the Technocracy movement, see Martin Pawley, *Buckminster Fuller* (Trefoil, 1990), pp. 86–89. On Obnoxico, see Lloyd Steven Sieden, *Buckminster Fuller's Universe* (Plenum, 1989), pp. 374–376.

93. Nelson, letter to Charles Eames, August 8, 1951.

94. Nelson, letter to Charles Eames, August 21, 1951.

95. Drexler (note 90 above), p. ix.

96. See Thomas Hine, *Populuxe* (Knopf, 1986), p. 119. Hine identifies the boomerang as the third key image.

97. Ralph Caplan, interview with Nelson (note 41 above). Fuller and Noguchi had met in 1929 at Romany Marie's, a Greenwich Village tavern that was a hangout for artists, gypsies, and mystics (including the religious guru Georgi Gurdjieff). Fuller had designed the restaurant, lighting it strongly but indirectly with high-voltage lamps in huge aluminum cones and furnishing it with tables and chairs that he not only designed but built himself; in payment, Romany Marie had offered Fuller a lifetime of free dinners (see Alden Hatch, *Buckminster Fuller: At Home in the Universe* [Crown, 1974], pp. 111–112). "Some time later," Noguchi moved into "an old laundry room on top of a building on Madison Avenue and 29th Street with windows all around it." Feeling himself "under Bucky's sway," he "painted the whole place silver, top, bottom and sides, to the effect that one was almost blinded by the lack of shadows" (Isamu Noguchi, "A Remembrance of Four Decades," *Architectural Forum,* January-February 1972).

98. On p. 44 of *Furniture: Twentieth-Century Design* (Dutton, 1986) Penny Sparke says: "The Modern style appeared first in public places—cocktail bars, hotel foyers, and cinemas— before it infiltrated the home, and then it was found in the kitchen before it finally entered the living room." Edward Lucie-Smith makes a similar observation on p. 176 of *A History of Industrial Design* (Phaidon, 1983): "Industrial design entered the domestic environment through the back door which led to the kitchen."

99. "After the Modern House," *Interiors,* July 1952; reprinted in *Problems of Design.*

100. Thomas C. Howard, letter to the author, May 27, 1991.

101. Interview with John Pile, December 9, 1989.

102. Nelson, letter to Charles Eames, August 21, 1951.

103. The Rotunda had been moved in 1936 from its original site at Chicago's Century of Progress Exposition. The suggestion that the central space be covered by a Fuller dome, rather than by conventional heavy steel construction, came from Niels Diffrient. Fuller's dome for the Rotunda was completed in April 1953. The building was destroyed by fire in 1962. See "Bucky Fuller Finds a Client: Young Henry Ford Translates the Geodesic Dome into Aluminum and Plastic," *Architectural Forum,* May 1953.

104. Howard letter (note 100 above).

105. Howard (ibid.) notes that Fuller—"with all his inventive capability, unable to work on more than one project at a time"—abandoned the MoMA dome. But in 1959 a Fuller geodesic dome finally appeared in the MoMA garden, along with two other Fuller constructions, an Octet Truss and a Tensegrity Mast, this last built by Shoji Sadao and Edison Price.

106. "Changing the World" (see note 42 to chapter 2 above).

107. "Body Beautiful: From the Business Side of the Footlights," *Interiors,* June 1950.

108. Ibid.

109. "Holiday Handbook of Beds," *Holiday,* August 1958. A patent drawing of such a "convertible bed room piano" is shown on p. 171 of David A. Hanks's *Innovative Furniture in America from 1800 to the Present* (Horizon, 1981). Hanks notes that an upright version of the piano bed was actually manufactured.

110. Bonniers, designed by Warner-Leeds and opened in 1949 at 605 Madison Avenue, was an important source of well-designed modern objects. For a description of the store, see *Interiors,* June 1949.

111. "Peak Experiences and the Creative Act." Paul Rudolph also used the plastic cocooning material in his design for Edgar Kaufmann, jr.'s 1952 "Good Design" exhibition at the Museum of Modern Art. Isamu Noguchi's Akari line of paper globe lamps, similar in appearance to the Bubble Lamps but not in technology, was introduced in 1966; both groups of lamps, of course, owe a debt to the traditional paper lanterns of the Orient.

112. "Squeeze in Aluminum," *Fortune,* February 1956.

113. William Dunlap, letter to the author, June 8, 1990.

114. Nelson, conversation with Mildred Friedman (note 78 above).

115. Interview with William E. Dunlap, Naples, Florida, March 7, 1989.

116. Dunlap, letter (note 113 above).

117. Nelson, "Reflections on Home-Psych," *Interior Design,* March 1984.

118. Dunlap, letter (note 113 above).

119. Ibid.

120. The system was developed by William Katavolos of the Nelson staff.

121. StrucTube was manufactured by the Affiliated Machine and Tool Co. in New York.

122. Nelson, conversation with Mildred Friedman (note 78 above).

123. The CSS, developed by John Pile of the Nelson staff, consisted of 20 components (desk, cabinets, shelving), could be delivered unassembled, and was infinitely expandable. It was manufactured by Herman Miller from 1959 to 1973.

124. Arto Szabo, letter to Joseph Bux of Herman Miller Co. (copy to Nelson), September 12, 1961. Although Nelson did not recognize the name, Szabo had been in the Nelson office briefly and, as he revealed in a later letter, had himself worked on the Omni pole system. For these letters, I am grateful to Hilda Longinotti, secretary to Nelson at the time and now a Herman Miller showroom executive in New York.

125. Nelson, letter to Arto Szabo, November 14, 1961.

126. Letter to Nelson (signed "Sam" Szabo), November 20, 1961.

127. Latham had worked in Raymond Loewy's office and had then become a design consultant to General Electric.

128. Kann had worked in the Chicago office of Ludwig Mies van der Rohe in its earliest days and had then worked as assistant to Florence Knoll before coming to New York and meeting Nelson.

129. Interview with Dunlap (note 115 above).

130. One of Engle's first independent jobs was freelance work for fellow Nelson office graduates Irving Harper and Philip George. Their young firm was working for Hallmark on one of the earliest open-plan offices and one of the earliest installations of Herman Miller Action Office furniture.

131. C. Ray Smith, *Supermannerism: New Attitudes in Postmodern Architecture* (Dutton, 1977). The most prominent practitioners of this style were Hardy Holzman Pfeiffer in the early 1970s.

132. Dunlap letter (note 113 above).

133. The Nelson staff designer in charge of the Coconut was George Mulhauser.

134. Irving Harper was the designer in charge of the Marshmallow.

135. Interview with Joe Schwartz, Marigold Lodge, Holland, Michigan, April 3, 1990. Schwartz was originally in Herman Miller's sales department, then vice-president of Miller's Health/Science Group, later head of the company's Special Projects Division.

136. The sofa's propensity for tipping was reported by Preston "Pep" Nagelkirk, a retired Herman Miller modelmaker who had worked with Nelson on finding a way to make the sofa, in an interview at Marigold Lodge, Holland, Michigan, April 3, 1990.

137. "George Nelson 'Pretzel Chair' ICF," in *Domus,* March, 1986. Around the same time, Gio Ponti was developing his "Leggera" chair design of 1952 into the even lighter "Superleggera," which would be shown in *Domus* in 1959. According to Jacqueline Nelson, designer Vico Magistretti spotted the Pretzel chair in the Nelson apartment years later at a time when Magistretti himself was working on his popular rush-seated "Modello 115" chair for Cassina. He admired the Pretzel, and the two designers planned for a while to collaborate on a chair that would combine elements of both designs. They intended to name it "Georgistretti."
 The Pretzel chair was developed in the Nelson office by designer John Pile.

138. The Swaged-Leg Group was developed in the Nelson office by Charles Pollock, under John Pile's supervision. Pollock would later become an important independent designer, his namesake chair for Knoll being introduced in 1965. A swage is a tool used with a hammer or a sledge to shape a piece of metal.

139. Interview with Max De Pree, Marigold Lodge, Holland, Michigan, April 3, 1990.

140. Nelson, letter to Frank Lloyd Wright, February 26, 1958.

141. Frank Lloyd Wright, letter to Nelson, March 7, 1958.

142. This story was told to the author by Jacqueline Nelson.

143. Working in the Nelson office on the Sling Sofa's development were Ronald Beckman, John Svezia, and Irving Harper, assisted by others.

144. Irving Harper, Ronald Beckman, and Rodney Hatanaka were responsible for developing the Catenary group designs.

145. *Progressive Architecture,* November 1963.

146. Speech to the American Institute of Architects, Detroit, March 22, 1951; published as "The Enlargement of Vision" in *Problems of Design.*

147. Edgar Kaufmann, jr., "Design sans peur et sans ressources," *Architectural Forum,* September 1966.

148. The question of profitability versus other motives is one that could also be applied to the Nelson office. Arthur Drexler, in his preface to Nelson's 1957 book *Problems of Design,* asked: "How does [Nelson] satisfy both the demands of his clients' advertising agencies and his own common sense? How does he remain an honest intellectual while actually making money?" In Nelson's case, it is far from clear that his office always *did* make money.

149. D. J. De Pree, letter to Nelson, August 12, 1970. The day De Pree was unsure of was probably during the first week of August 1945. De Pree's note to J. M. Eppinger dated July 13, 1945, suggests a date between the first and the fourth of August, and Nelson's letter of August 10 thanks De Pree for his "hospitality in Zeeland."

150. "The End of Architecture," *Architecture Plus,* April 1973. Paul Goodman's *People or Personnel* was published by Vintage in 1968.

Chapter 6: Education

1. Nelson, "The Georgia Experiment: An Industrial Approach to Problems of Education," manuscript dated October 1954. This is apparently a text for a speech to be given to a group of educators. It is marked "not read."

2. Fuller was invited by Dodd in the spring of 1953. On March 27, 1953, he wrote Dodd, "I should very much enjoy paying you a visit. George Nelson has spoken of what you are doing down there, and I have had an interest in your school for many years, due to the fact that Harold Bush-Brown was a next door neighbor of my early boyhood." Bush-Brown was then Dean of the School of Architecture at the Georgia Institute of Technology. Dodd had invited him to see "Art X," but he had been unable to attend.

3. Kiesler visited the school May 20 and 21, 1952, but plans for a more extended association did not materialize. On May 30, Dodd wrote Kiesler that it would not be "wise for us to undertake . . . specific proposals that you so graciously offered to perform."

4. Nelson remembered having declined Dodd's invitation, then accepting when Dodd called again. Dodd remembers an initial acceptance, then an attempt by Nelson to get off the hook.

5. Interview with Lamar Dodd, Athens, Georgia, May 21, 1990. Correspondence in the Lamar Dodd archives of the University of Georgia Library shows that a fee of $400 a day, including expenses, was finally arrived at (letter from Nelson to Lamar Dodd, April 23, 1952;

letter from Lamar Dodd to Nelson, April 28, 1952). Indicating the relative size of this offer is the fact that, a few months later, Dodd was offering Milton Avery a salary of $5,500 to $6,000 for the entire 1953–54 school year (letter from Lamar Dodd to Milton Avery, January 6, 1953).

6. Interview with Philip George, New York, August 21, 1990. Philip George worked in the Nelson office from 1958 to 1962 and was Nelson's chief assistant on the Moscow exhibition of 1959.

7. Nelson had also been a consultant to the Parsons School of Design and a member of the Corporate Visiting Committee of MIT's School of Architecture and Planning.

8. "Art X = the Georgia Experiment," *Industrial Design,* October 1954; reprinted in *Problems of Design* (see p. 15).

9. Nelson, letter to Charles Eames, May 22, 1952.

10. In an undated transcript in the Herman Miller archives of a conversation between D. J. De Pree and Nelson there is this dialogue about Nelson and Eames:

De Pree: Were your design philosophies the same, or just compatible?

George: I would say compatible.

De Pree: Your way of working was also different.

George: Charlie was a maniac about details, and said the connections are everything, and killed himself doing things I couldn't have touched. On the other hand, I had a way of thinking about things that got me some kind of mileage doing it differently. Too bad we couldn't have become partners. We were really an interesting pair.

De Pree: No, I think you were too individual to be partners. No, it never would've worked.

11. "Art X," p. 15.

12. *The Creative Experience,* ed. Stanley Rosner and Lawrence E. Abt (Grossman, 1970); interview with Mico Nelson, [date]; George Nelson, letter to Tom Pratt, September 8, 1984. Nelson apparently first went to Fromm c. 1941, after the publication of *Escape from Freedom,* asking him to be a consultant for a new magazine Nelson was developing for Time-Life; later Nelson was a patient for a time. The two men became lifelong friends.

A notebook in Nelson's study contained a dozen pages labeled "Fromm." In Nelson's handwriting, they seem to hold notes quickly written as Fromm talked, either in public lectures or private conversations, and confirm a teacher/student relationship beyond the usual analyst/analysee relationship.

One of Fromm's last books, published in 1976, would be titled *To Have or To Be.*

13. Erich Fromm, "Freedom and Democracy," in *Escape from Freedom* (Holt, Rinehart & Winston, 1941).

14. "Art X," p. 16

15. Eames never liked the title; later he always referred to it as "A Rough Sketch for a Sample Lesson for a Hypothetical Course."

16. "Art X," p. 16.

17. Nelson, letter to Charles Eames, May 22, 1952.

18. "The Georgia Experiment" (note 1 above).

19. "Art X," p. 16.

20. Lamar Dodd, letter to George Foote, January 30, 1953, Lamar Dodd archives, University of Georgia Library. Foote's Atlanta furniture store, The Pacer, had planned the display.

21. Lamar Dodd, letter to Nelson, January 21, 1953.

22. Nelson, letter to Dodd, January 29, 1953.

23. "The Georgia Experiment."

24. Eames's "communications process" and "communications method" segments were later excerpted and merged to form a 20-minute film called "A Communications Primer."

25. "Art X," p. 17

26. Nelson, letter to Dodd, June 11, 1953. Dodd had been unable to attend the California presentations.

27. Dodd, letter to Nelson, March 11, 1953.

28. William S. Howland, letter to Nelson, March 11, 1953.

29. Two leaders among them were Irwin Breithaupt and Harold Wescott.

30. "Georgia Adults Go Back to School in Unacademic Surroundings," *Interiors,* February 1958. The architects for the building were Stevens & Wilkinson of Atlanta, with D. J. Edwards as chief designer. Dolores Engle was the member of the Nelson staff in charge of the interior design. One innovation was the use of room-divider panels made of decoratively printed automotive safety glass.

31. Nelson, letter to Lamar Dodd, April 20, 1953. After hopes for a grant died, Nelson wrote Dodd on March 19, 1954: "I think it will be better for everyone, particularly the faculty, if they don't get the best of everything right off. . . ."

32. "Art X," p. 18

33. "Charles and Ray Eames, 'The Eames Report,'" *Design Issues,* spring 1991. Their report led to the establishment of the National Institute of Design in Ahmedabad in 1961.

34. R. Buckminster Fuller, *Education Automation* (Southern Illinois University Press, 1962), pp. 36–38.

35. "The Georgia Experiment."

Chapter 7: Exhibitions

1. "Fairs," *Architectural Forum,* September 1936.

2. The Exposition of 1851, in London, where, according to Nelson, "the world first became fully conscious of the machine."

3. Chicago, 1933.

4. Fuller, letter to Nelson, December 14, 1976. (Fuller remembered the year as 1937, not 1938.)

5. George Nelson, *Display* (Whitney Publications, 1953), p. 173.

6. Ibid., p. 9.

7. A structural system devised for Williamsburg by William Katavolos of the Nelson staff would later lead to the Omni pole system, discussed in chapter 5 above.

8. Nelson kept a logbook of the entire design procedure for the Moscow exhibition, on which the following account is largely based and from which all quotations are taken (unless otherwise noted). Some early excerpts from the log were published before the exhibition's opening in *Industrial Design* (April 1959). The complete log is in the collection of Jacqueline Nelson.

9. McClellan had been supportive of Eisenhower's presidential campaign and had also served as Assistant Secretary of Commerce for International Affairs (1955–1957).

10. The dome's parts had been fabricated in three months, flown to the site in a DC-4 and, with the help of Fuller's color-coding system, assembled in 48 hours by untrained but enthusiastic Afghan workers, who reportedly considered the dome a modern version of their traditional yurt.

11. In 1949 Wilder had commissioned Charles and Ray Eames to design a house for him. Although the house (meant to be a much larger version of the Eamses' own steel-framed house, finished the year before) was not built, Wilder remained friendly with them.

12. Interview with Jack Masey, New York, July 5, 1990. On Art X, see chapter 6 above.

13. Interviews with John Pile (New York, December 8, 1989) and Ronald Beckman (New York, December 11, 1990).

14. *New York Times,* February 28, 1959.

15. The plastics industry provided advice and material. Albert Dietz, a professor of building engineering at MIT, worked on the structure with Irving Harper. The hollow columns carried rainwater to an ornamental pond.

16. For example, the monumental roof of the 1956 Lambert airport terminal, in St. Louis, and the more delicate concrete-and-glass central roof of a 1957 conference center at Wayne State University, near Detroit.

17. The living room of the apartment was duplicated and shown for several months in 1959 at the Design Center for Interiors, at 415 East 53rd Street, which had opened in April 1958. Tom Lee, head of the Design Center, was in charge of all exhibits; his advisory board included fabric designer Dorothy Liebes, Parsons School of Design president Pierre Bedard, Meyric Rogers of the Art Institute of Chicago, and Nelson.

18. The furniture included not only Herman Miller products, as might be expected, but also some from Knoll, some from Paul McCobb, some from Kittinger, and Edward Wormley's designs for Dunbar.

19. *Charm,* May 1959.

20. Interviews with Jack Masey, New York, July 5, 1990, and with Philip George, New York, August 21, 1990

21. Interview with Philip George (see preceding note).

22. Nelson, "Impressions of Moscow," *Holiday,* January 1961.

23. Peter Blake, "Hype and Reality," *Interior Design,* December 1984.

24. Ibid.

25. Interview with Jacqueline Nelson, New York, July 12, 1990.

26. *New York Herald Tribune,* March 11, 1959.

27. "Reds Ban Free U.S. Cake: 'It Would Cause a Riot,'" *New York Herald Tribune,* July 27, 1959.

28. The exhibition attracted 20,000 visitors a day, according to *Time* (August 17, 1959).

29. Ibid.

30. Quoted in a letter by Nelson to the *New York Herald Tribune,* October 25, 1959.

31. Alden Hatch, *Buckminster Fuller: At Home in the Universe* (Crown, 1974), p. 210.

32. For an account of the Edsel fiasco, see p. 92 of Thomas Hine's *Populuxe* (Knopf, 1986).

33. John Kenneth Galbraith, *The Affluent Society* (Houghton Mifflin, 1958). Galbraith cites the earlier title in his introduction to the second edition (1969).

34. Hine, *Populuxe,* p. 129. Nixon admits that the debate was staged in *Six Crises* (Double-day, 1962).

35. *Industrial Design,* July-August 1967.

36. For a description see "Design Show Opens in India," *Industrial Design,* March 1959.

37. John Svezia, Gordon Chadwick, and Irving Harper led the Nelson office's work on the Chrysler exhibition. The office also did design work for the pavilion of the Republic of Ireland.

38. Vincent Scully, "If This Is Architecture, God Help Us," *Life,* July 31, 1964.

39. Ibid.

40. Nelson, letter to Tom Ptratt, November 12, 1984.

41. With the fabric designer Jack Lenor Larsen and the sociologist Herbert Gans as advisors.

42. Thomas Hine, "Shaping a Display of Design," *Philadelphia Inquirer,* October 13, 1983.

43. Of this cluster, Nelson said: ". . . maybe Stonehenge wasn't a bad image. Aren't we moderns also "technological barbarians"—perhaps semiliterate inhabitants of an impending Dark Age?. . . . The idea of arranging the highest high-tech stuff into a Stonehenge-type arrangement struck me as a delicious thing." (quoted in Sarah Bodine, "Anatomy of an Exhibition," *Industrial Design,* November-December 1983)

44. Nelson, quoted in William H. Jordy, "The 'Big Picture' in Philadelphia," *New Criterion,* January 1984.

45. *Design Since 1945* (Philadelphia Museum of Art, 1983).

46. Suzanne Slesin, "A Celebration of Design Since 1945," *New York Times,* October 13, 1983.

47. Max Bill and Ettore Sottsass, Jr., "Design and Theory: Two Points of View," in *Design Since 1945.*

48. "The Design Process," in *Design Since 1945;* reprinted in *Interior Design,* September 1983.

Chapter 8: The City

1. Interviews with John Pile (December 8, 1989) and Ivan Chermayeff (January 30, 1991), both in New York.

2. Unidentified, undated clipping in the collection of Jacqueline Nelson. The date must have been close to May 12, 1932.

 Interested as Nelson may have been in town planning, he was not sanguine about its efficacy, writing in his 1935 interview of Gio Ponti (*Pencil Points,* May) that it was "a field richer in promise than good examples."

3. Le Corbusier, chapter title in *When the Cathedrals Were White* (New York: Reynal & Hitchcock, 1947; first published as *Quand les cathédrales étaient blanches* (Paris, 1937).

4. After World War II, Wright would enlist the support of Bucky Fuller and others in petitioning the Roosevelt administration to implement the Broadacre City plans, but there was no positive response to the petition.

5. Wright and Stein, along with Catherine Bauer, had also helped prepare the housing section of the Museum of Modern Art's 1932 International Style exhibition. In 1933 Wright was appointed to the advisory group for the planning of the New York World's Fair.

6. Henry Wright, *Re-Housing Urban America,* with a foreword by Lewis Mumford (Columbia University Press, 1935).

7. Lewis Mumford, "Henry Wright," in *Encyclopedia of Urban Planning,* ed. Arnold Whittick (McGraw-Hill, 1974).

8. Revere presented Nelson's "Grass on Main Street" (1943) as "the thirteenth in a series bringing to the American public the concepts of noted architects and engineers for better homes and better living in days ahead." The *Architectural Forum* booklet, also published in 1943, was titled "Planning with You."

 According to Nelson's "Peak Experiences and the Creative Act" (see notes to introduction above), the title "Grass on Main Street" was "related to the 1932 campaign

for the presidency between Herbert Hoover and Franklin D. Roosevelt, when Hoover, in the heat of combat, said, 'If you elect that Bolshevik, grass will grow in Times Square.'"

9. "Peak Experiences and the Creative Act," p. 17.

10. Ibid.

11. "Grass on Main Street" (note 8 above).

12. "Innovation/Story," undated, in Nelson files.

13. Nelson, letter to the author, undated (c. January 1, 1980).

14. There had been smaller shopping centers before the war, of course—usually just rows of shops lining a parking lot. Aesthetically, the best of these was probably J. C. Nichols's 1923 Country Club Plaza in the suburbs of Kansas City.

15. Parallel efforts elsewhere included, most notably, the postwar redesign by J. H. van den Brock and Jacob Bakema of Rotterdam's Lijnbaan into a pedestrian street. Books such as Lewis Mumford's *The Highway and the City* (Harcourt, Brace & World, 1953), Colin Buchanan's *Traffic in Towns* (HMSO, 1963), Victor Gruen and Larry Smith's *Shopping Towns USA* (Reinhold, 1960), and Gruen's *The Heart of Our Cities, The Urban Crisis: Diagnosis and Cure* (Simon & Schuster, 1964) further popularized the planning concept of limiting automobile access.

 In 1968 the Nelson office finally tried its own hand at the shopping center, in the form of preliminary planning for the Rouse Company's Woodbridge (N.J.) Center Shopping Mall; Paul Heyer was the project designer.

16. Ketchum, Gina & Sharp's proposal for Rye was reported in the August 1946 *Architectural Forum*.

17. See, e.g., Marlise Simons, "Amsterdam Plans Wide Limit on Cars," *New York Times,* January 28, 1993.

18. Nelson, "Lifestyle," unpublished essay dated October 28, 1975 (possibly a draft for a chapter in the proposed book *The Synthetic Garden*).

19. Nelson, letter to Theo Crosby, February 2, 1971.

20. "U.S.—Us" was part of a two-day Visual Communications Conference sponsored by the Art Directors Club of New York, and was supported by Herman Miller Inc. After New York, the program traveled to Chicago, Atlanta, Houston, Los Angeles, San Francisco, Grand Rapids, and Aspen.

 In the same year, another former *Forum* editor, Jane Jacobs, made her views of the city (and of the destructive effects of modern architecture) known in *The Death and Life of Great American Cities* (Random House).

21. "The Product—It's 'Crowning Glory," but It's Junk, Nelson Tells Visual Communicators" (unidentified, undated newspaper clipping in Nelson files).

22. Harriet Morrison, "The Robots Are Taking Over," *New York Tribune,* December 15, 1961.

23. Nelson, "Problems of Architecture and Design," speech to American Institute of Architects, Detroit, March 22, 1951.

24. "New Haven and Its Mayor," *Holiday,* May 1966. Peter Blake's book *God's Own Junkyard: The Planned Deterioration of America's Landscape* was published in 1964 by Holt, Rinehart & Winston; parts of the text had appeared as "The Ugly America" in the May 1961 issue of *Horizon* and as "The Suburbs Are a Mess" in the October 5, 1963, *Saturday Evening Post.*

25. Interview with Irving Harper, Rye, N.Y., June 4, 1990. Fuller's calculations were found in the Nelson files.

26. Nelson, letter to Frank Lloyd Wright, December 18, 1947.

27. Norbert Nelson, interview with the author, New York, September 12, 1990. Norbert helped build some of the furniture during his visits to the house in Quogue.

28. Nelson, "Wright's Houses: Two Residences, Built by a Great Artist for Himself," *Fortune,* August 1946.

29. His first wife, the former "Fritzi" Hollister, whom he had met in Rome, and their two sons, Hollister and Peter. A daughter, born with severe brain damage, was in an institution.

30. Nelson, letter to Wright, December 18, 1947.

31. Nelson, "Design and Values" (unpublished, undated essay, probably c. 1961).

32. *Interiors* , May 1958.

33. "New Building Abroad: Switzerland," *Architectural Forum,* June 1963.

34. Nelson's slides of Venice were used to close "The Civilized City," a speech he gave to the Industrial Designers Society of America conference on June 4, 1974, and elsewhere. Some of them were also used to close his January 22, 1978, presentation about cities on the CBS television program *Camera Three.*

35. "Technology and Artistic Creation in the Contemporary World."

36. "Memo from Tbilisi," *Journal of the Industrial Designers Society of America,* March 1969. Nelson was editor-in-chief of the journal, but Walter Dorwin Teague served as guest editor for that issue.

37. The *Holiday* article, published in the February 1960 issue, would be condensed and retitled "Upside-Down in Japan" for *Reader's Digest* (April 1960), reprinted as "In Japan ist alles anders" in *Das Beste aus Reader's Digest* (June 1960), and adapted as "Japan: A Different Way" in *Science Research Associates,* a publication of IBM (November 1966). Other Nelson writings about Japan are "What I See in Japan," in *Jetro,* a publication of the Japan Trade Council (1959), and "A Matter of Fluidity," in *This Is Japan* (1959).

38. Nelson, foreword to Hideyuki Oka, *How To Wrap Five Eggs: Japanese Design in Traditional Packaging* (Harper & Row, 1967).

39. "Brasilia: Out of the Trackless Bush, a National Capital," *Saturday Review,* March 12, 1960. The architects were Lucio Costa (for overall planning) and Oscar Niemeyer (for design of the major buildings).

40. Ibid.

41. A memo dated August, 1964, in the Nelson office files listed the following "Management Group": "1. Walther Moreira-Salles [no identification] 2. Dr. Homero Souza e Silva, Chief partner in charge of Portugal operation 3. Mr. Antonio J. de Faria Filho, Son of Portugese ambassador to Vatican. In Lisbon office. Main function: government contacts. 4. Mr. André Gonçalves, Engineer, currently supposed to be operating head of Troia project. Director of the Portugese company 5. Mr. Henrique Mindlin, Now a director of Soltroia." A sixth name, added by hand to the typed memo, is illegible.

42. Nelson, undated memo (probably fall 1964).

43. Nelson, "Notes on the Troia Project," office memo, April 17, 1964.

44. Letter to Nelson from Henrique Mindlin, a director of Soltroia (the working title of the development group, the complete title of which was Sociedade Imobiliaria de Urbanizaçao e Turismo de Troia), September 11, 1964.

45. Nelson, undated memo (note 42 above).

46. Nelson, letter to Dr. Homero Souza e Silva, Rio de Janeiro, August 18, 1964.

47. Nelson, letter to Henrique Mindlin in Lisbon, December 9, 1964. Mindlin had been a leader (along with Neumeyer, Costa, and Reidy) in establishing the International Style in Brazil. His works included Brazil's first steel-framed skyscraper: the Avenida Central Building in Rio (1956). He had also written the authoritative book about the Brazilian movement: *Modern Architecture in Brazil* (Reinhold, 1956).

48. This idea was explored by Nelson at length in correspondence with General Electric, which was then experimenting with the manufacture of such cars, and with the Connecticut Light and Power Company, which had recently conducted a two-month test of such vehicles on Block Island, off the Connecticut coast. Problems of cost, of vehicle control, and, most critically, of travel range between battery recharges were all obvious, but the investigation was optimistically pursued.

On Nelson's investigation of electric cars, see the following letters: Nelson to Max Feldman, General Electric Co., Santa Barbara, December 24 and December 31, 1964, and January 13 and January 22, 1965; Feldman to Nelson, January 8 and January 19, 1965; Nelson to Jerry Hayden, Executive Vice-President, Connecticut Light and Power Co., Hartford, January 13, 1965; Paul V. Hayden, President, Connecticut Light and Power, January 15; Nelson to Hayden, January 19; Henry G. Hutchinson, President, [Block] Island Light and Power Co., to Nelson, January 25, 1965; Nelson to Hutchinson, January 28; Nelson to Henrique Mindlin, January 11, 27, and 31, 1965.

Nelson's January 11 letter, expressing disappointment with the price of the General Electric cars, reports: "We have come across two other companies already in production on vehicles of various sorts. Most of the models come with accessories such as canvas or plastic roofs. If Troia [were to place] an order for a few hundred, I am sure that we could arrange for all kinds of modifications such as rainproof enclosures, etc."

49. Nelson, undated memo (note 42 above).

50. The agreement to retain Constantine was part of the contract offered to Nelson on September 11, 1964. She visited museums and shops in 19 Portuguese cities and villages.

51. Nelson, letter to Max Feldman, January 22, 1965.

52. Henrique Mindlin, telegram to Nelson, March 10, 1965: PROJECTO FINALLY APPROVED YOUR LAST LETTER RECEIVED EVERYTHING OK LETTER FOLLOWS REGARDS HENRIQUE. Nelson replied: DELIGHTED NEWS GOVERNMENT APPROVAL. PLANNING LISBON ARRIVAL APRIL SECOND. REGARDS. GEORGE NELSON.

53. Nelson, letter to Henrique Mindlin, October 12, 1965.

54. Nelson, letter to Hildegardo de Noronha-Filho, March 9, 1966.

55. Noronha, telegram to Nelson, received April 15, 1966.

56. Noronha, letter to Nelson, April 14, 1966.

57. Nelson, "The Hidden City," *Architecture Plus*, November-December, 1974; reprinted in *George Nelson on Design* (Whitney Library of Design, 1979).

58. Nelson, "The Two-Hour City, or Out of the Mouths of Babes and Sucklings," unpublished article dated 1975.

59. Ibid.

60. Nelson, "The City as Mirror and Mask," in *MAN transFORMS* (Cooper-Hewitt Museum, 1976).

61. Nelson, *How To See: Visual Adventures in a World God Never Made* (Little, Brown, 1977).

62. *The Creative Experience,* ed. Stanley Rosner and Lawrence E. Abt (Grossman, 1970), p. 261.

63. Laszlo Moholy-Nagy, quoted in Sibyl Moholy-Nagy, *Moholy-Nagy: Experiment in Totality* (Harper, 1950).

64. It might have been the Springs house of the sculptor Costantino Nivola, where Le Corbusier painted some murals c. 1950.

65. If this was at Nivola's beach house, Le Corbusier might have been trying his hand at sandcast plaster sculptures, a technique much used by Nivola.

66. "Changing the World" (see note 42 to chapter 2 above).

67. "Architecture for the New Itinerants," *Saturday Review,* April 22, 1967.

68. Nelson, "Transformations and Contradictions," delivered at the University of Michigan, Ann Arbor, March 14, 1984; published in *Interior Design,* September 1984.

Chapter 9: The Office

1. Its progeny (such as the Hille Storage Wall System, introduced in Great Britain in 1963) would play a far greater role in subdividing the wide-open spaces of the postwar commercial interior.

2. It was described as "a take-off on Miller's Comprehensive Storage System" by *Home Furnishings Daily* (February 27, 1961).

3. As had the desk designed by Frank Lloyd Wright for his 1936 Johnson Wax headquarters in Racine and manufactured by Steelcase.

4. "The Office Revolution," in *George Nelson on Design* (Whitney Library of Design, 1979), p. 154.

5. Claud Bunyard, "Office Design in the USA," in *Design* (London), May 1984.

6. Lance Knobel, *Office Furniture: Twentieth-Century Design* (Dutton, 1987). See also *Interiors,* December 1950.

7. Undated transcript of a Nelson speech delivered in Philadelphia, sent to the author by Rolf Fehlbaum.

8. These began with a plan for 250 Buch & Tom workers at Gütersloh in 1961 and another for 1000 Krupp workers at Essen in 1962. For a history of open planning, from which this information is taken, see John Pile, *Open Office Planning* (Whitney Library of Design, 1978).

9. In 1967 for the Freon division of E. I. duPont de Nemours in Wilmington, Delaware; in 1968 for Kodak in Rochester, New York.

10. Nelson, "The Office Revolution" (note 4 above), p. 154.

11. By the mid 1960s, however, the fishbone connector had become part of the Herman Miller construction vocabulary.

12. Ralph Caplan, "Robert Propst," in Nelson Eames Girard Propst: The Design Process at Herman Miller, *Design Quarterly* 98/99 (Walker Art Center, 1975), p. 43

13. Mina Hamilton, "Herman Miller in Action," *Industrial Design,* January 1965.

14. William K. Zinsser describes the research survey in "But Where Will I Keep My Movie Magazines?" (*Saturday Evening Post,* undated clipping, c. late 1964).

15. The researchers did not, reportedly, learn of the German office landscape experiments (Hamilton, "Herman Miller in Action"); however, they must have noted, in connection with their study of office storage, the 1961 introduction, by modern furniture rival Knoll, Inc., of executive table desks—some of them round, some oval—that had no storage capacity at all, not even a stationery drawer. "I started eliminating the storage boxes attached to executive desks," Florence Knoll explained, "when I discovered that most executives didn't need them. Their main activity involved conferences." (*A Modern Consciousness: D. J. De Pree, Florence Knoll* [Smithsonian Institution Press, 1975])

16. "Herman Miller's 'Action Office,'" *Interior Design,* December 1964.

17. "The Herman Miller Action Office," *Interiors,* December 1964.

18. Nelson, "Notes on the Office" (April 2, 1982), a report sent to Arthur Gensler of Gensler Associates. Gensler is the founding principal of Gensler & Associates, Architects, with major offices in San Francisco, Los Angeles, New York, Houston, Denver, Washington, and London, and with a high reputation (as well as the country's highest volume) in commercial interior design. Nelson visited several of its offices, giving criticism on specific projects and advising Gensler about longer-range development as well.

19. "The Herman Miller Action Office" (note 17 above).

20. Zinsser, "But Where Will I Keep My Movie Magazines?" (note 14 above).

21. One of Nelson's first memos to the Herman Miller company, written in the summer of 1945, had proposed "for future consideration . . . the possibility of using some material other than wood as a desk surface."

22. Archizoom Associati and Superstudio would be established in Florence in 1966, Milton Glaser's poster of a rainbow-haired Bob Dylan would be an icon of 1967, and the animated Beatles film *Yellow Submarine* would be a hit of 1968.

23. Hamilton, "Herman Miller in Action" (note 13 above).

24. "An Agreeable Office," *Esquire,* December 1964.

25. "Office Furniture Tailored to the Job," *Business Week,* December 19, 1964.

26. Zinsser (note 14 above). For other enthusiastic reports see *New York Times,* November 23, 1964; *New York Herald Tribune,* November 23, 1964; *Interior Design,* December 1964; *Interiors,* December 1964.

27. Nelson, quoted in *New York Herald Tribune,* November 23, 1964.

28. At the end of 1958, Nelson had sent the company a 16-page report remarking that "the manufacture and sale of furniture for home use is no longer an important part of the Herman Miller business," but that this development was insufficiently recognized, so that "no action has been taken either to reverse this change or to adapt to it." The report continued with concrete suggestions for bringing "the mental picture on which we all operate" and the reality of the company's situation closer together.

29. A company breakdown by market of total orders for fiscal year 1974–75 reads: Office 64.7%; Health/Science 13.8%; Educational 6.2%; Government 13.7%; Airport/Airline 1.6%. In more recent years, however, many of the residential "classics" of Nelson, Eames, and Noguchi have been restored to the line.

30. Ronald Beckman cited the relationship in an interview with the author (New York, December 11, 1990).

31. Ibid.

32. "Design Display," *Progressive Architecture,* September 1966.

33. The "Skiddable Walls" system, also called "Hybrid Walls," was patented under the names of Ronald Beckman and Robert Propst.

34. Beckman, quoted in Lou Gropp's "Design Tempo" column, *Home Furnishings Daily,* January 3, 1966. The installation was also reported by C. Ray Smith in *Progressive Architecture* (August 1966).

35. Interview with Joe Schwartz, Marigold Lodge, Holland, Michigan, April 3, 1990.

36. Nelson, letter to Robert Blaich, January 4, 1970.

37. Interview with John Berry of Herman Miller, Los Angeles, March 18, 1993.
 Another measure of the success of Action Office 2 was imitation. The most distinguished among its early imitators (each of which added something) were Sistema 45, designed by Ettore Sottsass, Jr., for Olivetti (1969); the Stephens system, manufactured by Knoll in accordance with a program specified by Charles Pfister of Skidmore, Owings &

Merrill for the Weyerhauser Corporation's headquarters in Tacoma (opened in 1971); and the TRM (task response module) system, designed about the same time by William Pulgram for the McDonald's Corp. and manufactured by J. M. Eppinger, who had been at Herman Miller when Nelson was hired. The parade of introductions continued through the affluent 1980s, the year 1986 seeing the unveiling of the 9-to-5 system (designed by Richard Sapper for Castelli), the basically free-standing Nomos system (by Norman Foster for Tecno), and the Ethospace system (by Bill Stumpf for Herman Miller).

38. Later a founding partner of Kohn Pedersen Fox, architects, and of Kohn Pedersen Fox Conway, interior designers.

39. Olga Gueft, "Nelson Workspaces," *Interiors,* May 1977.

40. Ibid.

41. Nelson, letter to Theo Crosby, November 6, 1973. Later, Nelson had this to say: "Here's this space in which you could probably build two nuclear submarines at the same time, which is very impressive, but what they do there is process insurance applications. The lesson in this is that the designers of buildings and the designers of work spaces inside should get together at an earlier stage." ("Design and the Office in Transition—Part 1," in *Ideas* [Herman Miller, 1979])

42. Nelson, "Winners and Losers," *Interior Design,* May 1984.

43. "The Open Landscape Office," in Nelson Workspaces, a promotional booklet published by Storwal International of Toronto around 1977. Although unsigned, it reads as if written by Nelson.

44. "The plant or tree outside the worker's space is company property, company maintained. But for the plants in your workspace you can buy any seedlings you want, and if they die it's your own fault. This is your own private garden." (Gueft, "Nelson Workspaces" [note 39 above])

45. Gueft, "Nelson Workspces."

46. Ibid.

47. There are recent indications that Herman Miller may have come to agree with Nelson. One of these is the option of "windows" (though without blinds) in Miller's highly flexible Ethospace system of 1986. More recently, reporting on new office furniture design for Miller by Geoff Hollington, Hugh Aldersey-Williams has written: "The Hollington chair and the Relay furniture line indicate Herman Miller's intent to devote proportionally less of its resources to the once revolutionary, though now conventional, office systems that made its name through the 1970s and 1980s, and more to individual articles. Pieces of furniture rather than parts of systems, in other words. Inescapably mixed in with this

change is a sense of return to the glory days of Eames and Nelson, who designed the classic articles of furniture that made Herman Miller's reputation before the advent of the systems office." (*International Design* [formerly *Industrial Design*], September-October 1990)

48. From the rough minutes of a meeting held in Zeeland in late February of 1978 (present were Nelson, Ralph Caplan, Tom Pratt, Hugh De Pree, and Glenn Walters) and from Nelson's handwritten notes of the following month.

49. Nelson, letter to Hugh De Pree, March 29, 1979.

50. Nelson, "Notes on the Pad," July 14, 1978 (found among Nelson's office papers).

51. Ibid.

52. The shared office (the idea of which is that workers can check into an office of identical workstations just as travelers check into a hotel of identical rooms) is receiving new attention as this is being written.

53. Nelson, "Notes on the Office," April 2, 1982 (see note 18 above).

54. In a letter to the author, dated November 11, 1983, Nelson proposed writing a two-part article for *Interior Design,* to be called "Toward a Theory of the Workplace," and added: "It seems possible that there is a book here."

55. Pratt was Herman Miller's Senior Vice-president for Research and Design.

56. Nelson, undated letter to Tom Pratt (part of the "Goldenrod" correspondence). (Nelson and Pratt referred to their correspondence as Goldenrod because it was generally typed on common yellow paper. Goldenrod, Nelson said, was "composed of (a) wrong thoughts, (b) written down on the wrong paper. It is at least as important as Parkinson's Law and the Peter Principle." [letter to Pratt, March 23, 1984])

57. "Notes on the Office."

58. Ibid.

59. Nelson, "Theory of the Workplace, Introductory" (undated manuscript, probably ca. 1984).

60. "Notes on the Office" (Nelson's italics).

61. Nelson, "Transformations and Contradictions," delivered at the University of Michigan, Ann Arbor, March 14, 1984; published in *Interior Design,* September 1984.

62. Interview with Jacqueline Nelson, New York, July 12, 1990.

63. Nelson, letter to Tom Pratt, February 11, 1986.

Chapter 10: Common Themes

1. Nelson, "Theory of the Workplace" (undated manscript, probably ca. 1984).

2. Nelson, "Who Designs?," *Interior Design,* May 1986. The text was based on a lecture Nelson had given in the Art et Industrie showroom in New York the previous October. He had also lectured on a similar subject in Tokyo in July 1985.

3. Denise Scott Brown, letter to the author, January 1992. The exact source is forgotten.

4. Nelson, "Design on a Small Planet," *Industrial Design,* November-December 1983.

5. Nelson, "Design and the Office in Transition—Part 1," in *Ideas* [Herman Miller, 1979])

6. Nelson, undated text, possibly a tentative chapter for *The Synthetic Garden.*

7. Frank Lloyd Wright, *Genius and the Mobocracy* (Horizon, 1949).

8. Nelson, "Reflections on Home-Psych," *Interior Design,* March 1984.

9. Nelson, letter to Pratt, July 11, 1985.

10. "Who Designs?" (note 2 above).

11. Nelson, "Design on a Small Planet," *Industrial Design,* November-December 1983 (Nelson's italics).

12. Richard Sennett, *The Uses of Disorder: Personal Identity and City Life* (Vintage, 1970).

Index